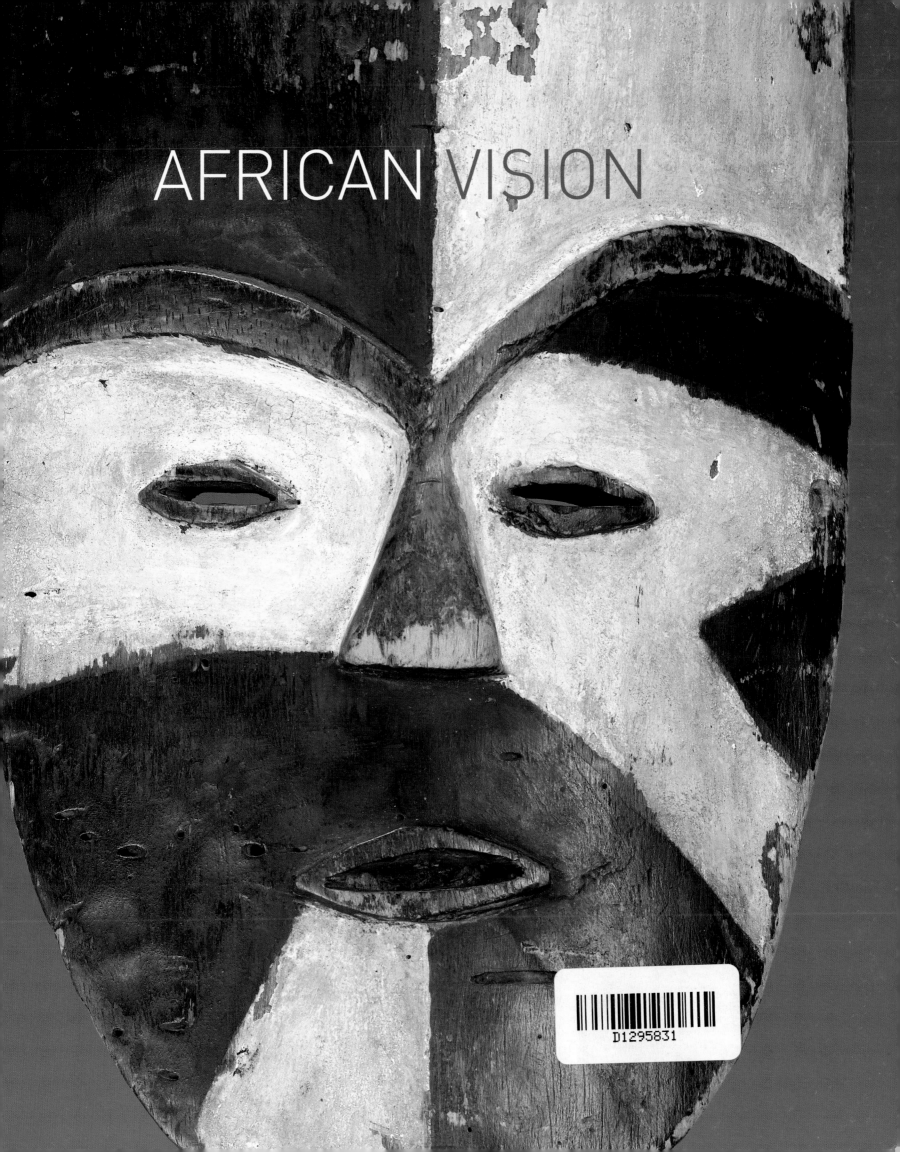

AFRICAN VISION

AFRICAN

Christine Mullen Kreamer

with contributions by Bryna Freyer & Andrea Nicolls

Introduction by Martin A. Sklar

VISION

The Walt Disney–
Tishman African
Art Collection

Smithsonian
National Museum of African Art

PRESTEL

MUNICH BERLIN LONDON NEW YORK

Published in conjunction with the exhibition *African Vision: The Walt Disney-Tishman African Art Collection,* organized by the National Museum of African Art, Smithsonian Institution, February 15, 2007–September 7, 2008.

Library of Congress Control Number: 2007 920 968

British Library Cataloguing-in-Publication Data is available from the British Library; the Deutsche Bibliothek holds a record of this publication in the Deutsche Nationalbibliografie; detailed bibliographical data can be found under: http://dnb.ddb.de

Prestel Verlag
Königinstrasse 9, D-80539 Munich
Tel. +49 (89) 38 17 09-0; Fax +49 (89) 38 17 09-35

Prestel Publishing Ltd.
4, Bloomsbury Place, London WC1A 2QA
Tel. +44 (020) 7323-5004; Fax +44 (020) 7636-8004

Prestel Publishing
900 Broadway. Suite 603, New York, N.Y. 10003
Tel. +1 (212) 995-2720; Fax +1 (212) 995-2733

www.prestel.com

Prestel books are available worldwide. Please contact your nearest bookseller or one of the above addresses for information concerning your local distributor.

National Museum of African Art
Publication direction by Migs Grove
Designed by Lisa Buck Vann
Map by DongWook Rho
Manuscript edited by Stephen Robert Frankel

Prestel Publishing
Editorial direction by Christopher Lyon
Production by René Güttler
Origination by Reproline mediateam, Munich
Printed by Aumüller Druck GmbH & Co. KG, Regensburg
Bound by Conzella Verlagsbuchbinderei GmbH & Co. KG, Aschheim

The paper used in this publication meets the minimum requirements of American National Standard for Information Sciences—Permanence of Paper for Printed Library Materials, ANSI Z39.48-1984

ISBN 978-3-7913-3802-6 (trade edition)
ISBN 978-3-7913-6114-7 (museum edition)

PHOTOGRAPHY CREDITS

Photography by Franko Khoury, unless otherwise noted.
Walt Disney Imagineering Collection, © Disney: pgs. 2–3; 16–17
Jess Allen, © Disney: pgs. 14, 18
© Musée du quai Branly: Hughes Dubois: pg. 28
William B, Fagg: pg. 31, courtesy Royal Anthropological Institute, London
Jerry L. Thompson: pgs. 57; 103 (fig. 28); 107, courtesy Metropolitan Museum of Art
Eliot Elisofon Photographic Archives, National Museum of African Art: pgs. 100, 115, 118
Martha G. Anderson: pg. 110 (fig. 40)
Robert Pringle: pg. 113

Cover
Mask (detail)
Boki peoples, middle Cross River region, Nigeria
Cat. no. 77

Back cover
Mask (detail)
Nuna peoples, Burkina Faso
Cat. no. 45

Page i
Mask (detail)
Tsogo peoples, Ogowe River region, Gabon
Cat. no. 25

Pages ii–iii
Mask
Nuna peoples, Burkina Faso
Cat. no. 45

Pages vi–vii
Bowl with figures (detail)
Artist: Olowe of Ise (c. 1875–c. 1938)
Yoruba peoples, Ekiti region, Nigeria
Cat. no. 10

Mask
Benin kingdom court style, Edo peoples, Nigeria
Cat. no. 2

Page viii–ix
Door (detail)
Workshop of Yalokone
Northern Senufo peoples, Boundiali, Côte d'Ivoire
Cat. no. 12

Page xii–xiii
Crown (detail)
Yoruba peoples, Ekiti region, Ikere, Nigeria
Cat. no. 69

Page xx
Veranda post (detail)
Yoruba peoples, Ekiti region, Nigeria
Cat. no. 4

Page 6
Female figure (detail)
Benin kingdom court style, Edo peoples, Nigeria
Cat. no. 1

Page 52
Male figure (detail)
Bembe peoples, Republic of the Congo
Cat. no. 27

Page 98–99
Mask (detail)
Attributed to Takim Eyuk (died c. 1915)
Akparabong peoples, Cross River region, Nigeria
Cat. no. 78

Page 228
Male figure (detail)
Hemba peoples, Niembo chiefdom, Democratic Republic of the Congo
Cat. no. 40

How does one fall in love?

—Paul Tishman

Contents

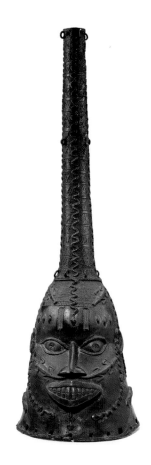

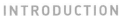

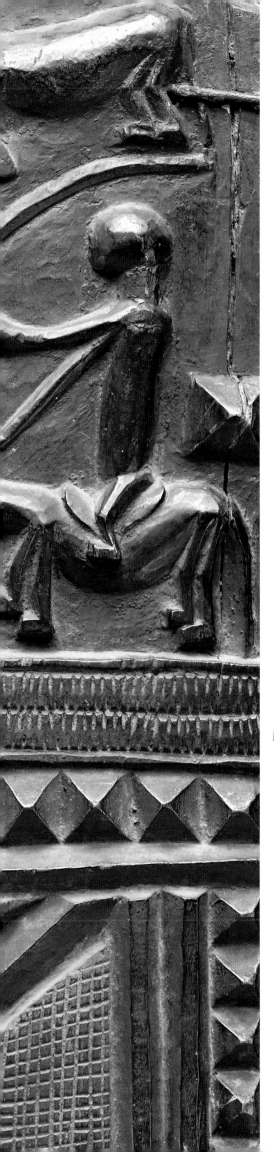

Foreword

THIS EXHIBITION and publication mark an important moment for the National Museum of African Art. The museum's tradition has been to exhibit selected works from its permanent collection organized around specific themes, such as *Images of Power and Identity* and *The Art of the Personal Object,* both of which have been on display for more than 10 years. Now, in 2007, in refurbished galleries, we present a recent major addition to the collection: the Walt Disney-Tishman African Art Collection.

It is one of the largest gifts ever given to the museum, with more than 500 works representing the African continent—west, central, east, and southern

Africa—dating from the 15th to the 20th century. Paul and Ruth Tishman, during the mid- to late 20th century, assembled an eclectic, remarkable collection that defies easy categorization, yet reflects their intellectual curiosity, visual bravado, and intuitiveness. The works in the Walt Disney-Tishman Collection display a breadth and variety of styles and imagery, mostly the human figure, rarely seen in private collections of African art in the United States today. The gift was announced in autumn 2005 by Michael D. Eisner, then chief executive officer of the Walt Disney Company.

The exhibition and its catalogue resulted from the efforts of two individuals, Bryna Freyer and Christine Mullen Kreamer. Freyer, curator of the exhibition, and Mullen Kreamer, combined their respective talents to present insights on the collecting efforts of Paul and Ruth Tishman.

Mullen Kreamer, who organized and wrote the thematic essays in this publication, acts as a guide to the collection while enriching our appreciation of cultures that few know about or understand. Here, she has provided an introduction to the collection and the history of African art, followed by a succinct discussion about the interface between art and history, and art's representation of philosophy, humanism and traditional society.

I am especially pleased to include the anecdotal essay of Martin A. (Marty) Sklar, executive vice president, Imagineering ambassador, Walt Disney Imagineering, who had a close friendship with Walt Disney and Paul Tishman, and is still close with Paul's nephew, John Tishman, and with museum founder Warren M. Robbins. Marty reveals Paul's vision, which was to educate the public about Africa through its art. We honor Paul Tishman's foresight with this inaugural exhibition and this publication.

The success of this project reflects the efforts of the dedicated individuals on the staff of the museum. Of particular note are Christine Mullen Kreamer, Bryna Freyer, and Andrea Nicolls, curators; Julie Haifley, registrar; and conservators Steve Mellor and Stephanie Hornbeck. Through their work on the catalogue, graphic designer Lisa Buck Vann and photographer Franko Khoury prove that design and imagery enhance our reading experience. I would also like to acknowledge the efforts of Migs Grove, editor, and Alan Knezevich, associate director for facilities, operations, and exhibitions, whose staff made this show exemplary. Ned Rifkin, under secretary for art, and Susan Talbott, director of

programs, policy, and planning, Smithsonian Arts, ensured that the project stayed on track during my absence.

Pivotal to the entire project is the gift of the Walt Disney-Tishman African Art Collection. I am therefore particularly grateful to Lawrence M. Small, secretary of the Smithsonian, and Jane Eisner, chair, Smithsonian National Board, whose persuasive skills and foresight delivered a national treasure to the Smithsonian Institution. I would also like to express my appreciation to Ms. Shirley Shapiro and the Robert T. Wall Family, whose generous contributions to the National Museum of African Art made this publication possible.

Sharon F. Patton, Ph.D.
Director, National Museum of African Art
Smithsonian Institution

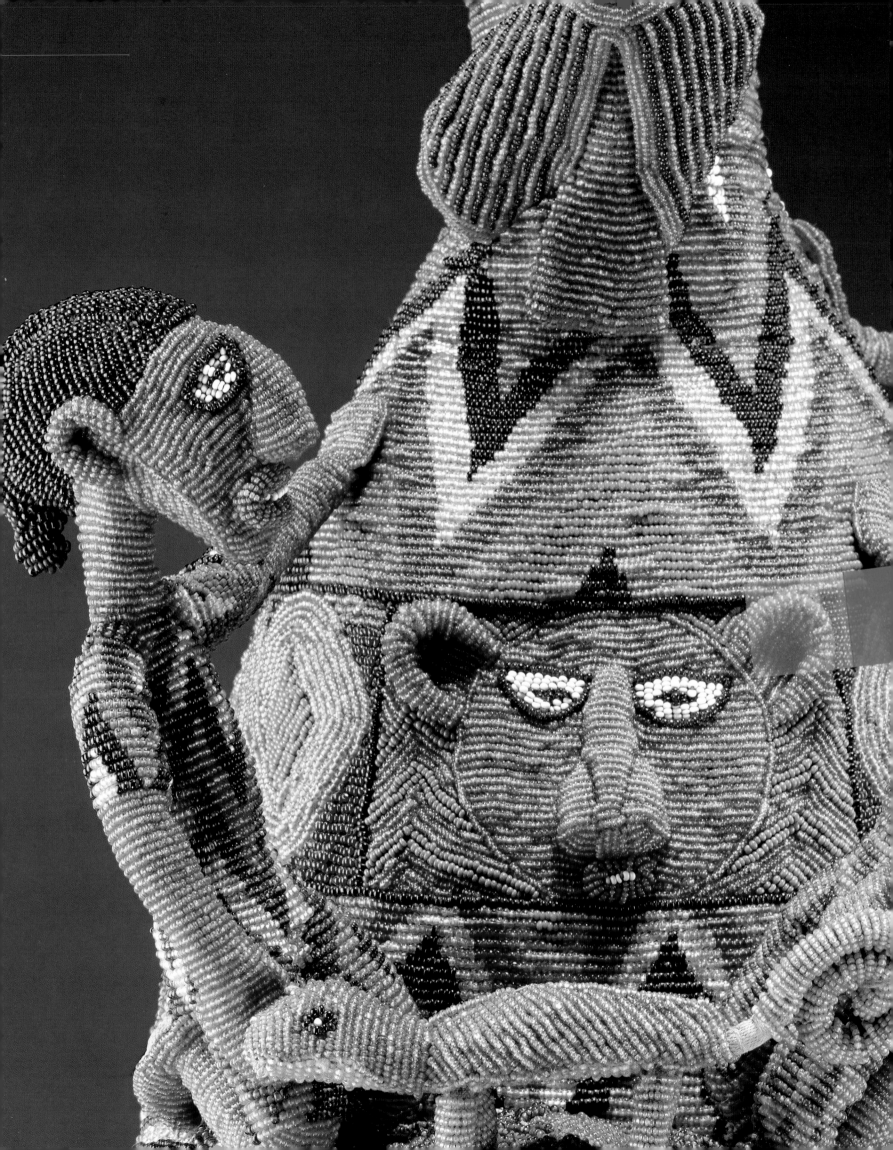

Acknowledgments

WHEN THE Walt Disney-Tishman African Art Collection was donated in 2005 to the National Museum of African Art, it was a dream come true for us, the curators. Rarely in a curator's professional life can one expect to be the custodian of a major collection that has played such an iconic, central role in the study of art history. With reverence and delight, we eagerly embraced the task of working with, and handling, works of art that had become familiar companions during our graduate-school years by our continual study of

the seminal publications that had focused on the collection. By the time these works arrived at the museum, they were old friends who had come home to us and to the care we would gladly provide. It became second nature for us to consult—through their important early publications on the Tishman Collection—Jacqueline Delange, Roy Sieber, Arnold Rubin, and Susan Vogel. We took special delight in discerning something new in such well-known and well-illustrated works: not one, but two Isoko *ivri* figures (cat. no. 36); the finger-painted red, black, and white dots on the interior of the Dogon stool (cat. no. 31); the richly textured surface of the Yoruba *epa* mask (cat. no 13); or the puzzling lack of beadwork on the soles of the kneeling figures adorning the Yoruba beaded crown (cat. no. 69). We relished the task of reconsidering attributions, revising dates, and reframing this venerable collection in ways that would contribute something new to our appreciation of it. And, of course, we look forward to continuing and publishing our research on the extraordinary works in the collection, in hopes of deepening our understanding of Africa's diverse cultures and the continent's rich artistic heritage.

It was an enormous, but joyful, undertaking to bring the Walt Disney-Tishman Collection to the National Museum of African Art and to prepare both a major exhibition and its accompanying publication. The efforts of many individuals contributed to the success of this work. First of all, we would like to thank Lawrence Small, secretary of the Smithsonian Institution, for his sustained efforts in promoting public awareness of the donation of the Walt Disney-Tishman Collection to the National Museum of African Art. Ned Rifkin, under secretary for art, and Susan Talbott, director of the programs, policy and planning, Smithsonian Arts, have consistently encouraged our work at the museum and provided invaluable assistance. Within the museum, Sharon Patton, director, Alan Knezevich, associate director, Cora Shores, administrative officer, and Holly Laffoon, staff assistant to the director, provided essential administrative support and oversight throughout the project. We are also grateful to the members of the museum's board for their enthusiastic support of all our undertakings.

Two former staff members of the National Museum of African Art, David Binkley (chief curator) and Roslyn A. Walker (director), played key roles in strengthening the museum's ties with the Walt Disney Company in the years preceding the donation of the Walt Disney-Tishman Collection. David, in particular, worked closely with Van Romans, who at the time was executive director of

cultural affairs at Walt Disney Imagineering, to secure long-term loans of major works of art from the collection.

Our work with the collection was greatly aided by various individuals from the Walt Disney Company. We are very grateful to the warm welcome and helpful assistance offered by staff members of Walt Disney Imagineering as we researched, packed, and shipped the collection to our museum, especially Michael Jusko, principal art archivist, Teri E. Long, manager of exhibitions, James Clark, ambassador representative, and Kristen McCormick, former curator. We also extend our thanks to Martin Sklar, executive vice president, Imagineering ambassador, for the moral and logistical support that he has provided throughout our work on this project, and for contributing an informative introduction to the collection for this catalogue.

It is a pleasure to acknowledge the contributions of the staff of the National Museum of African Art, who worked together in realizing both this publication and the exhibition that it accompanies. Museum registrar Julie Haifley took the lead in facilitating the packing, shipping, and cataloguing of the collection when it moved from Glendale, California to Washington, D.C. She was assisted in this work by former staff member Heather Moore, intern Danielle Bennett, and contract registrar Pam Steele, along with exhibit specialists Don Llewellyn, Kevin Etherton, Kelly Houghton, and former staff member Jerry Jarvis. Chief conservator Steve Mellor and associate conservator Stephanie Hornbeck invested an enormous amount of time and expertise in examining those works slated for publication and exhibition, recommending and carrying out treatments, and advising on appropriate mounts for object photography and exhibition. They were assisted by objects conservator Dana Moffett. Master armature maker Keith Conway brings creativity and artistry to bear in his ingeniously crafted object mounts, which virtually disappear when an object is photographed yet display the objects safely and beautifully when they are on view. The outstanding object photography that graces this publication is the work of Franko Khoury, who brings an artist's eye to every photograph. Both Franko and Keith maintained a supportive, can-do attitude when confronted with last-minute requests for their assistance. Amy Staples, senior archivist of the Eliot Elisofon Photographic Archives, played a critical role in managing all the object and contextual photographs in this publication; and she was assisted by Kareen Gualtieri. Helpful information on specific objects was contributed by our Education

Department, led by curator Veronika Jenke, and assisted by Crystal Campbell and Katherine Robinson Catoe, and by the research of docent Ramirez de Rallena. Sherrie White cheerfully provided critical computer support throughout, and technical support was provided by Doug Johnston and James Minor. Curatorial research was greatly assisted by the unflagging efforts of chief librarian Janet Stanley, whose scholarly expertise has resulted in an unparalleled resource for the study of African art—the collections of the Warren M. Robbins Library. Janet was ably assisted by Karen Brown. Jeremy Jelenfy, David Hsu, and former intern Dong Wook Rho provided production assistance on the catalogue, and Stephen Robert Frankel edited the manuscript. We are grateful to Kim Mayfield, Anita Henri, and Michael Briggs for their efforts to promote both the publication and the exhibition in print, on the Web, and through our membership. Finally, special recognition is due to Migs Grove, editor and publications director, who oversaw all editorial work on the catalogue, and to Lisa Buck Vann, design and production manager, who designed this beautiful publication. Above and beyond the call of duty is the only way to summarize the commitment that Migs and Lisa made to this book, which was completed in record time.

Our pleasure in working with the Walt Disney-Tishman African Art Collection has been greatly enhanced by the support of many colleagues, without whose help this publication could not have been realized. The list of scholars who so generously shared their expertise with us is long, reflecting the spirit of collegiality and cooperation that characterizes our field of African art history. We are especially grateful to Allyson Purpura for her valuable comments on earlier versions of the catalogue essays. We would also like to acknowledge the generous and enthusiastic support of Doran Ross, who graciously commented on the book prospectus and shared with us his extensive files and images accumulated over the many years that he worked with the Walt Disney-Tishman Collection. In addition—and with hopes that we haven't failed to mention someone—we would like to thank Rowland Abiodun, Martha Anderson, Mark Auslander, Barbara Blackmun, Jonathan Coddington, Herbert Cole, Kathy Curnow, William Dewey, Henry Drewal, Kate Ezra, Sarah Fee, Marc Leo Felix, Perkins Foss, Barbara Frank, Christraud Geary, Rick Huntington, Sidney Kasfir, Judith Knight, Alisa LaGamma, John Mack, Karel Nel, Simon Ottenberg, Philip Peek, John Pemberton, Robin Poynor, Allen Roberts, Mary (Polly) Nooter Roberts, Christopher Roy, Robert Farris Thompson, Monica Blackmun Visonà, Susan

Vogel, Rick West, and Jonathan Zilberg. Photographer Jerry L. Thompson and Virginia-Lee Webb, research curator, Department of the Arts of Africa, Oceania, and the Americas at the Metropolitan Museum of Art, were very generous in supplying photographs of selected works in the Walt Disney-Tishman Collection.

Over the course of the project, we benefited from the outstanding support of interns Stephanie Beck, Julie Geschwind, and Amanda Shoemaker, all of whom conducted object-based research toward the catalogue and the exhibition. This book would not have been completed without their help.

To the people of Africa, whose arts so inspire us, whose hospitality has sustained us in our work, we remain forever indebted.

Christine Mullen Kreamer
Bryna Freyer
Andrea Nicolls

EUROPE

ASIA

North Sea

Baltic Sea

Black Sea

Caspian Sea

Strait of Gibraltar

Algiers

Tunis

Mediterranean Sea

TUNISIA

Rabat

MOROCCO

Tripoli

Cairo

ALGERIA

LIBYA

EGYPT

WESTERN SAHARA (MOROCCO)

S A H A R A

Lake Nasser

Nile River

Red Sea

CAPE VERDE

MAURITANIA

MALI

NIGER

Niger River

CHAD

SUDAN

Khartoum

Blue Nile

Asmara

ERITREA

DJIBOUTI

Nouakchott

Senegal River

Praia

Dakar

SENEGAL

Niamey

BURKINA FASO

Lake Chad

White Nile

Djibouti

Banjul

Bamako

Ouagadougou

N'Djamena

SOMALIA

GAMBIA

GUINEA

Conakry

BENIN

NIGERIA

Addis Ababa

Bissau

GUINEA-BISSAU

CÔTE D'IVOIRE

TOGO

GHANA

Abuja

Benue River

CENTRAL AFRICAN REPUBLIC

ETHIOPIA

Freetown

Yamoussoukro

Porto-Novo

CAMEROON

Bangui

SIERRA LEONE

Accra

Lomé

Yaoundé

Uele River

Lake Albert

UGANDA

Lake Turkana

Monrovia

EQUATORIAL GUINEA

Malabo

Ubangi River

Congo River

Kampala

KENYA

Mogadishu

LIBERIA

São Tomé

Libreville

REP. OF CONGO

DEMOCRATIC REPUBLIC OF CONGO

RWANDA

Kigali

Nairobi

SEYCHELLES

SÃO TOMÉ AND PRINCIPE

GABON

Lake Victoria

Victoria

CABINDA (ANGOLA)

Brazzaville

Kasai River

BURUNDI

Bujumbura

Dodoma

ZANZIBAR

Kinshasa

Lake Tanganyika

Dar es Salaam

Luanda

Cuanza River

TANZANIA

COMOROS

ANGOLA

MALAWI

Moroni

ATLANTIC OCEAN

Cubango River

Zambezi River

ZAMBIA

Lusaka

Lilongwe

Lake Malawi

Mozambique Channel

Antananarivo

MAURITIUS

Port Louis

Lake Kariba

Harare

MOZAMBIQUE

NAMIBIA

BOTSWANA

ZIMBABWE

MADAGASCAR

Windhoek

Gaborone

Limpopo River

Pretoria

Maputo

RÉUNION (France)

Orange River

Maseru

Mbabane

Bloemfontein

SWAZILAND

SOUTH AFRICA

LESOTHO

Cape Town

AFRICA

Cape of Good Hope

INDIAN OCEAN

✿ National capital

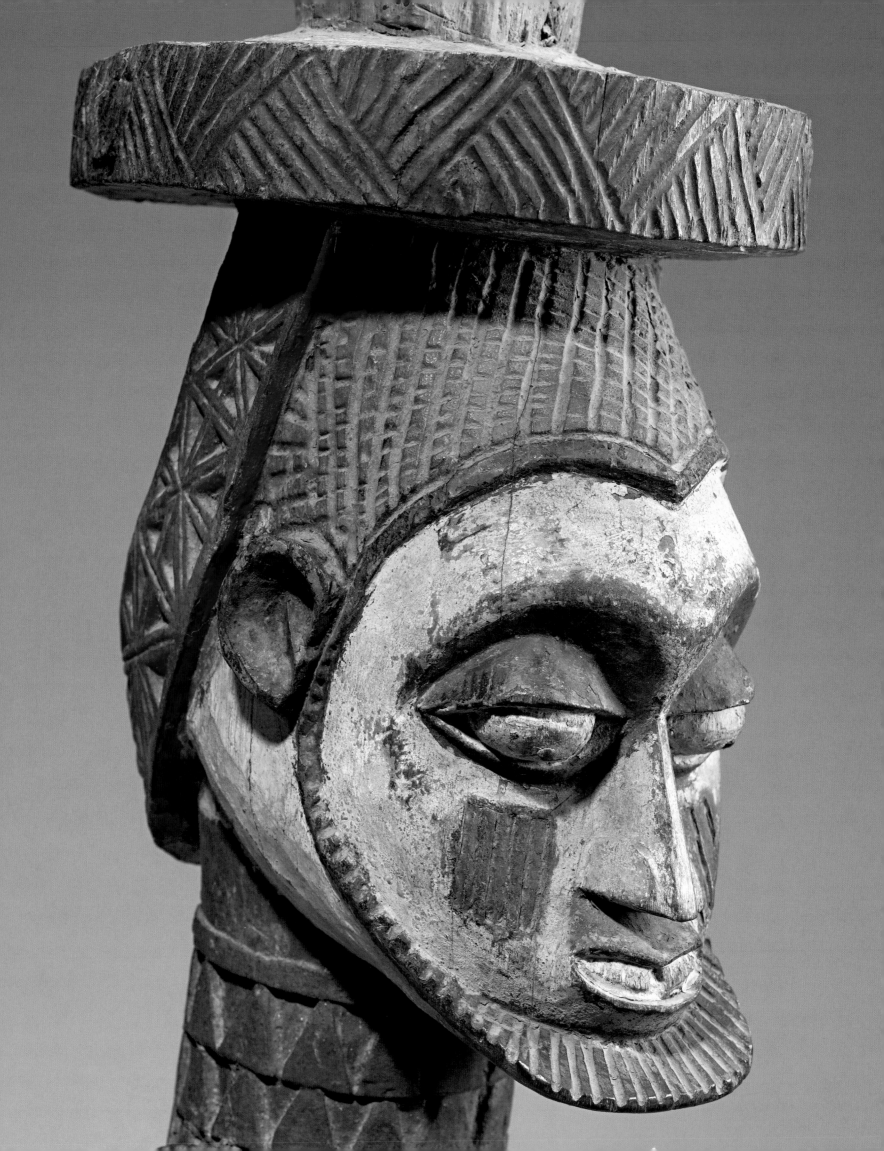

Guardians of an International Treasure: The Walt Disney–Tishman African Art Collection

Martin A. Sklar

EXECUTIVE VICE PRESIDENT

IMAGINEERING AMBASSADOR

WALT DISNEY IMAGINEERING

JOHN TISHMAN, the nephew of collectors Paul and Ruth Tishman, is not your ordinary developer and contractor. As chairman of Tishman Realty & Construction Company, he has led the construction (as developer/builder or owner) of such landmark projects as the original World Trade Center in New York and the Renaissance Center in Detroit. In addition, he has also been actively involved in educational and humanitarian endeavors, serving as chairman of the board of New School University in New York and a member of the Board of Directors for that same city's Museum for African Art, just to mention two of the institutions and organizations he has aided.

But it was the construction of a project far from New York that brought the professional Tishman and the family Tishman together with the Walt Disney Company and, ultimately, after a journey of 20-some years, resulted in the acquisition of the Walt Disney–Tishman African Art Collection by the Smithsonian Institution's National Museum of African Art.

I first saw some of the exquisite pieces from this collection in 1984 in the apartment on Sutton Place in New York where Paul and Ruth Tishman lived, and where these works of art were treated with enormous reverence and respect.

But Paul Tishman had a bigger plan for one of the world's greatest collections of African art in private hands. He and Ruth had begun collecting African art a quarter century earlier. Paul was intrigued by the sculptures' honesty and power, while Ruth noted their influence on modern art. Once, when they visited Pablo Picasso in his home in Mougins, France, Picasso related to them an insight that he had had about African art, which Paul often quoted: "C'est la verité," he said. "It is truth."

Although the Tishmans made several trips to remote regions of Africa during the late 1960s to see the origins of the works they owned, the bulk of their extensive collection was acquired over a period of 20 years from reputable galleries around the world. Eventually it grew to more than 500 pieces, and Paul and Ruth realized as they got older that it was important to assure an appropriate "home" for the work they loved so much. That is where the Walt Disney Company entered the picture.

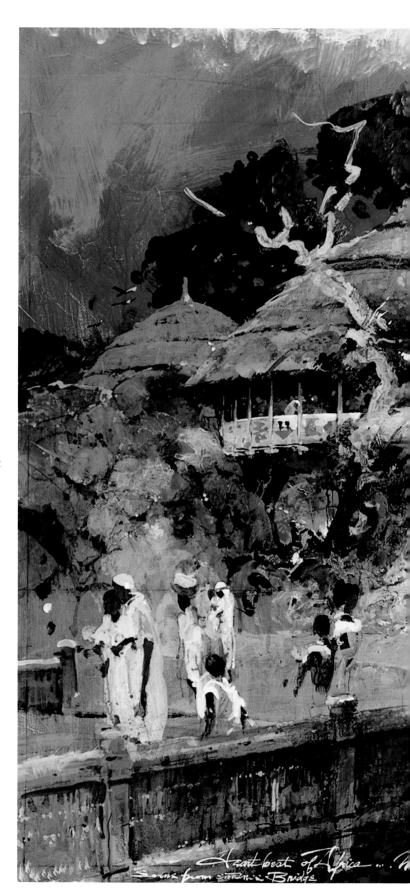

Interpretation for an Epcot pavilion representing the nations of central Africa. Artist: Herbert Ryman
© *Disney*

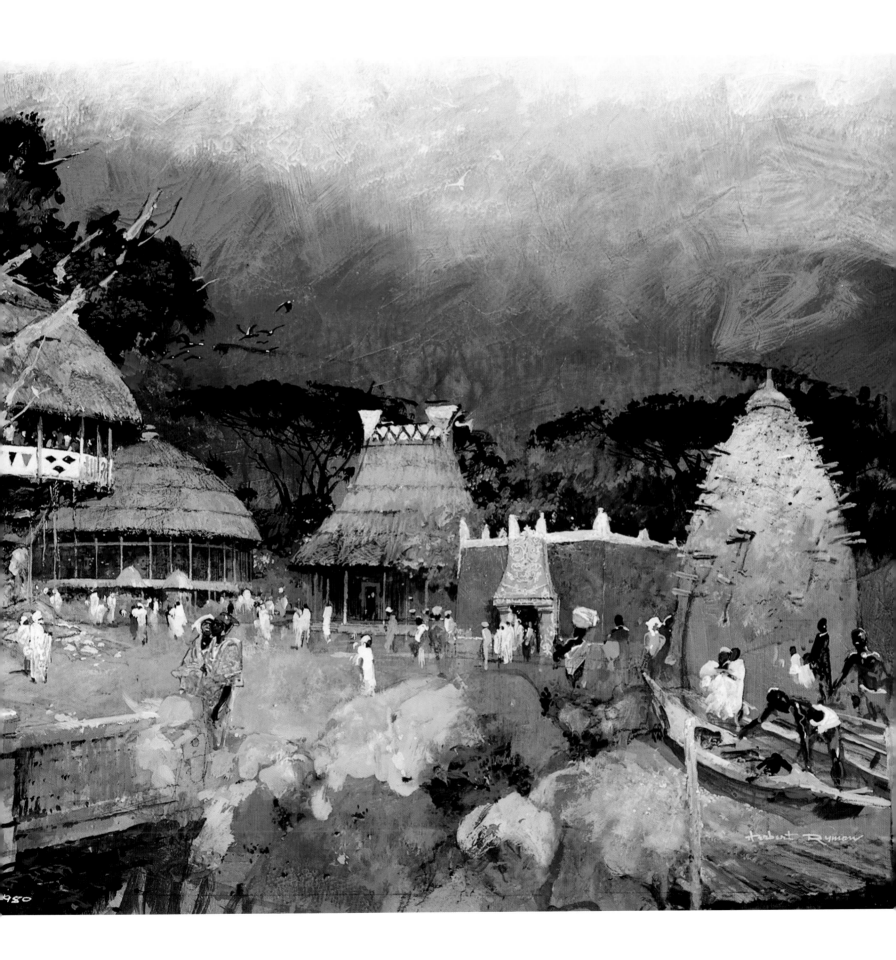

The last grand dream of Walt Disney was a concept he called Epcot: Experimental Prototype Community of Tomorrow. It was envisioned as the cornerstone of the development of Walt Disney World, the 28,000-acre property (twice the size of Manhattan Island) that Disney had acquired in the 1960s outside Orlando, Florida. I had the privilege of leading the Walt Disney Imagineering planning and design team who created Epcot—the largest project in the United States in the early 1980s—and the contractor who built it was John Tishman of New York.

At its opening in October 1982, Epcot consisted of two major areas, called "Future World" and "World Showcase." The latter included pavilions representing nine nations around the world, but our design team had created concepts for at least half a dozen more, with the hope of obtaining sponsorship to make any or all of them a reality. One of those concepts was for a pavilion representing countries and regions of the African continent.

Proud of his construction team's achievement (as I was of my Imagineering design team), John Tishman brought his uncle Paul to Epcot, and subsequently showed him the concepts we had developed for an African pavilion, working with *Roots* author Alex Haley as a key adviser. Paul was intrigued and excited by the conceptual work he saw, and the idea that the vast Epcot audience—more than 10 million visitors that first year—provided a potential opportunity to expose enormous numbers of people to the African art he loved. He offered to sell his collection to Disney, and in 1984 our company became its owner and guardian.

As fate would have it, the African pavilion would remain one of those dreams never realized. But the collection was never sequestered from public view. In fact, over the years, key pieces from the renamed Walt Disney-Tishman African Art Collection have been seen in more than 25 museums around the world, including the Metropolitan Museum of Art in New York, the Museé du Louvre in Paris, the Royal Academy in London and, of course, the Smithsonian Institution's National Museum of African Art.

Fulfilling in a certain respect Paul Tishman's original wish to share with the public the African art that he and Ruth had collected, an exhibition opened in 2004 entitled *Echoes of Africa*. It paired the works of contemporary African-American artists with traditional pieces from the Walt Disney-Tishman Collection, showing how traditional African art forms are recognized and reinter-

preted by today's artists in the West. The location? The American Adventure pavilion gallery in Epcot.

We at the Walt Disney Company are proud that this collection, with its permanent home here at the Smithsonian, will continue to play an important role in the world's understanding of African culture and history. African art lends itself naturally to the Disney way of storytelling, because the art itself is a story-telling medium. The Walt Disney-Tishman Collection comprises the works of more than 95 art-producing groups from 20 countries throughout sub-Saharan Africa, making it an ideal means of introducing the public to the arts of Africa. As a whole, the collection reveals part of the rich history of African art, from its emergence onto the European world stage at the end of the 1400s through the early decades of the 20th century. Every single object in the collection yields a small thread of cultural history; when woven together, the tapestry tells an impor-tant piece of the cultural story of sub-Saharan Africa.

The Walt Disney Company is so very pleased to have preserved this collection in its entirety, and now to make it available to the public in the most appropriate and significant venue in America dedicated to the research, conserva-tion, and exhibition of Africa's cultural history, and to increasing the public's awareness and understanding of that history. We are proud to play a key role in presenting this rich and complex story to current and future generations.

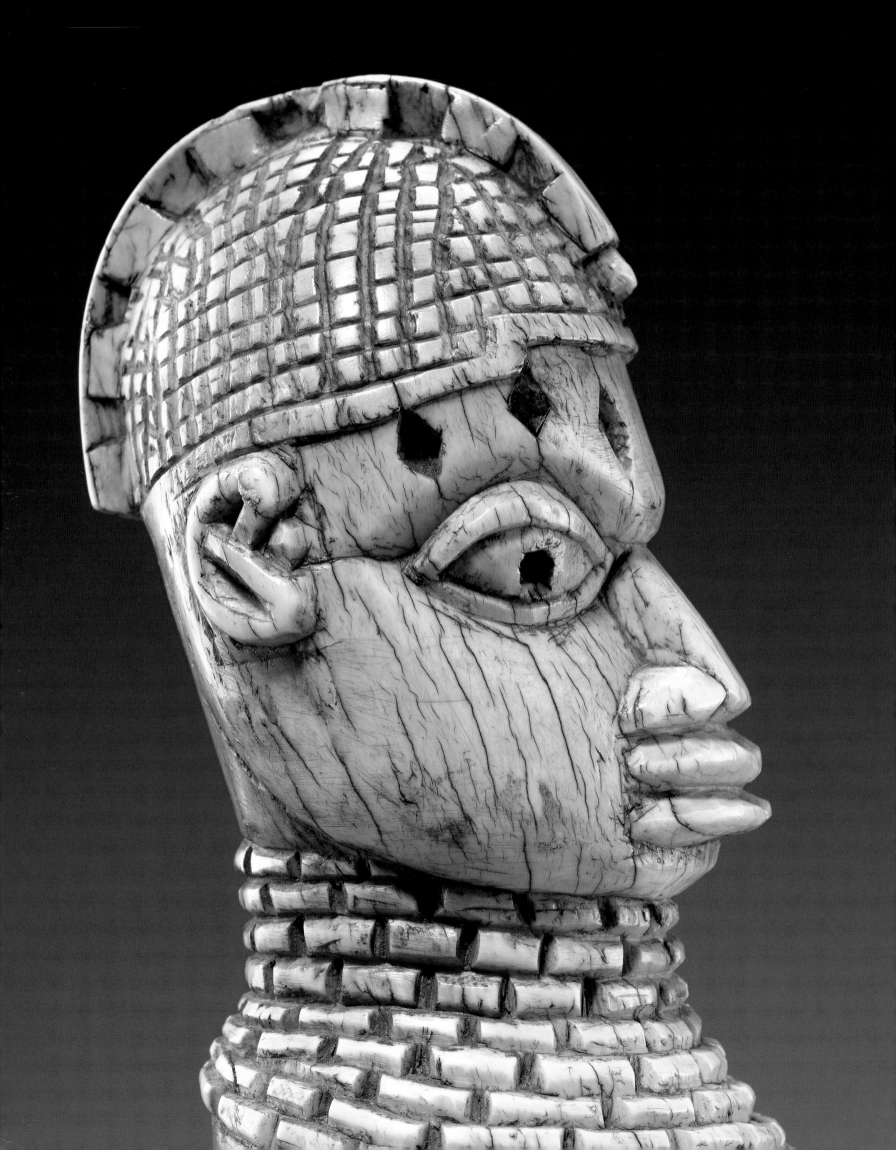

Defining the Discipline: African Art History and the Walt Disney-Tishman African Art Collection

Christine Mullen Kreamer

NE OF THE WORLD'S finest collections of African art—the Walt Disney-Tishman African Art Collection—was donated to the National Museum of African Art in 2005, a gift of Walt Disney World Co., a subsidiary of the Walt Disney Company. The collection, noted for unique and rare works of "traditional"[1] African art from throughout the continent south of the Sahara, has been instrumental in defining the field of African art history in the United States and abroad. Objects from the collection have been featured in scores of exhibitions and in a broad range of publications, including exhibition

catalogues, college textbooks, CD-ROMs, educational films, and encyclopedia entries. Thus, this collection not only traces the history of the discipline of African art history, but has also contributed significantly to both public and scholarly interest in the arts of Africa.

New York real-estate developer Paul Tishman and his wife, Ruth, acquired their first African sculptures for the collection in the late 1950s, purchasing two extraordinarily accomplished works: an ivory female figure (fig. 1) and a bronze mask (fig. 2), both produced by court artists from the Benin kingdom (present-day Nigeria). The confidence displayed by these early acquisitions continued over the next 20 years as the Tishmans expanded their collection. Primarily interested in masks and figurative sculptures—typical of collecting practice at that time—the

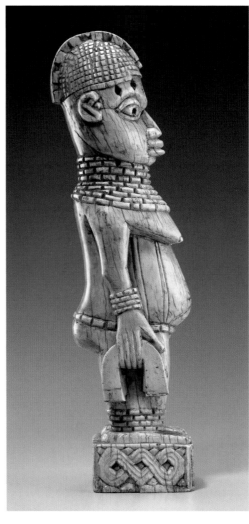

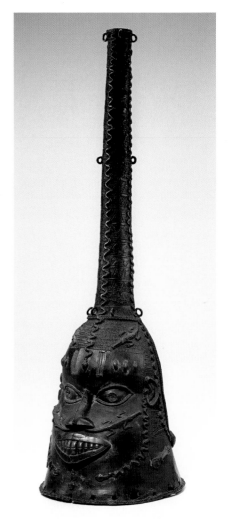

Fig. 1
[cat. no. 1]

Female figure
Benin kingdom court style, Edo peoples, Nigeria

Fig. 2
[cat. no. 2]

Mask
Benin kingdom court style, Edo peoples, Nigeria

Tishmans were drawn to large, powerful works that reflected the diversity of the continent's arts (see fig. 3). They clearly appreciated color (see fig. 4) and sought works in a variety of mediums—wood, ivory, metal, ceramic, and fiber. The result was an outstanding collection known for its high quality and broad range, ideal for survey exhibitions and publications designed to introduce the public to the diverse forms and visual potency of African art, particularly sculpture.

Furthermore, as an important collection (first private, then corporate) that has enjoyed close to 40 years of exposure through exhibitions and publications, the Walt Disney-Tishman Collection has played a significant role in the formation of "the canon"—objects that reflect the standards of quality and authenticity of African art history. Although the result of establishing such standards has in certain ways been positive, one must nonetheless consider more critically the influence that private collectors and their collections have exerted on

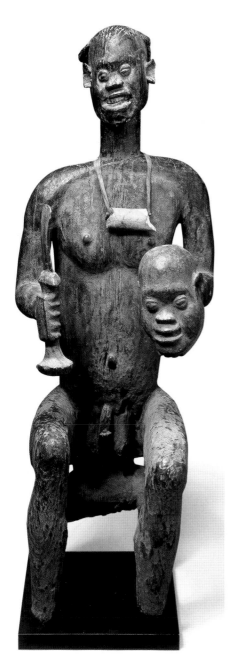

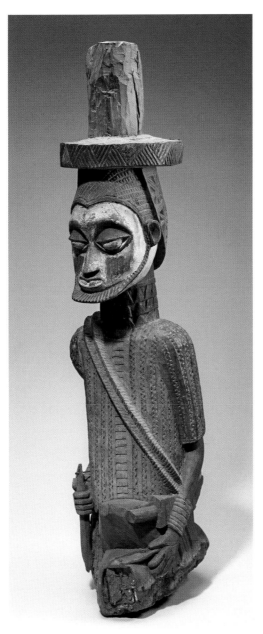

Fig. 3
[cat. no. 3]

Figure of King Bay Akiy
Artist: Bvu Kwam (active early 19th century)
Undetermined peoples, Isu Kingdom, Grassfields region, Cameroon

Fig. 4
[cat. no. 4]

Veranda post
Yoruba peoples, Ekiti region, Nigeria

the identification and validation of canonical works of African art and the shaping of aesthetic taste.[2] Anthropologist Christopher Steiner critiques the rigid hierarchical system of the canon, comparing it to a caste system that "excludes 'impure' categories of art and reduces certain classes of objects to the status of untouchable."[3] In the relatively new field of African art history, collectors often took the lead in stimulating interest in African art at universities and museums.[4] Exhibitions and catalogues featuring African works from private collections became the textbooks for early generations of art historians, but the limitations of these collections, determined by the "cultural assumptions and aesthetic preferences" of the collectors who formed them, tended to present a skewed vision of African art, reinforcing and reproducing the "aesthetic norms and ideals" that became the canon.[5] Over time, these factors assumed greater importance to the developing field of African art history and played into questions of value and authenticity that often placed collectors and scholars at odds. Collectors were interested in perpetuating the notion that African art of quality existed in pre-colonial times and largely free of European influence, thus reinforcing their aesthetic judgments and enhancing the value of their collections as the

market supply of art meeting this criteria dwindled. In contrast, scholars advocated for the embrace of a broad range of artistic forms that reflect the dynamism, complexity, and creativity of African societies historically *and* currently. Although these debates were not the concern of the Tishmans (or other early collectors) while they were building their collection decades ago, any assessment of a well-known private collection today must take these factors into consideration in light of the evolving nature of the field. The Walt Disney-Tishman African Art Collection thus serves as a touchstone not only in the development of the field of African art history, but in the ongoing debates that continue to define the changing nature of the discipline.

A celebrated collection: Paris and Jerusalem

Prior to this publication, four major exhibitions with accompanying catalogues had focused exclusively on the Tishmans' collection.[6] A common thread throughout these early exhibitions and publications was the impressive range of styles assembled within a single collection and the passion that Paul Tishman brought to acquiring works of African art. It was a passion, as he explained in 1966, that sought "to represent not diversity alone, but rather unity in diversity . . . unity of feeling, of supplication, of faith, of power and truth."[7]

The significance of the collection, less than a decade old at the time, was firmly established by its first public exhibition and catalogue, *Arts Connus et Arts Méconnus de l'Afrique Noire,* organized by Jacqueline Delange in 1966 at the Musée de l'Homme, Paris.[8] The catalogue listed 135 objects, about half illustrated as full-page black-and-white images, and some meriting detailed views to emphasize particular elements of form or style (see fig. 5). It was organized geographically, starting with objects from Mali in west Africa and moving eastward to conclude with objects from Tanzania, Zambia, South Africa, and present-day Zimbabwe. In her essay for the catalogue, Delange drew attention to critical concerns that would occupy the relatively new field of African art history for decades to come: the circulation of objects; the certainty that the names and reputations of outstanding artists "extended well beyond the frontiers of their own ethnic groups"; and the importance of evaluating works of art from within the aesthetic and interpretive systems of the cultures that produced them.[9]

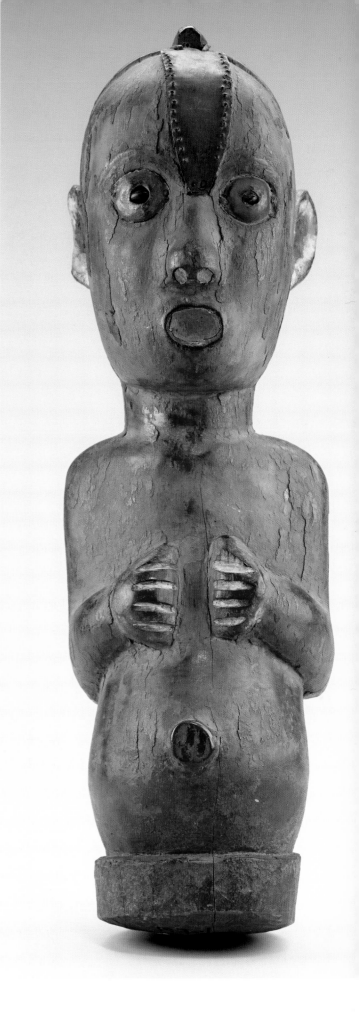

Fig. 5

Reliquary guardian figure

Tsogo peoples, Gabon

Late 19th to early 20th century

Wood, metal, pigment

38.2 x 12.2 x 13.2 cm
(15 1/16 x 4 13/15 x 5 3/16 in.)

Gift of Walt Disney World Co., a subsidiary of
The Walt Disney Company, 2005-6-102

Half-figures are used in ancestor veneration and associated with the Bwiti initiation society. This figure would have been placed, up to its abdomen, in a receptacle containing a range of items including fragments of human and animal bone, metal objects, shells, coins, and the like.

The Paris exhibition was followed by a larger one, comprising 221 objects, mounted in 1967 at the Israel Museum. Its scope was broader, showing more works from a greater number of ethnic groups, including a selection of objects from the islands of Madagascar and Réunion. The catalogue was short on text, but its object entries included, where available, the names of villages or regions where the works were presumably collected—information that must have been provided to Paul Tishman when he acquired them.[10] The Tishmans' commitment to share their collection with the public was strong, apparently even in the face of adversity. Some years after the exhibition at the Israel Museum, Paul Tishman nonchalantly recalled how "the collection [in Jersusalem] was removed only hours before the museum was bombed, then re-installed and opened to the public on the eighth day of the Seven-Day war."[11]

The Paris and Jerusalem catalogues reflected organizational strategies of the 1960s and earlier that tended to present African art as a collection of individual masterworks. The objects were admired for their aesthetic qualities and contexts of use and were ordered geographically as discrete

ethnic styles largely devoid of historical relationships. What was lacking was a broader organizational framework, grounded in history, that might link together the art, ethnic groups, and regions over time.

A new methodology: Los Angeles

The Tishman Collection served as a springboard for redressing this fairly limited approach to the history of African art. *Sculpture of Black Africa: The Paul Tishman Collection* (1968) was a groundbreaking exhibition and publication organized and authored by Roy Sieber and Arnold Rubin for the Los Angeles County Museum of Art, where it opened in the fall of 1968. It is no exaggeration to say that this publication changed the field of African art history, for it was the first to organize African art by broad stylistic, linguistic, and historical groupings.[12] This provided the new and growing field of study with a useful methodology for considering the continent's diverse art forms within interrelated contexts. Sieber and Rubin proposed that the correspondences between language and art were important and distinctive patterns of culture that "may reinforce hypotheses of historical relationships that cannot be documented by written history."[13] Moreover, the stylistic similarities of certain works of art within a particular region suggested then, as they do now, the permeability of borders and the interrelationships that are created over time through migrations, trade networks, warfare, and other forms of interaction. This approach, and the quality of the pieces in the Tishman Collection, challenged popular views prevalent at the time of what was often referred to as "primitive" art.[14]

That collection, with its range of works from throughout sub-Saharan Africa, allowed Sieber and Rubin to illustrate their ideas about shared linguistic, stylistic, and functional characteristics and "the profundity of shared meanings, [and] the basic urgency to make these meanings visible, that lends vitality to traditional African sculpture."[15] The exhibition featured works in wood, iron, copper alloy, ivory, terracotta, and glass beads, thus expanding on the more common format at the time of focusing almost exclusively on wooden masks and figures. Press coverage put the number of objects in the exhibition at close to 200, but the exhibition catalogue listed and described 169 objects, about half of them illustrated.

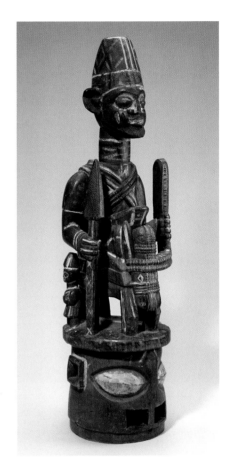

Fig. 6

Mask
Artist: Agunna of Oke Igbira
Yoruba peoples, Nigeria
Before early 1940s
Wood, pigment
110 x 27 x 36 cm
(43 5/16 x 10 5/8 x 14 3/16 in.)
Gift of Walt Disney World Co., a subsidiary of
The Walt Disney Company, 2005-6-76

Carved by Agunna of Oke Igbira, the pot-shaped form and superstructure depicting a mounted warrior identify this mask as an *epa* mask. The Yoruba peoples associate horses, which were rare in Yorubaland, with the military prowess of their neighbors to the north. Thus, the mounted warrior is a symbol that confers on the Yoruba the power that cavalry forces have over their enemies.

The success of the Los Angeles exhibition generated others featuring the Tishman Collection.[16] Paul and Ruth Tishman were struck by the positive impact that the Los Angeles exhibition had on the community there, realizing that "the collection could serve a meaningful social purpose, over and beyond aesthetic considerations, by providing an opportunity for black and white, young and old to view the richness and power of African sculpture, in many cases for the first time."[17] The idea for a large touring exhibition was proposed, and *Sculpture of Black Africa* circulated in 1970-71 (later extended to 1973) under the auspices of the International Exhibitions Foundation.[18] The catalogue for that show was reprinted with an addendum that featured 43 additional works, many new to the Tishman Collection, with entries authored by Roy Sieber and Robin Poynor (see fig. 6). Two of the venues, the Virginia Museum and the City Museum of Saint Louis, added even more works that were published in a "Special Addendum" for each of these locations.[19]

For more than a decade, the exhibition catalogue for *Sculpture of Black Africa* became a critical resource in the United States for teaching African art history, with the result that succeeding generations of art history students cut their professional teeth on works from the Tishman Collection. Furthermore, the framework proposed by Sieber and Rubin in 1968 continued to guide publications about African art for decades to come (with modifications and expansions, of course), including numerous exhibition and collection catalogues, and two comprehensive textbooks on the history of African art published in 1998 and 2001.[20]

Reports from the field: New York

In 1981 the Tishman Collection was once again the sole focus of a major exhibition and publication, *For Spirits and Kings: African Art from the Paul and Ruth Tishman Collection,* organized and edited by Susan Vogel. The exhibition opened at the Metropolitan Museum of Art, New York, and featured 150 works illustrating the aesthetic quality and geographic scope of the Tishman Collection, which had continued to grow and change over the intervening years.[21] The broad range of art forms on view—masks, figures, architectural elements, furnishings, emblems of status and prestige, beadwork, and ceramics—focused attention on the richness of African artistic creativity and ensured that objects other than masks and figures

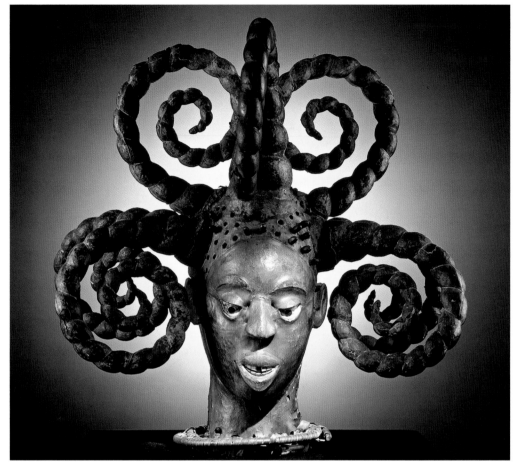

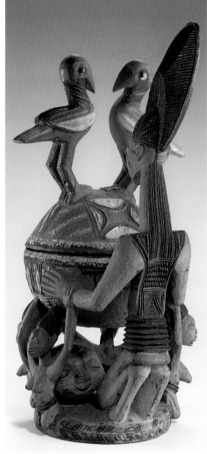

LEFT

Fig. 7

Mask

*Ejagham peoples, middle Cross River region,
Nigeria*

Early to mid-20th century

Wood, skin, basketry

*52.1 x 50.8 x 52.1 cm
(20 1/2 x 20 x 20 1/2 in.)*

*Gift of Walt Disney World Co., a subsidiary of
The Walt Disney Company, 2005-6-19*

The hairstyle of this mask may be an
exaggeration of the coiffure of a young
woman who has completed her coming-
of-age rituals and is thus ready for marriage.
Throughout the Cross River region, skin-
covered masks were owned by men's asso-
ciations and performed at initiation rituals
and at the funerary rites commemorating
association members.

received due consideration. Fifteen works in ivory reflected the Tishmans' inter-
est in collecting superb examples of art made out of this precious material.[22]

The Tishmans' recently acquired works, some of which had not
previously been illustrated in a major publication, included a magnificent Sapi-
Portuguese style hunting horn from Sierra Leone dating to the late 15th century
(see fig. 13, cat. no. 15). Nigeria, the origin of some 40 percent of the objects
illustrated, merited its own separate section, a reflection of the striking range of
art styles within that country but also indicating a major strength of the Tishman
Collection (see fig. 7). Particularly impressive were the number of objects, pri-
marily Yoruba, that were attributed to specific artists, villages, or regions. These
included a lidded bowl (fig. 8) by the Yoruba master artist Olowe of Ise and a pair
of figures honoring the Yoruba trickster deity Eshu (fig. 9) that are attributed to
Ijomu village, Igbomina region, and to one of two carvers—either Ogunremi

(d. 1933) or Onadokun (d. circa 1930).[23] Such precise attributions reflected a growing determination among researchers to identify known hands and workshops, thus countering the West's perceived anonymity of Africa's traditional artists and disseminating the history of artistic production in Africa. However, this focus on known hands and workshop styles did not begin with *For Spirits and Kings*. Rather, it suggests that in building their collection, the Tishmans were

OPPOSITE PAGE, RIGHT

Fig. 8

[cat. no. 10]

Bowl with figures

Artist: Olowe of Ise (c. 1875–c. 1938)

Yoruba peoples, Ekiti region, Nigeria

Fig. 9

Pair of figures

Artist: Attributed to Ogunremi or Onadokun

Yoruba peoples, Igbomina, Oro district, Ijomu village, Nigeria

1900-33

Wood

Female: 28.6 x 9.5 x 11.4 cm (11 1/4 x 3 3/4 x 4 1/2 in.)

Male: 27.3 x 7.6 x 11.1 cm (10 3/4 x 3 x 4 3/8 in.)

Gift of Walt Disney World Co., a subsidiary of The Walt Disney Company, 2005-6-165.1, -165.2

These figures are probably dedicated to Eshu, the Yoruba trickster deity who is the messenger of the gods. The imagery associated with Eshu on these figures includes the long phallic-shaped hairstyles, the medicine gourds carried by the female figure, and the flute played by the male figure.

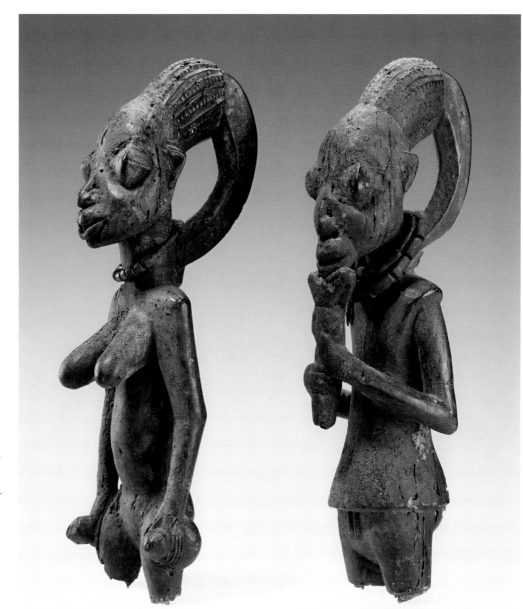

cognizant of recent research in this area and were responsive to the increased availability of Nigerian works on the art market.[24]

Impressive though the works of art clearly were, what made this project remarkable was the exhibition catalogue. *For Spirits and Kings* was a milestone achievement, a publication assessed at the time by reviewer Doran Ross as "the single most remarkable, ambitious, and stimulating catalogue ever assembled to survey the arts of sub-Saharan Africa."[25] Vogel, then curator of African art at the Metropolitan Museum of Art, had adopted a geographic/stylistic framework that roughly corresponded to that proposed by Sieber and Rubin more than a decade earlier. Maps, dates, provenance, publication history, an index, and a selected bibliography keyed to specific works supplied helpful information for students, scholars, and connoisseurs alike. Vogel's introduction emphasized the role of African art in serving as visual records and repositories of knowledge, and it highlighted a range of functions addressed by works in the collection, including continuity, religious beliefs, education, divination, leadership, and power. Her brief overviews to each geographic section provided a sense of the natural features, history, and cultures of the region, the characteristics of each region's major art forms, and some of the significant contexts for the production and use of the works of art that were presented.

For Spirits and Kings broke new ground by considering the featured works through the expertise of 71 Africanist scholars—primarily art historians and anthropologists—from the United States, Europe, and Africa, each of whom contributed object-specific entries much of which was based on original field research that was recent at the time and, thus, not published before. The edited contributions, many accompanied by comparative field photographs, focused on the works' iconography, history, artist or regional style, function, and meaning, revealing the range of research methodologies employed to study the art. In his review, Ross indicated some of the publication's distinctive features, such as an index that could facilitate consideration of institutions and contexts cross-culturally. He also emphasized the value of the scholarly contributions that could be used to consider the question of "primary source material" and "hypothetical reconstructions" that are brought to bear in interpreting the history and meaning of African works of art.[26]

Even though it did not purport to be a comprehensive textbook on African art, the publication had such a profound significance for the field that

For Spirits and Kings was adopted at many colleges and universities as a resource for teaching African art history. It made a unique and lasting contribution to scholarship, and for decades has been relied upon by generations of Africanist art historians and connoisseurs who honed their skills and expanded their knowledge base about African art and culture through the objects in this one remarkable private collection.

The Walt Disney years

In 1984, a few years after the publication of *For Spirits and Kings,* the Tishman Collection was sold to the Walt Disney Company. Although the sale surprised many in the art world, it fulfilled the Tishmans' desire to keep their collection together and to have it reach a wide public through periodic exhibitions. As Martin Sklar has pointed out in his introductory essay in the present volume, the collection was a critical element in the Disney corporation's plans for the African pavilion at Epcot Center in Orlando, Florida. The pavilion, never realized, was to have included a river ride, a heritage village, and a gallery showcasing an exhibition of some 120 works of African art from the Walt Disney-Tishman Collection (fig. 10). The exhibition, designed to introduce Epcot Center visitors to the richness of African arts and culture, was also proposed as a smaller touring exhibition

Fig. 10

Concept drawing for an exhibition gallery in an African-theme pavilion in the "World Showcase" area at Epcot. Artist: Frank Armitage
© *Disney*

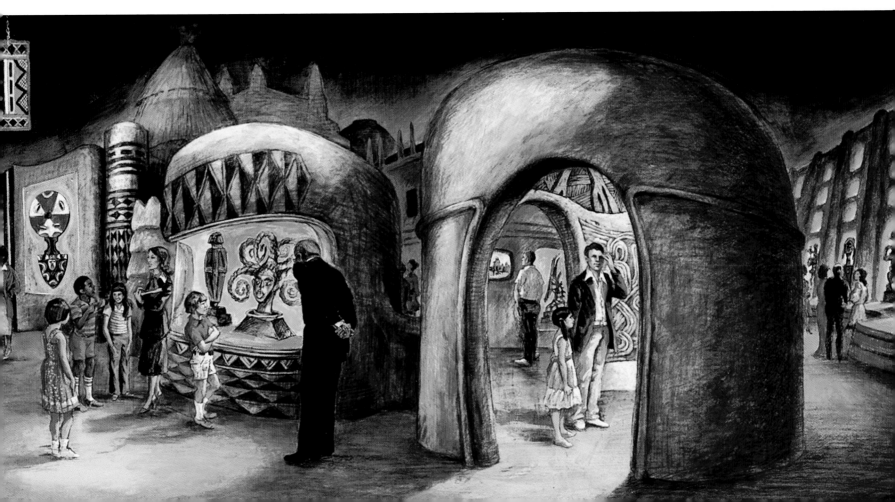

to raise the Disney company's profile in the art world and to help secure loans of artifacts in the future.[27] The collection also served as a design inspiration to the Disney Imagineering staff for many projects over the years, including the company's 1994 blockbuster animated film *The Lion King*.

As recently as 1999–2000, plans for Walt Disney World's Animal Kingdom theme park proposed using a limited number of works from the Walt Disney-Tishman Collection in the lobby area of the resort's lodge. Design proposals identified certain works with animal themes (see fig. 11), to be displayed in archival cases, that would relate to visitors' experiences with live animals in the wildlife reserve resort and would tell a story of humans and their relationships with animals. The strategy drew on the recent success of art exhibitions in non-traditional venues, such as the Bellagio and Venetian resort hotels in Las Vegas, as well as in airports, visitor centers, civic spaces, shopping malls, and so on.[28] Although planning meetings were held, and strategy documents produced, the goal of incorporating African art within the context of the Animal Kingdom theme park was never realized. The impasse may well have reflected the inability of exhibition planners to reconcile concerns that would inevitably arise in juxta-posing zoological specimens with the story of African peoples and their cultural achievements—a strategy that would have perpetuated 19th-century Western stereotypes about Africans as exotic and as part of the natural, rather than the cultural, world.

Twenty years elapsed before an exhibition of African art was achieved at Epcot: *Echoes of Africa* (2004-7) at the American Adventure pavilion gallery, which used selected works from the Walt Disney-Tishman Collection to illustrate how African art serves as sources of inspiration for contemporary African-American artists. The exhibition at Epcot thus emphasized an important message that had been promoted by Paul and Ruth Tishman decades before: the relevance of Africa to the American experience.

Throughout their stewardship of the collection, the Walt Disney Company was committed to sharing it with the public through exhibitions and educational programming. They had a special interest in making an impact among the communities near Walt Disney World and the Epcot Center in Florida and the ones near Disney Imagineering outside Los Angeles. Beginning in 1987 and continuing until 2000, the collection was the focus of eight tempo-rary thematic exhibitions organized at the Los Angeles County Museum of Art,

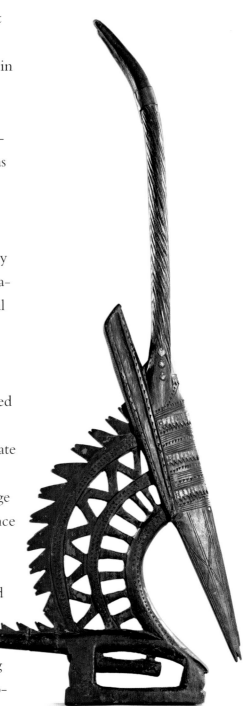

Fig. 11

Mask

Bamana peoples, Mali

Early 20th century

Wood, metal

*93.2 cm x 35.3 x 7.3 cm
(36 9/16 x 13 7/8 x 2 7/8 in.)*

*Gift of Walt Disney World Co., a subsidiary of
The Walt Disney Company, 2005-6-12*

This crest mask, worn on top of the head
with a fiber costume, honors Chi Wara,
the mythic being who brought the
knowledge of agriculture to the Bamana.
The wooden crests often combine fea-
tures of the antelope, aardvark, and pan-
golin—all animals that dig up the earth.
They were traditionally danced in male-
female pairs to emphasize the complemen-
tary roles of men and women, and were
performed for agricultural competitions,
annual celebrations, and entertainment.

Fig. 12

[cat. no. 79]

Staff (detail) and staff finial

*Kongo peoples, Democratic Republic of the
Congo*

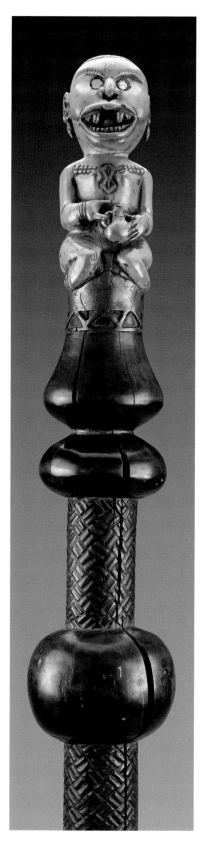

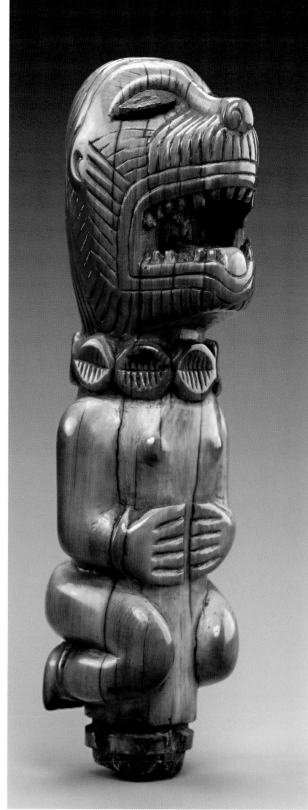

the California African American Museum (also in Los Angeles), the Bowers Museum of Cultural Art (in nearby Santa Ana), and the Orlando Museum of Art (in Florida).[29] In 2001, the National Geographic Society (Washington, D.C.) mounted the exhibition *The Artist as Explorer: African Art from the Walt Disney-Tishman Collection* in which 60 works received prominent exposure.[30]

Of particular interest to the field of African art history, however, has been the loan of key works from the collection to major African art exhibitions organized in the United States and Europe, all of which have been accompanied by exhibition catalogues. In the United States, several exhibitions of African art adopting a thematic, regional, or ethnic focus were prepared by leading institutions, including the Museum for African Art (New York), the U.C.L.A. Fowler Museum of Cultural History, the National Museum of African Art, the Metropolitan Museum of Art, and the Yale University Art Gallery. Exploring questions of identity, power, knowledge, iconography, authorship, and history, the exhibitions and their catalogues represented important directions in African art scholarship, with critical analysis based, in part, on works from the Walt Disney-Tishman African Art Collection. A significant number of the exhibitions traveled to other cities in the U.S., thus exposing a greater number of visitors to these ideas and to the breadth of African artistic creativity.

The Walt Disney-Tishman Collection has also received important international exposure. Three pieces—two Kongo ivories (fig. 12) and an imposing wood-carved male figure from Cameroon (see fig. 3)—were featured prominently in *Arts of Africa, Asia, Oceania, and the Americas* (2000), the first presentation of African art in the Musée du Louvre. Exhibited in the Louvre's Pavillon des Sessions, which functions as a satellite to the Musée du Quai Branly, a new museum dedicated to the art of the world's indigenous, tribal cultures, the artworks remained on loan through the fall of 2006. Two of these same works had been included several years earlier in the most comprehensive exhibition ever of African art, the 1995 exhibition and publication *Africa: The Art of a Continent*, organized by the Royal Academy of Arts, London. In addition, selected international loans over the years brought works from the collection to audiences in Paris, Brussels, Cologne, and Seville.

As guardians of an international treasure, the Walt Disney Company recognized the prominent role that the collection has played in 40 years of scholarship on the arts of Africa. With its gift of the collection to the Smithsonian

Institution's National Museum of African Art, the expectation is for continued research, exhibitions, publications, and wide dissemination of knowledge about Africa's artistic heritage. Using the Walt Disney-Tishman African Art Collection as a point of departure, and viewed through the ever-changing prism of scholarly enquiry, the journey promises new discoveries and lasting rewards.

Notes

1 By means of these quotation marks, I draw attention to the ongoing debate in the field of African art history over terminology appropriate to use in discussing the continent's sculptures, masquerades, textiles, utensils, personal objects, regalia, and so on, objects that, in most cases, reflect historical depth, change over time, and contemporary vitality. The concern with the word "traditional" is that it conveys objects, ideas, and contexts of use that are past, static, and unchanging. As Kate Ezra has pointed out, "Many of the most revered images of 'traditional' African art were once newly introduced forms or alterations of previous ones, and many of today's innovations will eventually appear conservative, standard, or even old-fashioned" (Ezra 2001: 87). The term has its usefulness in distinguishing such works from modern and contemporary African arts (painting, sculpture, mixed media, prints, video, and installation art) created by artists in and outside Africa, although the distinction falls apart for the modern and contemporary expressions of so-called traditional art that are amply evident in Africa. Suggested replacement terms such as "tradition-based" (one that I happen to favor, as it implies a contemporary time frame without causing confusion with other modern and contemporary art), "customary," "classical" and "canonical" all have their own limitations, as did the earlier terms "primitive" and "tribal," which were soundly rejected decades ago by art historians and others in the field. In the absence of a better term, I have used "traditional" (hereafter without the quotation marks), but I hope that the works of art and the discussions of them in this volume convey a sense of the continuing complexity and vibrancy of African arts in their changing social contexts.

2 Vogel (ed.) 1988; Steiner 2002.

3 Steiner 1996: 213.

4 Vogel (ed.) 1988, p. 5.

5 Steiner 2002, p. 133.

6 Paris 1966, Jerusalem 1967, Los Angeles 1968, and New York 1981. The 1968 exhibition in Los Angeles was expanded and toured from 1970 to 1973.

7 Tishman 1966, n.p.

8 The exhibition was extended from four to six months due to its popularity (Tishman 1970, p. VM-4).

9 Delange 1966, n.p.

10 During the 1960s and 1970s, the Tishmans worked closely with noted scholars of African art, including William Fagg, and probably purchased works from dealers and galleries in New York, Paris, and London that were flourishing at the time they were actively collecting. Provenance research—which seeks to trace the history and movement of objects from their source to their final destination—is ongoing in our work with the Walt Disney-Tishman Collection. In the museum field, it has become increasingly important for museums to exercise due diligence in determining the provenance of objects to the greatest extent possible in order to ensure that the acquisition of an object does not conflict with legal and ethical standards as determined by UNESCO, the American Association of Museums, and other professional and scholarly organizations.

11 Tishman 1970, p. VM-4.

12 Sieber and Rubin drew on the linguistic groupings proposed by linguist Joseph Greenberg (Greenberg 1963).

13 Sieber and Rubin 1968, p. 20.

14 One of the challenges tackled by scholars writing during the period from the 1950s to the 1970s on the arts of Africa was the disparaging and romanticized terminology used to describe the arts and cultures of Africa, the Pacific, and the Americas. In an article published in *Art in America* in 1969, Roy Sieber used selected works—primarily African—from the Tishman Collection as a platform for his forceful critique of terms such as "primitive," "tribal," "fetish," and "exotic" (Sieber 1969). Photographs of Tishman Collection objects—a Fang Ngi society mask, a Baule female figure with child, and a Kongo ivory staff top (acc. no. 2005-6-33; see cat. no. 79)—were among the many works that Sieber used to counter negative preconceptions about African art and culture and to foster the search for new vocabulary worthy of artworks rich in history and sophisticated in form and meaning.

15 Sieber and Rubin 1968, p. 16.

16 It was the basis for a 1969 exhibition at the Hayden Gallery, Massachusetts Institute of Technology, where Paul Tishman had graduated (class of 1924). The catalogue of 71 works included some that were absent from the Paris and Jerusalem exhibitions, or were listed but not illustrated in the Los Angeles exhibition. It also reproduced sections of the Los Angeles publication, including Roy Sieber's introduction, the overview of each of major style zone, and selected object entries that were edited or combined to reflect the works exhibited. In 1974, more than 150 objects from the Tishman Collection were exhibited at Guild Hall, East Hampton, in an exhibition designed by the Museum of African Art, Washington, D.C., and guided by that museum's director, Warren Robbins. In his Foreword to the exhibition checklist, Paul Tishman gave a sense of the size of his growing collection when he noted that the space at Guild Hall allowed for less than a third of his collection to be displayed.

17 Tishman 1970, p. VM-4.

18 Major public and university museums in Atlanta, Richmond, Austin, Saint Louis, Des Moines, Huntington, Columbus, San Antonio, and Champaign hosted the touring exhibition (Foss 1981: 86). The institutions pledged to encourage strong community response—a primary consideration for the Tishmans—through tours, media events, public programs, and outreach to schools.

Richmond's community outreach programs, mentioned in their 1970 "Special Addendum" publication, included an Artmobile exhibition of African sculpture that toured the state and was organized by the Museum of African Art in Washington, D.C., before it became part of the Smithsonian Institution.

19 Roy Sieber and Robin Poynor did not play a role in the object selections or entries reflected in the "Special Addendum" publications for Richmond (1970) and Saint Louis (1971).

20 Perani and Smith 1998; Visonà et al. 2001.

21 In reviewing the exhibition, Kate Ezra reported that two-thirds of the works in *For Spirits and Kings* were acquired over the preceding 10 years (Ezra 1981: 70). Paul Tishman stated in his collector's note to the catalogue that the collection numbered more than 350 works by that time.

22 Gone were a few that had been featured in previous publications: notably, a Guro mask from Côte d'Ivoire with a red-pigmented face and complex coiffure (not part of the collection purchased by the Walt Disney Company); a Fang mask from Gabon accented with red-and-black coloration that remains part of the collection; and a Chokwe caryatid stool (acc. no. 81-23-2) from what is now the Democratic Republic of the Congo that was one of three Chokwe artworks donated by the Tishmans to the National Museum of African Art in 1981.

23 Pemberton, in Vogel 1981, p. 98, citing stylistically similar figures published in Drewal 1980, figs. 108, 124. Of the 60 Nigerian objects illustrated in *For Spirits and Kings,* roughly a third of them were attributed to particular artists or to specific regions or villages. In addition, several works from Burkina Faso, Côte d'Ivoire, Cameroon, and what is now the Democratic Republic of the Congo were also accompanied by information on region or village of origin. In her review, Kate Ezra reported that 13 individual artists were identified and that almost half the objects in the exhibition "were pinpointed to a particular village or group of villages" (Ezra 1981: 71).

24 The late 1960s and early 1970s saw a flourishing of anthologies focusing on African artists, aesthetic concepts, techniques, and artistic creativity; contributions by William Fagg, William Bascom, Roy Sieber, Kevin Carroll, Daniel Crowley, and

Robert Farris Thompson are especially noteworthy in this regard. In the volume of essays edited by Warren L. d'Azevedo entitled *The Traditional Artist in African Societies* (D'Azevedo 1973), Robert Farris Thompson identified a number of Yoruba artists and their works as part of his consideration of Yoruba aesthetic criticism. In the same volume, William Bascom devoted his entire essay to the work on one Yoruba master artist, Duga of Meko; and James Fernandez and Dan Crowley (both in D'Azevedo 1973) discussed the work of specific Fang and Chokwe artists, respectively. Other essays in the volume dealt in a more general way with artistic training, production, and aesthetic criteria in carving, iron working, weaving, and music (although specific artists were occasionally mentioned). Some of these same scholars addressed aspects of African aesthetic criteria in earlier publications that were compiled in the anthology *Art and Aesthetics in Primitive Societies* (Jopling 1971). More recent scholarship has expanded our knowledge of African artists and aesthetic systems, aided in part by the important contributions of African scholars researching these topics, often within their own cultures.

25 Ross 1982: 12.

26 Ibid.: 14.

27 Information obtained from an undated document, "EPCOT Center World showcase Exhibition—Africn *(sic)* Pavilion," in the Walt Disney Imagineering archives, Glendale, California.

28 Information obtained from documents in the Walt Disney Imagineering archives, Glendale, California: "Disney's Animal Kingdom Lodge" (August 17, 1999); "The Disney Tishman Collection at Disney's Animal Kingdom Lodge" (September 9, 1999); and "Three Year Feasibility Study for the potential loan of the Disney Tishman collection to Disney's Animal Kingdom Lodge" (January 24, 2000).

29 Drawing on particular strengths in the Walt Disney-Tishman Collection, the topics explored included masks, women, the ancestors, musical instruments, icons of power, ancient empires, Yoruba art, and the art of Nigeria. Art historian Doran Ross served as a guest curator for several of these exhibitions. He also curated the selection of Walt Disney-Tishman works that were featured, briefly, in the 1988 movie *Coming to America* (Paramount Pictures) starring Eddie Murphy. I am very grateful to Doran for sharing with me not only his files on the exhibitions he organized but also his considerable knowledge of the Walt Disney-Tishman African Art Collection.

30 The exhibition, on view at National Geographic from August 30, 2001 through February 28, 2002, was co-curated by Rowland Abiodun, Allen F. Roberts, Mary Nooter Roberts, and Doran Ross. No catalogue was produced.

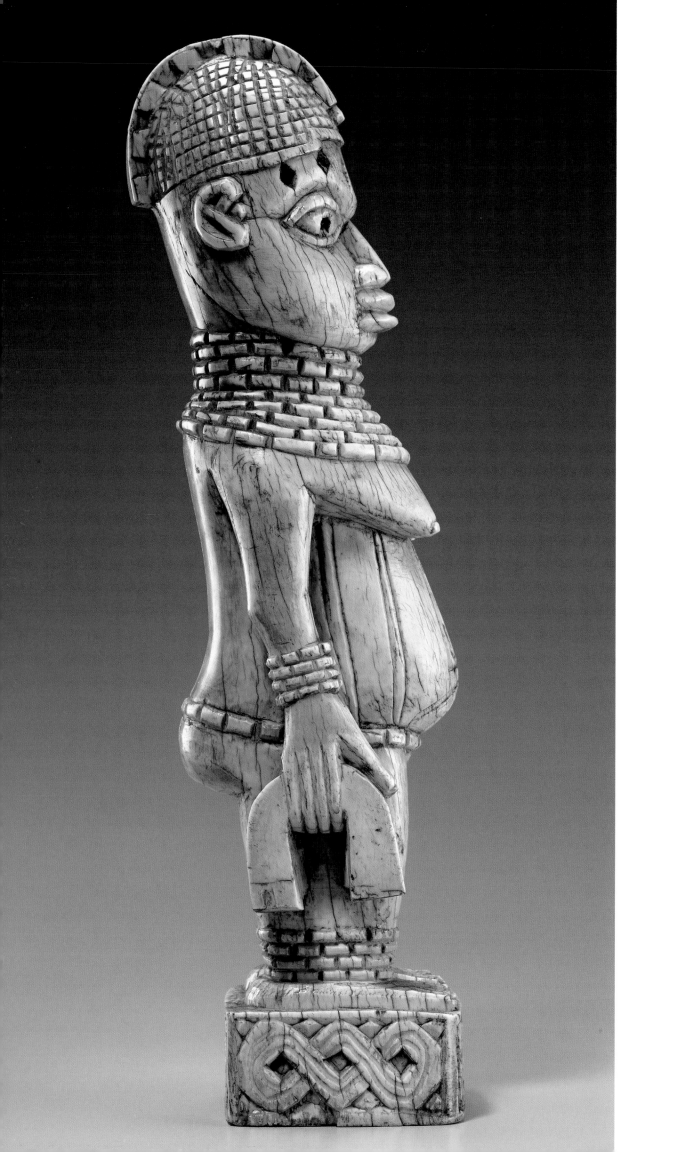

Female figure

Benin kingdom court style, Edo peoples, Nigeria

Early 19th century

Ivory

37 x 9.4 x 10.3 cm (14 1/2 x 3 3/4 x 4 in.)

Gift of Walt Disney World Co., a subsidiary of The Walt Disney Company, 2005-6-3

Ivory can be almost universally interpreted as a symbol of importance and wealth. This figure depicting a young woman portrays a role rather than a specific person. The crest hairstyle and body scarification, together with the strands of coral beads around her neck, waist, wrists, and ankles identify her as an attendant to the queen mother. Since the mid-16th century, when Oba Esigie gave his mother Idia the title of *iye oba,* the king could formally install a living queen mother. She would have had her own palace with a separate court and attendants, and after her death the king would have commissioned an altar in her memory. This figure, which was probably intended for such an altar, depicts a member of the court—one of the attendants of graded ranks and duties who kept important people from ever being alone. The C-shaped form in her hand may be a copper or brass manilla, a type of imported currency that was the source of much of the metal used by Benin casters.

—BF

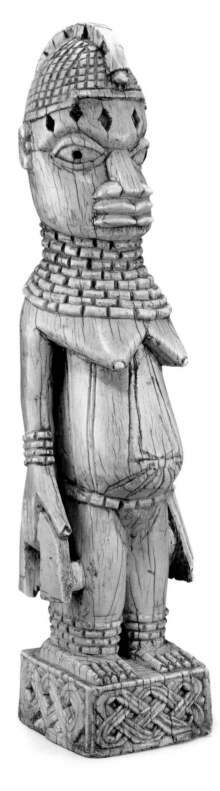

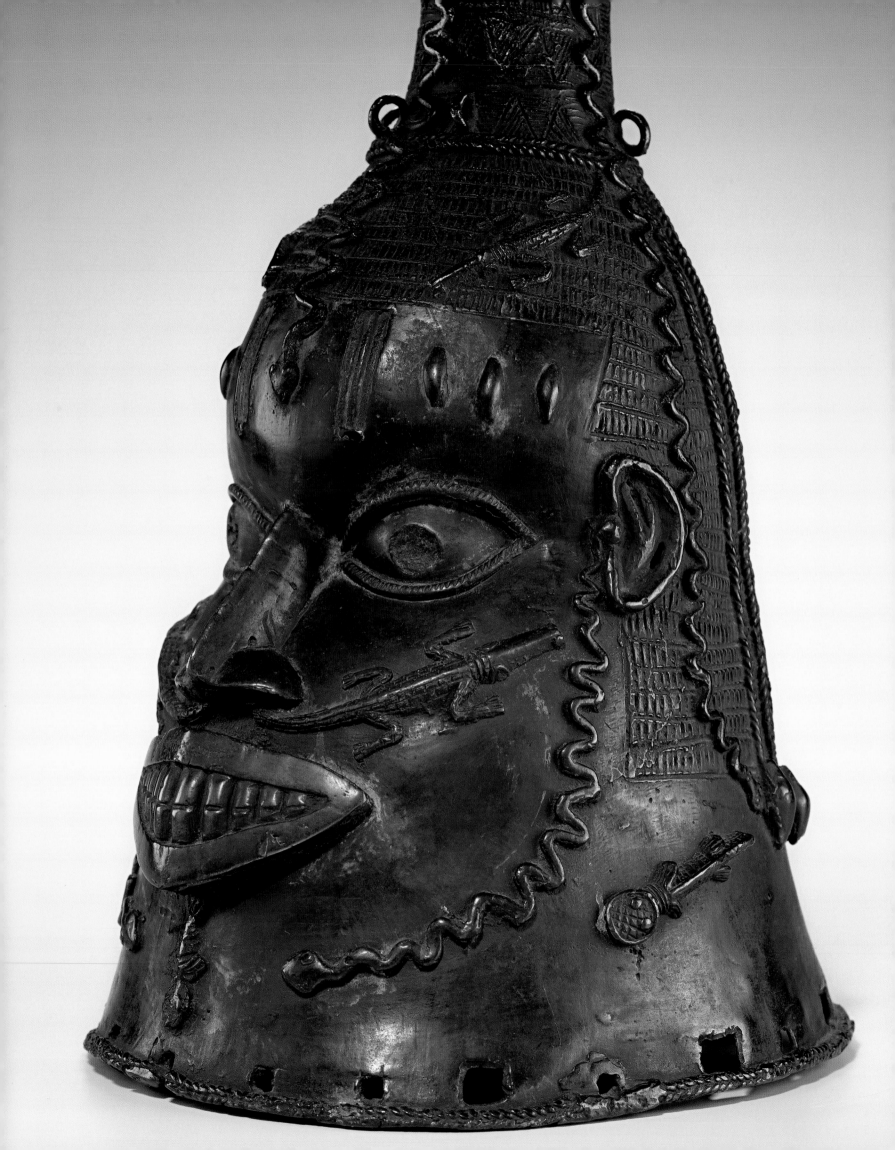

Mask

Benin kingdom court style, Edo peoples, Nigeria

18th century

Copper alloy, iron

71.1 x 24.1 x 22.2 cm (28 x 9 1/2 x 8 3/4 in.)

Gift of Walt Disney World Co., a subsidiary of The Walt Disney Company, 2005-6-2

This mask, which has human features similar to the male commemorative heads placed on royal altars (see fig. 16), was worn during the Ododua masquerade performance that protects the king and commemorates the founding of the Benin kingdom—a ceremony that continues today. This ceremony, with its group of copper-alloy mask pairs (male and female), was introduced by Oba Eresonyen (reigned c. 1735–50), replacing a festival dedicated to more recent ancestors.[1]

While the four known male masks of this type now in museum collections vary in some details, they all share a similarity of form and iconography. The cone shape relates to a special fiber cap worn during the ceremony by certain priests and chiefs and by the king; it also resembles certain metal crowns. The snakes and crocodiles refer to the dangerous spiritual forces that are controlled by herbalist-diviner specialists and the king. The placement of the python on the mask's vertical projection recalls the serpent sculptures that once undulated down the roof turrets of the palace. Snakes and crocodiles are both capable of killing a man, and refer here to the power that, in the past, only the king had in sentencing a man to death.[2]

The unique iconographic details of this mask are the small whiskerless fish seen in relief under the lips and on the sides of the mask. Most fish in Benin art look like catfish and are commonly referred to as mudfish. They are royal symbols combining the traits of several species, such as the ability to inflict an electrical shock or to survive on dry land. However, according to field informants in the 1970s or earlier, the fish associated with this mask are a species used as sacrificial offerings to the "gods of the Benin nation" at a palace shrine.[3]

—BF

Notes

1. Ben-Amos 1999, pp. 35, 111–12.
2. Ibid., pp. 35, 114–15.
3. Ibid., pp. 76, 116.

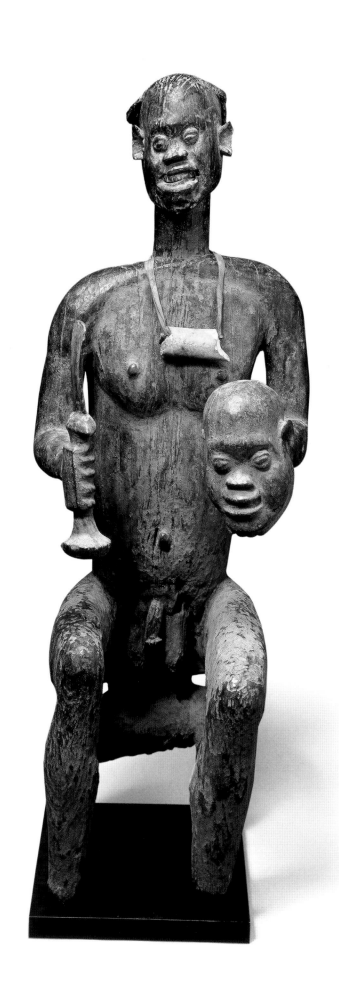

Figure of King Bay Akiy

Artist: Bvu Kwam (active early 19th century)

Undetermined peoples, Isu kingdom, Grassfields region, Cameroon

Early 19th century

Wood, ivory, pigment, bone, cloth

113 x 31.8 x 45.7 cm
(44 1/2 x 12 1/2 x 18 in.)

Gift of Walt Disney World Co., a subsidiary of The Walt Disney Company, 2005-6-31

This masterpiece of Grassfields carving is dramatic and expressive. The figure has an exultant, confident air, amplified by his open mouth with an ivory tooth plate, the tilt of his head, and his gestures. These sculptural qualities may be associated with the personal style of Bvu Kwam, an early-19th-century master sculptor who is believed to have carved this imposing figure.[1] In writing about this sculpture, Pierre Harter noted that the name of the artist was only confirmed by one individual at the Isu palace, Elias Kum, who was "the last guardian of the effigy."[2] Thus, the artist attribution for this work is somewhat speculative, requiring further research.

Based on information collected by German sculptor Rothe in 1912, the figure is said to portray Bay Akiy—the fourth ruler of the Isu (or Esu) kingdom, who reigned in the late 18th century[3]—here depicted as returning from victory over the Nshe, a neighboring group.[4] Iconographic elements evoke his prowess. He is seated on the fragmentary remains of a carved animal, probably a leopard, which is a symbol of power in the region. A bone pendant is suspended around his neck; Harter described the figure in 1981 as also wearing a large Venetian glass chevron bead, which is now lost. The red pigment covering the figure has been interpreted as indicative of the ruler's vitality and his power to ensure abundant births, good harvests, and success in war and hunting.[5]

The figure's seated posture, prominent genitalia, and the display of a blade in one hand and a trophy head (said by Harter to represent the ruler of Nshe) in the other recall stylistic conventions associated with Igbo *ikenga* figures linked with personal achievement.[6] Thus, the figure may not represent a king or ruler at all, but rather an individual of significant accomplishments, a possibility proposed by Grassfields specialist Christraud Geary, who noted the weakness of chieftaincy in this area of Cameroon during the 19th century.[7] Given the complexity of art forms in the region, and because published information on this sculpture stems primarily from one source, additional research is needed to further our understanding of this enigmatic, powerful work of art.

—CMK

Notes

1. Harter 1986, p. 242.

2. Ibid.

3. Harter, in Vogel 1981, p. 192.

4. Harter 1986, p. 242.

5. Notué, in Kerchache 2001, p. 150.

6. Cole 1989, pp. 98–99.

7. Geary, telephone conversation with the author, June 23, 2006.

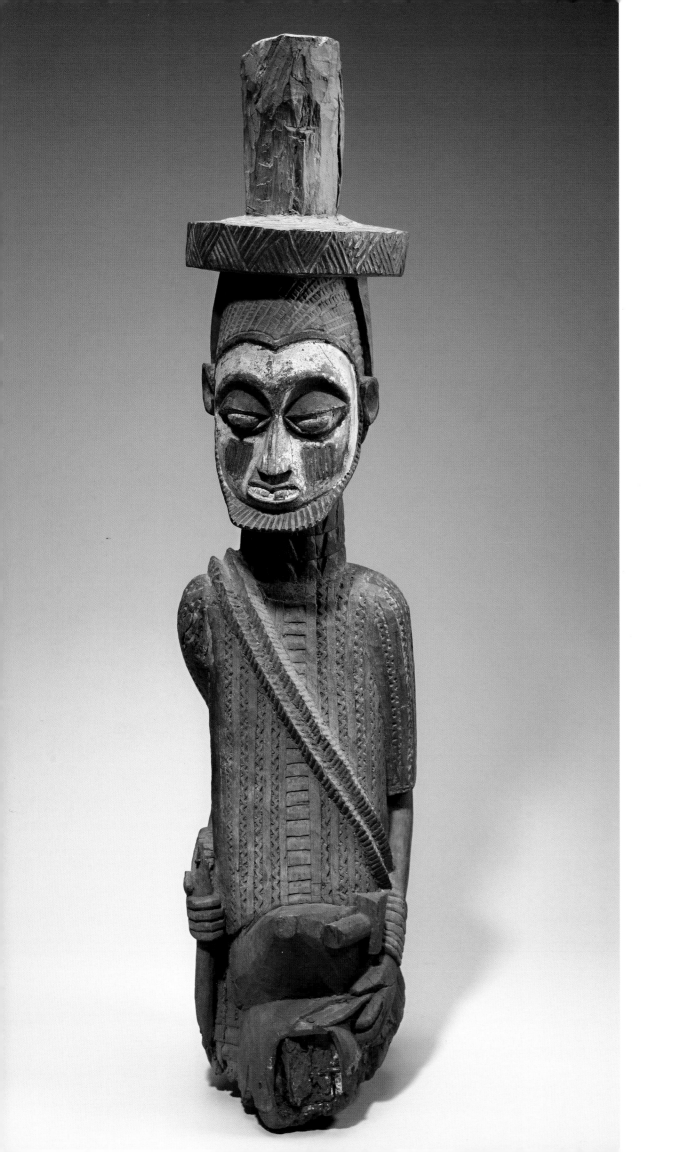

Veranda post

Yoruba peoples, Ekiti region, Nigeria

Mid- to late 19th century

Wood, paint

139.7 x 28.6 x 37.5 cm
(55 x 11 1/4 x 14 3/4 in.)

Gift of Walt Disney World Co., a subsidiary of The Walt Disney Company, 2005-6-75

This was one of 12 posts that ringed a magnificent palace courtyard before the town of Idanre was relocated off the cliffs into the plains during the colonial era. The design of the courtyard palace allowed for the collection of rainwater and created a large, dramatically framed meeting place for the ruler to hold court and to welcome and impress visitors. Carved posts and doors testify to the ruler's wealth, and their iconography indicates his spiritual and military power. The two most common Yoruba iconographic themes are the mother and child and the equestrian warrior. The first is emblematic of the woman behind the throne and the continuity of the lineage. The second is a symbol of male prestige and power, and a central theme in Yoruba art, although actual living horses are rare in the region. Historically, horses are associated with the cavalry of the Islamic states in what is now northern Nigeria, where they posed a longtime threat to the neighboring Yoruba. Horses are not suited for the forest climate and are vulnerable to its insects, and thus, outside the northern plains, they were only rarely owned by those wealthy and powerful enough to have attendants to pamper them.

In this sculpture, the rider was given much greater prominence than the horse. Most Yoruba sculptors use relative size to emphasize the importance of man. This is particularly true of the artist who created this post, whose name is lost to us. His treatment of the man's features and body proportions and the extensive incised surface patterning are unique among Yoruba figures. Such figures often have a solid, full form and a closed mouth; here, the concave cheeks and the open mouth with projecting teeth stretch the stylistic canons. Unlike most Yoruba figures, which have an oversize head, this one has a long torso, making that element dominant. The overall chip carving on this figure's surfaces is in contrast to the smooth surfaces that many artists seem to have favored. The choice of colors—red, white, and green—differs from the red and white found on many larger Yoruba carvings, and from the indigo blue on many smaller ones.

—BF

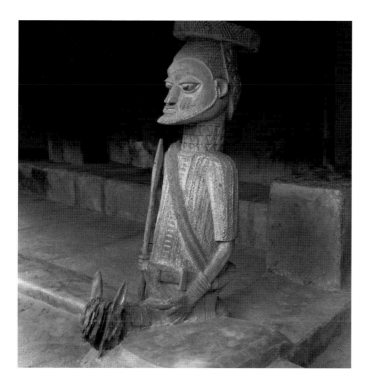

Veranda post at the old palace
Idanre, Ekiti region, Nigeria
Photograph by William B. Fagg, 1959
Courtesy Royal Anthropological Institute, London

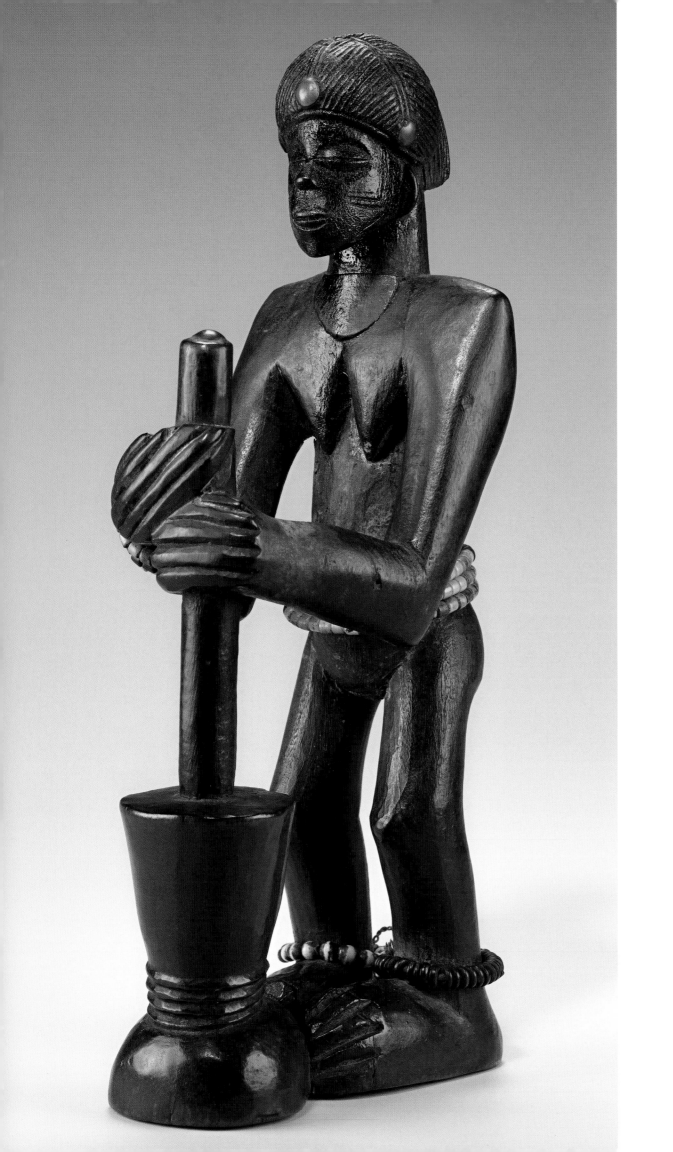

Female figure

Chokwe peoples, Angola

Early 20th century

Wood, brass tacks, glass beads, plant fiber, oil patina

32.5 x 10.5 x 14.5 cm
(12 13/16 x 4 1/8 x 5 11/16 in.)

Gift of Walt Disney World Co., a subsidiary of The Walt Disney Company, 2005-6-116

Male figures in Chokwe art focus on the multiple roles of the great culture hero Chibinda Ilunga—political leader, blacksmith, hunter, and storyteller. Female figures, however, seem to represent multiple characters: the great ancestor, the great queen, the chief's primary wife. This figure probably is *mukwakuhiko,* the younger wife of a chief who has the responsibility of cooking his meals.[1] This is hard work, but the assignment of this task also suggests great trust, since the one who cooks the food could poison the food. In most representations of the young wife, she can be identified by a cooking pot. In this example, she is using a mortar and pestle.

This domestic scene is also an interesting statement of Chokwe expansion and exposure to other cultures. Before the second half of the 17th century, the Chokwe depended on sorghum and millet, and oral history tells of finding hollows in the rocks where the grain was pounded.[2] Then cassava (manioc) was introduced from South America. Toxic in its raw form, it requires the roots to be soaked, dried, pounded in a mortar, and sieved before a stew can be made.

Still another "foreign" contact is suggested by the figure's facial scarification. The L marks on the sides of the face, called *tukone,* were adopted by the Chokwe from the Lwena peoples.[3] Daniel J. Crowley, in an earlier publication,[4] suggested that this was a late piece made for sale to the Portuguese colonists and possibly related to the genre figures carved on the rungs of chairs. However, the oiled surface suggests use in an African context, and Chokwe artists did make carvings for neighboring peoples as well as for local use.

—BF

Notes

1. Bastin 1982, p. 155.

2. Ibid., p. 38.

3. Ibid., p. 72.

4. Crowley, in Vogel 1981, p. 227.

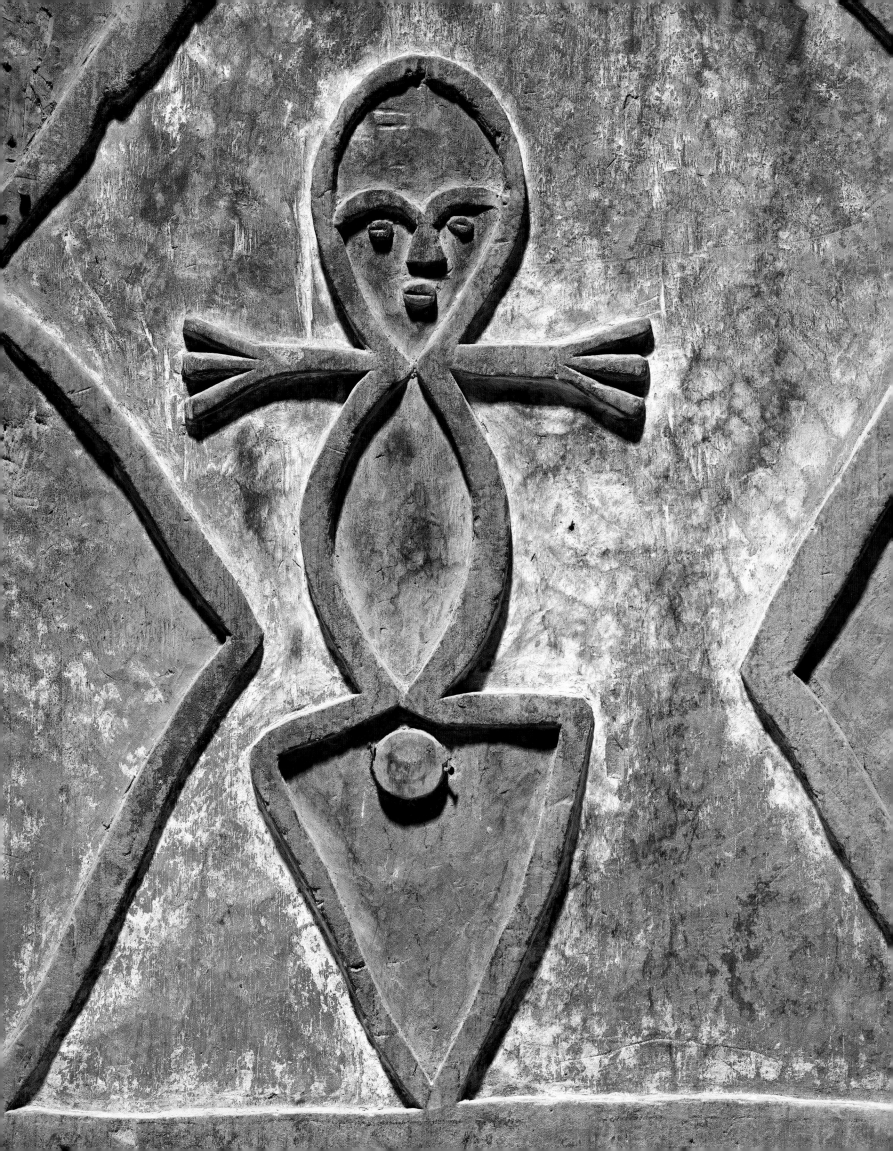

Door

Tsogo peoples, Ogowe River region, Gabon

Late 19th to early 20th century

Wood, pigment, iron nails, plant fiber

*147.3 x 66 x 3.8 cm
(58 x 26 x 1 1/2 in.)*

Gift of Walt Disney World Co., a subsidiary of The Walt Disney Company, 2005-6-100

In the 1860s, Paul Du Chaillu wrote several popular books about his adventures in Africa. On his visit to a Tsogo village, he was most impressed by the "attempt at decorative work on the doors of many of the houses"; he described them as "neatly built with walls formed of the bark of trees, . . . their doors painted red, white and black, in complicated and sometimes not inelegant patterns. These doors were very ingeniously made: they turned upon pivots above and below which worked in the frame instead of hinges."[1] Although the engravings in his book depict very different geometric patterns—rows of circles, and an X with a circle at its center—they do suggest relief carving, and the colors and form of this door fit with Du Chaillu's observations.

Photographs of Tsogo carved wooden doors associated with the men's cult of Bwiti (or Bwete) have been reproduced in Gollnhofer[2] and Mary.[3] According to anthropologist Judith Knight, carved doors may also define a sacred space within the cult house that is accessible only to those initiated into Bwiti.[4]

The human figure on this door probably has a protective function, an idea that is reinforced by the more naturalistic relief figures found on doors among nearby peoples. For example, an Mbete door relief resembles an Mbete reliquary guardian figure, and a Punu door features a displayed female figure with the face of a Punu white-faced spirit mask. The stylization of this Tsogo figure does suggest Tsogo masks, and its pear-shaped torso is a version in outline of the much more naturalistic Tsogo reliquary guardian figures that are covered with red pigment (see fig. 5).

—BF|CMK

Notes

1. Du Chaillu 1867, pp. 264-65.

2. Gollnhofer et al. 1975, p. 45, fig. 61.

3. André Mary, in Perrois 1997, p. 64.

4. Judith Knight, in conversation with the authors, October 3, 2006.

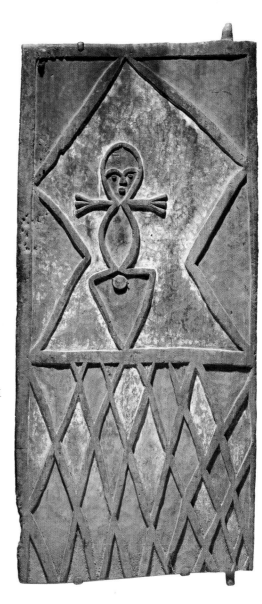

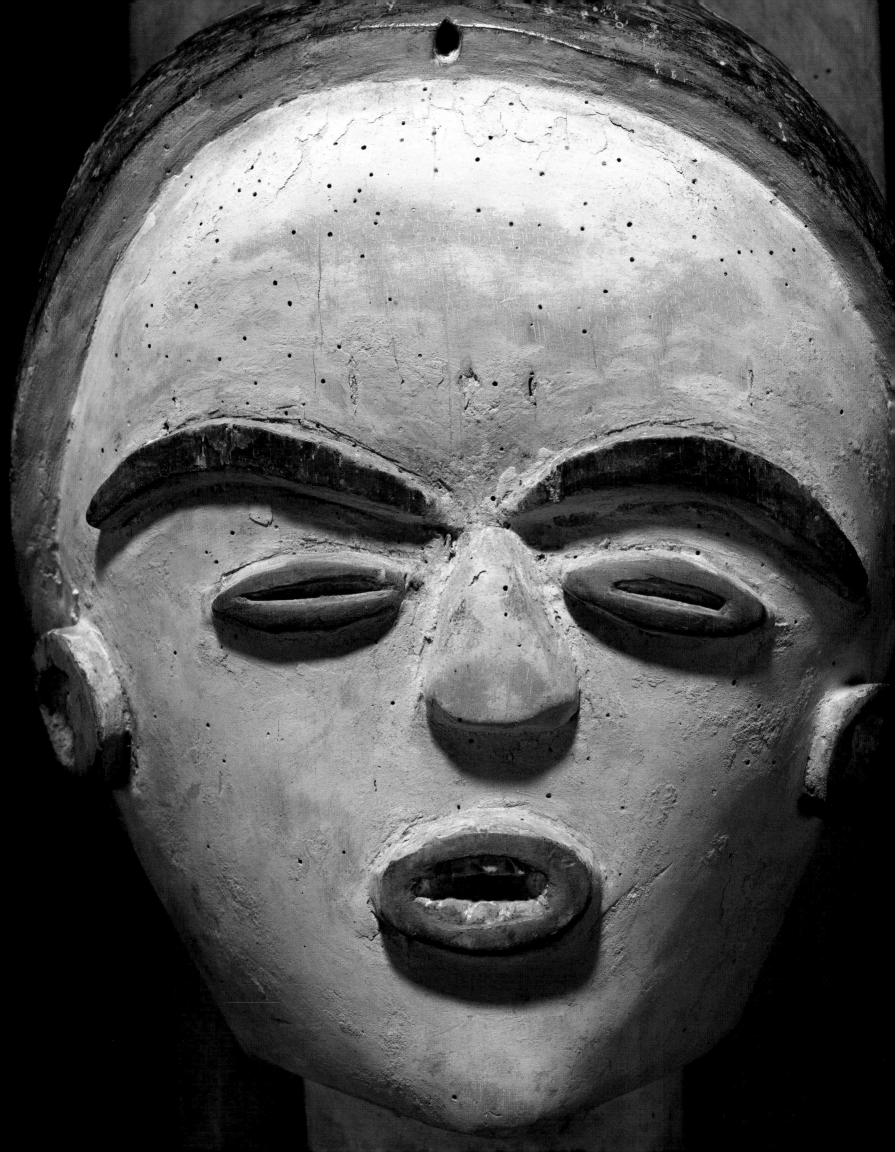

Post

Tsogo or Sango peoples, Gabon

Early to mid-20th century

Wood, pigment, cloth

190.5 x 17.8 x 14.6 cm
(75 x 7 x 5 3/4 in.)

*Gift of Walt Disney World Co., a sub-
sidiary of The Walt Disney Company,
2005-6-226*

The traditional sculptures of the Tsogo and Sango peoples of the mountainous region of central Gabon are connected with initiation societies, particularly the men's cult Bwiti (Bwete). Bwiti, which is particularly associated with the Tsogo, is prevalent in Gabon, along with its syncretic offshoot sometimes also known as Bwete.[1] Leon Siroto reports that in Tsogo and related villages a single cult house, "large, oblong partly open-sided," was built "to hold the sacred objects used in celebrating the rites of their cult of family relics."[2] Pillars, often figurative, carved in the round and polychrome, were employed to support the structure.

Flattened posts, such as this example, may have defined a "sacred space of a provisional altar."[3] Writing about a pair of planklike Tsogo figurative posts with lintel, Gollnhofer noted that the sculpted posts were on view only temporarily during mourning ceremonies associated with Bwiti, when they were erected against a temporary altar or planted in the ground in front of the altar, which would have been installed toward the back of the Bwiti cult house. The figures on each post—one female, the other male, oriented left and right, respectively —represented the primal couple.[4] More recent field observations by anthropologist Judith Knight indicate that such figures and altars are also erected as part of initiation rites that take place in the Bwiti cult house.[5] Thus, this post, which depicts a female figure, may originally have been paired with its male counterpart. The dotted pattern that adorns the torso of this figure could reflect scarification patterns or body-painting motifs associated with initiation.[6] The V-shaped notch at the top of the post suggests that it was designed to hold a beam.

The somewhat rounded and naturalistic treatment of this figure may suggest an origin other than Tsogo—perhaps Sango, as the original collection information suggested. The uncertainty reflects the limited research conducted in this region, where different groups have closely related art styles.

—CMK

Notes

1. Siroto 1995, pp. 14–15.

2. Ibid., p. 15.

3. Ibid.

4. Gollnhofer et al. 1975, p. 40, fig. 56.

5. Judith Knight, in conversation with the author, October 3, 2006.

6. Ibid.

DEFINING THE DISCIPLINE

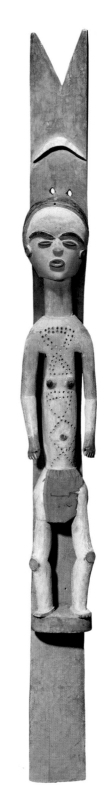

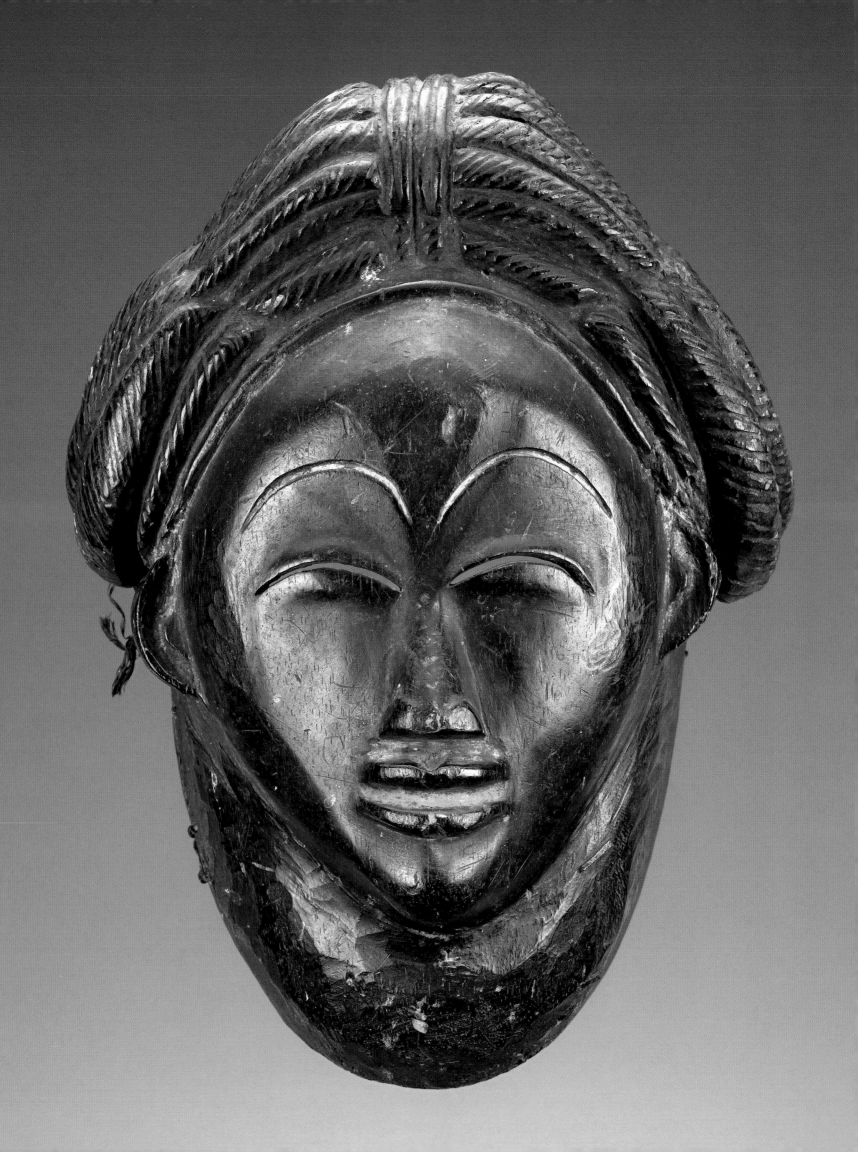

Mask

Lumbo or Punu peoples, Gabon

Late 19th to early 20th century

Wood, pigment

29 x 22.5 x 13 cm
(11 7/16 x 8 7/8 x 5 1/8 in.)

Gift of Walt Disney World Co., a subsidiary of The Walt Disney Company, 2005-6-99

Ideal feminine beauty seems to be an almost universal concept, as suggested by this mask's elaborate coiffure and refined facial features. The expression here is calm and almost literally inward-looking, judging from the shape and appearance of the eyes. Masks that depict feminine beauty are well known from the peoples of the Ngunie River basins. However, nearly all examples of female masks that are in collections and attributed to these peoples are coated with white kaolin, and black masks such as this one are rare. The surface color is not the result of wear or alteration but a deliberate choice. Many earlier publications suggest that the white masks portray the spirits of beautiful maidens and appear at funerals, and that the black masks had a judicial function; but through dissertation research and fieldwork among the Punu, Alisa LaGamma has identified a more complex relationship between the two colors of masks.[1]

LaGamma's informants linked the color white with beauty, and black with ugliness. White is considered female, and black is often male. The white masks, called *mukudj,* are worn in the daytime, in formal, closely structured performances. The black masks, called *ikwar,* may be carved in the same form as the white female masks or as deliberately more grotesque male masks, and are worn at night; they are regarded as spontaneous and less sophisticated. Although *mukudj* and *ikwar* do not perform together, the Punu compare and contrast the two in describing and critiquing the masquerades. One standard that they use to distinguish between them would be unknown to most outsiders: both masks are worn by stilt dancers, but the *mukudj* is significantly higher— 3 to 3.5 meters, versus 1 meter or less for the *ikwar.*

The mask performances were described to LaGamma as occurring during celebrations of happy days and good health within the Punu community.

—BF

Notes

1. LaGamma 1996, pp. 141-51.

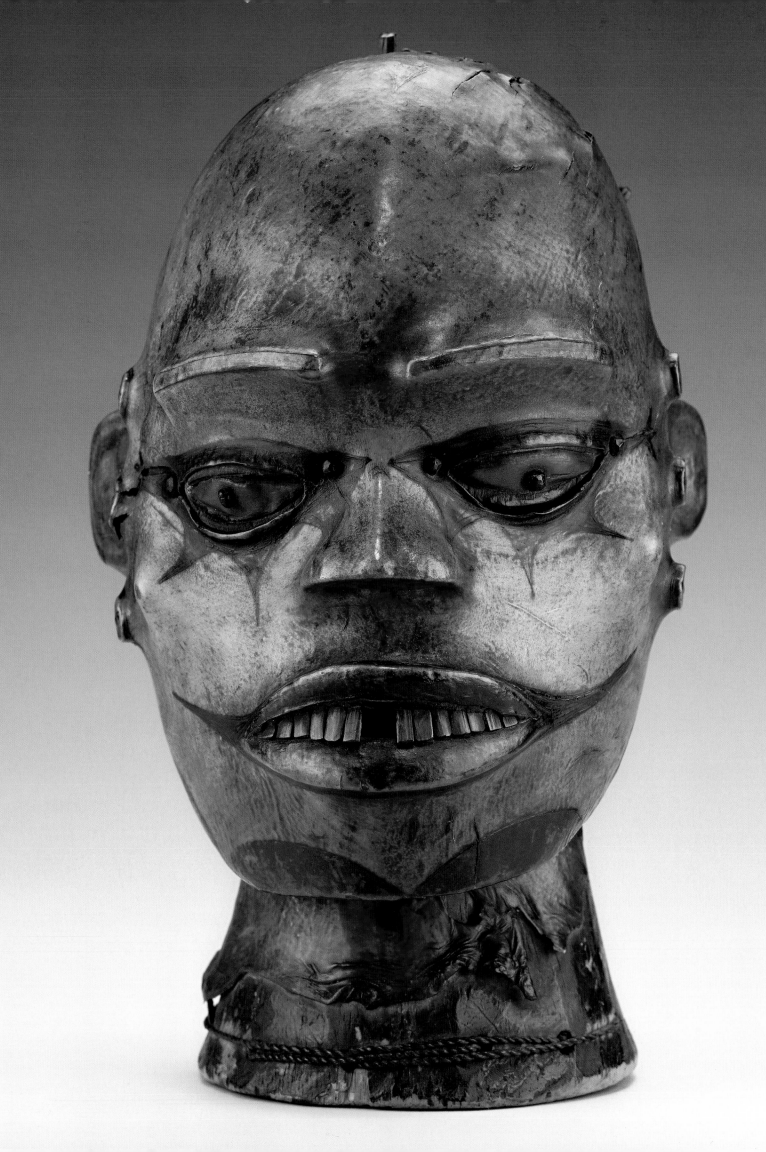

Mask

Ejagham peoples, Cross River region, Nigeria

Late 19th century

Wood, skin, metal, plant fiber, dye

*26.5 x 17 x 17.5 cm
(10 7/16 x 6 11/16 x 6 7/8 in.)*

Gift of Walt Disney World Co., a subsidiary of The Walt Disney Company, 2005-6-91

The carver of this mask portrayed its facial features with a realism that emphasized its large, staring eyes, prominent nose with flaring nostrils, and open mouth exposing a set of teeth made from the bark of a palm midrib. The fierceness of the mask's countenance was further accentuated when the artist made tattoo markings by applying natural pigment around its hairline, eyes, eyebrows, mouth, chin, and neck. The head once had a basketry attachment, which is now missing.

Ekpo Eyo described its use on various occasions, such as entertainments and funerals by the Asirikong society, a group of wealthy and powerful men.[1] Eyo also noted that similar crest masks are found on examples in other collections, including one in the National Museum, Lagos, Nigeria, which may be from the village of Krakor, Ikom, Cross River State and carved around 1880.[2]

—AN

Notes

1. Eyo, in Vogel 1981, p. 173.

2. Ibid.

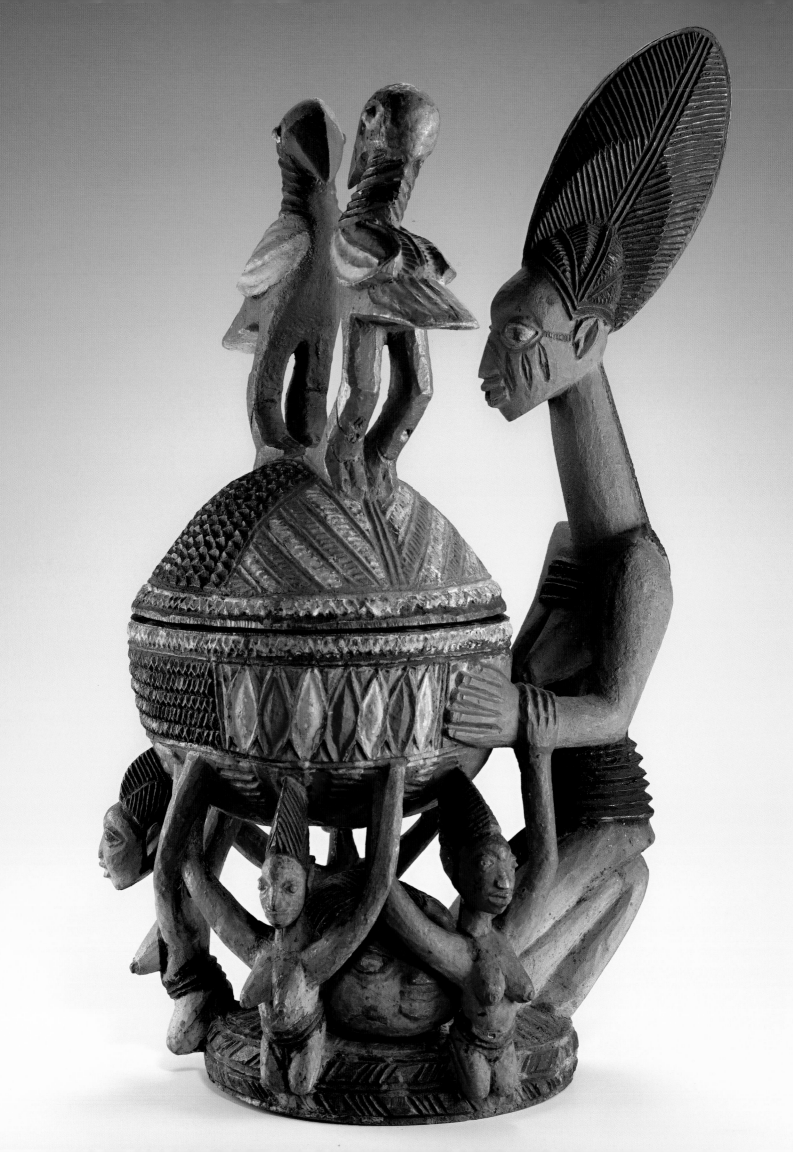

Bowl with figures

Artist: Olowe of Ise (c. 1875–c. 1938)

Yoruba peoples, Ekiti region, Nigeria

Early 20th century

Wood, paint

53.8 x 25 x 35 cm
(21 3/16 x 9 13/16 x 13 3/4 in.)

Gift of Walt Disney World Co., a sub-sidiary of The Walt Disney Company, 2005-6-34

Bowl

Artist: Olowe of Ise (c. 1875–c. 1938)

Yoruba peoples, Ekiti region, Nigeria

Early 20th century

Wood

16 x 32.7 x 34.1 cm
(6 5/16 x 12 7/8 x 13 7/16 in.)

Gift of Walt Disney World Co., a subsidiary of The Walt Disney Company, 2005-6-167

The outstanding composition of this lidded figural bowl by the Yoruba master artist Olowe of Ise justi-fies the words of his *oriki* (praise song) extolling him as "outstanding among his peers, one who carves the hard wood of the iroko tree as though it were as soft as a calabash." [1] Kneeling behind the bowl, and grasping it with her hands, is a large, elongated, deli-cately carved female figure. From below, the bowl is elevated and supported by the upraised arms of four small and more compactly rendered kneeling female figures, painted in different hues and perched along the edge of the circular base. The figures all embody Yoruba conventions of ideal feminine beauty, with an emphasis on complex coiffures, facial scarification marks, prominent breasts, and postures that suggest devotion, inner strength, and stability. Olowe's virtu-osity is indicated by the loose bearded head that moves within, but cannot be removed from, the "cage" created by the figures' interlocking arms. Two large fowl (one restored) stand atop the lid, framing the face of the dominant figure. The surface, including the backs of the figures, is covered with incised designs arranged in linear, diamond, zigzag, and ropelike patterns. The composition is enlivened by a palette of red, buff, white, black, and a surpris-ing use of green—a color rarely found on African carvings before the early 20th century.

This prestige bowl, owned by someone of high status, probably held kola nuts, a traditional gesture of hospitality presented to guests and offered to deities during rituals. Olowe served the Arinjale (king) of Ise, but he also accepted commissions from other Yoruba kings and wealthy patrons. [2] The bowl was in England early in the 20th century, brought back by a member of the British Royal Navy, Harry Hinchcliffe (d. before 1934), who was stationed in Nigeria. [3] It is believed to be an earlier version of a lidded bowl that is also in the collection of the National Museum of African Art (acc. no. 95-10-1), which dates from the mid-1920s.

Olowe of Ise was born about 1875 in Efon-Alaiye, an important center of Yoruba carving. His distinguished career included the creation of master-fully carved doors, veranda posts, figurative bowls, single figures (including twin figures) and group compositions, dolls, boxes, drums, a mirror case, and one extant *epa* mask. True to his reputation as an innovator, Olowe designed a non-figurative bowl (see below) that is believed to be unique in African sculpture. [4] Carved of a single piece of wood, it is "a remarkable shape, with its cantilevered miniature bowl suspended over the center" of the footed bowl, which bears the artist's characteristic richly textured designs on the rim and exterior surface. [5] It has a corroded interior base that suggests use, but its pur-pose is unknown.

—CMK

Notes

1. Walker 1998, p. 25.

2. Walker, in National Museum of African Art 1999, p. 69.

3. Fagg 1974, p. 17, cited in Walker 1998, p. 92.

4. Walker 1998, p. 100.

5. Fagg, in Vogel 1981, p. 102.

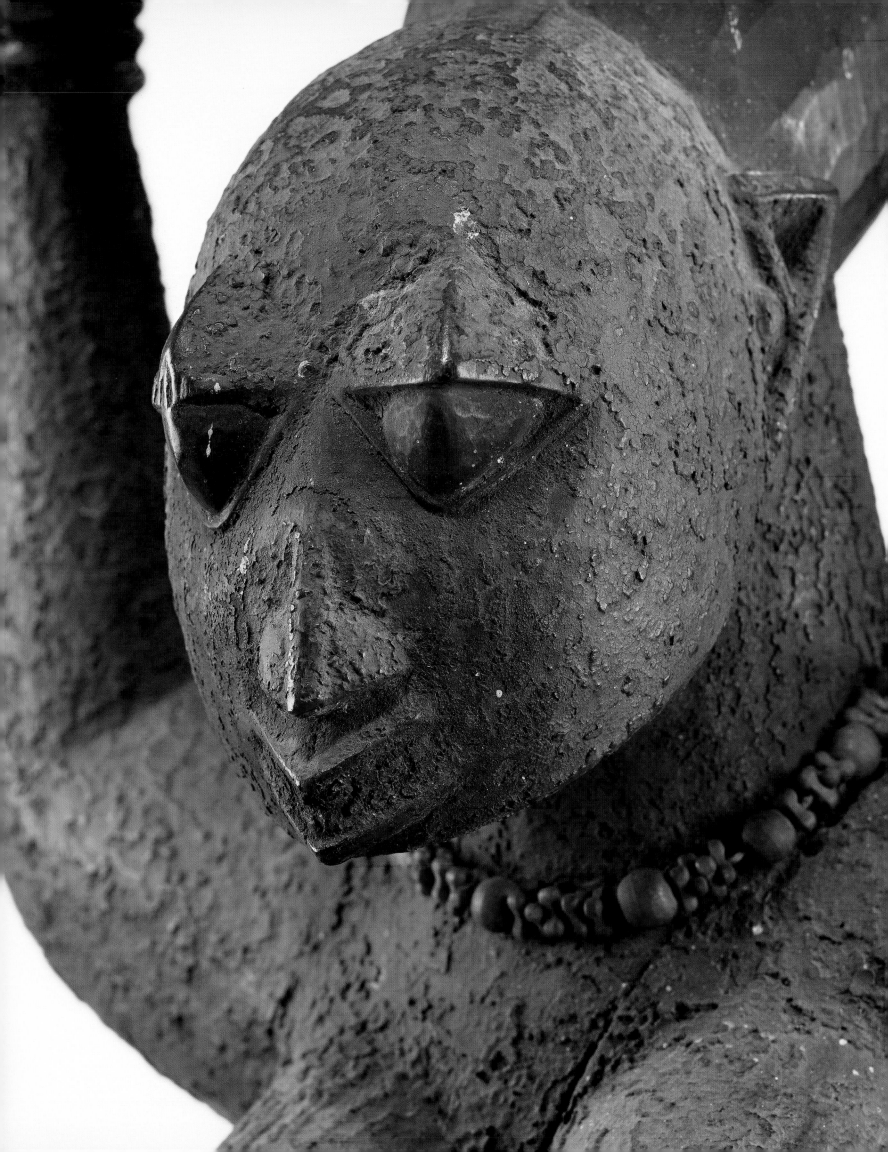

Door

Workshop of Yalokone

*Northern Senufo peoples, Boundiali,
Côte d'Ivoire*

1920s

Wood, iron

*149.5 x 75 x 10.4 cm
(58 7/8 x 29 1/2 x 4 1/8 in.)*

*Gift of Walt Disney World Co., a subsidiary of The Walt Disney Company,
2005-6-6*

Wealthy and powerful individuals in the northern Senufo region commissioned intricately carved doors as symbols of prestige. The human and animal relief-carved motifs are associated with the beliefs in the powers of divination, nature spirits, and the supernatural held by members of Poro, the men's initiation society that is found among a number of groups in west Africa.

Art historian Anita Glaze's 1981 commentary on this door remains the most complete analysis of its iconography. She noted that the motif of the hunter and his prey, at the top, "reflects the hunter's high status in Senufo culture, but also recalls his privileged access to animals used protectively in healing and aggressively in sorcery."[1] The top panel also includes two face masks similar to those owned and used by the men's and women's initiation societies, although at times they are also performed for entertainment. At the bottom of the door, a crocodile devours a snake—a motif that suggests "aggression, sorcery, and personal power" and the knowledge required to combat them.[2] As a counterbalance, the central motif is adapted from a scarification pattern adorning a woman's navel, a symbol that "evokes social order as ordained by the Creator."[3]

Robert Goldwater, in his 1964 book *Senufo Sculpture from West Africa,* indicated that this door, then in the Verheyleweghen collection, Brussels, was similar in style to a door collected by Dr. Albert Maesen in 1939. That door was dated to 1925 and identified as the work of the carver Yalokone from Boundiali village.[4] The distinguishing characteristic of doors by this carver or his workshop "is the insertion of figures on the hatched fields of the central plane," but it may also reflect a broader regional approach.[5] Its Bamana-style lock suggests the cultural and artistic connections between the Bamana region of Mali and the northern Senufo region of Côte d'Ivoire.

—CMK

Notes

1. Glaze, in Vogel 1981, p. 51.

2. Ibid.

3. Ibid.

4. Goldwater 1964, p. 29 and caption to fig. 157.

5. Ibid., p. 29.

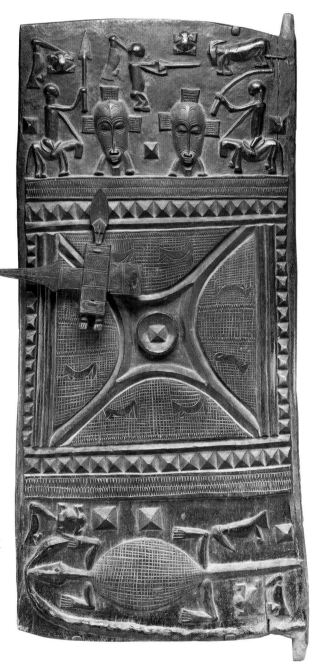

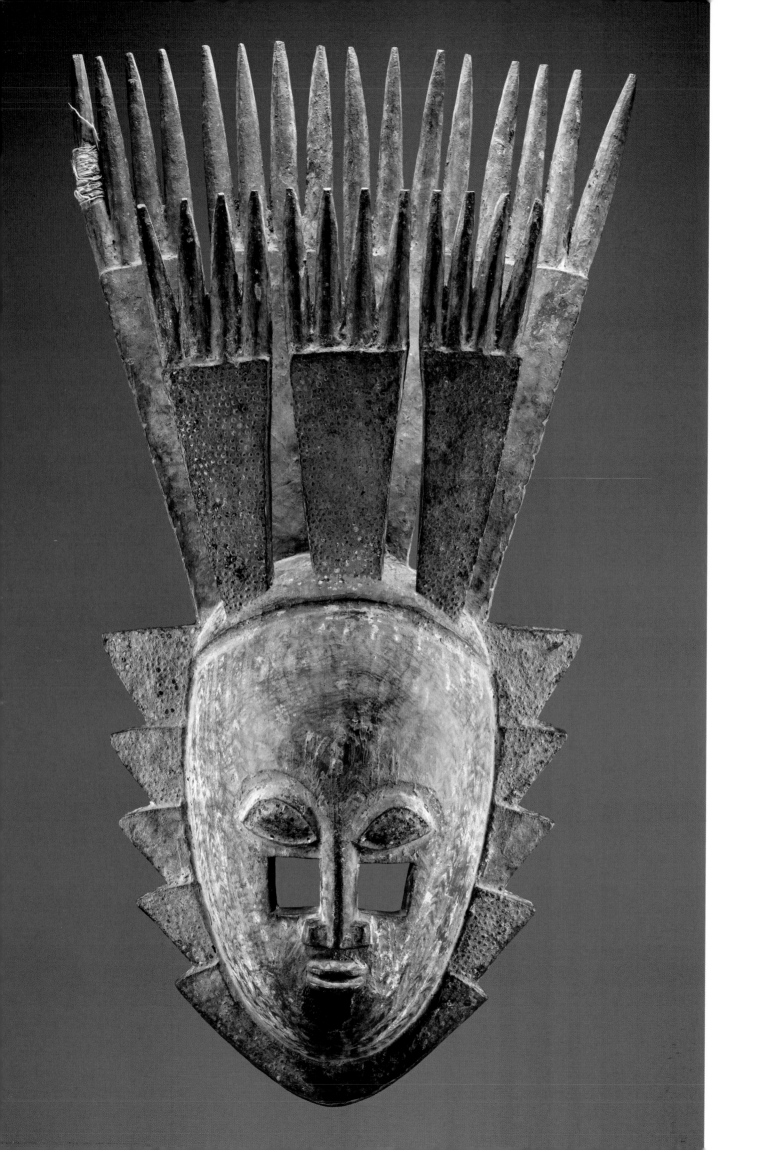

Mask

Artist: Attributed to Ajere Elewe of Epe

Yoruba peoples, Opin area, Nigeria

Late 19th to mid-20th century

Wood, pigment

69.7 x 38.5 x 13 cm
(27 7/16 x 15 3/16 x 5 1/8 in.)

Gift of Walt Disney World Co., a subsidiary of The Walt Disney Company, 2005-6-77

Yoruba masks are usually worn either like a slanted cap or over the head like a helmet. Yoruba face masks, however, are unique to a dozen villages populated by the clan in the Opin area, in the northeast region of Yorubaland.[1] This particular mask belongs to the category of masquerades called *epa,* which are performed to ensure community well-being. The various characters in an *epa* mask performance (i.e., herbalist, warrior, mother, king) reinforce the history and hierarchical structure of the community, group, or region. According to field informants, this mask was one of three *epa* masks that belonged to a Yoruba family, and appeared during the funerals for the family and the local ruler.[2]

One of the names for this type of mask, *oloju foforo,* means "the owner of the deep-set eyes,"[3] a reference to the cut holes through which the wearer sees. These openings resemble the eyes that are typically carved in the more common helmet form of *epa* masks, which are also from the northern Yoruba region (see fig. 6). Another praise name for this mask is *epa oloyiya* or "owner of combs,"[4] a reference to the seven combs arranged vertically in two registers atop the head. Although women use combs to style their hair and include them as ornaments in some coiffures, they are not focal objects in Yoruba art or ceremony. Rather, they hold symbolic value. For the Yoruba, projections from the top of figures or masks (such as the combs atop this mask) are associated with inner power, vital force, and the divine.[5] The Yoruba also believe that properly coiffed hair is a mark of honor to the inner head, the spiritual self. The comparison is made between the woman's head of hair and the maintenance of a grove that holds a sanctuary.[6] Perhaps the comb could be considered as a special tool in that metaphorical context.

—BF

Notes

1. Carroll 1967, p. 79.

2. Carroll, in Vogel 1981, p. 120.

3. Carroll 1967, p. 163.

4. Carroll, in Vogel 1981, p. 120.

5. M. Drewal 1977: 44, 49.

6. Araba 1978, cited in Lawal 2000, p. 95.

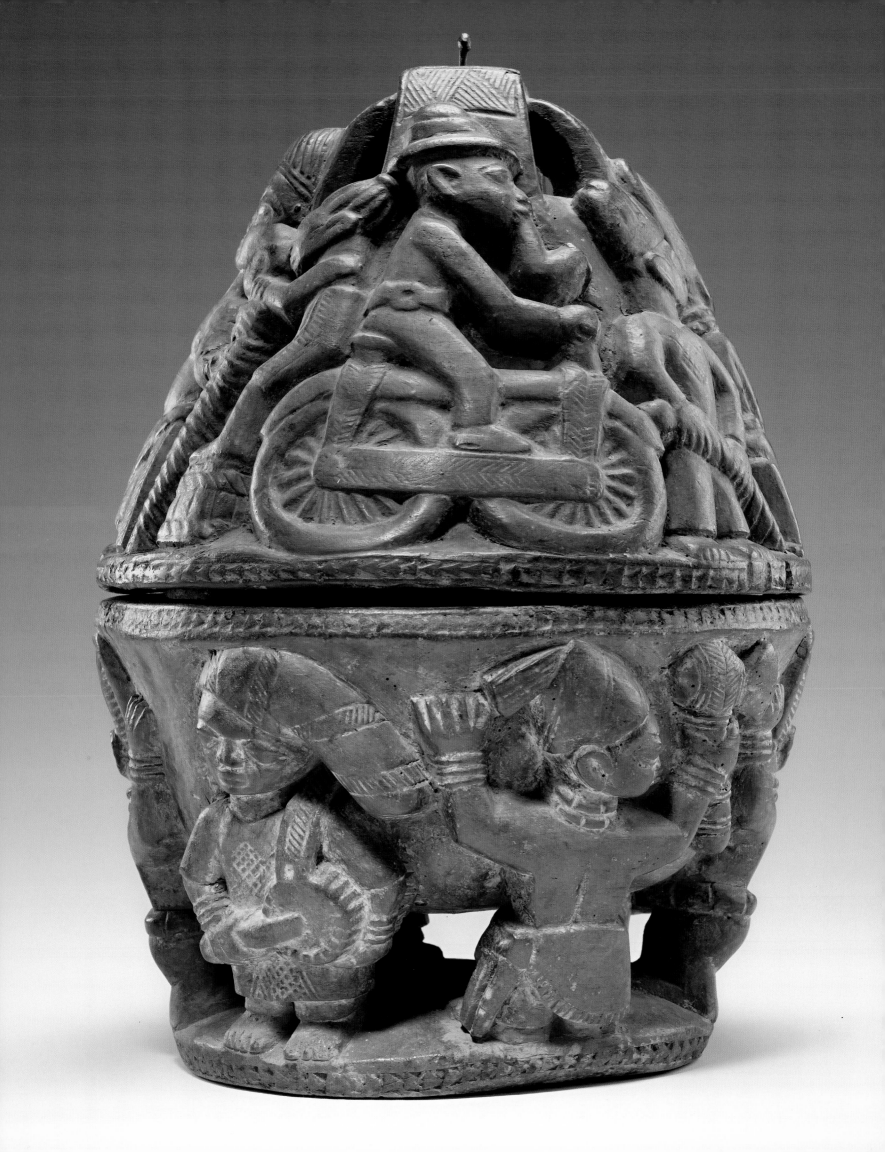

Bowl with lid

Artist: Attributed to Areogun of Osi-Ilorin (1880–1954)

Yoruba peoples, Ekiti region, Nigeria

Early 19th to mid-20th century

Wood, pigment, iron

41 x 27 x 29.5 cm
(16 1/8 x 10 5/8 x 11 5/8 in.)

Gift of Walt Disney World Co., a subsidiary of The Walt Disney Company, 2005-6-68

This figurative lidded bowl is attributed to the master artist Areogun, who lived, worked, and died in or near the village of Osi-Ilorin in northeastern Yorubaland. Knowledge about Areogun and his work derives from Father Kevin Carroll of the Society of African Missions, who first became acquainted with this artist in 1948 and who worked with him to document his work and that of other Yoruba artists.[1] Numerous doors, house posts, masks, and divination bowls are identified as being carved by (or attributed to) Areogun and his workshop.

This piece is typical both of Areogun's best work and Yoruba stylistic canons—including the use of low relief to display solid compact figures that fill the composition.[2] The bowl's use is uncertain. It lacks the interior divisions found in other examples owned by Ifa diviners. At first glance, several of the figures and attributes on the bowl suggest an association with Shango, god of thunder. However, alternate interpretations and associations with other deities are possible, as the figures portrayed and their attributes also suggest the Yoruba cosmos—a universe where transformation, interdependence, and interaction are ever present. For example, on the lid is the figure of a man on a bicycle or motorbike wearing a pith helmet and smoking

a pipe; this is a reference either to Shango, who is also associated with speed and noise and who in earlier carvings was shown on a horse, or to Eshu, the famous trickster deity, a messenger to the gods who is often shown smoking a pipe. Also on the top register is a male figure carrying a bird-topped herbalist staff and an equestrian warrior wearing a pith helmet. On the lower portion of the bowl is a man with upraised hands, the right hand holding a hafted axe with a triangular blade in the form of a thunderstone—a possible reference to either Shango or Ogun, the Yoruba god of iron. There is also a figure of a Shango priest wearing the special leather bag used to carry the god's thunderstones; in his left hand he carries a spear and, in his right, a staff with a textured pattern on top. The notion of the Yoruba cosmos portrayed with the inclusion of the figures associated with deities is reinforced by the arches on the lid—symbolized by a crown or axis of the world held in place by an iron spike driven down through the center.

—BF | AN

Notes

1. Picton 1994: 46.

2. Drewal and Pemberton with Abiodun 1989, p. 19.

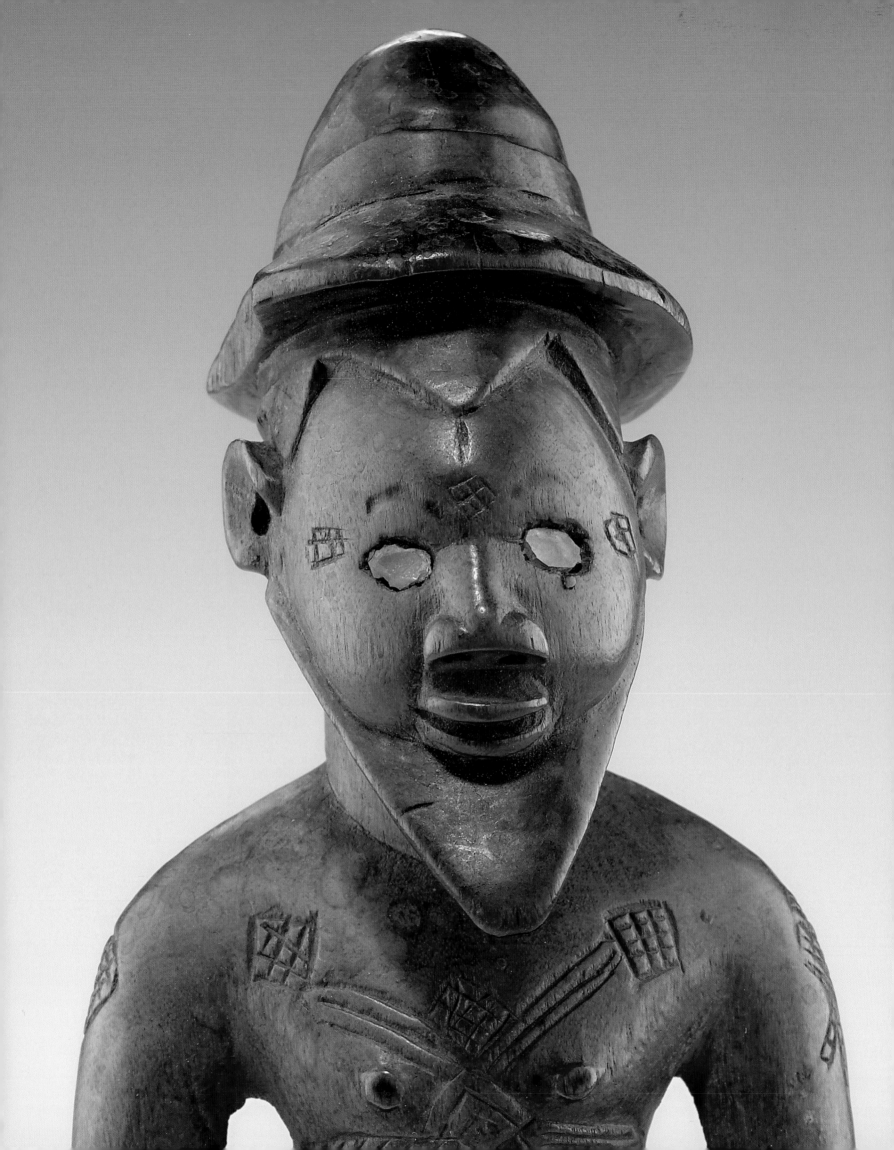

African Art/African History

Christine Mullen Kreamer

THE WALT DISNEY-TISHMAN African Art Collection includes superb works of art reflecting the continent's rich history that has shaped and been shaped by interactions with the wider world, including Africa's colonial and post-colonial histories. Thus, it serves as a valuable tool for exploring the continent's artistic traditions over time, especially sculpture from west and central Africa. The collection spans an impressive four centuries, its earliest object dating to the late 15th century and its most recent to the early and middle decades of the 20th century. In addition, specific works of art in the collection address issues relevant to the broader history of art in Africa.

As visual documents, works of art serve as archives of knowledge and impart information. Their forms, materials, iconography, and contexts of use can be read and interpreted in light of social, political, economic, and intellectual history. Thus, they are a piece of a complex puzzle that is the human experience. Considered together with archaeological evidence, oral traditions, written documentation, and contemporary practice, works of African art inform our understanding of that continent's dynamic history and its active engagement within global arenas.

Trade, patronage, and the circulation of objects

An exquisitely carved ivory hunting horn, perhaps the oldest work in the Walt Disney-Tishman African Art Collection, and the midsection of an ivory saltcellar are evidence of an early history—with contemporary relevance—of trade and social interaction along the west African coastal region. They are part of a group of export-oriented objects referred to as Afro-Portuguese ivories that were commissioned by

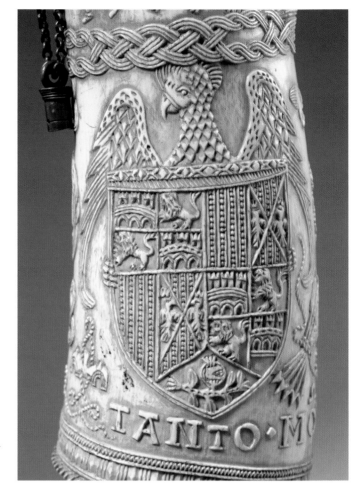

Fig. 13
[cat. no. 15]

Hunting horn (detail)

Sapi-Portuguese style, Bullom or Temne peoples, Sierra Leone

Portuguese explorers and commercial agents who worked along the west African coast from the late 15th century to the end of the 16th century. The term "Sapi-Portuguese ivories" identifies works dating from about 1490 to 1530 made by artists that the Portuguese called the Sapi—ancestors of present-day Bullom (or Sherbro), Kissi, Temne, and Baga peoples in what is now Sierra Leone and Guinea.[1] Bini-Portuguese ivories were produced c. 1525–1600 by court artists from the kingdom of Benin in present-day Nigeria.[2]

As a historical document, the Sapi-Portuguese ivory horn in the Walt Disney-Tishman Collection (fig. 13) yields important stylistic and iconographic information (the coat of arms of Portugal and Spain, an armillary sphere, the motto of Spanish king Ferdinand v), which together enabled scholars to propose the date of its manufacture between 1497 and 1500 and to identify the hand of the master carver who created it.[3] It is one of four such horns (also called oliphants) and two powder flasks attributed to the unnamed artist that art historians

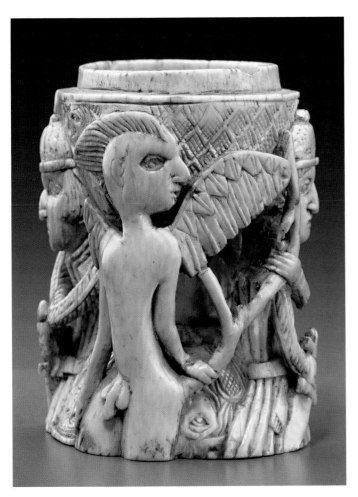

call the Master of the Arms of Castile and Aragon, the insignia of Ferdinand v.[4]

The Bini-Portuguese ivory saltcellar midsection (fig. 14) is the only extant work that, to date, has been attributed to the carver identified as Artist iv. While the subject matter is familiar for this type of object—male angels depicted nude and flanking Portuguese male figures in European attire—the naturalistic proportions of the angels and the fact that their legs clearly extend into the lower section (missing) of the saltcellar reveal an approach unique to this hand.[5] Based on the consistent iconography of Bini-Portuguese saltcellars and horns, scholars Ezio Bassani and William Fagg proposed that the works were commissioned by a single patron, possibly a Portuguese official who worked for some years in the region, who provided the ivory carvers with reference material.[6]

The horns, saltcellars, spoons, forks, pyxes (lidded liturgical vessels to hold consecrated hosts), and powder flasks that comprise Afro-Portuguese ivories reveal exceptional artistry and a fascinating blend of African and European (primarily Portuguese) sources of inspiration. Made of precious ivory and executed with magnificent virtuosity, Afro-Portuguese ivories served as prestige items for rulers and the wealthy in Renaissance Europe and were among the first works of African art to enter European collections. In commissioning these complex and delicate works in ivory, the Portuguese recognized the artistry and technical expertise of the African carvers entrusted with fashioning works that would appeal to foreign expectations and tastes. At the same time, African artists invested these works with their own artistic vision, employing local and foreign imagery to spectacular effect. The results are rare and unique masterworks in ivory that are among the more highly regarded African works of art in museums and private collections today.

Many of the designs on Afro-Portuguese ivories were derived from two-dimensional illustrations in European prayer books and other publications that were provided as source material for the artists, who then translated them

Fig. 14

[cat. no. 18]

Saltcellar

Benin kingdom, Bini-Portuguese style, Edo peoples, Nigeria

with impressive skill and accuracy onto three-dimensional objects. African artists also drew on an indigenous repertoire of motifs, including decorative patterns used by the local cultures and flora and fauna common to the local environment. In the case of Sapi-Portuguese ivories, the manner in which many of the human figures were rendered is closely aligned to centuries-old stone figures that were found and reused as ritual objects by local populations in Sierra Leone and Guinea (fig. 15; see also cat. no. 17). To date, none of these stone carvings has been documented in situ as part of an archaeological excavation; thus, dating them to the 15th or 16th century is speculative, and their original purpose remains a mystery. However, their stylistic similarity to the Sapi-Portuguese ivories "can be taken as representative of the art style that preexisted the Portuguese arrival on the coast."[7]

Similarly, the production of Bini-Portuguese ivories fit within a broader context of art and patronage that existed in the Benin kingdom before the arrival of the Portuguese (and that has continued to the present time). They were made by carvers who belonged to the kingdom's ivory guild, whose artistic output was primarily local and dedicated to the production of royal arts to serve the *oba* (king) and his court (see cat. no. 1). With permission, court artisans were able to produce works for other patrons, including the Portuguese.

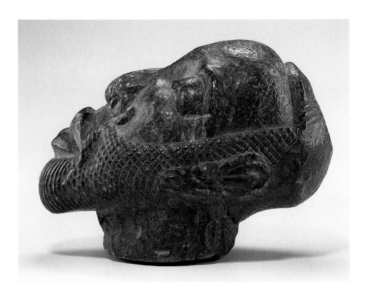

Fig. 15
[cat. no. 16]

Male head
Undetermined peoples, Sierra Leone

The kingdom of Benin, consolidated in the 13th or 14th century in present-day Nigeria, expanded in the 15th and 16th centuries, profiting, in part, from trade relations with the Portuguese that began in 1485.[8] The royal arts of the Benin kingdom sometimes portrayed the Portuguese in three-dimensional and relief sculptures, although they were often depicted as smaller, supplementary characters to signal their subservience to the *oba*—a reflection of their presence in the kingdom and the king's power over his subjects, both local and foreign. Trade in metals brought in by the Portuguese during the 16th and 17th centuries increased the availability of this raw material in the kingdom. It was put to good use by the

Fig. 16

Commemorative head of a king

Benin kingdom court style, Edo peoples, Nigeria

18th century

Copper alloy, iron

26.67 x 17.78 x 17.78 cm
(10 1/2 x 7 x 7 in.)

Gift of Walt Disney World Co., a subsidiary of
The Walt Disney Company, 2005-6-18

This head was once displayed on an altar
honoring a particular *oba,* or king. It is
not a specific portrait but an image of the
status and regalia of kingship, which is
emphasized in the depiction of the collar
and crown made of imported coral beads.

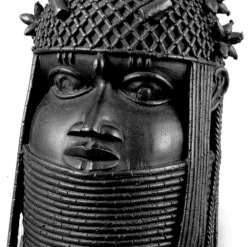

royal brass-caster's guild, which employed the lost-wax method to fashion human
and animal figures (see cat. no. 19), commemorative heads (fig. 16), plaques, altar-
pieces, gongs, boxes, vessels, and pendants of high technical and aesthetic merit.

An 18th-century mask (cat. no. 2), which was worn by a diviner-healer
as part of the Ododua masquerade performance linked to royal power, exempli-
fies the exceptional workmanship of guild artists. Their tradition of excellence
dated back to the late 14th century and continued until 1897, when Benin City
was captured, the king exiled, the palace sacked, and royal artworks confiscated in
a punitive expedition mounted by the British.[9] As a result, thousands of seized
artworks were exported to Britain, where they made their way into European
public and private collections. In 1914, the British permitted a new *oba,* the
king's son, to return to Benin City and restore the monarchy, albeit with a smaller
palace and court. Royal patronage became less restrictive and court artists were
permitted to sell their works on the market, a practice that continues to the pres-
ent.[10] Works of art seized in 1897 from the palace complex, however, were not
returned to the kingdom. Instead, they remained in private hands or became part
of important museum collections in the West, where the royal arts of Benin are
on public view to illustrate a high point of African aesthetic achievement—a pos-
itive message that holds little consolation to those who have advocated for the
return of at least some of these treasures either to the Benin kingdom, as part of
their cultural heritage, or to the government of Nigeria, as emblems of a broader
national identity.

In central Africa, the kingdom of Kongo was well-established by 1483 when
Portuguese explorers arrived. There they found "a centrally organized nation
with governors ruling over provinces on behalf of a king."[11] Oral traditions place
the founding of the kingdom toward the end of the 14th century under the lead-
ership of the ruler Nimi a Lukemi, who established his capital, Mbanza Kongo,
south of the mouth of the Congo River.[12] The Kongo kingdom flourished in the
15th century and remained a powerful presence in central Africa during the 16th
and 17th centuries. At its height, the "kingdom was known throughout much of
the world and sent diplomats to Europe and Brazil."[13] Its territory extended

along the coastal regions of present-day Angola, the Republic of the Congo, and the Democratic Republic of the Congo.

The prestige and wealth of the Kongo kingdom rested on its control of lucrative trade routes and on the commercial alliances that it made, first with Portugal and later with other European nations. Christianity, introduced by the Portuguese, took hold in the kingdom in 1491 when the king converted, and was established as the state religion under the subsequent rule of his son.[14] Kongo artists set to work producing objects used in Christian rituals, at first making faithful copies of European prototypes.[15] Later, a more local aesthetic predominated, as is evident in the copper-alloy crucifix (cat. no. 20) in the Walt Disney-Tishman Collection that displays distinctly African features and dates to the 17th or 18th century.

Christianity did not supplant local beliefs there; rather, it was probably adopted by Kongo rulers as a political strategy to ensure smooth relations with foreign powers. Conversions were concentrated mainly among the elite and probably had little practical effect among the general populace. Over time, Christian objects were absorbed into indigenous practices, joining a range of art forms used as emblems of authority and employed for healing, divination, and other purposes (see fig. 17).[16] Stone and wooden mortuary figures produced by Kongo artists during the 18th and 19th centuries (see cat. 21) reflected the resiliency of local beliefs in the region, where they served as prestige markers on tombs as part of long-standing local customs commemorating the ancestors.

The Portuguese were the first Europeans to explore the coastal regions of west and central Africa at the end of the 15th century, and were soon followed by the Dutch, Danish, Swedish, British, and French. Well-established trading systems that existed in Africa prior to European contact expanded to meet new market opportunities. Although these interactions resulted in some positive outcomes, early European presence in Africa was far from benign. The transatlantic slave trade spanned nearly four centuries and was a direct consequence of the rise of European commercial interests on the continent. Its profound disruption to African societies, particularly during the period 1701–1850 when the trade inten-

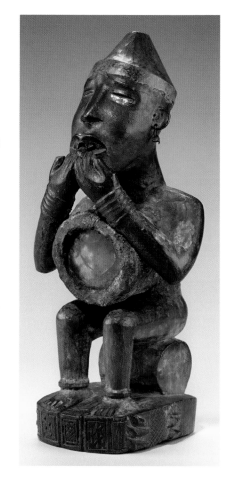

Fig. 17

Figure

Kongo peoples, Democratic Republic of the Congo

Late 19th to early 20th century

Wood, mirror, metal, encrustation

*36 x 13.5 x 13 cm
(14 3/16 x 5 5/16 x 5 1/8 in.)*

Gift of Walt Disney World Co., a subsidiary of The Walt Disney Company, 2005-6-110

This figure, called an *nkisi,* is the physical container for a spirit from the other world, the land of the dead. When activated by a specialist, or *nganga,* it has the power to heal, to protect, or to punish.

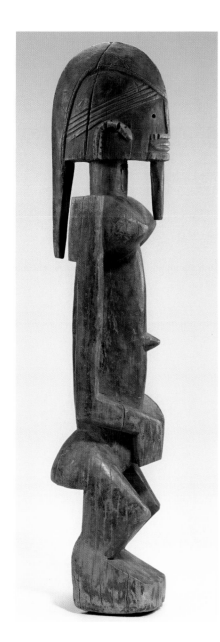

Fig. 18

[cat. no. 22]

Female figure

Dogon peoples, Mali

sified, had both immediate and cumulative effects on the continent. As artistic subject matter, the traffic in enslaved Africans and its consequences may not have fit the themes and contexts typically served by the traditional arts.[17] Limited depictions of enslavement—individuals in bondage or chained together, representations of shackles—exist in 19th-century export ivories carved along the Loango coast and in selected examples of Benin kingdom castings and 20th-century Akan stools and Fon ritual objects, for example; but these are more the exception than the rule and may be indications of a broader notion of oppression and servitude rather than specific records of the history of transatlantic slavery. That the traditional visual arts of Africa were largely silent in recording this tragic history was perhaps a reflection of the extent to which African social relationships and cultural institutions were both implicated in and ripped apart by this "cruelest commerce,"[18] the legacy of which endures today within and outside of Africa.[19]

Colonialism, African creativity and the "era of collecting"

The Walt Disney-Tishman African Art Collection was built by Paul and Ruth Tishman over slightly more than 20 years, from the late 1950s to the early 1980s. This was a period of time that corresponded to what art historian Susan Vogel has called the "era of collecting . . . [a] hundred-year-long cycle . . . [when] a majority of all extant nineteenth and early twentieth century sculptures poured out of Africa largely into the collections of Europe and America."[20] Fueled by early explorations, colonial expansion, and collecting expeditions on the African continent, African works of art attained increasing public recognition through their display in colonial expositions, in newly founded ethnographic museums, and, a bit later, in art museums and art galleries. The Tishmans' acquisition of a Dogon figure from Mali (fig. 18), a Senufo mask from Côte d'Ivoire (cat. no. 23) and a Fang reliquary head from Gabon (fig. 19) were object types that had become part of "the canon" by virtue of their early embrace by Western artists and collectors and fueled by an ongoing market interest in Europe and the United States for art from former French and Belgian colonies.[21]

Most of the objects in the Walt Disney-Tishman Collection date from the late 19th to the early- and mid-20th century, a time that coincided with increased Western economic interest on the continent and the establishment of

colonial rule by European powers. The Berlin Conference of 1884–85 is often seen as the beginning of the colonial era in Africa. It partitioned the continent among Britain, France, Germany, Belgium, Portugal, Italy, and Spain, thus legitimizing the "Scramble for Africa" that had intensified in the 19th century in the search for raw materials and expanded overseas markets for the products of Western industrialization. Colonialism exerted far-reaching influences, many of them negative, on nearly every aspect of African society: language, social and political institutions, education, economic and health systems, transportation networks, cultural traditions, and the arts.

Selected sculptures in the Walt Disney-Tishman Collection illustrate some of the ways that African artists and cultural institutions creatively engaged with the colonial encounter, demonstrating that Africans were not passive recipients to the autocratic rule of colonizing forces. One of the strategies that Africans adopted for subverting and resisting Western hegemony was to appropriate symbols of colonial authority for their own purposes. The ivory finial of a staff from Côte d'Ivoire serves as an excellent case in point (fig. 20). An Attie (or Akye) ruler or dignitary emphasized his elevated social status by carrying a prestige staff topped with an elegantly carved finial of a man in European attire and seated upon an imported chair. Whether the figure represents a European or an Attie man of means is uncertain. His long straight hair and bushy mustache would seem to be features of a foreigner, but his formal pose and his gesture of raising hands to beard suggest modes of repre-

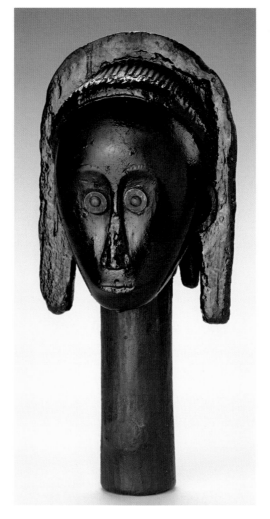

Fig. 19

[cat. no. 24]

Reliquary guardian head

Fang peoples, Gabon

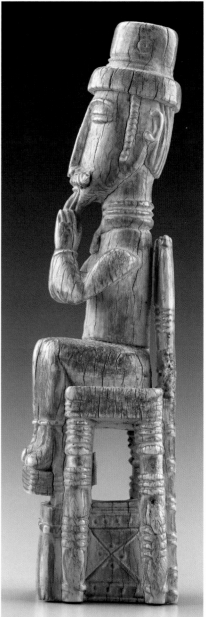

Fig. 20

[cat. no. 26]

Finial depicting a male figure

Attie (or Akye) peoples, Côte d'Ivoire

senting African men of prominence. Regardless, the use of European markers of status clearly indicates the absorption of foreign motifs into Attie idioms of power that emphasized continued local authority in the face of European colonial pressure.

A similar message is conveyed in the Bembe carving of a man, possibly a chief, seated on a composite creature that, aside from the small projecting horns, resembles a leopard, a symbol of chiefly authority in central Africa (fig. 21). An emblem of European colonial authority—the pith helmet—has been absorbed by the Bembe into their own set of symbols expressing rank. On one level, the pith helmet may have suggested prestige accrued by association with something new, foreign, or exotic. It may equally have reflected the reality of living under colonialism: the fact that local leaders and civil servants were often coerced to collaborate with colonial officials or be replaced by those who would. Yet, in its context of use, this charming figure was a potent ritual object. Originally, it would have been activated by a religious specialist able to bring the spirit of an ancestor into the carving through holes in its underside, which would then be secured.[22] In this setting, the pith helmet probably symbolized how chiefs, ritual specialists, and others in authority exerted their influence by harnessing multiple sources of power.

A *bedu* mask made by a Nafana artist in eastern Côte d'Ivoire or western Ghana (fig. 22) illustrates African artistic ingenuity in the face of colonial opposition and artistic change over time. An innovation of the 1930s, the mask took new form but was based on an earlier masquerade tradition, the *sakrobundi* anti-sorcery masks, which had been "pressured into hiding by colonial officials and missionaries in the 1920s."[23] *Bedu* masks appeared in pairs, a smaller male horned mask and a larger female mask usually with a disk superstructure. These figures performed during the time after harvest and resolved the same problems as the older *sakrobundi* masks, but in more public, positive ways and without colonial reprisals.[24] Thus, they served a vital and stabilizing social role in a region disturbed by the pressures of both British and French colonization.

The contexts of *bedu* masquerade performances have continued to evolve, although to some extent they still serve to reaffirm the positive values associated with community life. Fieldwork in the Bondoukou region of Côte d'Ivoire by Karel Arnaut in the 1990s documents the masks at a political meeting flanking a portrait of the president-elect and at New Year festivals, which take

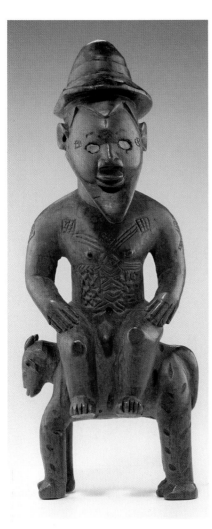

Fig. 21
[cat. no. 27]

Male figure
Bembe peoples, Republic of the Congo

place during the dry season. He noted that *bedu* masquerade performances may coincide with the ritual period *Zorogo*, a rowdy gendered circular dance in which male and female participants exchange explicit sexual insults that call into question the routines of ordinary life. The more formal appearances of *bedu* masks are associated with cleansing rituals, the ancestral foundations of power and land ownership, and "performances that stress the political and ethnic dimensions (and divisions) of community life."[25]

The colonial period in Africa gave rise to increased Western interest in collecting and exhibiting African art and material culture. The great ethnographic museums of Europe and America, most of them founded during the 19th century, followed an evolutionary model that classified the material culture of "other" societies by form, material, and geography and tended to reinforce a message of Western racial and cultural "superiority" over the colonized, which were prevailing attitudes in the West at that time.[26] In a related development, colonial expositions hosted in European cities in the late 19th and early 20th centuries touted the economic benefits (to Europe) of trade with colonial subjects.[27] The expositions, popular with the general public, also provided opportunities for "vicarious tourism" through the African performances and the human and artifact displays that were part of the exhibitions' mock cultural villages representing particular African societies.[28] These colonial expositions and early museum-display practices reinforced a Western sense of self and legitimized an imperialist agenda based on trade, extraction of resources, and the subjugation of "the other," thus raising a variety of philosophical and ethical concerns about ownership and representation that continue to be examined today.[29] Africa was brought to the table unequally through these colonial modes of representation, with the result that African peoples, cultures, and art forms achieved greater public awareness in the West but were perceived through the distorted gaze of Western imperialist constructions of "the other" rather than as rich and viable expressions of human experience. In the arts, the ongoing practical and philosophical struggle has been to recognize, reject, and redress the limitations imposed by the colonial legacy on the understanding of African art and culture in the West, and thus to foster the appreciation of Africa's arts not as exotic artifacts of Western curiosity but as rich and sophisticated systems of aesthetics and philosophy.

OPPOSITE PAGE

Fig. 22

Mask

*Nafana peoples, Bondoukou region,
Côte d'Ivoire and Ghana*

Mid-20th century

Wood, paint

*269.2 x 125.7 x 15.2 cm
(106 x 49 1/2 x 6 in.)*

*Gift of Walt Disney World Co., a subsidiary of
The Walt Disney Company, 2005-6-45*

In the 19th century in the Bondoukou region, large flat triangular masks called *sakrobundi* opposed witchcraft that caused infertility. The colonial government banned them as belonging to a secret society and being a threat to its authority. New masks similar in form but called *bedu* appeared in the 1930s. Their performances—then and now—reinforced positive social values.

Fig. 23

Reliquary guardian figure

Kota peoples, Gabon

Late 19th to early 20th century

Wood, brass, cowrie shell

*61.5 x 40 x 12.1 cm
(24 3/16 x 15 3/4 x 4 3/4 in.)*

*Gift of Walt Disney World Co., a subsidiary of
The Walt Disney Company, 2005-6-104*

Kota sculptures of this type protect ancestral relics. Their abstracted forms suggest a human face with hairstyle and a body. The double face of this figure is unusual (an oval face of equal size adorns the reverse of this Janus figure) and the amount of precious metal used is particularly striking. The metal serves as both an offering and a tangible metaphor for diverting harm.

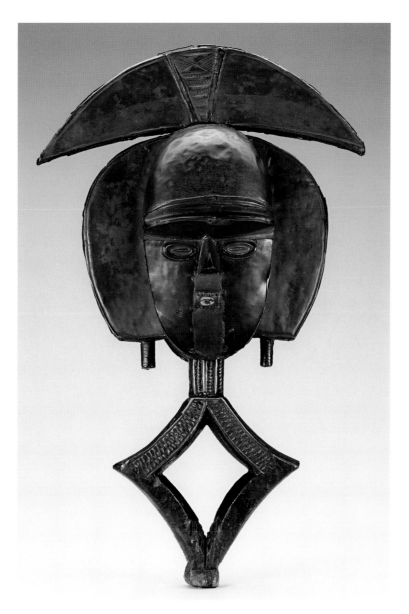

Early advocates for a positive perception of African art included modern European artists who were exposed to African sculptures through their display in expositions, museums, and galleries. They were intrigued by non-Western arts, including African, which provided them a new way of seeing and conceptualizing form in their own works. The abstraction and visual power of Kota reliquary figures (fig. 23) and Tsogo masks (cat. no. 25), for example, appealed to an avant-garde aesthetic. It is revealing, however, that Pablo Picasso's famous encounter with African masks displayed at the old Musée d'Ethnologie du

Trocadéro in Paris in 1907 had less to do with African forms and more to do with their self-affirming resonances to his own work. In a 1937 conversation with André Malraux published in 1974 in *La Tête d'obsidienne,* Picasso recalled:

> The masks weren't like other kinds of sculpture. Not at all. They were magical things. . . . The Negroes' sculptures were intercessors . . . Against everything, against the unknown, threatening spirits. I kept looking at the fetishes. I understood; I too am against everything. I too think that everything is unknown, is the enemy! I understood what the purpose of the sculpture was for the Negroes. Why sculpt like that and not some other way? After all, they weren't Cubists! Since Cubism didn't exist . . . all the fetishes were used for the same thing. They were weapons. To help people stop being dominated by spirits, to become independent. Tools. If we give form to the spirits, we become independent of them. The spirits, the unconscious, emotion, it's the same thing. I understood why I was a painter . . . *Les Demoiselles d'Avignon* must have come to me that day—not at all because of the forms, but because it was my first canvas of exorcism—yes, absolutely![30]

Picasso's language is illustrative of a Western fascination with "the primitive" that emerged in Europe and the United States at the end of the 19th century and the early decades of the 20th century. Its appeal was exotic, romantic, dangerous, connected to mystery, magic, the unknown, and the untamed, all emblematic of the way that many in the West perceived the "Dark Continent."

Although a detailed discussion of primitivism and its connection to African art is clearly beyond the scope of this essay, it is important to recognize that primitivism was part of a broader historical phenomenon that linked ideas about race, empire-building, and ways of thinking about cultural "others" and their objects. Ironically, this fed into a process in which Western perceptions, aesthetics, and classification systems shifted, transforming African objects in the Western imagination from curiosities to ethnographic specimens to art.[31]

For example, the aesthetic dimensions of African art were recognized in several early publications and exhibitions. Carl Einstein's *Negerplastik* (1915), Roger Fry's essay "Negro Sculpture" in his book *Vision and Design* (1920), and *Primitive Negro Sculpture* (1926) by Paul Guillaume and Thomas Munro all elevated African objects as art.[32] In 1914, photographer Alfred Stieglitz mounted

an exhibition at his gallery, 291, that may well be the first exhibition featuring African sculpture as art rather than as ethnographic material culture.

This may have been part of the trajectory that led the Tishmans to collect African art. In 1968, Paul Tishman recalled how, at first, his early interest in collecting African art was not shared by his wife, "who was absorbed in Western art, [but] it was not long before the purity and force of the material worked their spell on her."[33] The language, clearly a reflection of its time, conveys less about Africa and more about the power of African art on the Western imagination. Some years later, when the Tishmans met Picasso at his home in Mougins, Picasso summed up his feelings about African art by declaring, "C'est la verité" ("It is truth"), a sentiment shared by Paul and Ruth Tishman.[34]

Our knowledge of the history of African art continues to advance as a result of new research and fresh interpretations. Of course, works of art sometimes raise more questions than they answer. Little is known, for example, about the purpose and meaning of an enigmatic stone figure in present-day Zimbabwe (fig. 24) that has been tentatively attributed to the site of Great Zimbabwe,[35] a site dating from about the 13th to the 15th centuries that was constructed possibly as a religious center of a powerful Shona kingdom and was associated with two major trading networks.[36] The folded wings that run along the back of this stone figure resemble the carved soapstone birds from Great Zimbabwe that are believed to be ancestral symbols associated with Shona rulers; but figural sculpture is unknown from Great Zimbabwe, aside from one very similar figure in the collection of the British Museum. In the absence of archaeological evidence confirming their origins to Great Zimbabwe, attributions and interpretations of this intriguing work of art remain speculative.

The Walt Disney-Tishman African Art Collection remains a valuable tool for the study of African creativity over time. The collection's breadth of historical time, its geographic range, and its diversity of form and materials provide ample opportunities for renewed scholarship as works of art are reconsidered in the light of new research, interpretations, and theories. Far from static, works of art continue to have a life beyond the time in which they were created, providing

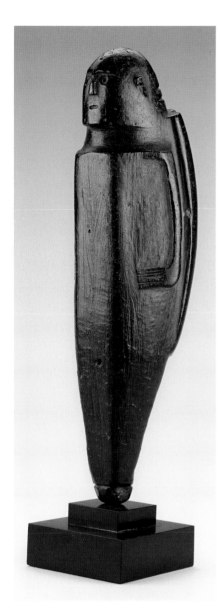

Fig. 24
[cat. no. 29]

Figure

Possibly Shona peoples, possibly Zimbabwe

insights into the past, commentary on the present, and lessons for the future. Ending the discussion with a work of art that raises questions brings the discussion full circle, for it reinforces the ongoing process of scholarly enquiry that occurs as one confronts the object and endeavors to uncover its mysteries.

Notes

1 Visonà at al. 2001, p. 171.

2 Recent research by art historian Peter Mark suggests that the terminus dates for Afro-Portuguese ivories is later, drawing on the work of historian Avelino Teixeira da Mota (Peter Mark, e-mail to the author, April 27, 2006).

3 Specific information on the iconography of this Sapi-Portuguese horn may be found in the entry for cat. no. 15.

4 Bassani and Fagg 1988, p. 139. Of the three other oliphants believed to be by this same hand, one, formerly in the collection at Drummund Castle, is now in the Australian National Museum, Canberra; another was formerly in the collection of Feodor Varela Gil, Spanish Consul in Southampton, England, but its current location is unknown; and a third is in the Museo Nacional de Artes Decorativas, Madrid (Bassani and Fagg 1988, p. 234, entries 75-78). One of the powder flasks is in the Instituto Valencia de Don Juan, Madrid; the other was part of the Carlo Monzino Collection (ibid., entries 79 and 80).

5 Ibid., p. 182.

6 Ibid., p. 166.

7 Ibid., p. 48.

8 Visonà et al. 2001, pp. 310-11.

9 Briefly, in 1897, a newly appointed British deputy official sought to travel to Benin City at a time when the king was performing rituals and, thus, would not receive visitors. When the official and his entourage persisted, they were attacked en route; all but two of the eight Englishmen and 60 of the 200 bearers were killed. This resulted in swift reprisals by the British navy, who mounted a punitive expedition (Freyer 1987, p. 10).

10 Ibid., p. 17.

11 Visonà et al. 2001, p. 367.

12 Ibid. Felix et al. suggest an earlier date of c. 1200 A.D. for the kingdom's founding (Felix 2003, pp. 61-62).

13 Ibid., p. 367.

14 Ibid., p. 369.

15 Cornet, in Vogel 1981, p. 205.

16 Ibid.

17 For a discussion of the problematic term "traditional" as applied to African art, see note 1 in Chapter 1 of the present volume.

18 Palmer 1992.

19 The legacy of enslavement is reflected in the resilience, ingenuity, and flourishing of people of African descent living outside of Africa in what is known as the African Disapora. Because the majority of Diasporan peoples are descended from enslaved Africans (the largest population being in Brazil), the creative, hybrid cultural expressions of the African Diaspora pivot profoundly on this history, but also reflect engagement with and adaptation to new peoples and surroundings in a process of reinvention that creates new traditions and cultures. More recently, social, political, and economic challenges in Africa have contributed to the increase of African emigrants and asylum-seekers seeking new opportunities outside the continent.

20 Vogel 2006: 14.

21 Anthropologist Christopher Steiner questions the social structure of the canon itself, "based as it is on a standard of cultural or ethnic purity—that is, an object that is untainted by outside influence" (Steiner 1996: 214). Steiner asserts that the canon "is a *structuring* structure which is in a continuous process of reproducing itself, mediating its

identity through market forces, and negating the social conditions of its production by covering the tracks of its arbitrary and subjective formations" (ibid.: 217). For an extended discussion of the canon, see Chapter 1 in the present volume, pp. 8–10.

22 Söderberg, in Vogel 1981, pp. 210-11.

23 Bravmann, in Vogel 1981, p. 30.

24 Ibid.

25 Arnaut, in Lamp 2004: 148. Karel Arnaut's photographs and research data documenting *bedu* masks in Côte d'Ivoire in the 1990s are available on the website of the Brighton & Hove Museums (England) at: www.virtualmuseum.info/collections/themes/bedu/html/index.html.

26 Robert Goldwater, in his *Primitivism in Modern Art,* notes that P. F. von Siebold in 1843 advocated in favor of colonial powers establishing ethnological museums, which were believed to promote "understanding of the subject peoples and of awakening the interest of the public and of merchants in them—all necessary conditions for a lucrative trade" (Goldwater 1986 [1938], p. 5). Colonial punitive expeditions in Africa also contributed to the swelling of collections, as thousands of objects taken as war booty were displayed in regimental houses, sold at public auction, or acquired by ethnographic museums.

27 According to historian Curtis Hinsley, the first international exposition, the *Great Exhibition of the Works of Industry of All Nations* at London's Crystal Palace in 1851, "was classically imperialist in conception and construction: on display was the material culture of an industrial, commercial empire, with an emphasis on manufactured goods derived from colonial raw materials. The Paris Exposition of 1867 celebrated another form of colonial appropriation in featuring archaeological and ethnological materials" (Hinsley 1991, p. 345).

28 Coombes 1991: 194.

29 See, for example, Coombes 1991 and 1994; Hinsley 1991; Schildkrout and Keim 1998; and Stocking 1985.

30 Pablo Picasso, 1937, quoted in Malraux 1974, pp. 17-19.

31 See Clifford 1988; MacGaffey, in Schildkrout and Keim 1998.

32 Goldwater 1986 [1938], pp. 35-38; also quoted in Clarke 2003: 44.

33 Tishman, in Sieber and Rubin 1968, p. 8.

34 Tishman, in Vogel 1981, p. 4.

35 Musée de l'Homme 1966: entry 134; the Israel Museum 1967: fig. 212, p. 20; Sieber and Rubin 1968, p. 144; Vogel 1981, p. 241.

36 Garlake 1973, p. 121.

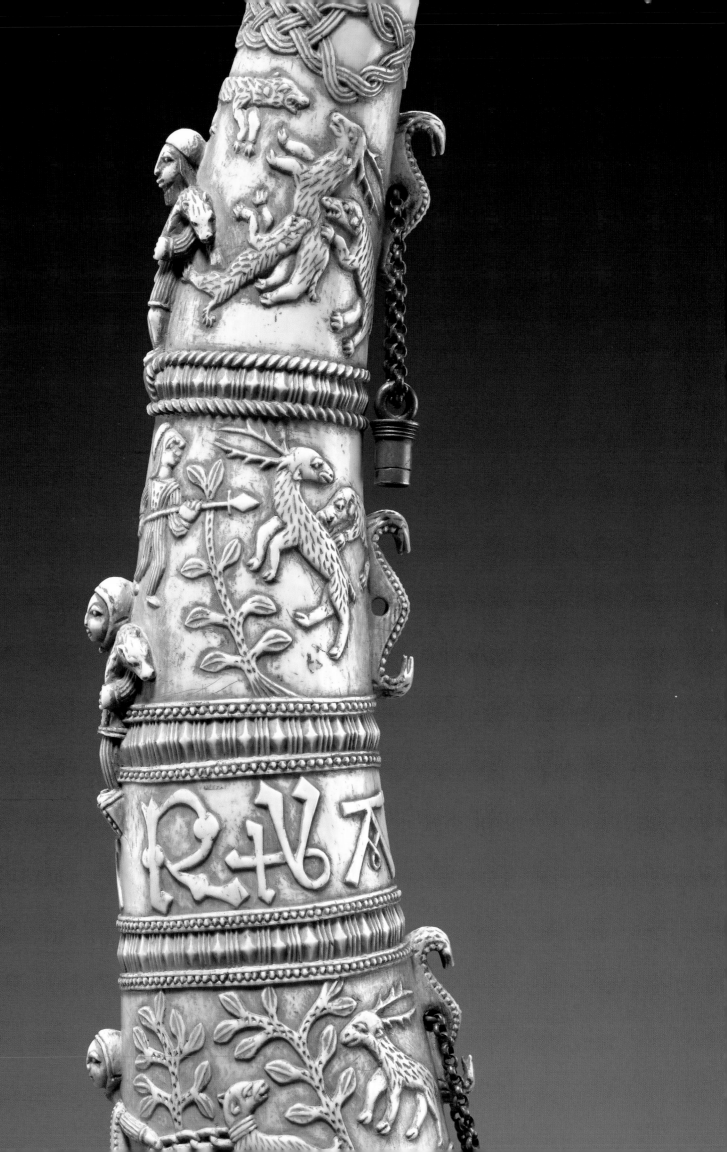

15

Hunting horn

Sapi-Portuguese style, Bullom or Temne peoples, Sierra Leone

Late 15th century

Ivory, metal

*64.2 x 16.4 x 9 cm
(25 1/4 x 6 7/16 x 3 9/16 in.)*

Gift of Walt Disney World Co., a subsidiary of The Walt Disney Company, 2005-6-9

This exquisitely carved ivory hunting horn, perhaps the oldest work in the Walt Disney-Tishman Collection, contains a wealth of visual evidence for the interaction of Africans and Portuguese along the west African coast beginning in the late 15th century. Undoubtedly fashioned for a European patron, it has a mouthpiece at the horn's tip rather than along the side, carved lugs for suspension, heraldic emblems, and scenes showing hunters and their dogs amidst foliage.

While a range of Sapi-Portuguese horns (also called oliphants) portray human figures with African features similar to those of ancient Bullom and Temne stone carvings, the human figures on this horn seem to depict Europeans in Western attire of the period. Almost all of the designs are European-inspired. Woodcuts and illustrated pages from European prayer books, such as the Book of Hours, probably served as source material for the hunting scenes. Two high-relief figures on this horn, each with an animal draped across his shoulders, suggest the Good Shepherd, a reference to Christ. However, in a departure from Christian imagery, both figures carry a spear, and the animal is not a lamb but an unidentifiable animal that appears to have been killed.[1] The coat of arms of the House of Aviz, which ruled Portugal from 1385 to 1580; the armillary sphere, which was Dom Manuel's personal symbol; and the cross of the Military Order of Christ[2] all "refer to the Portuguese sovereigns, and in particular to Dom Manuel 'the Fortunate' who reigned as King Emanuel I from 1495 to 1521."[3] The coat of arms of Ferdinand v of Castile and Aragon is also depicted, along with Ferdinand's motto *Tanto monta,* suggesting that the group of horns in this style were commissioned between 1492 and 1516, the year of

Ferdinand's death.[4] Indigenous motifs, such as the snake designs for the lug suspensions in this example, or the representation of crocodiles found in other Sapi-Portuguese ivories, suggest that imagery with local significance was also incorporated into the decoration of these export ivories.

This horn, the work of a master carver from present-day Sierra Leone, is one of three surviving horns attributed to the same hand.[5] Two powder horns are also by the same artist, known to art historians as the Master of the Arms of Castile and Aragon.[6] The heraldic devices and inscriptions—which refer to the Treaty of Tordesillas in 1494 or to the two successive marriages of King Manuel I of Portugal to two daughters of King Ferdinand v of Spain, Isabella in 1497 and, after her death, Maria in 1500[7]—suggest that it was made to mark a significant event in the joint histories of Portugal and Spain.

—CMK

Notes

1. Curnow 1983, p. 144.

2. Ibid., p. 140.

3. Bassani and Fagg 1988, p. 106.

4. Ibid., p. 109. Ferdinand v's motto *Tanto monta* could be loosely translated as "I'll do it my way." It refers to the legendary test of the leadership potential of Alexander the Great when faced with the problem of the intricate Gordian knot: rather than puzzle over how to untie it, he cut it, saying *Tanto monta, monta tanto, cortar como desatar* (it amounts to so much, so much it amounts, cutting or untying). Thanks to Annette Ramirez de Rallena, a docent at the National Museum of African Art, who conducted research on this motto in 2006.

5. Curnow 1983, p. 117.

6. Bassani and Fagg 1988, p. 139.

7. Fagg, in Vogel 1981, pp. 64, 67.

Male head

Undetermined peoples, Sierra Leone

15th to 17th century

Stone

19.3 x 12.3 x 13 cm
(7 5/8 x 4 13/16 x 5 1/8 in.)

Gift of Walt Disney World Co., a subsidiary of The Walt Disney Company, 2005-6-56

Mahen yafe means "spirit of the chief."[1] This is what the Mende peoples call these carved stone heads, which they find buried in their territory and reuse in divination rituals. They are attributed to those who have gone before, probably the ancestors of the present-day Temne peoples, known to the 15th-century Portuguese as the Sapi, their collective term for the Bullom, Baga, Temne, and other groups near the coast in the region.

These stone heads are related to the west African tradition of carving full figures of stone (see cat. no. 17). In both cases, the full, ovoid heads have large eyes and broad nostrils. The unattached heads face upward and have a variety of textures for the hair and beard. They are often embellished with jewelry, such as the nose rings on this piece. The elaborate hairstyles and jewelry are both mentioned in 17th-century accounts.[2] These accounts, however, do not mention their being carved of stone; perhaps the stone heads are an earlier or later tradition, were kept hidden, or were simply not of interest to the Europeans. Although they do not depict any European themes, the rationale for dating them between the 15th and 17th centuries is that the ivory horns (see cat. no. 15) and saltcellars made for the Portuguese beginning in the late 15th century do include figures with physical features that recall these stone heads.

—BF

Notes

1. Siegmann, in Schmalenbach 1988, p. 105.

2. Ibid.

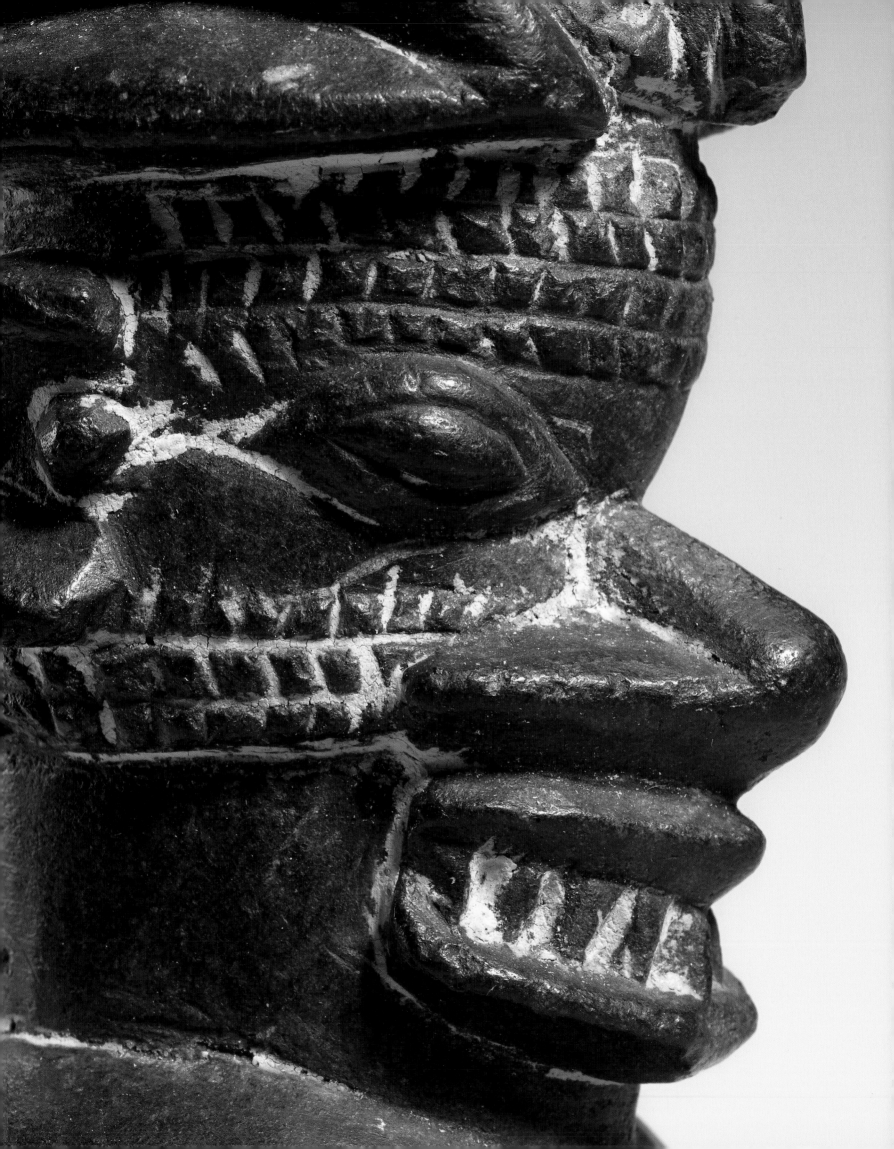

Male figure

Undetermined peoples, Guinea

Possibly 16th to 17th century

Stone, pigment

18.8 x 6 x 6.3 cm
(7 3/8 x 2 3/8 x 2 1/2 in.)

Gift of Walt Disney World Co., a subsidiary of The Walt Disney Company, 2005-6-55

The most important distinguishing attribute of this figure is its material, stone. There are few areas in sub-Saharan Africa where stone carving occurs at all; significantly, all are represented by works in the Walt Disney-Tishman Collection. The roughly cylindrical vertical form of this male figure, the emphasis given to the broad features of nose and eyes, and the open toothy mouth are typically associated with stone figures from the region on the border of Liberia, Sierra Leone, and Guinea. Field research in the mid-20th century, before the disruptions of the civil conflicts in these countries, determined that they were usually found by farmers clearing ground or digging a well.[1] In the literature and in such pieces now in collections, this style is most associated with the present-day Kissi peoples; however, carved stone figures are also found in neighboring peoples' territories. Dating of these stone figures is not confirmed.

Their origin is ascribed to former inhabitants of the land or to a non-human spontaneous creation associated with a specific ancestor. Once a figure is found, the Kissi do not move it but wait until a dream identifies the particular ancestor to the person who uncovered the sculpture. Such figures are described as "*pomdo,* the dead or images of the dead."[2] Each figure receives offerings and is placed with others on an altar; some may be used in divination, oath taking, or protection of initiates.

—BF

Notes

1. Siegmann 1977, p. 37.
2. Paulme, in Vogel 1981, p. 61.

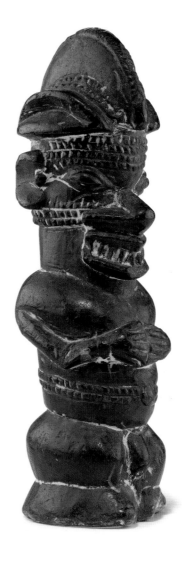

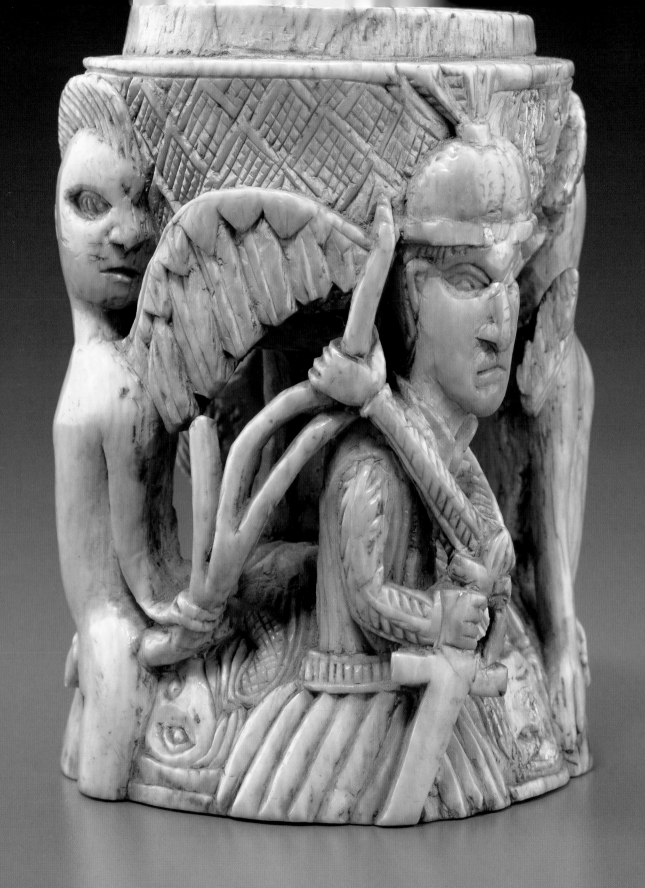

Saltcellar

Benin kingdom, Bini-Portuguese style, Edo peoples, Nigeria

16th century

Ivory

8.3 x 7.6 x 7.6 cm (3 1/4 x 3 x 3 in.)

Gift of Walt Disney World Co., a subsidiary of The Walt Disney Company, 2005-6-36

The ivory carvers' guild in Benin was under royal patronage and control. Permission granted to foreigners to commission saltcellars, hunting horns, and spoons was a mark of particular favor. This small section, carved from a single piece of ivory, is all that remains of an object with a complex visual and historical message. Originally, the saltcellar consisted of two vertically linked spherical containers. The lid and base are now missing; this is the top container, which also served as the lid for the bottom container. As the old phrase "above or below the salt" suggests, its importance was not so much as a functional condiment holder but as an indicator of status. Its mere possession indicated wealth, good breeding, and cultural awareness—the type of object that would have been owned by a Medici or a Hapsburg, or by a very wealthy merchant.

The Portuguese reached Benin in the late 15th century and set up a trading partnership with the king's representatives. Objects made for the royal court in ivory and copper alloy included images of foreigners with prominent noses and straight hair. Often, the hair and mustache were shaped to recall the barbells and tail of a mythological magical fish, which was an emblem of royal powers and a reference to the god Olokun, ruler of the waters. This fits the Portuguese role as seafarers who brought copper ingots, coral beads, cloth, and gunpowder. The figures on the bowl also depict armed Portuguese men. Their costumes and accouterments are more detailed and their facial features seem more pronounced—the hairstyles and beards, when present, lack the fish metaphor—but their relationship to the depictions of Portuguese on Benin kingdom court objects is apparent.

The most unusual feature is the inclusion of two nude male winged figures with their heads shown in profile and holding a bare branch. They have been described as angels,[1] although they are atypical in their lack of clothing and their adult male body. In European art, the small, winged, childlike figures called cherubs are nude, whereas adult-size angels are clothed. Indeed, cherubs seem an odd juxtaposition with the armed Portuguese, but they do appear in borders framing European engravings. African artists usually do not depict children realistically, instead portraying them as adults. Here, each winged figure's odd crest hairstyle and the way in which its single eye is shown from a frontal perspective suggest that the European prototype was not completely assimilated.

The almost obsessive use of surface ornament in the foreground costumes and the total filling of any background space with ornamental designs are in keeping with Benin court art tradition, although the result here is notably different in style from traditional Benin figures.

—BF

Notes

1. Bassani and Fagg 1988, cat. no. 121; Curnow 1983, cat. no. 78.

Rooster

Benin kingdom court style, Edo peoples, Nigeria

18th century

Copper alloy

55.9 x 18.4 x 46.2 cm (22 x 7 1/4 x 18 3/16 in.)

Gift of Walt Disney World Co., a subsidiary of The Walt Disney Company, 2005-6-37

At first glance, this sculpture appears to be a relatively naturalistic depiction of a rooster. It displays the obsession with pattern and the technical expertise in lost-wax casting that typifies the great works made by brass casters at the Benin kingdom court. However, Joseph Nevadomsky's field work and his review of the literature reveal a much more complex history and context for the bird, one of about 20 known examples.[1]

The core problem of identifying its context is that although wood-carved hens are placed on chiefs' maternal altars, people today in the Benin area say that the metal roosters were not placed on altars for the king's mother.[2] While there are mentions of bird figures in earlier accounts, identification of the material used to make the sculptures is confused or absent, and no mention is made of function.

By studying the symbolism assigned to the rooster in folklore, daily household life, and court life, Nevadomsky found that this animal can be a sacrifice, but is also a champion, the leader of the barnyard, and a spy, and is used in anti-poisoning charms.[3] Its name is given to the king's senior wife, the one in charge of the women. The Benin taxonomy is not divided according to male-female categories alone, but by qualities of dominance. For example, in proverbs and ritual, it is important that the rooster be mature enough to have spurs. It is not improbable, Nevadomsky theorized, that the rooster figures were once used on shrines dedicated to notable women, whether queen mothers or only those queen mothers who were also senior wives.

The figure's square base is a form found on several types of altarpieces. It is decorated with three heads, either of rams or of cows, which are also sacrificial animals that often indicate prosperity. The looped-strap design also symbolizes "long life and prosperity."[4] Also present on the base is a Maltese cross, a cosmic symbol that is particularly but not solely associated with the reign of Oba Eresonyen (reigned c. 1735–50), and seems to relate both to his emphasis on Osanobua, the high god, and his claim to the spiritual powers of his royal ancestors.[5]

—BF

Notes

1. Nevadomsky 1987: 221-39.

2. Ben-Amos, in Vogel 1981, p. 134.

3. Nevadomsky 1987: 226-29.

4. Ibid.: 238.

5. See Ben-Amos 1999, pp. 103-16.

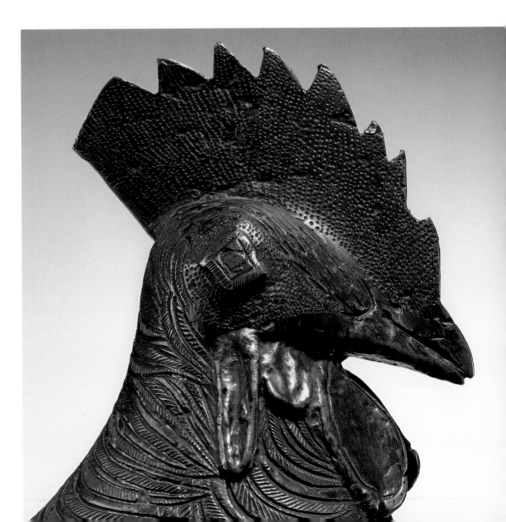

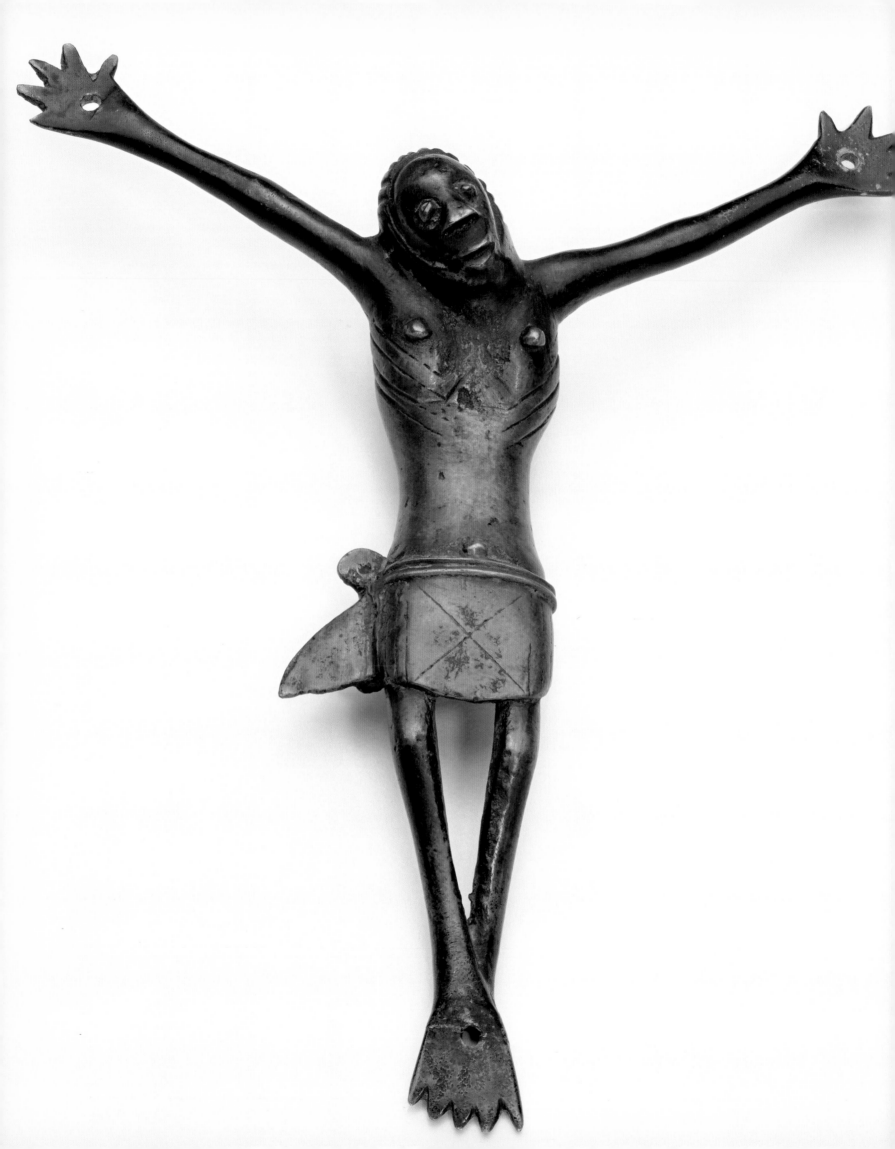

Crucifix

Kongo peoples, Democratic Republic of the Congo

17th century

Copper alloy

*21.6 x 17.5 x 3.5 cm
(8 1/2 x 6 7/8 x 1 3/8 in.)*

Gift of Walt Disney World Co., a subsidiary of The Walt Disney Company, 2005-6-106

The ivory horn (see cat. no. 15) is identified with the beginning of the reign of Portugal's Manuel I, and the Kongo crucifix is the legacy of his influence. The Portuguese reached the Kongo kingdoms in 1483, and their authority was strengthened by Pope Alexander VI in 1499. In 1512, Manuel would propose a plan for a Christian monarchy, expanding on the conversions of local rulers.

The missionaries and Portuguese emissaries seem to have grasped the concept of emblems of status among Kongo rulers. While ivory staff finials created by local artists identified the owner as a ruler (see cat. nos. 79, 81), copper-alloy crucifixes presented as gifts by the foreigners assumed a similar function and prestige. Local artists would continue this expansion of their tradition even after the departure of the missionaries in the mid-18th century.

Today, two forms of crucifixes can be identified: those where the figure is cast on a cross, and others that were originally nailed onto a wood cross, as the one shown here would have been. These images of Christ tend to have African features but not the traditional proportions of many Kongo and other African figures. Rather than an emphasis on the head and a relatively solid body, here there is an attenuated body with rather sticklike limbs. The body does hang with the head tilted, but it lacks the feeling of suffering or the stigmata that many European prototypes have; and the rather oversize splayed hands and feet suggest an African tradition of gestural symbolism rather than a biblical emphasis on the nails. The cross in Kongo cosmology represents the meeting of this world and the spirit world, of the living and the dead—an interpretation of the crucifix that may have ensured its continuity in the Kongo context.

—BF

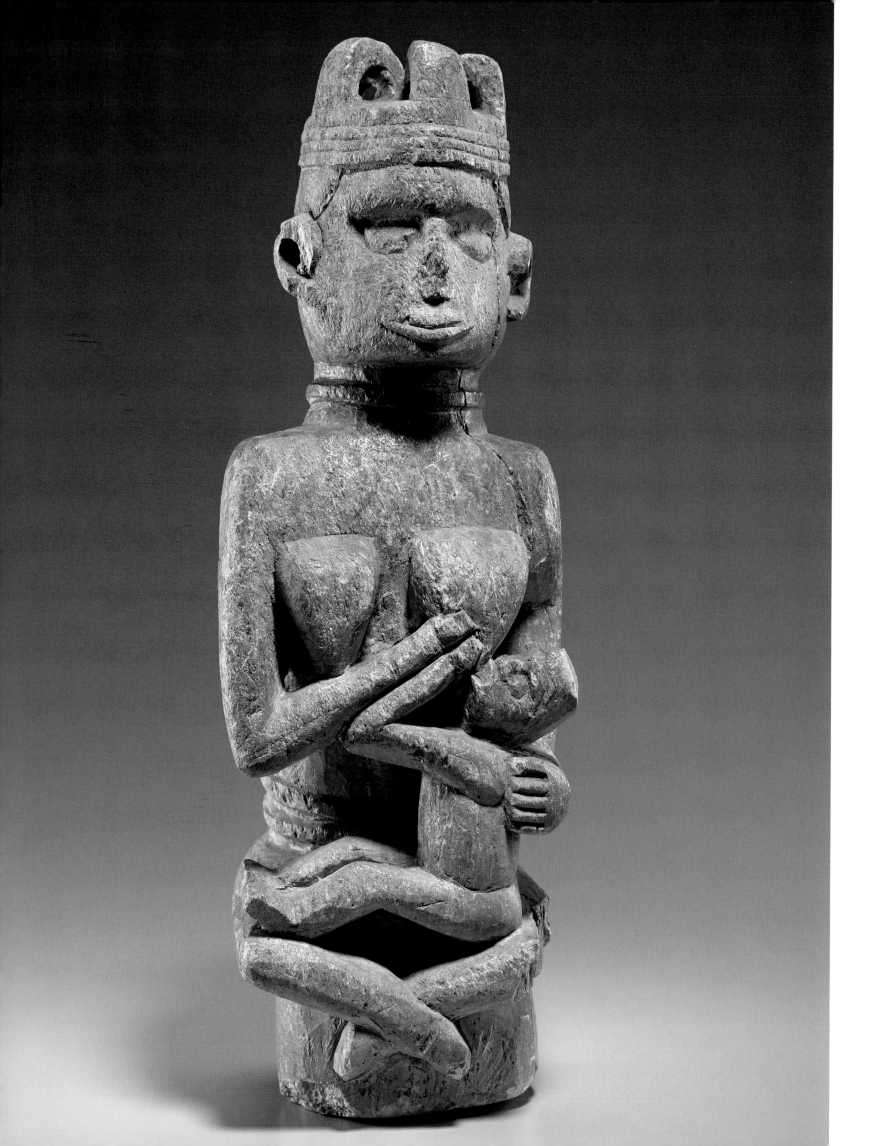

Female figure with child

Kongo peoples, Boma region, Democratic Republic of the Congo

19th to early 20th century

Stone

34.5 x 12 x 12 cm (13 9/16 x 4 3/4 x 4 3/4 in.)

Gift of Walt Disney World Co., a subsidiary of The Walt Disney Company, 2005-6-107

Among the Kongo peoples, graves were places where the living could approach the ancestors for assistance. Earth from the graves of distinguished individuals was an important component in Kongo ritual healing and judicial "medicines."[1] Traditionally, graves are decorated with a variety of markers and offerings, such as European china, elephant tusks, gin bottles, peanuts, guns, and carved figures. What is used depends on the importance of the deceased, their role in the community, their gender, the region, and the date of the grave. Stone figures are particularly associated with the region around Boma during the late 19th and early 20th century. These figures, whether male or female, are noted for their expressive gestures and poses, and for the carved details of jewelry and headwear that indicate the deceased's status.

In Kongo belief, a mother-and-child figure is not mere genre representation. The image of a mother nursing a child represents a "mother of a great family."[2] She is the woman who, by having a child, has saved her family line from extinction and whose honor goes beyond the grave. The seated, cross-legged pose is that of someone expecting respect—an elder or a ruler, someone stable and responsible. Her power is emphasized by the leopard-claw hat, which was worn by initiated chiefs. When a woman wears one, she is acting as regent, succeeding her brother or uncle until a new chief can be appointed.[3]

—BF

Notes

1. MacGaffey, in MacGaffey and Harris 1993, pp. 60-61.

2. Thompson, in Thompson and Cornet 1981, p. 125.

3. Ibid., pp. 127-31.

Female figure

Dogon peoples, Mali

Late 19th to early 20th century

Wood

*73.5 x 13 x 16.3 cm
(28 15/16 x 5 1/8 x 6 7/16 in.)*

Gift of Walt Disney World Co., a subsidiary of The Walt Disney Company, 2005-6-38

This figure gives an impression of great size and presence. The pose, with arms away from her sides and hands in front of her pelvis, indicates pregnancy or the capacity to bear children. The long-lip labret is exaggerated in form; a real lip plug would have been a millet stalk.[1]

Although collection data is not known for this carving, there is a group of perhaps as many as 20 others, and information has been obtained about several of them. In 1935 a nearly identical figure (it has carved bracelets) was acquired for the Musée de l'Homme from the village of Ogol in the Sanga region of Mali. While the carvings probably were done in several villages by several sculptors over a period of time, the identification of the Master of Ogol as the carver of this style of figure is common in the literature. It was described as a display piece that was brought out onto the terrace for a man's funeral. Another example was associated with a shrine to women who died in childbirth and helped restore fertility to supplicants. Containers of water are prominent features in this type of shrine, and the link of water and fertility is strengthened by the particular hairstyle of the figures: a crest that is likened to a sheatfish, which is regarded as a symbol for the fetus in the waters of the womb.[2]

A later review of the literature and the approximately 20 similar examples suggest that this type of figure was probably owned by women and symbolized a female ancestor. It would have been kept apart from the other statues owned by the family and brought out for births and burials, when it would be displayed near an altar on a terrace for a man's funeral or taken to the house of a deceased woman.[3] This type of figure was cleaned and oiled regularly,[4] resulting in a very different surface from the encrusted surface on the Dogon objects that receive sacrificial libations.

—BF

Notes

1. Dieterlin, in Vogel 1981, p. 16.

2. Ibid., p. 16.

3. Leloup 1994, pp. 507-9, no. 84.

4. Ibid., no. 85.

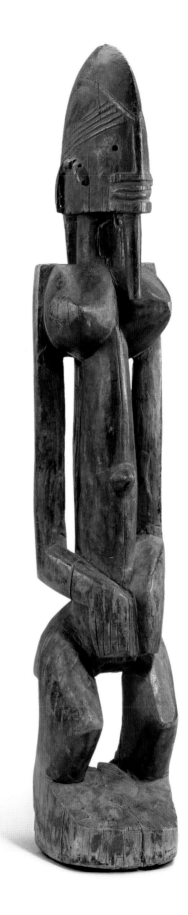

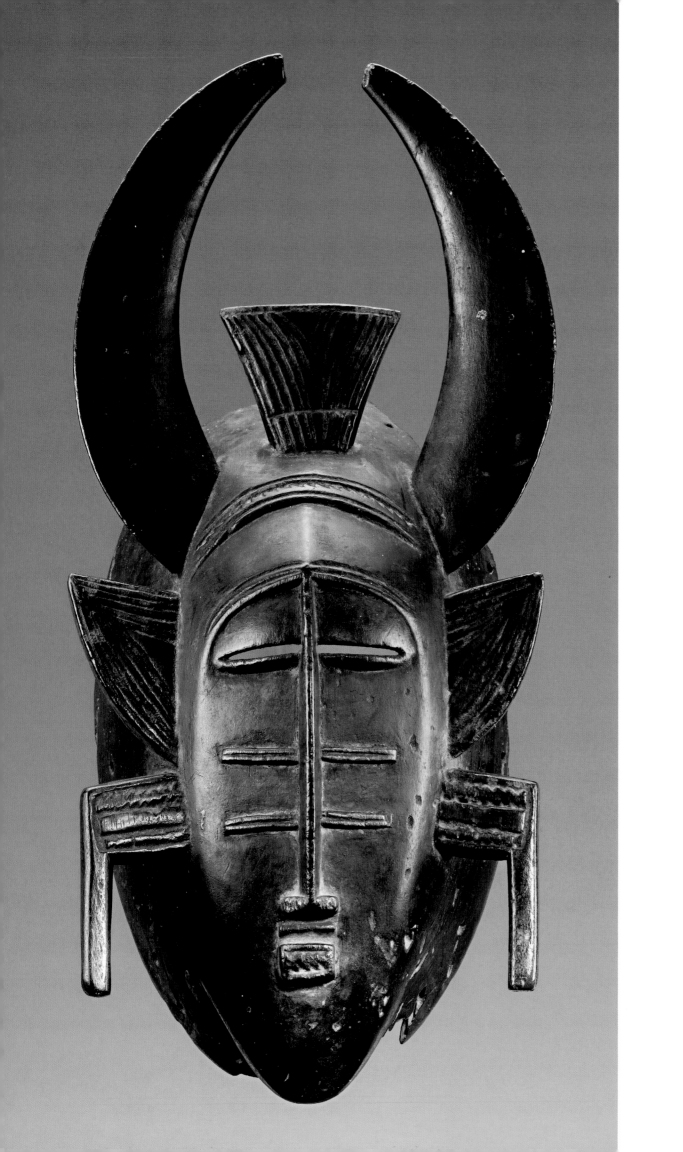

Mask

Senufo peoples, Côte d'Ivoire

Late 19th to early 20th century

Wood

36 x 17.2 x 10.5 cm
(14 3/16 x 6 3/4 x 4 1/8 in.)

Gift of Walt Disney World Co., a subsidiary of The Walt Disney Company, 2005-6-50

Used in Poro society male initiations and funerals and, more recently, in public dances, face masks are common among the Senufo. Such a mask typically has small to life-size human facial features and projections from the top and sides. Generally, the mask's projections are compared to sacrificial offerings such as chickens or a primordial animal such as the hornbill bird, the emblem of nurturing and fidelity. The physical details of the masks vary, as do the names and explanations given. Artists are mobile and, especially in modern times, open to stylistic changes. Although this mask does not have one of the common shapes (palm spike, hornbill bird, female figure, kapok thorns), the top central projection is often used with mixed success to link a mask without field data to a specific occupation-related lineage (blacksmith, woodcarver, farmer) and to a grade (junior or senior) within the Poro society.

To appreciate the skill of the sculptor, it helps to hold this mask. It is carved from a fine-grained hard wood and is very thin. The eye is drawn to the subtle concave shape of the horns and the flat planes of the face. The buffalo horns are positive symbols and are part of the secret metaphors of the Poro society.[1]

—BF

Notes

1. Glaze, in Vogel 1981, pp. 41-42.

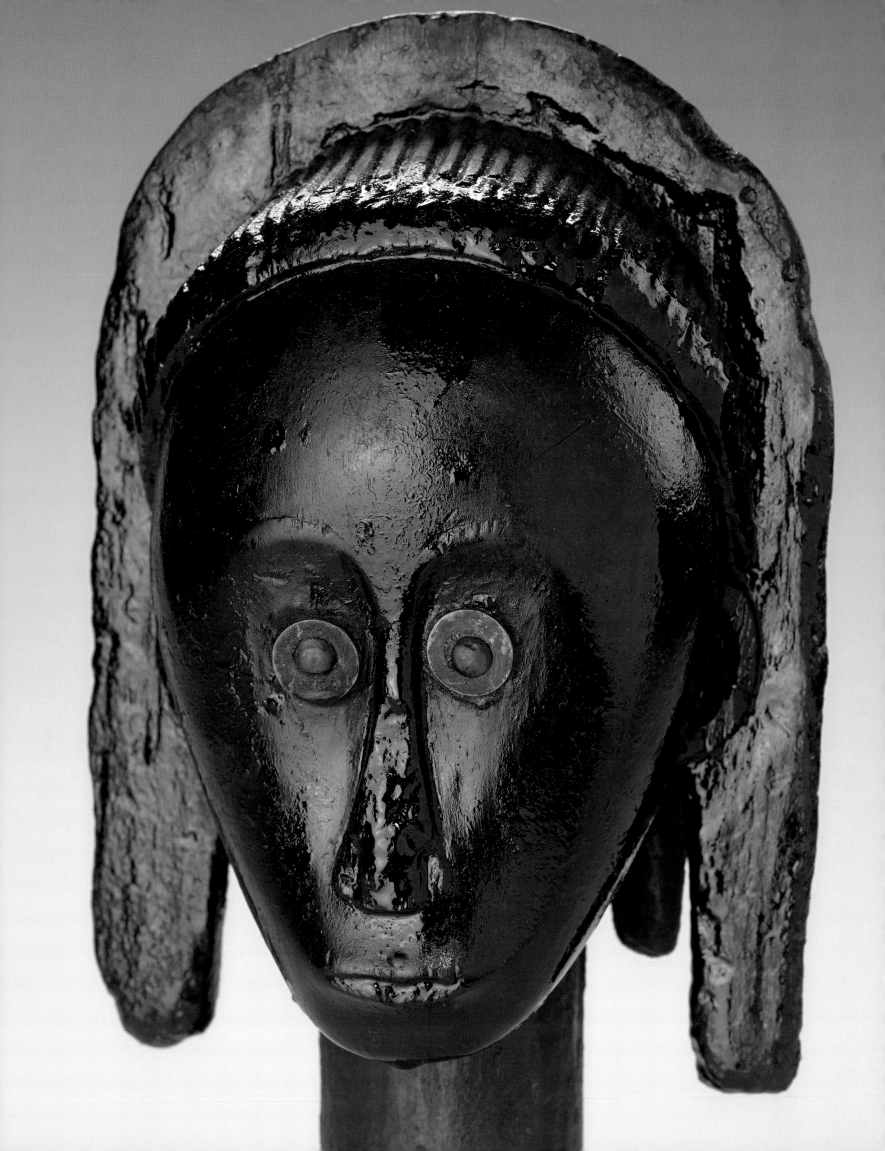

Reliquary guardian head

Fang peoples, Gabon

Late 19th to early 20th century

Wood, metal, oil patina

34.5 x 14 x 8.5 cm
(13 9/16 x 5 1/2 x 3 3/8 in.)

Gift of Walt Disney World Co., a subsidiary of The Walt Disney Company, 2005-6-98

The Fang *byeri* cult existed to honor a family's ancestors and ask for their help in ensuring the continuity of the family and their well-being. This was done both by remembering their names and deeds and by keeping physical relics in cylindrical boxes of bent and sewn bark. The relics would typically be human bones, especially pieces of the skull, and would be guarded by an attached carved wooden head or figure. While ideally the bones would include a relic of the founder of the group, women who had many children might also be honored. The carving could also represent a male, or less often a female; this head is believed to be female.[1]

Though varied within the style, each sculpture was not an individual portrait in the sense we use the term today but an idealized representation, with a prominent forehead, open gaze, small mouth, and a carved depiction of a plant-fiber wig with a crest and extensions. These depictions of wigs are simpler looking than the actual wigs that were worn by Fang dignitaries—elaborately ornamented with cowrie shells, glass beads, buttons, and brass tacks—which are no longer in use, but can be seen in early-20th-century photographs.

Brass or copper alloy—always associated with wealth and prestige because of its ties to long-distance trade, either within Africa or with Europe—occasionally appears as jewelry on full figures, but was used for the eyes on some heads. Shining eyes convey spiritual power, and would provide added drama when the figures were used in rituals. The shiny metal is also associated with daylight, and may be applied to the figure to strengthen its defense against intruders of the night, when evil is stronger.[2] This shiny quality may also be seen in the literal sheen of the wood's oil patina, the result of frequent rubbing with vegetable oils—a cleansing, often with palm oil, that occurs before the ceremony of taking requests from the living family,[3] and that acts as a connection, an offering, and a way of honoring the elders.

—BF

Notes

1. Fernandez, in Vogel 1981, p. 189.

2. Siroto 1995, p. 15.

3. Fernandez, in Vogel 1981, p. 189.

Mask

Tsogo peoples, Ogowe River region, Gabon

Late 19th to early 20th century

Wood, pigment

*32 x 21.3 x 8.5 cm
(12 5/8 x 8 3/8 x 3 3/8 in.)*

Gift of Walt Disney World Co., a subsidiary of The Walt Disney Company, 2005-6-101

Looking at this mask, one might readily think of a magnificent stylized painting on a sculpted surface, or compare it to paintings by early-20th-century Western artists such as Paul Klee, Georges Braque, or Pablo Picasso. The striking disconnect between the divisions of this painted surface and the underlying carved form is an aspect of African art that first entranced Western audiences. The Western lack of awareness of context for African art was such that when this mask was exhibited in the 1950s in France, it was identified as coming from what is now the northeastern Democratic Republic of the Congo. Later research attributed it to the Tsogo peoples as part of the wider regional tradition of divided color faces on masks among several peoples, including the Aduma, Sango, Galwa, and, most recently, the Nzebi.[1]

Originally, each Tsogo mask had "a name, a specific meaning, a song, and a mode of dancing," which together formed a complete character, usually a forest spirit.[2] A precise function for this mask has not been determined, although masks among related groups are performed for a variety of social functions, such as mourning rituals, initiation rites, and ceremonies linked to the birth of twins.[3]

—BF

Notes

1. Siroto 1995, p. 35, no. 21.

2. Perrois, in Vogel 1981, p. 192.

3. Perrois 1985, p. 206.

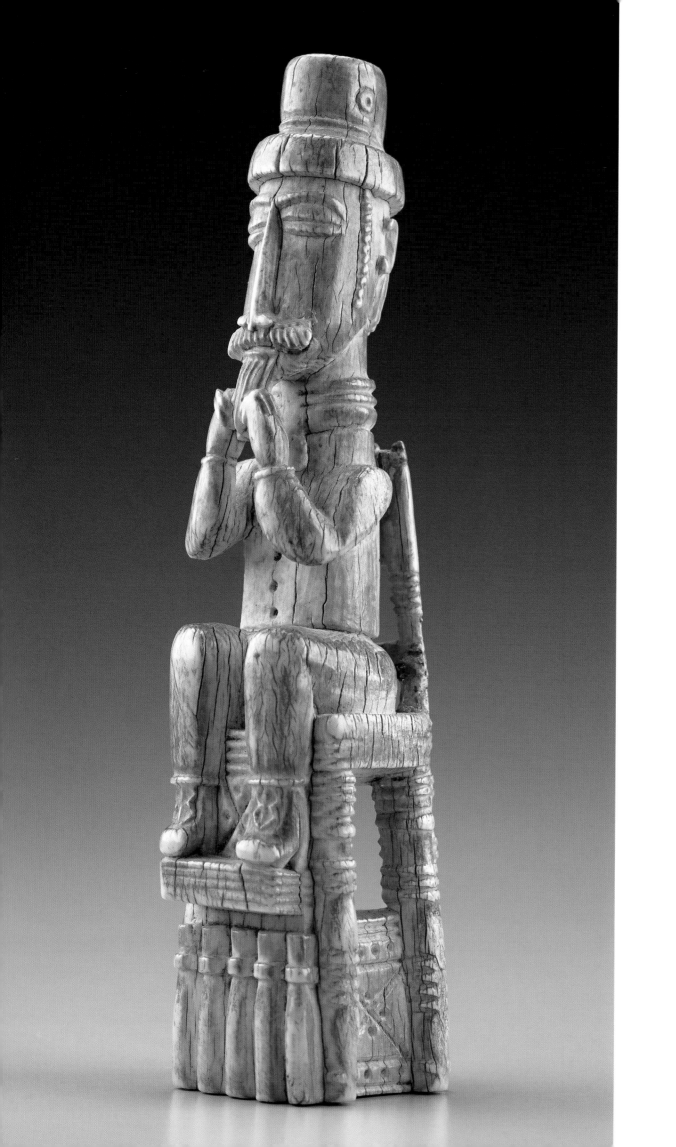

Finial depicting a male figure

Attie (or Akye) peoples, Lagoons region, Côte d'Ivoire

Late 19th to early 20th century

Ivory

*12.9 x 2.9 x 3.5 cm
(5 1/16 x 1 1/8 x 1 3/8 in.)*

Gift of Walt Disney World Co., a subsidiary of The Walt Disney Company, 2005-6-62

An Attie (or Akye) ruler or dignitary from the Lagoons region of Côte d'Ivoire may have taken great delight in emphasizing his authority or prominence by carrying a staff, cane, or spear topped with this beautifully carved ivory figure shown seated upon an imported chair. Curiously, two of the chair's lower panels lack surface decoration and thus appear unfinished. Initial impressions suggest that the figure depicts a European who has an aquiline nose and sports a mustache, a trimmed beard, and fashionable Western attire of the period—trousers, long-sleeved shirt with buttons, and lace shoes. The symmetrical, frontal position of the legs reflects the respectful seated posture that Africans in many parts of the continent (as well as informed foreigners) adopt in formal situations, such as visiting a notable, viewing a ceremony, or attending a public event.

But does this ivory finial depict a European? His long, straight hair and bushy mustache would seem to suggest that this is the case. However, after art historian Monica Blackmun Visonà examined a similar object in the Barbier-Mueller Museum, perhaps carved by the same hand or workshop, she concluded that these visual clues do not necessarily identify the subject matter as European. She noted that the "hat may be African or European . . . long, curved noses are admired in the lagoons area, and elders once grew long beards."[1] Furthermore, depicting a figure in European attire may reflect the practice of local rulers who indicated their prominence through the display of "imported finery appropriate to [their] elevated social and financial" standing.[2]

Equally uncertain is whether such carvings were intended for local or foreign use. Visonà proposed a number of possibilities: that they were local insignia of authority, presentation gifts to foreigners, or prestige works commissioned by Western patrons.[3] Though attributed to the Attie, other Lagoons groups such as the Gwa and Abure employed similar objects.[4] All this suggests the dynamic role of the arts in documenting history, change, and social interactions in this region during the colonial period. Whether this sculpture is meant to assert a ruler's continued authority in the face of European colonial pressure is unknown, but it undoubtedly indicates the absorption of foreign motifs into local idioms of power and status.

—CMK

Notes

1. Visonà, in Barbier 1993, p. 175.

2. Visonà 1983, p. 50.

3. Visonà, in Barbier 1993, p. 175.

4. Ibid.

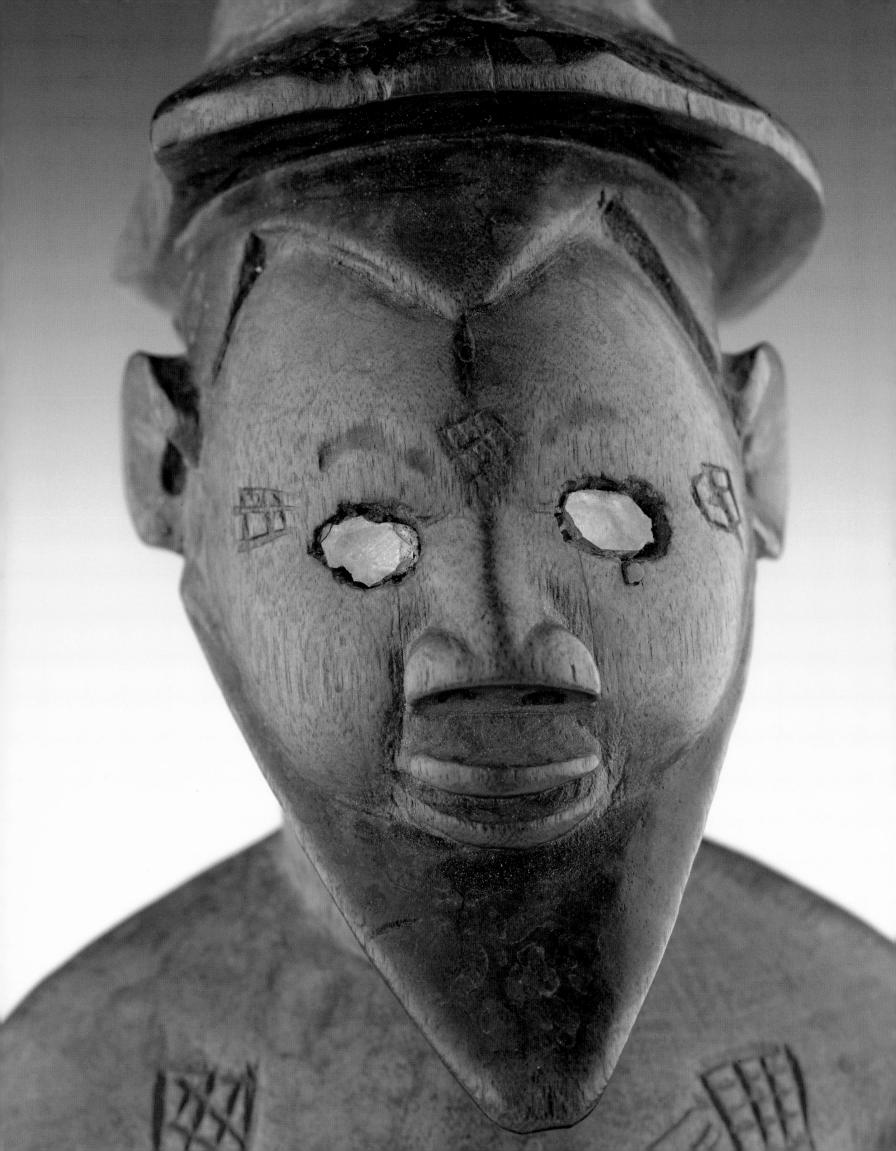

Male figure

Bembe peoples, Republic of the Congo

Early 20th century

Wood, glass

17.5 x 7 x 5 cm
(6 7/8 x 2 3/4 x 1 15/16 in.)

Gift of Walt Disney World Co., a subsidiary of The Walt Disney Company, 2005-6-111

Bembe figure carvings are associated with ancestors, fertility, and healing. Religious specialists activate these figures by breathing the spirit of the ancestor—and in this case, the animal also—into cavities cut into the underside of the carving. This figure probably depicts a chief seated in a position of power on a composite animal that has horns and a spotted pelt. The pith helmet atop his head is a foreign emblem of European colonial authority that the Bembe peoples incorporated into their own set of symbols expressing rank.

The man's facial features are characteristic of Bembe carved figures: inlaid glass or porcelain eyes (in this case, glass), a wide nose, prominent lips, a beard, and a particular form of the ears. The scarification marks on his body were used in ancient times and may have been borrowed from the Bwende, a neighboring group.[1]

—AN

Notes

1. Söderberg, in Vogel 1981, pp. 210–11.

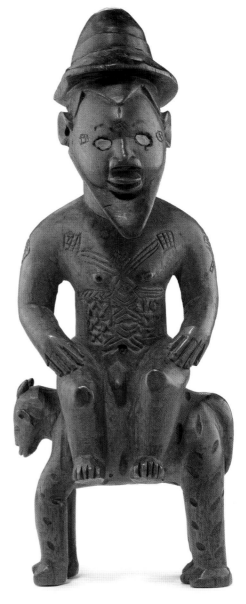

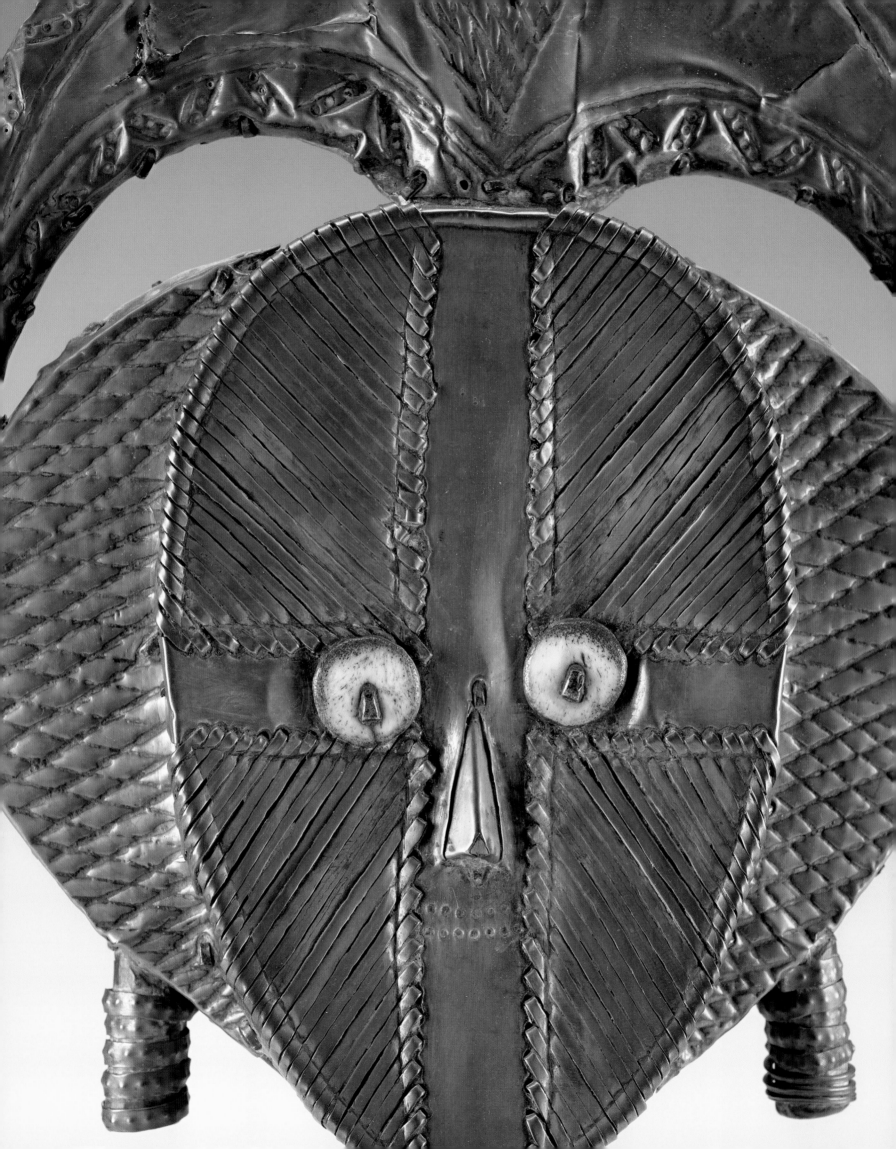

Reliquary guardian figure

Kota peoples, Gabon

Late 19th to early 20th century

Wood, brass, copper, bone, iron

*51 x 24 x 5 cm
(20 1/16 x 9 7/16 x 1 15/16 in.)*

Gift of Walt Disney World Co., a subsidiary of The Walt Disney Company, 2005-6-105

The Kota created guardian figures, called *mbulu ngulu,* and installed them on baskets containing the sacred relics of revered ancestors. They were placed in separate sanctuaries away from their houses. Anthropologist Judith Knight reports that such objects are still made and used among Kota-speaking groups in eastern Gabon as well as in the southeastern region that extends into the Republic of the Congo. Carved of wood and covered with metal, they are viewed in ritual contexts as "portals to the ancestors" and are consulted for advice in resolving problems and allaying concerns. In areas where their ritual use is waning, the objects remain important symbols of Kota identity, with new carvings sometimes displayed decoratively in homes.[1]

This double-faced figure is a masterwork of abstract, geometric shapes. The large, ovoid head has a concave face on both sides, each featuring cross-shaped solid brass strips bisecting it vertically and horizontally. One face is also covered with diagonal copper and brass strips and has disc-shaped eyes made of bone, while the other one's eyes are metal discs. A crescent moon-shaped piece, perhaps a coiffure, sits atop the head with its lower edge curved, and its ends joined to similar shapes at the sides. The base is lozenge-shaped, and the entire figure, except for the base, is covered with copper alloy over a wood superstructure.

Particularly remarkable is the small face on the reverse in high relief, which has only two bands of metal crossing at the eyes and a nose.[2] Perrois, who reports that this type of reliquary guardian figure was made only in the Sebe and upper Ogowe River valleys in Gabon, suggests that the extra pair of eyes may have been to enhance the figure's efficacy.[3]

—CMK | AN

Notes

1. Knight, in conversation with Christine Mullen Kreamer, October 10, 2006.

2. Perrois, in Vogel 1981, p. 201.

3. Ibid.

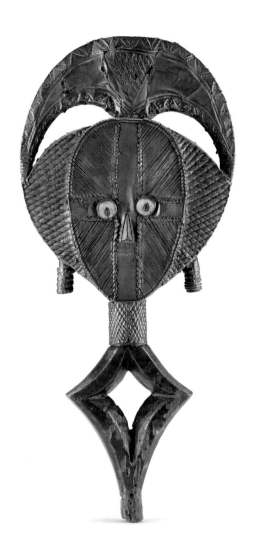
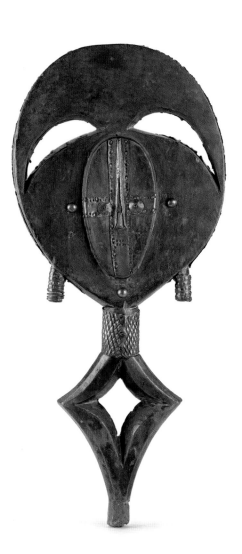

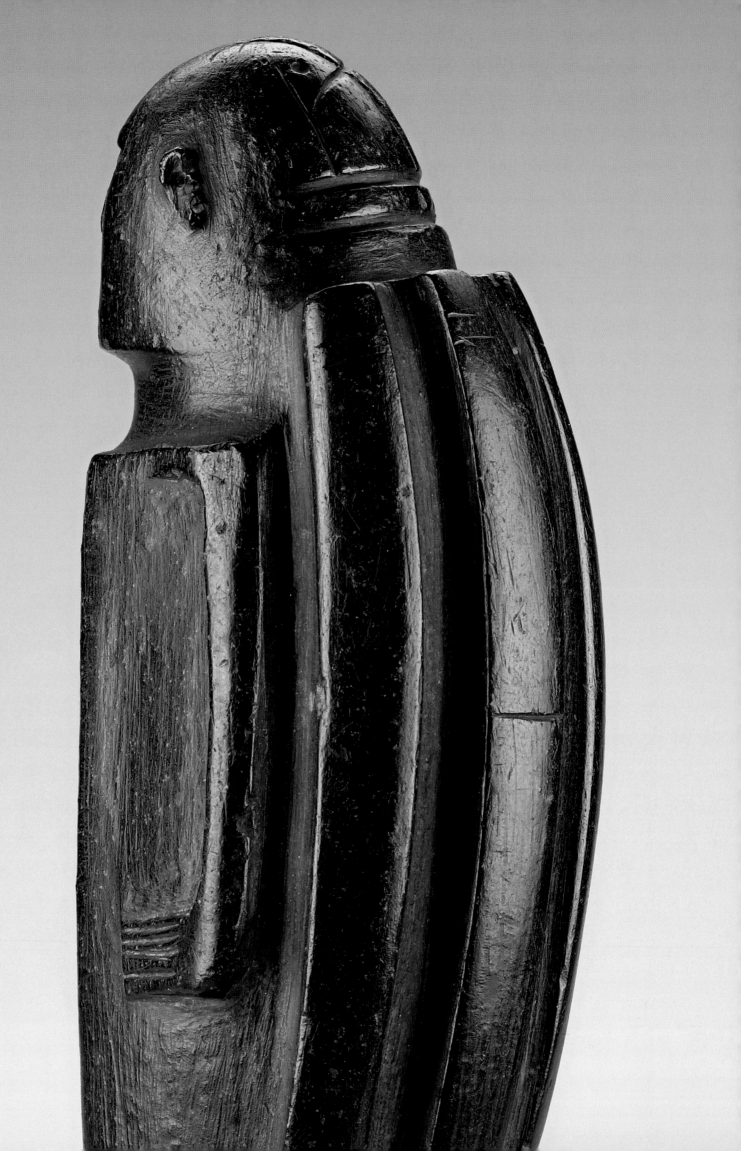

Figure

Possibly Shona peoples, possibly Zimbabwe

Date unknown

Stone

*33 x 9.5 x 9 cm
(13 x 3 3/4 x 3 9/16 in.)*

Gift of Walt Disney World Co., a subsidiary of The Walt Disney Company, 2005-6-119

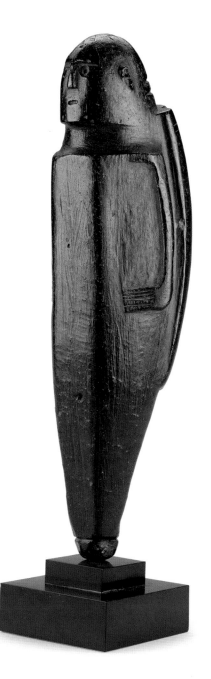

Previous publications have tentatively attributed this stone figure to the site of Great Zimbabwe,[1] a collection of granite-and-clay wall enclosures, stone towers, platforms, and mud buildings dating from about the 13th to the 15th centuries. Constructed as a religious center of a powerful Shona kingdom and located in present-day Zimbabwe, it is believed to have attained prominence through its links to major trading networks, one along the Zambezi River and the other to the east African coast.[2]

The curved ribs that run along the back of this stone figure resemble the folded wings of carved soapstone birds from Great Zimbabwe that are believed to be ancestral symbols associated with Shona rulers. However, figural sculpture from Great Zimbabwe is unknown, aside from one very similar figure in the collection of the British Museum (acc. no. 1923.6-20), also said to be from Great Zimbabwe, which was acquired in 1923. Neither is accompanied by archaeological data. The British Museum example depicts a female figure with a tapered phallic-shaped body, small protruding breasts, rudimentary arms carved in low relief along the torso, and a rounded head. Chip-carved geometric designs arranged in rectangular registers along the torso link the female figure with the incised patterns found on a soapstone monolith found at the Dhlo Dhlo ruins.[3] Also known as Danangombe, Dhlo Dhlo is a late Iron Age site located northeast of Bulawayo, Zimbabwe, where a community flourished from the 17th to the 19th century. As at Great Zimbabwe, the architecture of Danangombe was characterized by dry-stone terrace walls and house platforms.

Is it possible that the two stone figures attributed to Great Zimbabwe were carved at a later date by Shona, Venda, or Tsonga sculptors in the region? Stone analysis might yield some useful information, but until similar objects are documented in situ, the origin of this intriguing male figure, as well as the related female figure in the British Museum, remains speculative.

—CMK

Notes

1. Early publications of this figure include Delange 1958, p. 65, entry 511; Musée de l'Homme 1966, entry 134; the Israel Museum 1967, p. 20, fig. 212; Sieber and Rubin 1968, p. 144; Laude 1971, p. 48, fig. 31; and Vogel 1981, p. 241. Since then, photographs of the sculpture have appeared in numerous publications of African art, as recently as the 2003 catalogue *Material Differences*, edited by Frank Herreman and published by the Museum for African Art (New York), p. 59, cat. no. 47. Jacqueline Delange, in her comprehensive entry on this sculpture in the Tishman Collection catalogue published by Musée de l'Homme in 1966, noted that "it may have appeared in 'a sale in South Africa' in 1948 [when] . . . it was bought by an English colonel who then yielded it to a French collector" (Delange, in Musée de l'Homme 1966, entry 134). In 1958, it was identified as part of the collection of René Rasmussen, Paris (Delange 1958, p. 65, entry 511).

2. Garlake 1973, p. 121.

3. Ibid., plate 82.

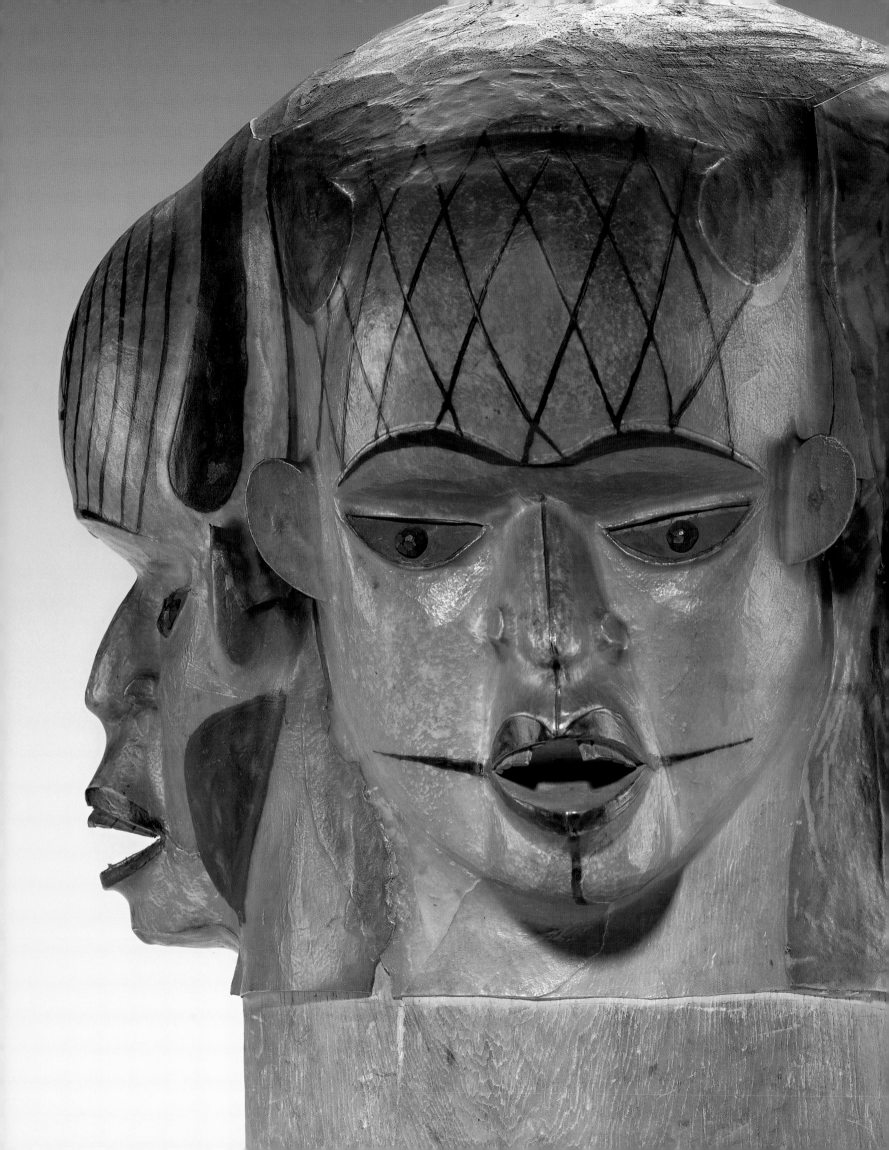

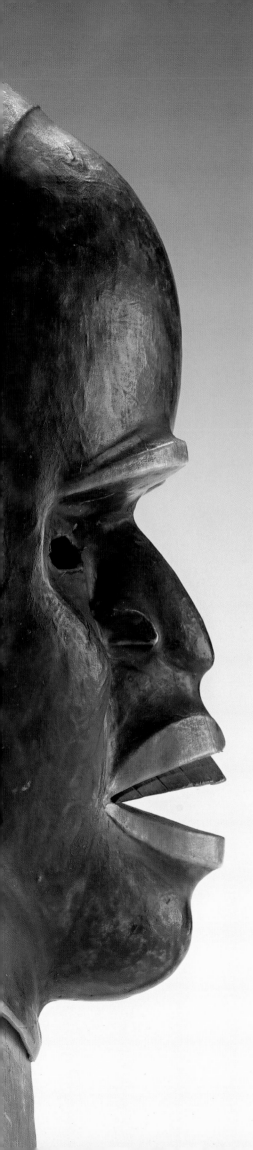

Perceiving Realities: African Arts Performed

Christine Mullen Kreamer

MAJOR FOCUS of African art is the human condition, explored not as literal representations of reality but as affective expressions of multiple realities—actual and imagined—that characterize and respond to what it means to be human. Masks, figures, architectural works, and prestige objects in the Walt Disney-Tishman African Art Collection illustrate this human-centered approach of Africa's traditional arts.[1] They also demonstrate the visual and communicative power of art and its contemporary relevance to enduring ideas and values. As symbolic representations, objects conceived in human form are visual expressions of value systems that confirm or challenge the ideal.

Physical beauty and its opposite are frequently used as metaphors in African art to reflect important ideas and values. African aesthetic concepts also address these through works that are well made and that balance form and design in culturally specific ways. The resulting works may be assessed as beautiful, and convey through their beauty ideal qualities associated with good character. Works of art that are deliberately distorted, fierce, or composite (combinations of human, animal, and the fantastic) may indicate opposing, disruptive behavior—the antithesis of the ideal—that should be avoided, or they may reflect extraordinary, potentially dangerous powers that must be harnessed for beneficial use.

With the proviso that sweeping generalizations detract from the diversity of African cultures and their arts over time, it is generally recognized that there are commonalities of form, context, and meaning that broadly unite works of art from various parts of Africa, due to the "extension of artistic traditions"[2] that has occurred in Africa through migration, trade, conflict, and other forms of social interaction. These historical processes generate similar themes, beliefs, and philosophies—some, in fact, universal—that find powerful visual expression through the arts.

The traditional arts of Africa are rarely static. Rather, works of art change over time and in many instances are themselves performative—that is, embodying motion, location, action, gesture, or the potential for movement.[3] Furthermore, they are employed in performance contexts (including ritual, display, instruction, and entertainment) that provide a more integrated, holistic framework for their interpretation and meaning (see fig. 25). Works of art rely on human agency for their creation, presentation, and reception. The makers and users of these objects anticipate that their symbolic and metaphoric capacities and their performance situations will be visually compelling and will engage the viewer intellectually and emotionally. The visual arts in performance thus offer creative and dynamic mechanisms for exploring the realities of everyday experience and emphasize the underlying human dimension that informs African expressive culture.

Fig. 25

Igbo male and female shrine figures in the rest house of Agbogo Ward

Mgom village, Nigeria

Photograph by Simon Ottenberg, c. 1952

Eliot Elisofon Photographic Archives, National Museum of African Art, Smithsonian Institution, EEPA 2000-007-0089

The human ideal: African figural arts

As a powerful vehicle for communication, the human body is prominent in African art. Figural sculptures tend to portray the human form in an idealized manner, in that they convey a social ideal through reference to exemplary physical attributes. Formal properties draw attention to culturally significant details—including hairstyle, scarification, clothing, jewelry, gesture, and posture—to communicate aspects of gender, ethnicity, status, or achievement, along with the qualities of good character, adherence to tradition, and service to others (see fig. 26). A figure's disproportionately large head may elicit associations with intelligence, individual destiny, or authority, while prominent sexual characteristics may refer to the procreative roles of men and women. In most cases of traditional African art, figural sculptures are not portraits of specific men and women, nor do they typically function as narratives of particular events. Their purposes are generally broader, necessitating a visual vocabulary of forms, symbols, and contexts capable of addressing wider social concerns. As art historian Herbert Cole pointed out, even when figure carvings signify particular individuals, they are usually rendered in more stylized ways, although "they may be personalized" through distinctive body ornamentation, objects, or symbols.[4]

These same ideas may also be conveyed through masquerades, architectural forms such as doors and posts, and by ladles, pipes, and other personal objects that represent or evoke the human form (fig. 27; and see also cat. nos. 12, 33). Representations of deities, ancestors, and other spirits rely on a familiar visual format—the body—to foster links between human potential and the abstract, extraordinary capacities and ethical teachings associated with the sacred (see cat. no. 40). The underlying message in many cases is to reinforce the ideal qualities that men and women should aspire to as they endeavor to respect the moral foundations of their society and to live their lives as productive members of families and communities.

In African art, depictions of the human form—full or partial—appear variously as single figures, pairs, or group compositions. They may adopt fairly conventional formats or be rendered as Janus (i.e., dual), multi-headed, or composite beings, some with both human and animal characteristics. Their intriguing forms suggest rich, culturally specific systems of metaphor and symbolism that infuse the works with aesthetic and communicative power. They address vital

Fig. 26
[cat. no. 42]

Funerary sculpture (detail)
Sakalava or Bara peoples, Madagascar

human concerns including history, gen-
der relations, and ideas about knowl-
edge, power, and spirituality. Decon-
structing such complex works of art by
examining their iconographic elements
and contexts of use reveals the interde-
pendence of form and meaning in
African art and their use in embodying
complex philosophical principles.

 For example, an individual
figure carving, male or female, is
perceived not in isolation but as repre-
senting wider social networks that form
the fabric of human culture. African
sculptors have often employed stylistic
conventions—such as an upright pos-
ture, balanced features, clearly indicated
sexual characteristics, details of dress
and body markings—to portray ideal
physical attributes associated with well-
socialized adult men and women (fig.
28). Indications of movement or ges-
ture—a striding stance, hands carrying
a weapon, supporting a vessel, or resting
against abdomen or breasts—may con-

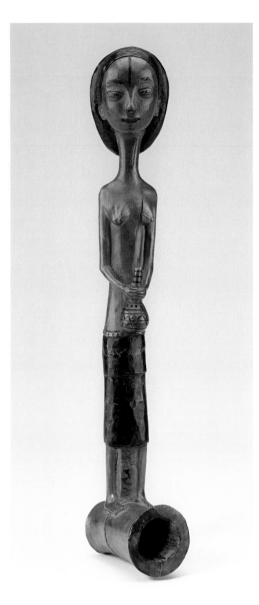

Fig. 27

Pipe
Ovimbundu peoples, Angola
Late 19th to early 20th century
Wood, metal
25.8 x 4.5 x 7. 3 cm
(10 3/16 x 1 3/4 x 2 7/8 in.)
Gift of Walt Disney World Co., a subsidiary of
The Walt Disney Company, 2005-6-184

Skillfully rendered and decorated personal
objects, such as this pipe, bring beauty to
everyday life and enhance the prestige of
those who own and use them. The stem of
this pipe is carved in the form of a standing
female figure. Her plaited coiffure, facial
markings, and delicate features may indi-
cate Ovimbundu notions of ideal feminine
beauty.

O P P O S I T E P A G E , L E F T

Fig. 28

Female figure
Baule peoples, Côte d'Ivoire
Late 19th to early 20th century
Wood, beads
18.4 x 10.2 x 9.5 cm
(7 1/4 x 4 x 3 3/4 in.)
Gift of Walt Disney World Co., a subsidiary of
The Walt Disney Company, 2005-6-14

The ideal moral qualities of a mature Baule
woman are conveyed by the exemplary
physical attributes of this exquisitely carved
female figure. Her elaborate coiffure, body
scarification patterns, filed teeth, restrained
facial features, and upright posture suggest
adherence to traditional social norms of
feminine decorum. Such figures—male
and female—are carved on the advice of
diviners, who recommend them to clients
whose lives have been disrupted by a dis-
gruntled spirit. The figures are placed on
shrines and receive offerings to appease
the spirits.

vey ideas about decisiveness, leadership, initiative, nurturing, or the value of work
(fig. 29 and fig. 30). The contexts in which African figural sculptures are
employed—as altar and shrine sculptures, initiation objects, divination and medic-
inal figures, emblems of membership, status and authority, and so on—suggest the
active human engagement that brings such works of art into daily life periodically
or on a regular basis as part of rituals, ceremonies, and public displays.

 The abundance of African sculptures portraying a female figure with
child reinforces the fundamental social importance of having children and raising
them to be positive members of society. Carved female figures are shown nursing
their children, supporting them on their laps, or carrying them on their backs—

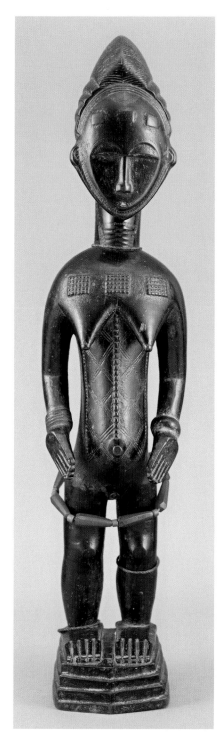

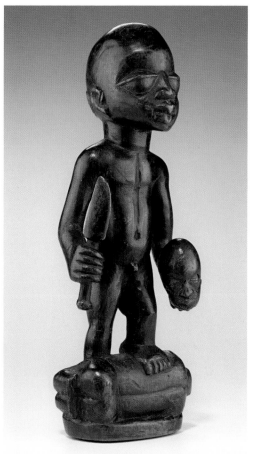

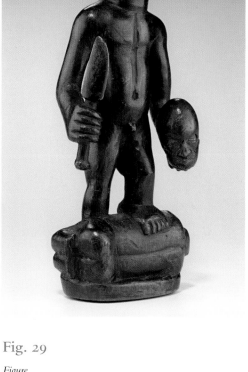

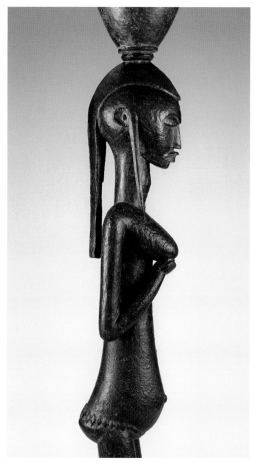

Fig. 29

Figure

Fon peoples, Benin

Late 19th to early 20th century

Wood, pigment

22 x 8 x 6 cm
(8 11/16 x 3 1/8 x 2 3/8 in.)

Gift of Walt Disney World Co., a subsidiary of The Walt Disney Company, 2005-6-65

The awesome power of the Fon king over life and death is conveyed by the actions of the royal executioner who holds a long-bladed knife and the severed head of the body he steps on. The circular tufts of hair further identify the executioner as a servant of the king. The destinies of the king, executioner and victim—as devotees of Gu, the Fon god of iron and war—are intertwined through their use of the tools of civilization (hoes) and the weapons of violence (swords), which are emblems of Gu.

Fig. 30

[cat. no. 32]

Female figure (detail)

Bamana peoples, Mali

gestures that indicate the nurturing role of women and the responsibilities of motherhood (see cat. nos. 21, 32, 37). However, their conventional interpretation as maternity figures may be secondary to deeper levels of meaning when considered within their broader ritual contexts. For example, a Senufo mother and child figure from Côte d'Ivoire (fig. 31) was displayed to symbolize "the central divinity of the initiation cycle (Poro)"[5] who nurtured, protected, and then delivered the neophytes back to the community after their training was completed.

This emphasis on human continuity is reflected in the concept of duality, an organizing principle evident in African art. Janus and paired masks and figures present opposing and complementary ideas, binary structures such as male/female, birth/death, day/ night, nature/culture, and so on that are relevant to the social, moral, and spiritual dimensions of communities. With the male facing one direction and the female the other, Janus (or double) images (fig. 32; see also cat. 53) tend to contrast gender, visually emphasizing distinctions while unifying them within a single composition. Metaphorically, these may relate to gender-specific domains of power and to the role of art and ritual "to mediate these inter-penetrating realms."[6] At times, such

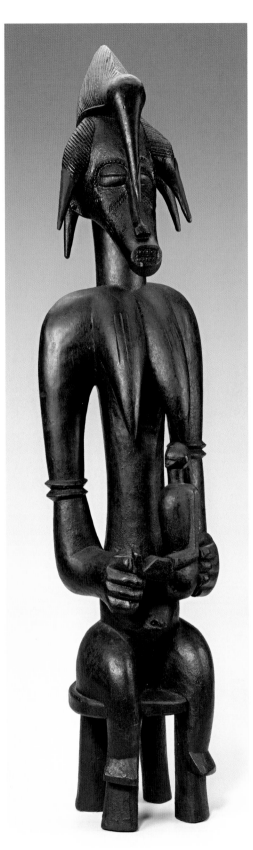

Fig. 31

Female figure with child
Senufo peoples, Côte d'Ivoire
Early to mid-20th century
Wood
89 x 21 x 22 cm
(35 1/16 x 8 1/4 x 8 11/16 in.)
Gift of Walt Disney World Co., a subsidiary of
The Walt Disney Company, 2005-6-51

Male and female figures were used in the context of the Poro society, the men's initiation association found in parts of west Africa. The coiffure represents a bird, possibly a hornbill, with its long beak suspended down over the woman's forehead. This figure's surface suggests its preparation for ritual use, when it would have been rubbed with shea butter, blackened, and oiled.

OPPOSITE PAGE, LEFT

Fig. 32
[cat. no. 38]

Double figure
Kuyu peoples, Republic of the Congo

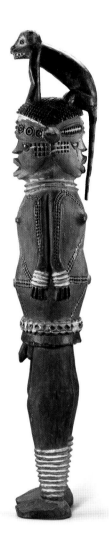

RIGHT

Fig. 33

Pair of figures

Lobi peoples, Burkina Faso

Late 19th to early 20th century

Wood, pigment

Male: 111.3 x 22.9 x 19.4 cm
(43 13/16 x 9 x 7 5/8 in.)

Female: 89.1 x 20.3 x 20 cm
(35 1/16 x 8 x 7 7/8 in.)

Gift of Walt Disney World Co., a subsidiary of
The Walt Disney Company, 2005-6-46.1, -46.2

Lobi wooden figures are powerful emis-
saries of the spirit world. They are placed
on altars and help spirits provide protection
from harm and relief from illness and mis-
fortune. Their distinctive surface treatments,
a mixture of shea butter and reddish lat-
erite soil, probably conform to the orders
of the spirit whose wishes were revealed
during divination.

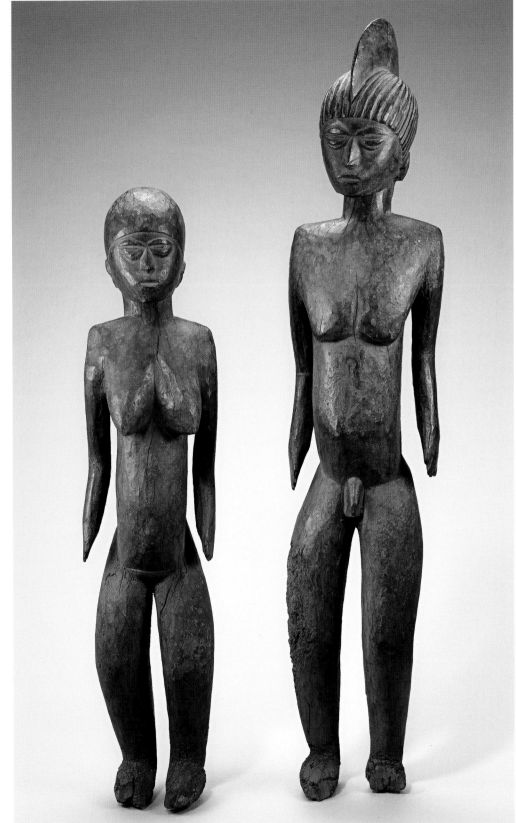

ideas are used to signify the dual nature of founding ancestors
or other spirits who, in the myths of some African societies,
are described as androgynous beings embodying the charac-
teristics and powers of both genders. Of course, dual classifi-
cations operate simultaneously with other systems that
organize information and experience in different ways, thus
providing alternative models for perceiving and interpreting
the world and one's place in it.

In African art, paired images visually reinforce
notions of cooperation and collaboration, whether they are
carved as separate freestanding figures (fig. 33) or joined
together within the same composition. For example, a
Dogon stool from Mali incorporates four pairs of figures,
hands upraised, as its central supports (fig. 34). Although the
pairs have been identified as female,[7] they are visually related
to figures in other Dogon carvings that are identified as
nommo, the eight primordial ancestors conceived as four male-female pairs of
twins who were sent to earth by Amma, the Creator deity, during "the final stage
of creation, when order was restored to earth."[8] Other African cultures, such as
the Senufo of Côte d'Ivoire and the Kongo and Lega of the Democratic
Republic of the Congo, also refer to the primordial couple—which "epitomizes
ideal social pairing"[9]—in their myths of origin and their arts.[10] Protective
guardian and nature spirits used in shrines and as emblems denoting membership
in particular associations may also be represented as couple or Janus figures, con-
veying simultaneously the "paradoxical unity in both life and art . . . the notion
of the human couple as simultaneously two and one."[11]

In some African traditions the birth of twins—a special kind of pair
that is both two and one—brings both joy and apprehension. As doubles, twins
may be held in high regard, believed to share a single soul and to possess the abil-
ity to bring fortune or misfortune to their families. The powerful capacities of
twins are also reflected in the arts. Among the Yoruba of Nigeria, for example,
twins (who are regarded as the children of Shango, the deity of thunder) are
honored and placated to secure their blessings. On the death of a twin, a memo-
rial figure called *ere ibeji* may be carved (fig. 35). A single *ibeji* figure thus embod-

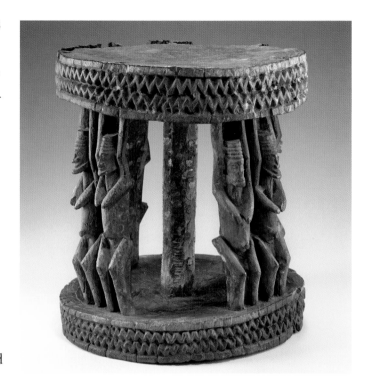

Fig. 34
[cat. no. 31]

Stool

Dogon peoples, Mali

ies the notion of two and allows the mother to continue to care for her deceased child as in life, ensuring the continued goodwill of her special children.

The meaning of multiples is more enigmatic in African art, as illustrated in the carving of a standing female figure made by an accomplished Dogon artist from Mali (fig. 36). The curious treatment of the head—an openwork construction composed of 11 small heads, each resting atop a thick neck—defies precise explanation. Though interpreted as representing *nommo* (the original Dogon water spirit reconfigured into the four pairs of founding ancestors),[12] the question "Why 11?" remains unanswered. Nonetheless, the sculpture evinces a visual potency through its composite form that suggests a being in transformation or in communion with the supernatural.

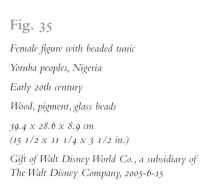

Fig. 35

Female figure with beaded tunic

Yoruba peoples, Nigeria

Early 20th century

Wood, pigment, glass beads

39.4 x 28.6 x 8.9 cm
(15 1/2 x 11 1/4 x 3 1/2 in.)

Gift of Walt Disney World Co., a subsidiary of The Walt Disney Company, 2005-6-15

Among the Yoruba, twins are regarded as special, as they are believed to confer good fortune on their families. When a twin dies, a commemorative figure called *ere ibeji* may be carved, kept in a family's twin shrine, and cared for as in life: it is bathed, clothed, adorned with beads, rubbed with oil, provided offerings of food, and sometimes carried in the folds of a mother's wrapper. Even if a twin has died in infancy or at a young age, the carvings depict them in the prime of life. This figure's beaded vest is a connection to the Yoruba deity Shango.

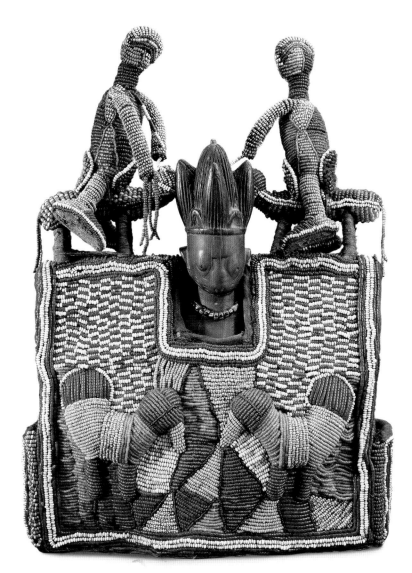

Indeed, figures that are composite—blending human with animal characteristics or adding elements of extraordinary creatures defying precise identification—lend an aura of the astonishing to certain African sculptures. The contrasts that are visually established by the deliberately dissonant combinations in such works suggest unfamiliar, potentially dangerous and powerful realms that are beyond settled community life and ordinary human abilities. Ferocious, fantastic, and composite depictions often serve as counterpoints to the ideal, reinforcing positive notions about behavior through objects and the ideas they embody that are associated with negative, anti-social qualities that should be avoided. For example, in sculptures known as *ivri* made by the Isoko (Nigeria), forceful personality traits that may be tamed or channeled into appropriate behavior are represented by a ferocious-looking animal with gaping maw that is subdued by the powerful male figure astride it (fig. 37).[13] Such objects illustrate that anomalous creatures as well as recognizable denizens of the animal kingdom may be called upon—through visually compelling works of art—to exemplify moral teachings, and, by so doing, to enter into beneficial relationships with humans.

This is not to suggest that art's sole function is to reinforce social order and the ideal. Works of art are also employed to challenge authority, advocate for change, or satirize the status quo. They provide counterpoints to positive role models, thus creating opportunities for airing disagreements, proposing new kinds of gender relations, and claiming power that may be at odds with established notions of social cohesion.

Performing realities: African masquerades

Masquerades are among Africa's most dynamic and enduring art forms, fulfilling vital social functions and "continually evolving to meet new needs."[14] As with figural sculptures, masked performances bring African art into daily life, enriching public celebrations, ceremonies, and everyday experience. They serve as popular, effective artistic and educational contexts, where core ideas and values are communicated in compelling, entertaining performances that represent, reconfigure, ridicule, and celebrate the realities of social life.

Masks, of course, are just one element of complex, multimedia masquerade performances that integrate the senses and usually involve costume, music, dance, gesture, vocalization, and audience participation. These compo-

Fig. 36
[cat. no. 30]

Female figure with 11 heads (detail)
Dogon peoples, Mali

OPPOSITE PAGE, LEFT
Fig. 37
[cat. no. 36]

Figure
Southern Isoko peoples, Nigeria

OPPOSITE PAGE, RIGHT
Fig. 38
[cat. no. 47]

Mask
Bassa peoples, Liberia

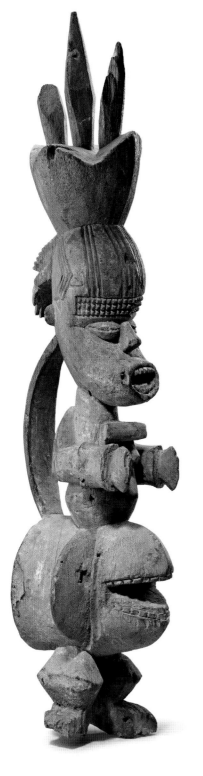

nents—including improvisation as performers and audience interact—are all part of the "message-system" of masquerades,[15] the purposes of which include moral education, entertainment, and, sometimes, communication with spirits. African masquerades derive their aesthetic and communicative power by "establishing a relationship between imagination and manipulation," thus allowing performers to create a "coherent artistic product" that motivates audiences to recognize the important values being conveyed.[16]

An overarching characteristic of African masquerades is that they involve transformation, an alteration of the human masker into the spirit/character/force embodied in the masked performance. This facilitates the capacity of masquerades to mediate between human and spiritual realms that are often expressed through oppositions—male/female, culture/nature, village/wilderness, life/death, secular/sacred, human/divine, and so on. At times, the transformed performer adopts human form, depicted by an anthropomorphic mask with carefully articulated facial features, scarification marks or tattoos, and an elaborate coiffure, along with a costume and movements that, taken together, suggest male or female traits. For example, in the case of the Bassa mask called *gela* (fig. 38) that belongs to the men's No association, the mask's refined form and graceful movements are associated with feminine qualities, even though it "is conceived as

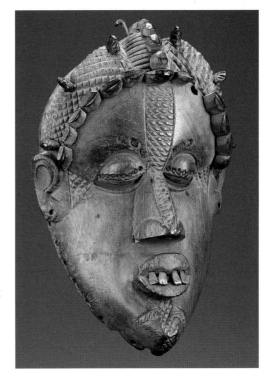

something non-human and of a different order of being, without gender."[17] In the Attie (Akye) face mask (cat. no. 49), the addition of fur hair and beard may suggest masculine qualities, but it, too, represents a spirit, one of a cast of characters including human, animal, composite, and ferocious that are performed as part of Do masquerades.[18] Both these masks are described as entertainment masks, although their performances within the contexts of men's societies suggest the serious intent of everyone involved, who recognize that spirits command respect and must be placated to secure their goodwill.

Masks that embody ideals of physical beauty—balanced features, appropriate facial markings, elaborate hairstyle—express positive qualities often associated in Africa with traditional structures of education and socialization. These include coming-of-age rites and membership in men's and women's associations,[19] contexts in which masquerades often perform. Such formal properties exhibited in a work of art may reflect the beneficent character of a particular spirit represented in the mask or be designed to appeal to a spirit believed to be capricious and thus potentially harmful—considerations relevant for a particular type of Urhobo mask from Nigeria (cat. no. 55) that is called "the girl with the youthful body."[20]

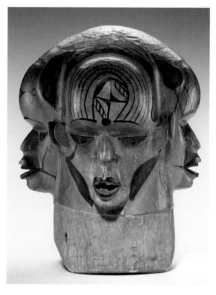

Fig. 39
[cat. no. 78]

Mask
Artist: Attributed to Takim Eyuk (died c. 1915)
Akparabong peoples, Cross River region, Nigeria

Fig. 40

Water spirit mask performing at a festival for the Kolokuma clan war god
Central Ijo, Rivers State, Nigeria
Photograph by Martha G. Anderson, 1979

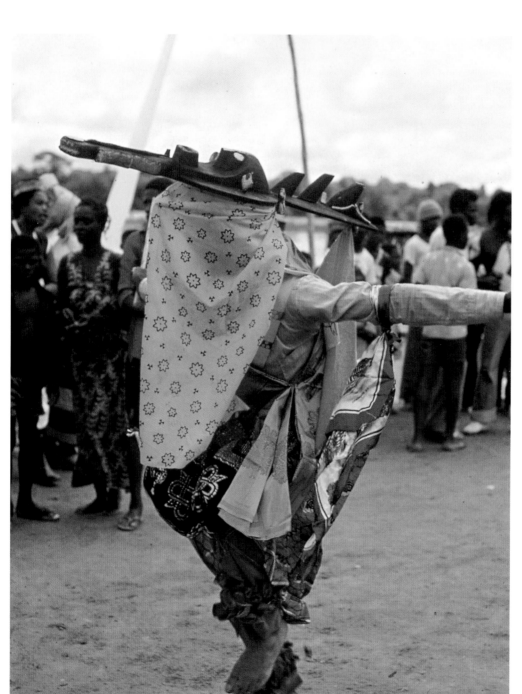

Beauty, of course, is in the eye of the beholder. To outsiders, the Wee face mask (cat. no. 48), with its exaggerated facial features and its attached brass bells, tacks, and human hair, seems the antithesis of beauty. Masks of this type, however, are called "young maiden."[21] Its accumulation of materials may simply be a dramatic visual device to enhance the spectacle of these entertainment masks, amplified through the cloth and raffia fiber costumes characteristic of Wee female masks.

As with figural sculptures, masks appear variously in single, double, multiple, or composite formats for visual and, at times, symbolic effect. Janus and double-faced masks, for example, generally suggest the idea of duality, be it gender distinctions, the concept of paired ancestors, or, on occasion, the power of twins (see cat. nos. 46, 50). Multiples—three or more images within a single mask—may suggest broader social relationships, the extraordinary capacities associated with spirits, or the desire of a mask maker or a patron to present a new or extraordinary form that enhances the spectacle and entertainment value of masquerade performances (see fig. 39).[22]

Animals, as the subject of African creation myths, folktales, and proverbs, are often endowed with personalities and behaviors akin to humans and thus can be used to impart moral teachings when invoked in the verbal and visual arts. Many African masquerades include characters that adopt animal forms or combine human-animal characteristics (fig. 40). Ordinary domesticated animals, such as roosters, oxen, rams, and dogs, are occasionally the subject matter of African art, as in a Bijogo ox mask (fig. 41). Their meanings, however, are far from ordinary, for they may suggest ideas about knowledge and power or the role that such animals play in religious offerings.

Animals that inhabit the forest, savanna, or waterways—environments that are regarded as being outside the boundaries of human settlements—are more prevalent in African art. They provide inspiration for masquerades in which the masked performer transforms into a wilderness spirit whose mannerisms may mimic the animal depicted. Animals considered dangerous, unpredictable, or unusual in appearance or behavior—such as aardvarks, bush buffaloes, chameleons, crocodiles (see cat. no. 43), hornbills, and snakes—"provide the most useful symbolic expressions of human situations."[23] Although both human and animal masquerades often evoke the spirit world, they also provide entertaining perspectives on village life, thus reinforcing the multiple messages masquerades convey as popular spectacles that explore the range of human experience.

Works of art that combine human and animal features bring the domesticated and the wild together. Such composite creatures, clearly "not part of the visible, everyday world,"[24] suggest capacities that are well beyond the limits of human experience. For example, a butterfly mask from Burkina Faso (fig. 42; see also cat. no. 45) portrays aspects of creatures—butterfly, bird, chameleon, human—that inhabit celestial and terrestrial domains. The masquerade visually reflects its function as a nature spirit, but one that intersects the world of human beings through its multiple contexts—agricultural, initiation, funerary, and entertainment. The patterned wings refer to the butterfly's coloration; but the swarming behavior of butterflies before the rains[25] may make this insect an appropriate form for masquerades associated with continuity and renewal. Among the Senufo peoples of Côte d'Ivoire, the curving horns of a face mask (cat. no. 23) convey a positive quality linked to "advancement and regeneration in the Poro cycle, the path to adulthood and fulfillment."[26] What these examples demonstrate, of course, is that there are a multitude of culturally specific interpretations assigned to the forms employed in African masquerades, some linked to the physical and behavioral characteristics of the beings depicted, and others that are less explicit yet are imbued with symbolic significance. Thus, composite works of art provide mechanisms in Africa for addressing the challenges and uncertainties of daily life, including beliefs in supra-human powers that may be called upon to intercede on people's behalf. Their performances in funerals, cyclical agricultural rites, initiation ceremonies, and other critical contexts emphasize the reality that the intersection of human and spiritual forces is required for a secure world.

Masks that are deliberately ferocious or grotesque are meant to surprise, frighten, or inspire awe. Such is the case in the fusion of human and

Fig. 41

Mask
Bijogo peoples, Guinea-Bissau
Early to mid-20th century
Wood, cow horns, glass, plant fiber, paint
27 x 50 x 30 cm
(10 5/8 x 19 11/16 x 11 13/16 in.)
Gift of Walt Disney World Co., a subsidiary of
The Walt Disney Company, 2005-6-53

Bijogo bovine masks are used to indicate the wearer's grade within the initiation society. This mask, representing a domesticated ox, retains its rope tether (passed through the ox's nostrils) to symbolize an early stage in the initiation process, before the individual's strength has been controlled.

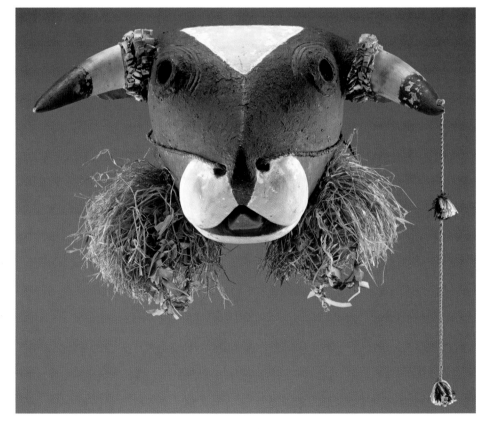

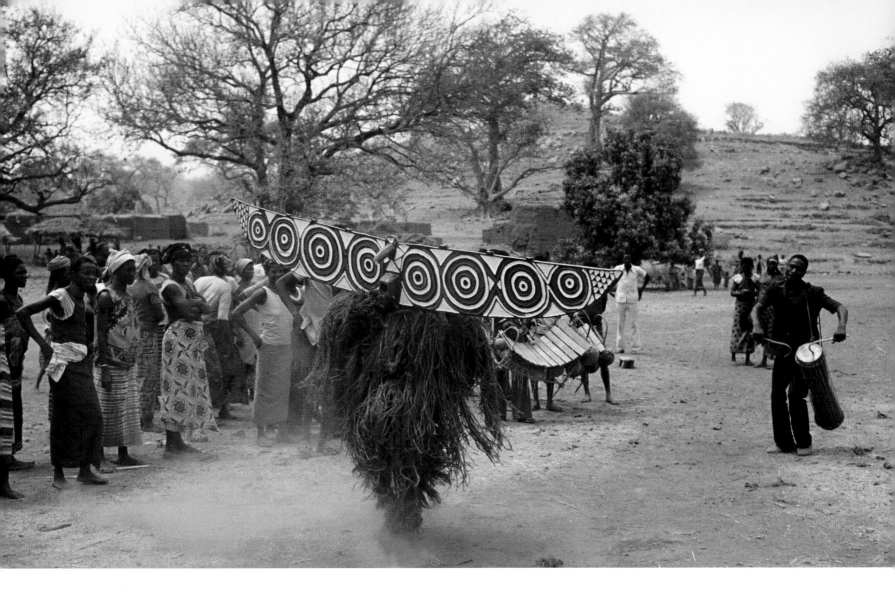

Fig. 42

Butterfly mask performing

Dosi peoples, Burkina Faso

Photograph by Robert Pringle, 1985

animal imagery in a mask from the Benin kingdom, Nigeria (cat. no. 2), where snakes descend the length of the columnar crest and along the cheeks, and crocodiles emerge from the nostrils of the human face. The iconography suggests the transformative capacities of kingship and the extraordinary powers of Oshun that are called upon in rituals to protect the king.[27] In the Walt Disney-Tishman Collection are several masks that art historian Roy Sieber might have deemed "tough in concept, subject and form . . . fierce,"[28] such as an Ejagham or Boki skin-covered crest mask from Nigeria (fig. 43) and a Bamum crest mask from Cameroon (cat. no. 60). These dramatic, powerful compositions—achieved through exaggerated features and the use of materials derived from the wild, including animal skin, horns, fiber, and spider silk—are clearly meant to signal power. Because they also challenge Western aesthetic sensibilities, they are the types of objects less visible in Western collections. When considered within their aesthetic and performance contexts, such works of art can then be understood, by both indigenous and foreign audiences, as complex expressions of knowledge, status, and authority.

Masquerades, as dramatic art forms that engage the senses as well as the intellect, communicate several messages on multiple levels, often simultaneously. They employ the power of spectacle to generate emotions—awe, reverence, pride, amusement—that stimulate memory, learning, and meaning-making. "In Africa masks are genuine 'mobiles' . . . Shapes, textures, colors and patterns of varied masking ensembles move within a kaleidoscope of balances and oppositions of motion and speed, activating the visual field in which they appear."[29] Their forms and contexts function as visual archives of ideas, events, and the aesthetic underpinnings of human experience. Even when performed largely for entertainment, masquerades involve transformations that "manifest metahuman and otherwise intangible spirit forces,"[30] which give masquerades their potency.

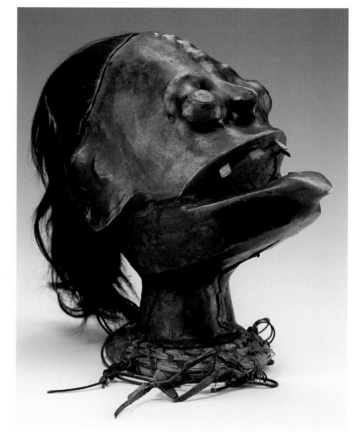

Perceiving power: African arts of leadership, status and prestige

Perceptions of the ideal—actual or imagined—are also addressed in Africa's arts of leadership, status, and prestige. Through form, material, iconography, and contexts of use, works of art are potent mechanisms for articulating the dynamics of power, both sacred and secular, in human experience. The traditional systems of authority and power in Africa that were and continue to be addressed by leadership and prestige arts range from elite and fairly rigid hierarchies associated with hereditary rule and centralized, well-defined kingdoms, at one end of the political spectrum, to more fluid, individual or corporate forms of control characteristic of decentralized governing structures, at the other end.[31] Within these systems, prominent individuals exercise power or influence over others in social, economic, political, and spiritual domains that often intersect or overlap.

The ideas conveyed by leadership and prestige arts—importance, authority, affluence, knowledge—are, in many cases, universally recognized, and thus communicate on certain levels cross-culturally. For example, most people would recognize the valued materials and exceptional artistry evident in a Yoruba (Nigeria) beaded crown or a pair of ivory armlets, and would surmise that these

Fig. 43

Mask

Ejagham or Boki peoples, middle Cross River region, Nigeria

Early to mid-20th century

Wood, animal skin, basketry

27 x 12 x 28 cm
(10 5/8 x 4 3/4 x 11 in.)

Gift of Walt Disney World Co., a subsidiary of The Walt Disney Company, 2005-6-93

In Nigeria's Cross River region, men's associations controlled the production and use of skin-covered masks. They performed for initiation rites and the funerary celebrations commemorating association members. The grimacing, skull-like features of this mask are particularly fierce and aggressive, and the attachment of animal fur for hair is unusual. It clearly communicates the power that was associated with men's societies in this region.

Fig. 44

Oba Ademuwagun Adesida II the Deji of Akure, on his throne

Akure, Nigeria

Photograph by Eliot Elisofon, 1959

Eliot Elisofon Photographic Archives, National Museum of African Art, Smithsonian Institution, EEPA 2071

objects were used by, and possibly belonged to, individuals of wealth and prominence (fig. 44). When examined in some detail, the objects evince an important aspect characteristic of traditional leadership in Africa: namely, the capacity of leaders "to commission, control and distribute works of art, and to inform them with meaning."[32]

Copper alloy, gold, beads, and ivory, all employed in traditional leadership and prestige arts in various regions of Africa, were valued in the past as

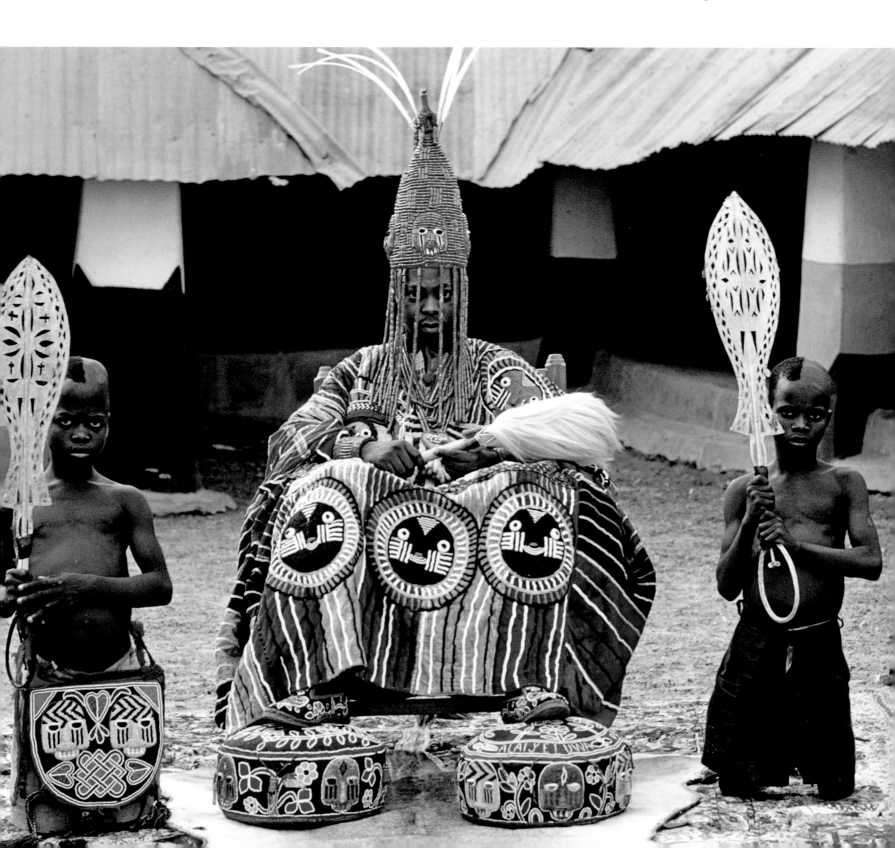

currencies and commodities in regional and long-distance trade networks
that brought prosperity to rulers and their territories. Regalia made
from these materials, often by artists working in guilds under royal
patronage, emphasized the strength and stability of the kingdom
that was inextricably linked to the ruler and the institution of
chieftaincy that controlled these sources of wealth—ostensibly
for the betterment of the kingdom. While the state and private
sector in Africa now control the raw materials that were formerly
the prerogative of chiefly authority, their use as symbols in
the arts of leadership remains relevant, although they are usually com-
bined with more contemporary indicators of power and status similar
to those found elsewhere in the world.

Iconography, or symbolic representation, is an effective method for
conveying through visual means complex messages about power and status.
Motifs such as the fish-legged figure or the head with nostril protrusions on
Yoruba ivory armlets (fig. 45) or the birds depicted on a Yoruba beaded crown
(cat. no. 69) visually recall for the Yoruba peoples the divine origins of their king-
dom and the extraordinary, sacred powers embodied in their traditional rulers. In
a similar way, the exceptional capacities of a 19th-century Kongo ruler (from
what is now the Democratic Republic of the Congo) were reflected in the ivory
staff top that depicts a human figure with the head of a snarling animal, either
feline or canine (cat. no. 79). Its composite imagery connects leadership with the
power of transformation, the potential to harness forces of the wilderness, and the
ability to mediate between the natural and supernatural worlds in the exercise of
authority. If the finial depicts a feline, then it refers to chiefly authority, since
leopards and other spotted cats have long been symbols of leadership in Africa; if
a canine, then it suggests the role of dogs in Kongo beliefs as hunters in the spirit
realm. Regardless of its precise imagery, the particularly ferocious and aggressive
representation in this Kongo example leaves no doubt that the intention of such
an object was to inspire awe and, in so doing, reinforce the dominating, coercive
power of the ruler.

It is important to emphasize that leadership regalia also include motifs
that reflect more collaborative or cooperative notions of power, as may be sug-
gested in a Kongo ivory finial of a woman (cat. no. 81). Although its meaning is
far from certain, it may well convey a sense of the broader community over which

Fig. 45
[cat. no. 65]

Armlet

Yoruba peoples, Owo region, Nigeria

a ruler presides. Thus, it may illustrate the point that power is not localized in any one person and instead is "employed and exercised in a net-like organization" in which "individuals are the vehicles of power, not its points of application."[33]

Worn or carried on public occasions, such markers of status, position, and power are characterized by their visibility, the "elitist functions of their art forms" inextricably tied to their facility to be seen and interpreted by others.[34] Beautifully crafted from valued materials, leadership regalia also proclaim the good taste and refined aesthetic sensibility of those in authority, thus serving to further emphasize their prestige.

Emblems of leadership were recognized as important examples of African material culture by European explorers, merchants, and colonial officials, a factor that may account for the acquisition of such works for museum and private collections in the West. In Africa during the colonial period, European administrators, missionaries, and others in authority collected objects that appealed to Western aesthetic sensibilities and confirmed their notions of the trappings of leadership. Many of these were more elaborate forms associated with the elitist function of the leadership arts of centralized kingdoms. It is important to note, however, that less ornate expressions of power and authority associated with less centralized political systems are equally meaningful, possibly reflecting "a more fluid structure with a great deal of individual mobility and changes in status."[35] Power may be achieved not by entitlement but through personal accomplishments that gain support and a power base that can quickly erode if personal fortunes turn. Objects such as fiber whisks in parts of central Africa or earthen-packed animal horns in much of west Africa have long been overlooked by the West, yet they are important signifiers of rank and authority.

Power in the religious sphere (which is sometimes part of a political ruler's responsibilities) may be signaled by such modest emblems or by dazzling works of art that use valued materials and iconographic motifs related to the arts of chieftaincy. A diviner's beaded bag, the iron and wooden staff and beaded sheath made for a religious sect, and an intricately carved divination board convey complex aspects of Yoruba cosmology (fig. 46; and see cat. nos. 68, 70, 71). Their meanings are understood not by the general public but by trained specialists whose education and expertise permit them to own and use these objects. Thus, in addition to functional purposes, objects serve to reinforce status and prestige that is achieved through the acquisition of specialized knowledge.

Art forms controlled by specific men's and women's associations also signal power, confer rank, and mark accomplishments gained through training and the mastery of particular skills. In the Cross River region of Nigeria, a specialized form of communication known as *nsibidi* was developed by the Ejagham. Composed of "graphic, spoken and gestured . . . signs,"[36] *nsibidi* is an ideographic system of some 1,000 signs conveying nouns, verbs, and complete thoughts.[37] Its use was restricted to members of the men's Leopard society (called Ekpe, Ngbe, Egbo) that controlled trade in the region and was charged with social, judicial and political authority. Knowledge of *nsibidi* was associated with upward mobility within the men's Leopard society and was used to demonstrate power and prestige, especially to rivals. The prominence of the Leopard society was also communicated through their control of skin-covered masks, some inscribed with *nsibidi,* that performed at funerals, initiations, and festivals (see figs. 39, 43). The masks functioned as visible signs of largely secret or restricted powers that were unavailable to non-members.

Fig. 46

Ifa diviner

Itefa, Imodi, Nigeria

Photograph by Henry John Drewal, 1982

Eliot Elisofon Photographic Archives, National Museum of African Art, Smithsonian Institution, EEPA 1992-028-02024

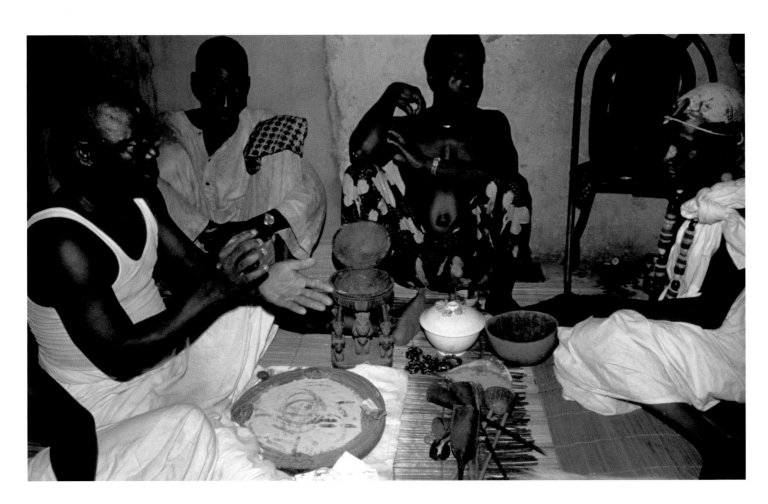

As objects used in performance, African works of art actively engage the social sphere and thus embody agency.[38] More than just symbols, objects may be called upon to identify problems, to mediate social relationships, or to move individuals or groups to action. Guardian figures fashioned by the Fang and Kota peoples of Gabon have a job to do: they are placed over reliquary bundles to safeguard the ancestral relics within (cat. nos. 24, 28). The relics, by virtue of *their* powers, which were hidden from view, "had a kind of personhood" of their own.[39] Among the Luba of the Democratic Republic of the Congo, a gourd sculpture called *kabwelulu* (cat. no. 82) was activated and accrued power through the items that were placed in the gourd by successive groups of initiates inducted into Bugabo, a society "dedicated to hunting, healing and fighting crime."[40] Over time, the object "produced the memory of the event of activating the sculpture,"[41] and therefore actively recorded and reproduced the collective memory and the power of the association.

Expressions of power are "cultural resources that produce and structure action,"[42] and African art plays an important role in the dynamics of power and in articulating the creative interface between power and ideology.

The meanings and functions of traditional African figural sculpture, masquerades, and arts of leadership, status, and prestige are as varied as their forms and performance contexts. All, however, address human concerns and thus are expressions of the social and spiritual realities that define the human experience. Put another way, "art sharpens our perceptions of life by re-creating human experience in fresh forms, bringing a new sense of significance and connectedness of life."[43] This is not to suggest that African works of art depict reality—far from it; although they have a significant impact on daily life, the functions of masks and figures are not mundane. As visual mechanisms for communication, they are dependent upon the processes of sensory perception, imagination, and "insightful seeing"[44] that connect objects with meaning. Through form, context, and symbolism, Africa's traditional arts address the challenges and uncertainties of daily life and call into play powers that extend beyond human capabilities.

Notes

1 For a discussion of the problematic term "traditional" as applied to African art, see n. 1 in Chapter 1 in the present volume.

2 Sieber, in Sieber and Rubin 1968, p. 12.

3 Thompson 1974.

4 Cole 1989, p. 42.

5 Bochet, in Vogel 1981, p. 46.

6 Cole 1989, p. 70.

7 Dieterlen, in Vogel 1981, p. 19.

8 Ezra 1988, p. 20.

9 Sieber, in Sieber and Walker 1988, p. 29.

10 Herbert Cole notes that the practice "of an original human pair memorialized in visual art" may not be particularly widespread in Africa (Cole 1989, p. 61). Citing the work of Felix (Felix 1987), Cole notes the belief in primordial couples among the Ngbaka, Ngbandi, Rungu, Zela, Ngala, Hemba, Bembe, and Banja peoples of the Democratic Republic of the Congo (Cole 1989, p. 191, n. 7).

11 Cole 1989, pp. 53, 68-69.

12 Laude, in Vogel 1981, p. 20.

13 Peek reports that, in addition to the Isoko, the "*ivri* complex" is found throughout much of southern Nigeria. Among the Urhobo, the figures are known as *iphri;* the Ijo call them *ifiri;* the Igbo call them *ikenga.* The Edo peoples, court of Benin, employ altars to the cult of the hand called *ikegobo* to celebrate the accomplishments of exceptional individuals (Peek, in Anderson and Peek 2002, p. 120).

14 Cole 1985, p. 16.

15 Ibid., p. 17.

16 Agovi 1988: 7.

17 Siegmann 1977, p. 27.

18 Visonà 1983, p. 128.

19 There are a broad range of associations, societies, or organizations in Africa that control and employ masquerades and other art forms as part of their social functions. They may be gender-specific or open to both men and women. Some associations are segregated by age or accomplishment. Many are concerned with educating youth or establishing solid relationships that can be relied upon over the course of a lifetime. Some are dedicated to particular religious beliefs. Members gather and exert their collective influence at key events in the cycle of life, such as coming-of-age rituals, the investiture of leaders, and funerals. The control of knowledge and power and the achievement of rank are common elements in African associations, with some members wielding considerable authority over secular and spiritual affairs. Works of art are extensions of these groups, serving a wide variety of social, political, and spiritual ends.

20 Foss, in Vogel 1981, p. 146.

21 Ezra, in Vogel 1981, p. 70, quoting Himmelheber.

22 Keith Nicklin noted that the quantity and complex forms of Ejagham masks from Nigeria's Cross River region appear to have coincided with increased agricultural and commercial wealth in the region during the 19th century. This led artists "to produce ever more elaborate, grotesque, or serene forms for their wealthy patrons," whose prestige would be elevated by more elaborate masquerades that enhanced the spectacle and entertainment value of their public performances (Nicklin, in Vogel 1981, p. 167).

23 Roberts 1995, p. 118.

24 Ibid., p. 152.

25 Christopher Roy, e-mail to the author, June 24, 2006.

26 Glaze, in Vogel 1981, p. 42.

27 Ben-Amos, in Vogel 1981, p. 136.

28 Sieber 1990, pp. 342-43.

29 Cole 1985, p. 17.

30 Ibid., p. 7.

31 See, for example, Steiner 1990 and Fraser and Cole 1972.

32 Fraser and Cole 1972, p. 295.

33 Foucault 1980, p. 98.

34 Fraser and Cole 1972, p. 299.

35 Steiner 1990: 432.

36 Cole and Aniakor 1984, p. 61.

37 Campbell 1983: 42, 45.

38 Gell 1998.

39 Beidelman 1993, p. 46.

40 Roberts and Roberts 1996, p. 204.

41 Ibid.

42 Arens and Karp 1989, p. xiv.

43 Preble and Preble 2002, p. 20.

44 Ibid.

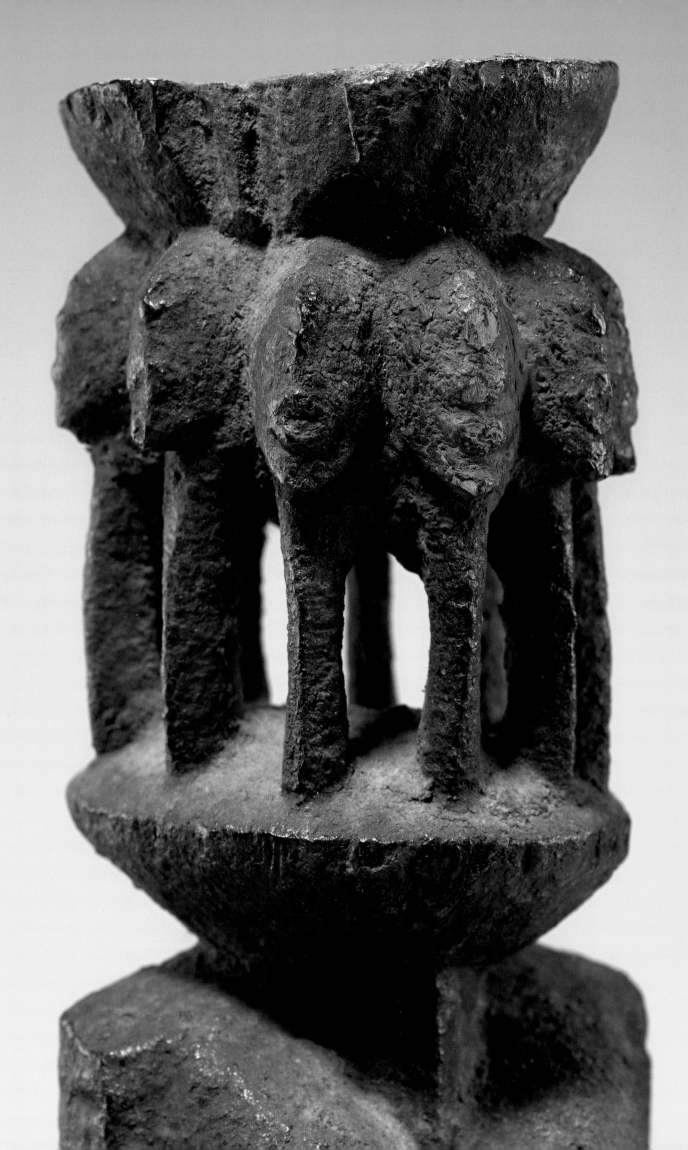

Female figure with 11 heads

Dogon peoples, Mali

19th to early 20th century

Wood, encrustation

*37 x 8.5 x 8.5 cm
(14 9/16 x 3 3/8 x 3 3/8 in.)*

Gift of Walt Disney World Co., a subsidiary of The Walt Disney Company, 2005-6-41

The breasts and solid form of this figure with her hands over her stomach, suggesting the capacity to bear children, recall the classic hierarchic female of Dogon sculpture; and the presence of a labret (lip plug) reinforces its traditional female appearance. However, the replacement of the head with an 11-headed form suggests a more complex iconography. The sinuous, long necks of the 11 small heads suggest the fluid nature of the *nommo,* the primordial spiritual beings that are the focus of much of Dogon cosmology. Above and below the 11 heads are two disks that represent the sky and the earth connected by the *nommo,* as on Dogon stools (see cat. no. 31). The disk on top of the heads would act as an altar surface for libations.[1]

Another interpretation of multiple-head figures has them being commissioned by a lineage group or kinship group to defend the family and testify to the value of family harmony. According to this view, the heads are gazing at the horizon in all directions as guardians.[2]

—BF

Notes

1. Leloup 1994, no. 90.

2. Ibid., no. 86.

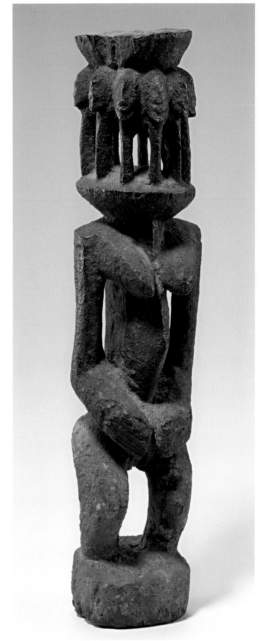

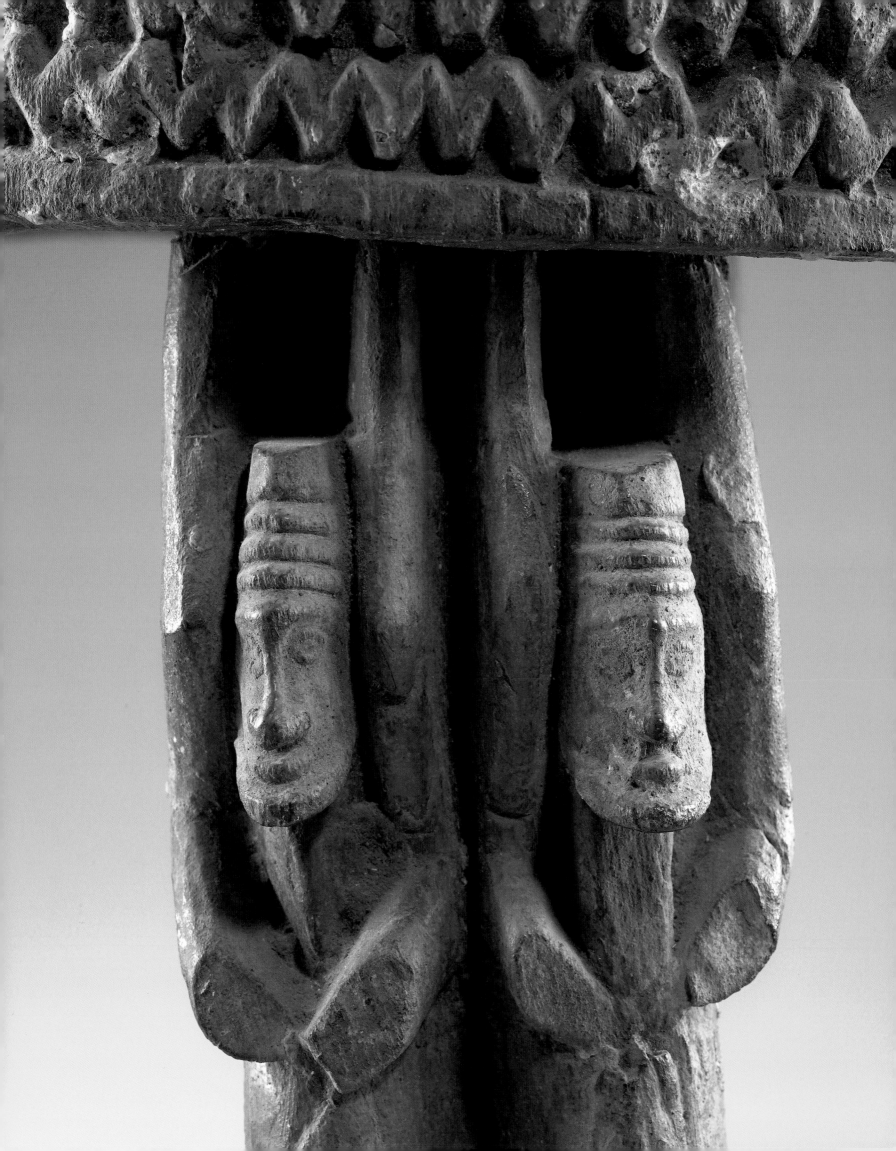

Stool

Dogon peoples, Mali

Possibly late 19th to early 20th century

Wood, pigment

36.5 x 32.8 x 31.8 cm
(14 3/8 x 12 15/16 x 12 1/2 in.)

Gift of Walt Disney World Co., a subsidiary of The Walt Disney Company, 2005-6-40

Our understanding of Dogon beliefs and art has been shaped by the studies begun in the 1930s by French ethnologists Marcel Griaule and Germaine Dieterlen and their colleagues and students. Even those who disagree with or wish to reevaluate their work start with their research. This stool depicts the Dogon belief of the cosmos as two disks forming the sky and earth and connected by a tree. The four pairs of caryatid figures represent the founding ancestors of mankind: the four pairs of *nommo* twins in their descent from sky (their father) to earth (their mother), spiritual beings involved in the creation of man and culture.

On the stool, the *nommo* appear female, an identification that Dieterlen made based on the number four in their headbands.[1] They could also be thought of as beyond or before gender at this point, as fluid, non-human beings. The decorative zigzag patterns suggest flowing water, or the path these mythical beings took when they made their descent. The pattern is also the symbol of Lébé, the first human and the first priest, who was transformed into a serpent after his death.[2]

This stool has the unusual feature of dots of red, white, and black pigment that survive on the sides and backs of the figures and on the center post. Although there are painted designs on Dogon masks, and paintings on shrine houses and on sheltered cliff sides, most figures and stools are unpainted, and have an encrusted or eroded surface, suggesting use by a *hogon* (lineage priest), who is the oldest direct descendant of the founder.

—BF

Notes

1. Dieterlen, in Vogel 1981, p. 19.

2. Imperato 2003, p. 90.

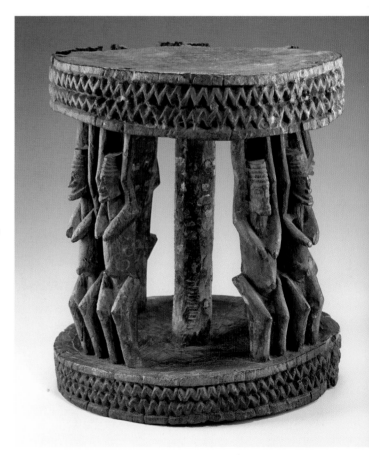

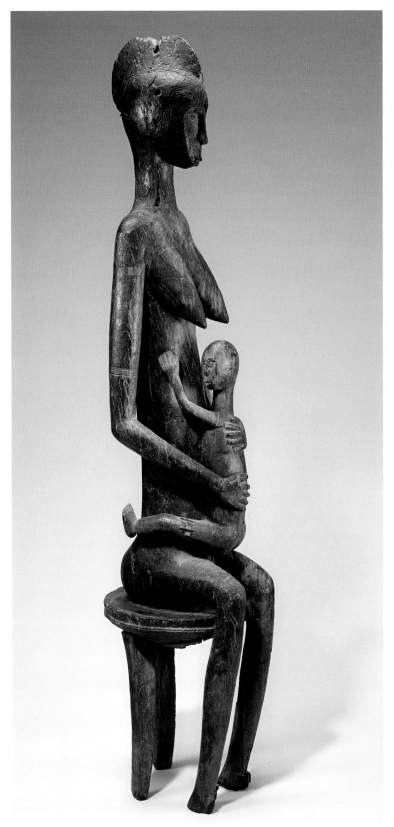
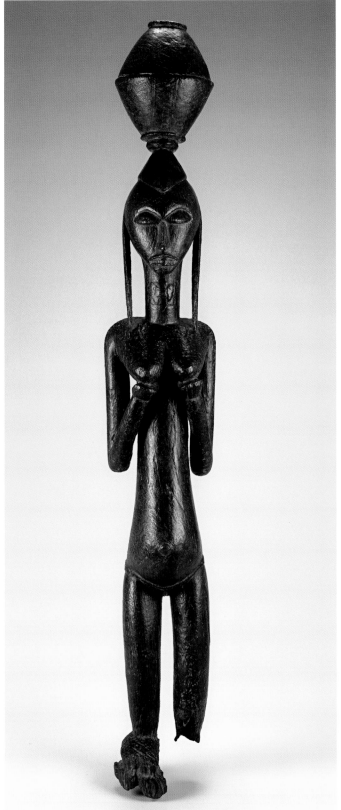

Female figure with child

Bamana peoples, Mali

Late 19th to early 20th century

Wood, iron

*161.9 x 33.7 x 38.6 cm
(63 3/4 x 13 1/4 x 15 3/16 in.)*

Gift of Walt Disney World Co., a subsidiary of The Walt Disney Company, 2005-6-42

Female figure

Bamana peoples, Mali

Late 19th to early 20th century

Wood

*93.5 x 14 x 13.5 cm
(36 13/16 x 5 1/2 x 5 5/16 in.)*

Gift of Walt Disney World Co., a subsidiary of The Walt Disney Company, 2005-6-43

These two female figures—one with child, the other described as an attendant—are part of a distinct group of Bamana figural sculptures from Mali that were largely unknown in Western collections until the late 1950s. They are differentiated by their large size and rounded, naturalistic forms, in marked contrast to the more geometric, angular planes characteristic of the majority of typically smaller Bamana carvings depicting the human figure. Art historian Kate Ezra has determined that the carvings, which originated from south-central Mali near the towns of Bougouni and Diola, were used in Gwan, a division within the Jo initiation society (open to both men and women) that addresses problems associated with fertility and childbirth.[1]

In addition to seated mother-and-child figures, Gwan carvings also depict male and female figures shown standing or seated, many ornamented with carved representations of leather amulets and medicinal horns. As Ezra noted, the sculptures were part of sculptural displays used in Gwan rituals and the annual ceremonies of Jo, and they "were washed and oiled to keep them clean, shining and thus beautiful."[2] This treatment probably accounts for the darkened, weathered surface and the almost imperceptible linear scarification patterns incised on the face, arms, and back of the large seated female figure holding a child. The child's legs have been repaired. It is one of four works (two in the Menil Collection, the other in the Metropolitan Museum of Art) that are related to each other stylistically by their height, gestures, and more naturalistic proportions.[3]

The standing female figure is described as an attendant; the vessel on her head refers specifically to the tasks of women bringing water and washing both the Gwan sculptures as well as the bodies of the newly initiated.[4] On a broader level, the vessel she carries and her gesture of supporting her breasts with both hands emphasize more general ideas about the nurturing role of women.

—CMK

Notes

1. Ezra, in Vogel 1981, p. 26; also Ezra 1986.

2. Ezra, in Vogel 1981, p. 26.

3. Ezra 1986, p. 28, n. 29.

4. Ezra, in Vogel 1981, p. 27.

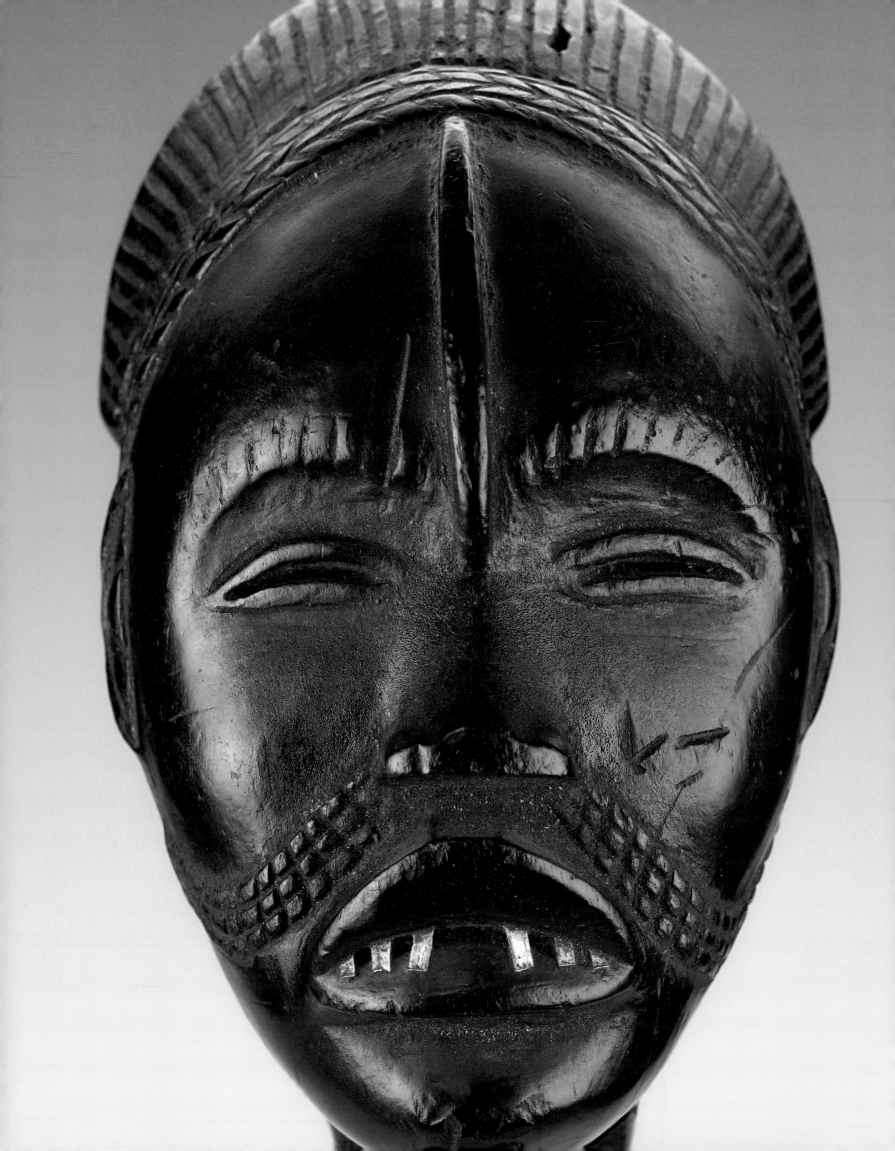

Ceremonial spoon

Wee peoples, Liberia and Côte d'Ivoire

Late 19th to mid-20th century

Wood, metal, oil patina

*62.5 x 16.5 x 8.5 cm
(24 5/8 x 6 1/2 x 3 3/8 in.)*

Gift of Walt Disney World Co., a subsidiary of The Walt Disney Company, 2005-6-58

Several neighboring peoples in Liberia and Côte d'Ivoire, notably the Wee and the Dan, honor the woman who is the most hospitable among them. She is the one who can not only feed her household, but with a generous hand accommodates unexpected visitors, traveling musicians, and seasonal farm workers. The emblem of her achievement is a specially carved ceremonial ladle that embodies the spirit of generosity and may sometimes be a generalized portrait of the owner.[1] It may take the form of either a scoop or an oval bowl spoon with a handle ending in human legs or with a handle topped by a female face with a carefully arranged coiffure. On this example, the cheek and forehead scarification is similar to that seen in photographs of older Wee women[2] or on masks. On special occasions, the honored woman holds the spoon as she dances with attendants through her section of town.

For the Wee peoples, as for many other African cultures, beauty is linked with moral values—in this case, hard work. The woman's success also reflects the hard work and achievement of her husband, who supports her generosity.

—BF

Notes

1. Siegmann, in Vogel, p. 1981.
2. Himmelheber 1997, p. 20.

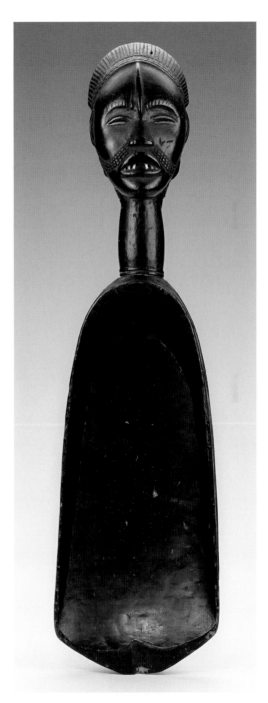

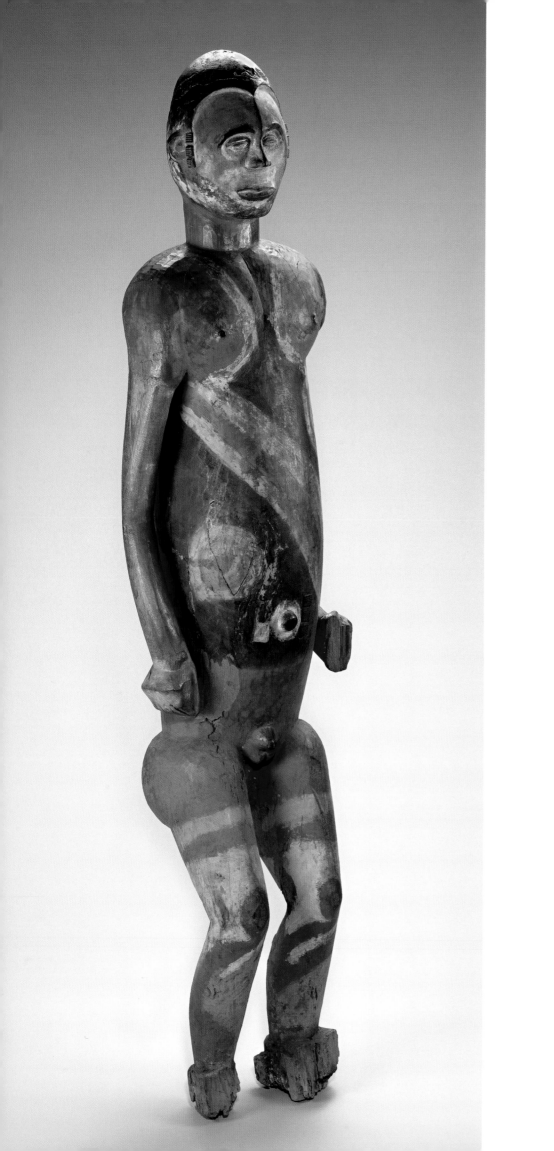

Male figure

Igbo peoples, Amogdu Abiriba, Cross River region, Nigeria

Early to mid-20th century

Wood, pigment

*141.6 x 35.6 x 25.4 cm
(55 3/4 x 14 x 10 in.)*

Gift of Walt Disney World Co., a subsidiary of The Walt Disney Company, 2005-6-81

This figure probably represented a community's founding ancestor or a warrior, and was one of a large number of monumental figures kept in the men's meetinghouse to guard the private areas from intrusion. It is likely to have been part of a group of figures that also included those depicting the founding ancestor's wife as well as others in the community, including warriors and hunters.

Its origin is probably the Cross River region at Amogdu Abiriba,[1] and it exhibits the rounded forms consistent with northern Igbo sculptural style.[2] In addition to its size, the figure's most striking feature is the broad, bold use of color that reinforces the strength of the carving. Among the Igbo, such ancestor figures are sculpted by men and painted by women, and the colors are said to be decorative.[3]

—AN

Notes

1. Herbert M. Cole, e-mail to the author, June 29, 2006.

2. Cole and Aniakor 1984, p. 96.

3. Burssens, in Herreman 2003, p. 26, caption to cat. no. 16.

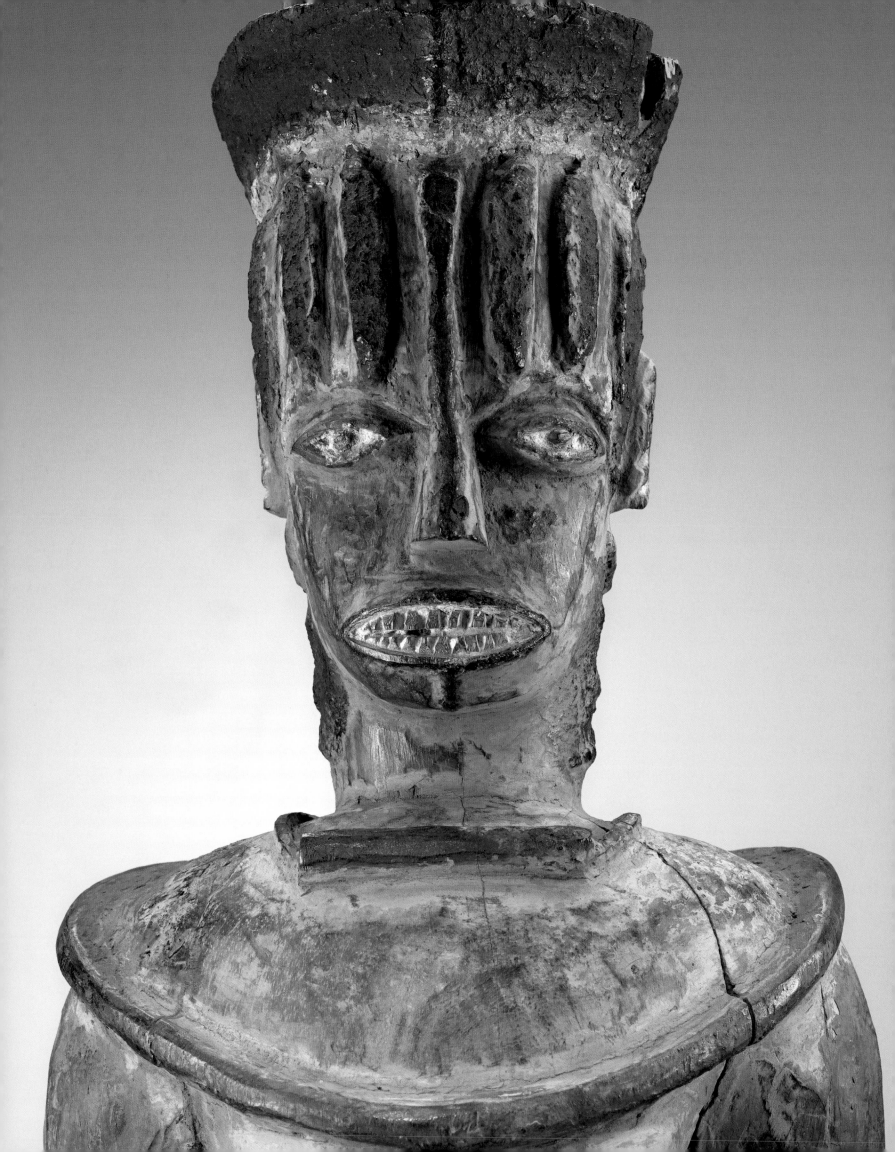

Female figure

Urhobo peoples, Agbarho or Agbon village groups, Nigeria

Late 19th century

Wood, pigment

*101.6 x 30.4 x 18.4 cm
(40 x 11 15/16 x 7 1/4 in.)*

Gift of Walt Disney World Co., a subsidiary of The Walt Disney Company, 2005-6-10

This figure, with her jewelry and conical coiffure, depicts a bride being publicly honored by her husband's household and village. It would have been displayed with others in a shrine to honor a forest or water spirit. In Urhobo ceremonies, a bride parades by herself through her village and, as depicted here, would be decorated with dyes made from a mixture of red camwood and palm oil.[1] Red represents life, and is a symbol of "fertility, mystery and danger."[2] The vertical marks on her forehead are scarifications that, in the past, adorned both men and women.

—AN

Notes

1. Foss, in Vogel 1981, p. 145.

2. Onobrakpeya, in Foss 2004, p. 95.

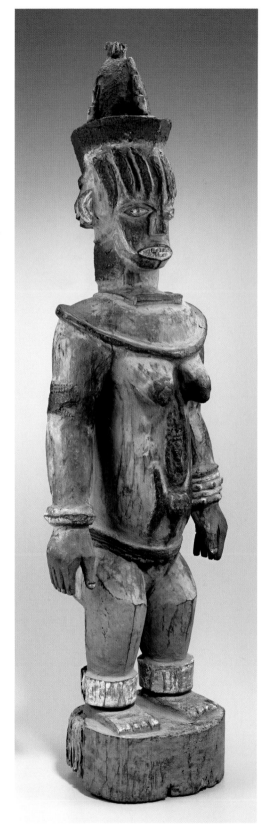

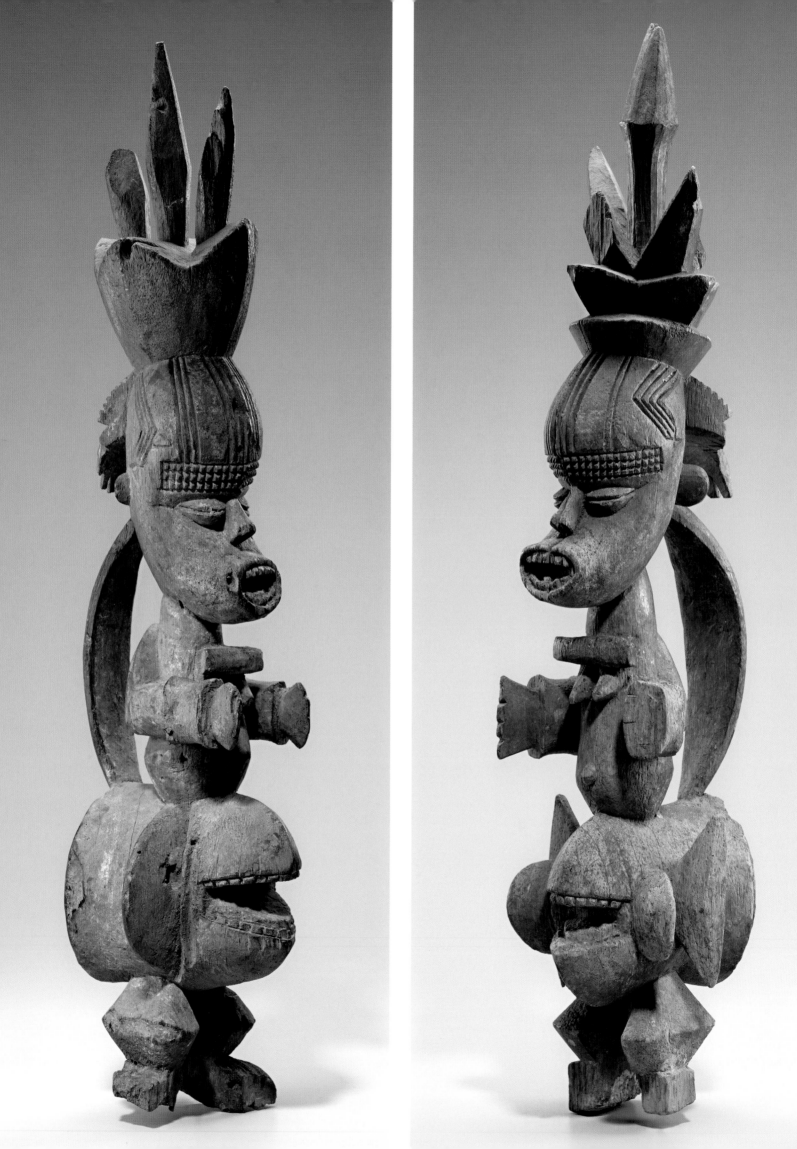

Figure

Southern Isoko peoples, Nigeria

Early to mid-20th century

Wood

70 x 14.5 x 17 cm
(27 9/16 x 5 11/16 x 6 11/16 in.)

Gift of Walt Disney World Co., a sub-
sidiary of The Walt Disney Company,
2005-6-82

Figure

Southern Isoko peoples, Nigeria

Early to mid-20th century

Wood

66 x 14.5 x 16.5 cm
(26 x 5 11/16 x 6 1/2 in.)

Gift of Walt Disney World Co., a sub-
sidiary of The Walt Disney Company,
2005-6-122

For the Isoko peoples, one type of personal shrine is the *ivri*. It is thought to refer to a protective deity as well as to both the idea of personal determination and to the composite sculptures that embody the idea. Carved *ivri* figures explicitly merge human and animal traits, with the human image astride and thus controlling an open-mouthed beast.

The teeth and horns on these two figures are sharp, bared, and exaggerated, in keeping with their role as protective, aggressive combatants for their owners. Contrasting rounded volumes define each figure's head and body as well as the animal's head below; one figure is missing a hand. The stylistic similarity of these two works suggests that they were carved by the same hand or workshop.

—AN

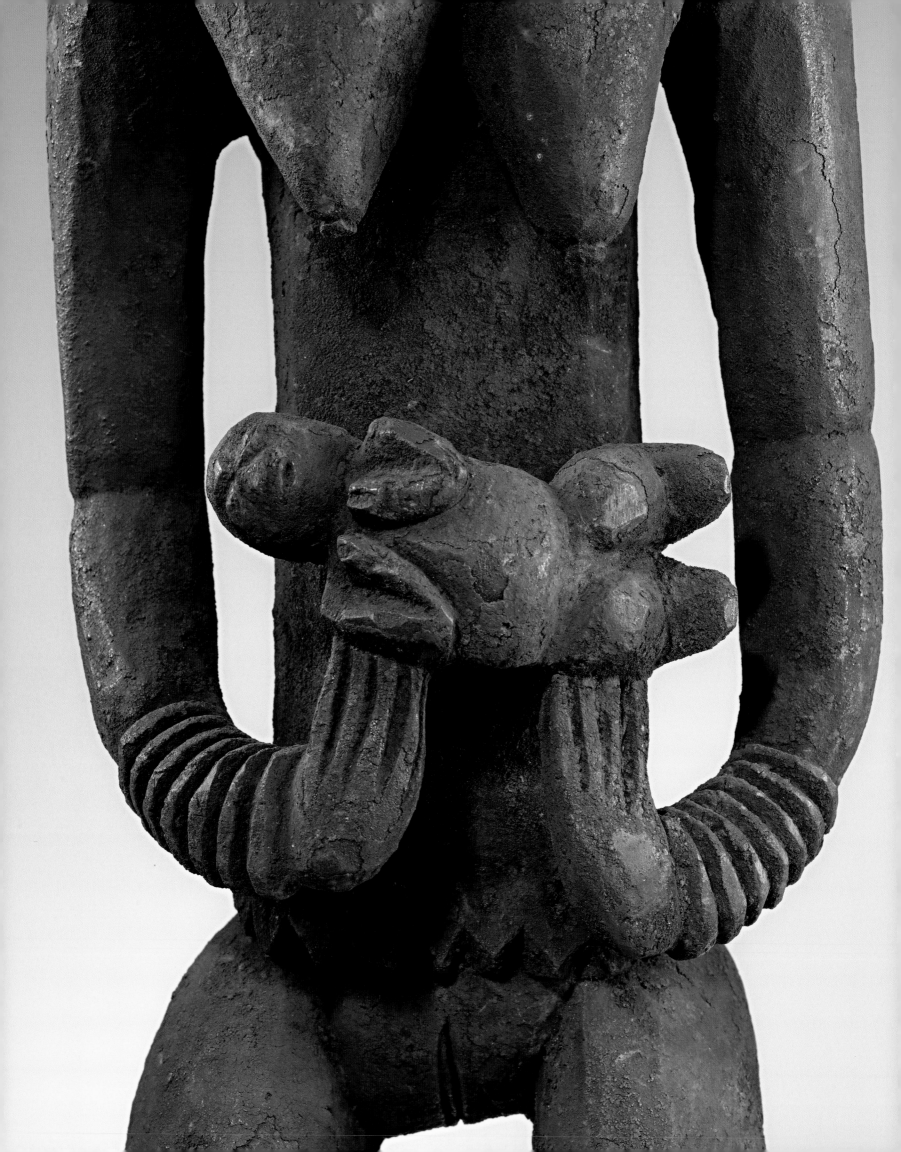

Female figure with child

Bangwa peoples, Cameroon

Late 19th to early 20th century

Wood, encrustation

88.9 x 26.7 x 16.5 cm
(35 x 10 1/2 x 6 1/2 in.)

Gift of Walt Disney World Co., a sub-sidiary of The Walt Disney Company, 2005-6-179

Typical of Bangwa portrait sculptures, this particular figure may represent a royal wife and a mother of twins. She is shown with carved representations of jewelry that are indicative of gender and status. These include a waistband—appropriate attire in the past for women throughout the region—and ivory bracelets and anklets, which are a sign of her status as a royal wife. Her pendulous breasts and the child she holds in her arms emphasize fertility and the nurturing role of women.

The carved bands of her necklaces may identify her as a mother of twins. However, these are usually described as made of cowrie shells—not clearly visible in this example—and therefore may simply be indicators of prestige or royal status. According to Robert Brain (who worked in the Bangwa region in the 1960s), even when a mother of twins is carved, it is not unusual for only one child to be represented.[1] Tamara Northern identified such sculptures as memorial figures, thereby suggesting that they served to commemorate royals and others of high status.[2]

—CMK

Notes

1. Brain, in Vogel 1981, p. 184.
2. Northern 1984, pp. 84-91.

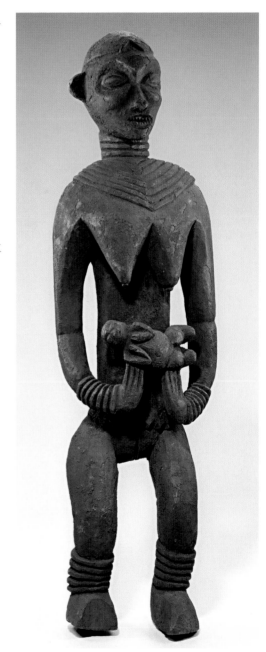

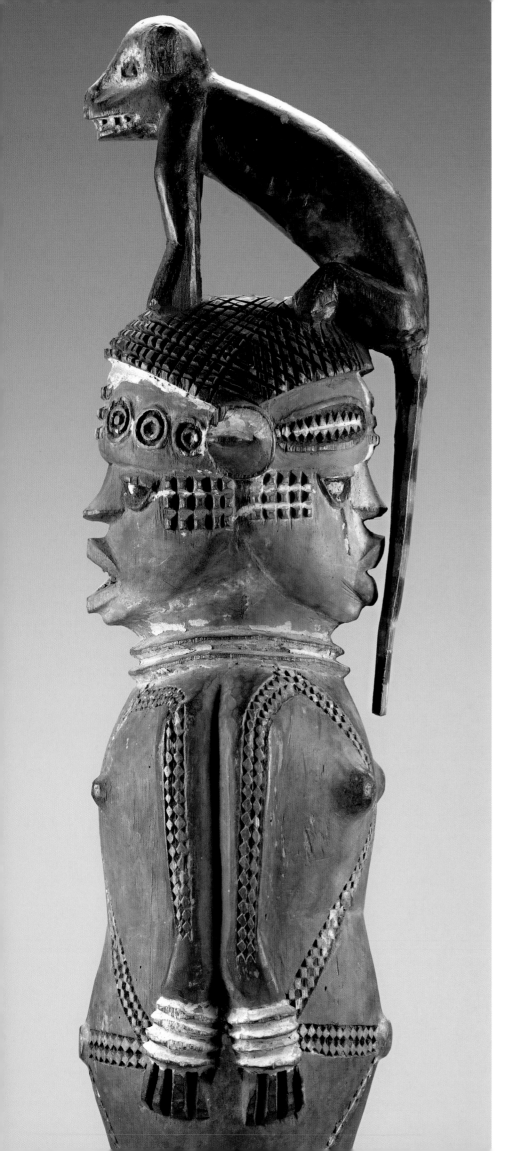
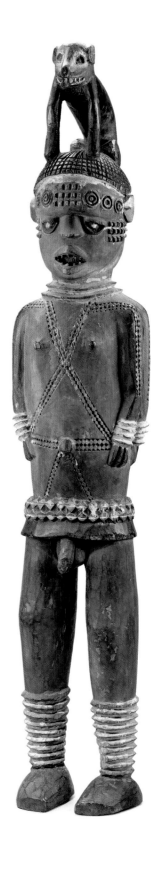

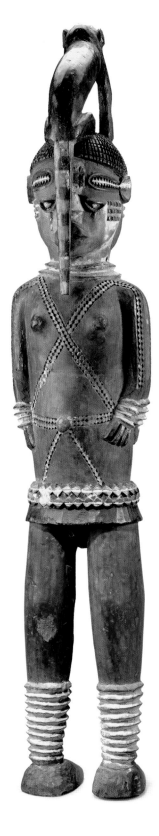

Double figure

Kuyu peoples, Republic of the Congo

Late 19th to early 20th century

Wood, pigment

81.9 x 15.2 x 15.2 cm
(32 1/4 x 6 x 6 in.)

Gift of Walt Disney World Co., a subsidiary of The Walt Disney Company,
2005-6-103

The carved panther atop the head of this double or Janus figure suggests its origin as western Kuyu, where the animal was claimed by local chiefs as a totemic spirit or mythic ancestor,[1] although a female panther cult existed among the eastern Kuyu.[2] Alfred Poupon, posted in the Congo during the early 20th century, described Kuyu initiation rites in which carved male and female figures would be carried and displayed, each fashioned with the coiffure, scarification patterns, and ornaments of an ideal Kuyu adult. That may well have been the context for this intricately carved Janus figure, but such figures are rare and were usually collected without much data. A male Kuyu figure illustrated in the 2006 Collection Verité auction catalogue[3] was described as ancestral.

Although the attribution of Kuyu is usually assigned to such figures, and to the more numerous carved heads, anthropologist Anne-Marie Bénézech proposes the term Mbochi, which encompasses several ethnic groups in the region.[4] In attempting to delineate the region's art styles, Bénézech focused especially on carved treatments of the coiffure or headdress, scarification patterns, and facial features.

—CMK

Notes

1. Poupon 1918: 312.

2. Bénézech 1988: 56.

3. Collection Verité 2006, no. 202, pp. 228–29.

4. Bénézech 1988: 52.

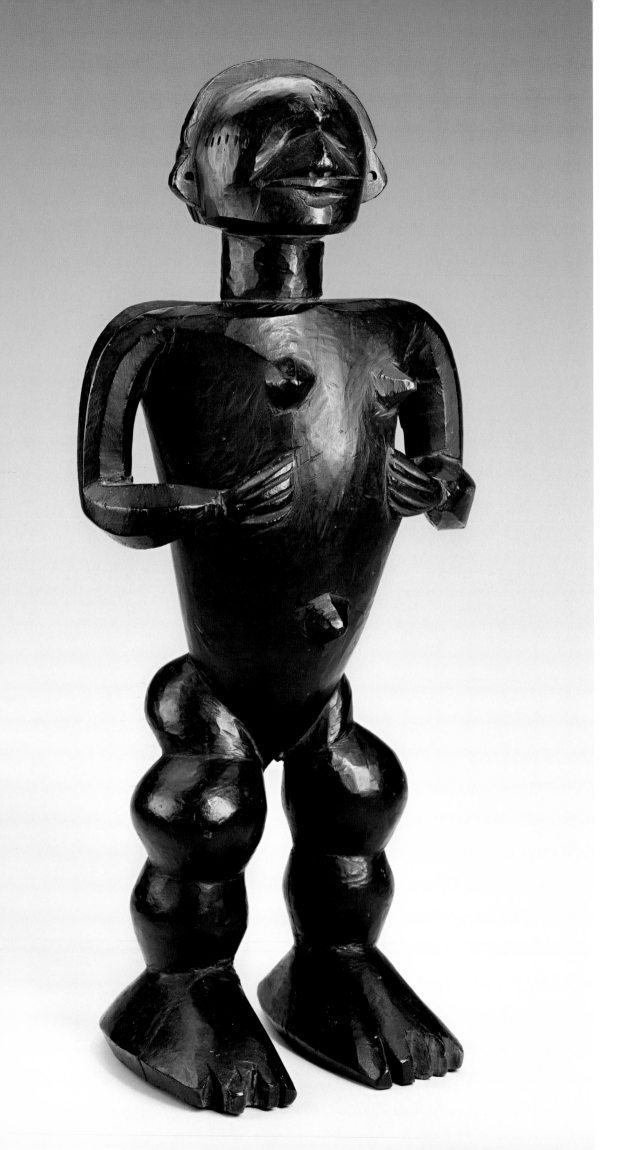

Female figure

Boa or Ngelima peoples, Democratic Republic of the Congo

Late 19th to early 20th century

Wood

44.1 x 19.1 x 14.9 cm
(17 3/8 x 7 1/2 x 5 7/8 in.)

Gift of Walt Disney World Co., a subsidiary of The Walt Disney Company, 2005-6-190

There is enormous visual appeal in this powerfully rendered carving of a standing female figure. Her coiffure, forehead markings, and pierced ears (which originally may have held ear ornaments) convey essential traits of womanhood. However, this particular execution of the human form suggests an unconventional interpretation of feminine beauty, due to a gifted artist's innovative approach. The bulbous volumes that define her legs and buttocks contrast with the swelling, smooth form of her torso and the angular planes of her shoulders and arms. The rounded contour of the head, abruptly flattened at the jaw line, and the downward-curving incisions for the eyes are echoed in the way the arms are rendered. The broad triangular shape of the nose is repeated in the treatment of the small, protruding breasts and navel. She stands firmly on two oversize feet.

The most extensive discussion of this figure remains the catalogue entry in Susan Vogel's *For Spirits and Kings* written by Herman Burssens, a specialist on the arts of the northern Congo region. According to Burssens, stylistic elements link the origin of this figure to both the Boa and the Ngelima, two groups located in the northern part of the Democratic Republic of the Congo. He hypothesized that such figures may have served "as grave sculptures, as is sometimes the case among some Boa groups . . . [or as] commemorative images made by and for outstanding individuals."[1] This figure's well-preserved condition, similar to four stylistically related works that Burssens has identified in other collections, suggests that it may have been kept in some sort of built structure or protected under a shelter.[2] Marc Leo Felix, who has a particular expertise in the art of the Congo, states that Boa figures are related to those of the Bira and Lese; but he also mentions the Boa's history of trade and interaction with the Mangbetu and Zande,[3] which may have been another influence on Boa arts.

—CMK

Notes

1. Burssens, in Vogel 1981, p. 236.

2. Ibid.

3. Felix 1987, p. 16.

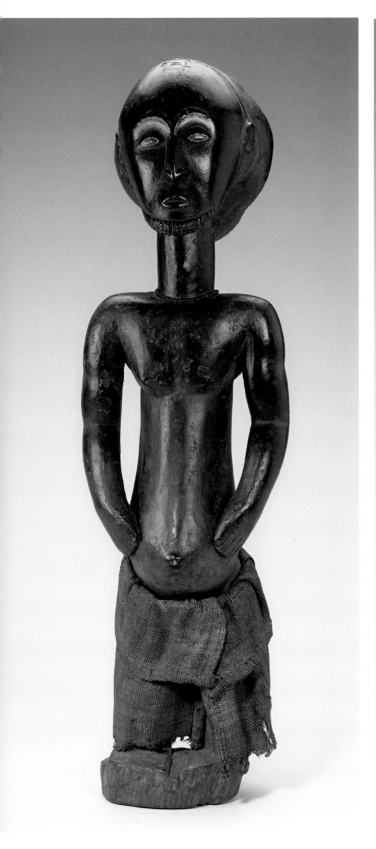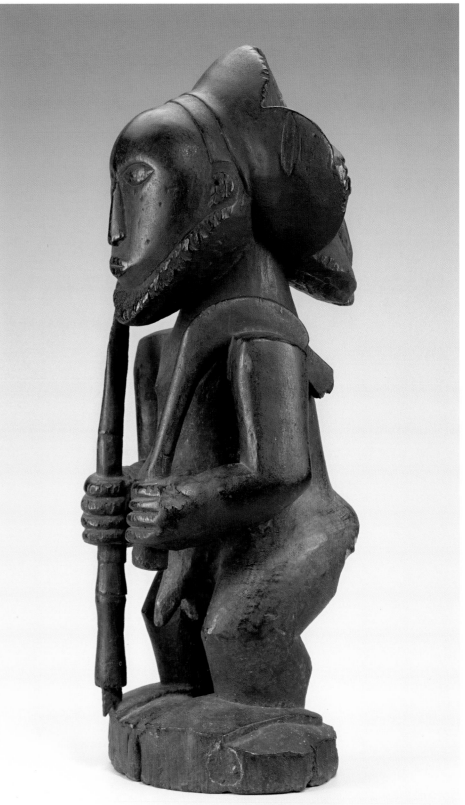

FAR LEFT

Male figure

Hemba peoples, Niembo chiefdom, Democratic Republic of the Congo

Late 19th to early 20th century

Wood, plant fiber, glass beads

*77.5 x 23.8 x 17.1 cm
(30 1/2 x 9 3/8 x 6 3/4 in.)*

*Gift of Walt Disney World Co., a sub-
sidiary of The Walt Disney Company,
2005-6-181*

LEFT & DETAIL

Male figure

*Hemba peoples, Kahela chiefdom,
Kasenda Ndega village, Democratic
Republic of the Congo*

Late 19th to early 20th century

Wood

*49.2 x 19.8 x 20.1 cm
(19 3/8 x 7 13/16 x 7 15/16 in.)*

*Gift of Walt Disney World Co., a sub-
sidiary of The Walt Disney Company,
2005-6-182*

The ancestors—those who have gone before us—remain relevant in the lives of many Africans today. As with people the world over, Africans call on their ancestors to intercede on their behalf, to bring solace in times of trouble, to provide strength and clarity in the face of life's challenges, to celebrate good fortune, and to ensure continued well-being. Africa's traditional arts have long provided mechanisms for the materialization of ancestors and their powers, including the creation of figure sculptures.

Among the Hemba peoples of the Democratic Republic of the Congo, carved wooden figures represented male ancestors who were venerated and linked to ownership of the land and to ideas about clan and lineage authority.[1] Consistent with figure sculpture in much of Africa, the form of Hemba ancestral figures conveyed notions of ideal physical and moral qualities. In both carvings shown here, the powerfully rendered male figure displays well-balanced forms, refined and serene facial features, and markers of gender, status, and achievement. Each is embellished with an elaborate cruciform coiffure (somewhat lobed on the warrior figure), a carefully rendered beard, and clearly defined genitalia. The warrior figure carries emblems of his status—a lance and an adze—and wears "a narrow bracelet of authority" on his right wrist.[2] François Neyt attributed the taller figure to "the styles of the southern Niembo in the Mbulula region," while the warrior figure's less refined rendering and stocky physique suggest an eastern Hemba style and has been identified as from Kasenda Ndega village, Kahela chiefdom.[3] He noted that both figures "recall to the collective memory the political and military roles filled in the past by these illustrious personages."[4] While the figures are said to portray particular ancestors, they are conceived with generalized traits rather than individual, distinguishing characteristics.

—CMK

Notes

1. Neyt, in Vogel 1981, p. 217.

2. Ibid., p. 218.

3. Neyt, in Vogel 1981, pp. 217-18, based on Neyt and de Strycker 1975 and Neyt 1977.

4. Neyt, in Vogel 1981, p. 218.

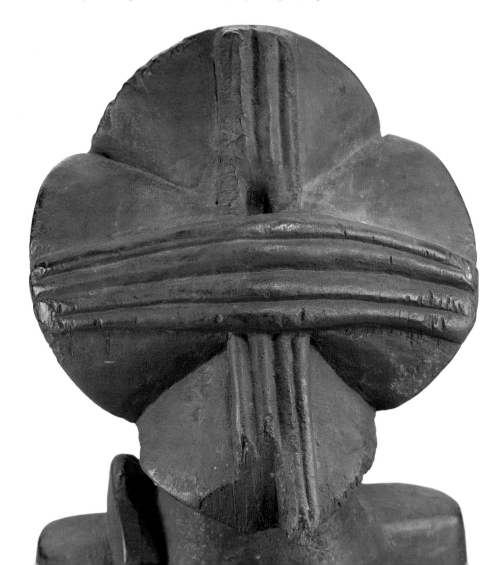

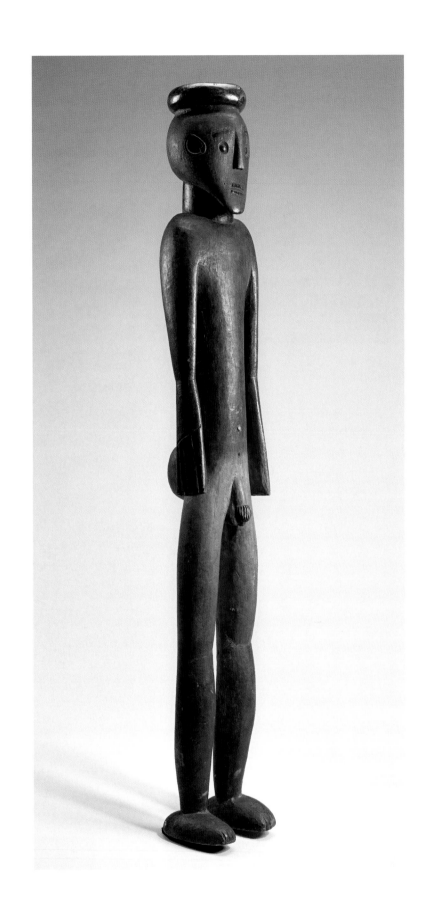

Male figure

Tsonga peoples, South Africa

Late 19th century

Wood

98 x 16 x 12 cm
(38 9/16 x 6 5/16 x 4 3/4 in.)

Gift of Walt Disney World Co., a subsidiary of The Walt Disney Company, 2005-6-120

The function of this standing male figure is uncertain. However, it embodies traditional markers of gender (prominent genitalia, further emphasized by a carved penis sheath) and status (the headring) that, during the 19th century and early 20th century, defined ideal adult male qualities among Nguni-speaking peoples. The headring was worn by the Zulu as well as many of the northern Nguni groups to signal age, rank, and one's readiness for marriage.

The figure conforms stylistically to late-19th-century carvings attributed by Anitra Nettleton to the Tsonga.[1] The figures, usually made as male-female pairs, are characterized by "slim proportions with elongated torsos, small heads, rather sharp jaw lines, spatulate hands and unarticulated feet."[2] In discussing a pair of Tsonga figures in the Standard Bank Foundation Collection (University of the Witwatersrand, South Africa), Rayda Becker and Nettleton noted that such carvings may have been used as didactic tools in male initiation ceremonies, "and may also have been set up in or near the houses of chiefs, as emblems of rank, especially when young men were given their headrings."[3] Related 19th-century examples are in several museum collections, including those in Tervuren, London, Paris, Leiden, Vienna, Berlin, and Frankfurt.[4] Figure carvings were also produced for sale to Europeans during the 19th century, and their forms were "remarkably similar to the didactic figures Tsonga-speaking carvers made for use in male initiation ceremonies."[5] Anthropologist Mark Auslander observed more recent use of figure sculptures among the Tsonga in the mid-1980s. He noted that these carvings were employed in ritual contexts to communicate with spirits and were usually clothed[6]—which is suggested here by this figure's lack of surface patina around the hips and thighs, and confirmed by published examples from Tervuren and London that retained their cloth attire.

Although an attribution of Tsonga is proposed for this figure, it is important to recognize that the mobility of populations in the region during the 19th century influenced artistic production and resulted in shared forms and styles among the area's art-producing groups.

—CMK

Notes

1. Nettleton 1988.

2. Becker and Nettleton 1989, p. 12; see also Nettleton 1988.

3. Becker and Nettleton 1989, p. 13.

4. Nettleton 1988, p. 86, n. 3; Becker and Nettleton 1989, p. 13.

5. Klopper 2002, p. 45.

6. Auslander, in conversation with the author, May 2006.

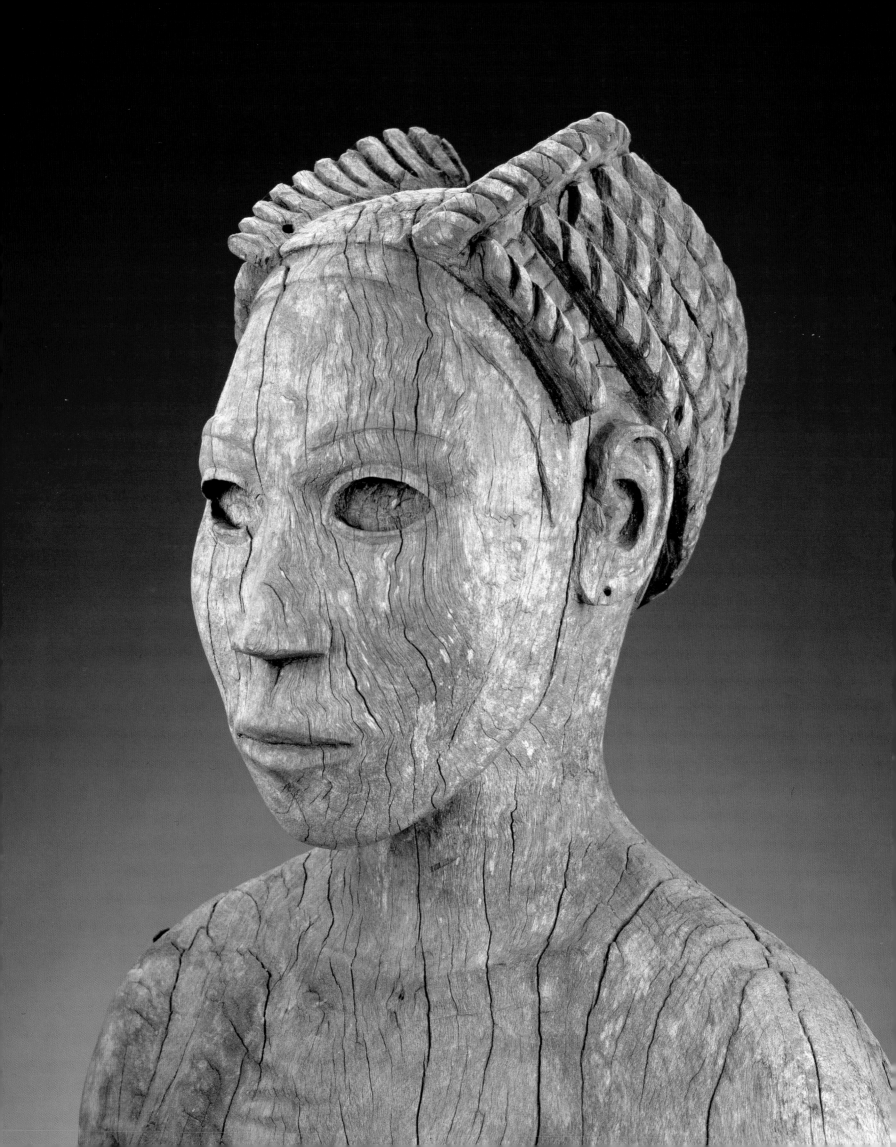

DETAIL

Funerary sculpture

Sakalava or Bara peoples, Madagascar

Early to mid-20th century

Wood, pigment, metal

*180 x 24.5 x 27.5 cm
(70 7/8 x 9 5/8 x 10 13/16 in.)*

*Gift of Walt Disney World Co., a sub-
sidiary of The Walt Disney Company,
2005-6-4*

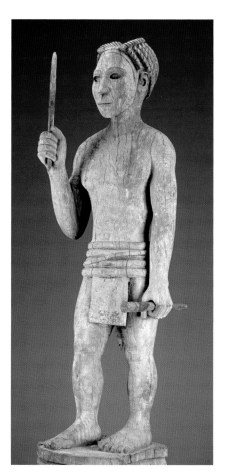

Funerary practices in Africa offer mechanisms for
addressing loss, celebrating accomplishments, and
reinforcing the fabric of social life. They are also
occasions for the creation, display, and use of art. In
Madagascar, an island in the Indian Ocean off the
coast of east Africa, hand-woven textiles are the pri-
mary art form for funerary rites, in which they are
employed to honor the deceased and to strengthen
family and community bonds.[1] In addition, in the
southwestern and southern regions of Madagascar,
prominent individuals were and continue to be
commemorated by wooden funerary sculptures,
some erected singly or in groups over tombs located
out in the countryside, others set up elsewhere as
memorials.[2]

The remarkable naturalism of the male figure
depicted in this funerary sculpture is unique, and
does not conform closely to any documented style.
Rendered as a powerful warrior with a muscular
body, striding stance, strong hands each clenching a
spear, and a piercing gaze, the figure radiates author-
ity and prominence. Status is indicated by his tufted
coiffure and by his loincloth, a traditional form of
male attire in Madagascar that is wrapped in such a
way as to display the decorated ends,[3] suggested here
in the traces of red pigment faintly visible on the
surface.

Earlier attributions suggested Bara or Tanosy
origins for this memorial sculpture.[4] However, there
are few Tanosy posts carved to this high standard,
and it now seems more likely that it originated from
the Bara or Sakalava regions.[5] It may have been a
memorial post rather than a sculpture decorating a
tomb,[6] but the lack of collection documentation

means that both its function and its ethnic attribu-
tion remain speculative.

In writing about this sculpture in 1981, Susan
Vogel noted that the practice of carving "large indi-
vidualized portraits of the deceased" was attributed
to the influence of Betsileo carvers who moved into
southern Madagascar about 1918.[7] Urbain-Faublée's
discussion of Bara funerary sculptures indicated that
their styles tended to correspond to the influences
of other groups—the Tanosy, Betsileo, Sakalava, and
Mahafaly—who moved into or passed through the
Bara region.[8] More stylized treatments of the human
form characterize funerary posts from the Vezo and
Sakalava areas of western Madagascar and from the
Mahafaly region in the south. Mahafaly grave posts
may also include depictions of zebu, cattle, and
birds, as well as an increasing array of newer motifs
(airplanes, buses, and the like) that evoke modernity
and reinforce the enduring relevance of certain
funerary practices.[9]

—CMK

Notes

1. Kreamer and Fee 2002.

2. Mack, in Phillips 1995, pp. 148–50.

3. Fee, in Kreamer and Fee 2002, p. 38.

4. Vogel, in Vogel 1981, p. 243.

5. John Mack, e-mail to the author, June 30, 2006.

6. Rick Huntington, e-mail to the author, June 30, 2006.

7. Vogel, in Vogel 1981, p. 243, citing Urbain-Faublée 1963,
 p. 116, fig. 94.

8. Urbain-Faublée 1963, p. 52.

9. Mack, in Phillips 1995, p. 148.

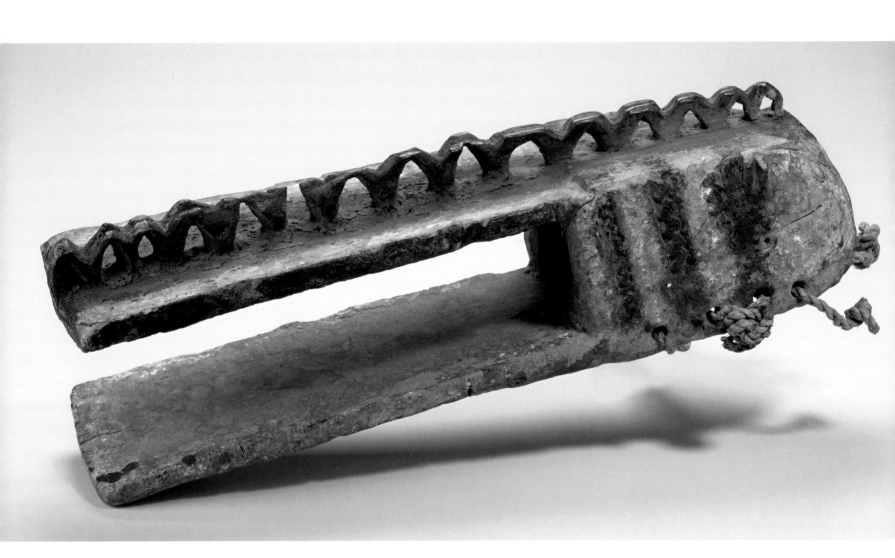

43

Mask

Dogon peoples, Mali

Early 20th century

Wood, pigment, plant fiber

*11.4 x 12.7 x 39.4 cm
(4 1/2 x 5 x 15 1/2 in.)*

*Gift of Walt Disney World Co., a subsidiary of The Walt Disney Company,
2005-6-239*

As part of a complex years-long ritual cycle, masks were part of the Dogon peoples' initiation rites and played an important role in funeral ceremonies. Since the 1930s, masks have also been performed for visitors to Dogon villages, and at expositions and other events.

Dogon crocodile masks vary from village to village, appearing most often as large horizontal masks. This mask is painted, as is typical, but it also has carved details and is smaller than most published examples. The decorative zigzag pattern suggests flowing water, which is in part a reference to the natural habitat of the crocodile; it is also a spiritual reference to the *nommo,* the fluid mythic beings born of sky and earth and involved in the creation of mankind and culture, specifically to speech and weaving.[1] The pattern is also the symbol of Lébé,

the first human and the first priest, who was transformed into a serpent after his death.

In Dogon culture, the crocodile is often described in positive terms as a servant of the *nommo* and a protector of scarce pools of water. However, some village myths include an element of danger. For example, one myth portrays the crocodile as a siren luring people into danger;[2] another one tells of men who killed a crocodile that was eating fiber being dyed for cloth, then made a crocodile mask to appease the animal's spirit.[3]

—BF

Notes

1. Laude 1973, p. 60.

2. DeMott 1982, p. 109.

3. Griaule 1938, p. 509.

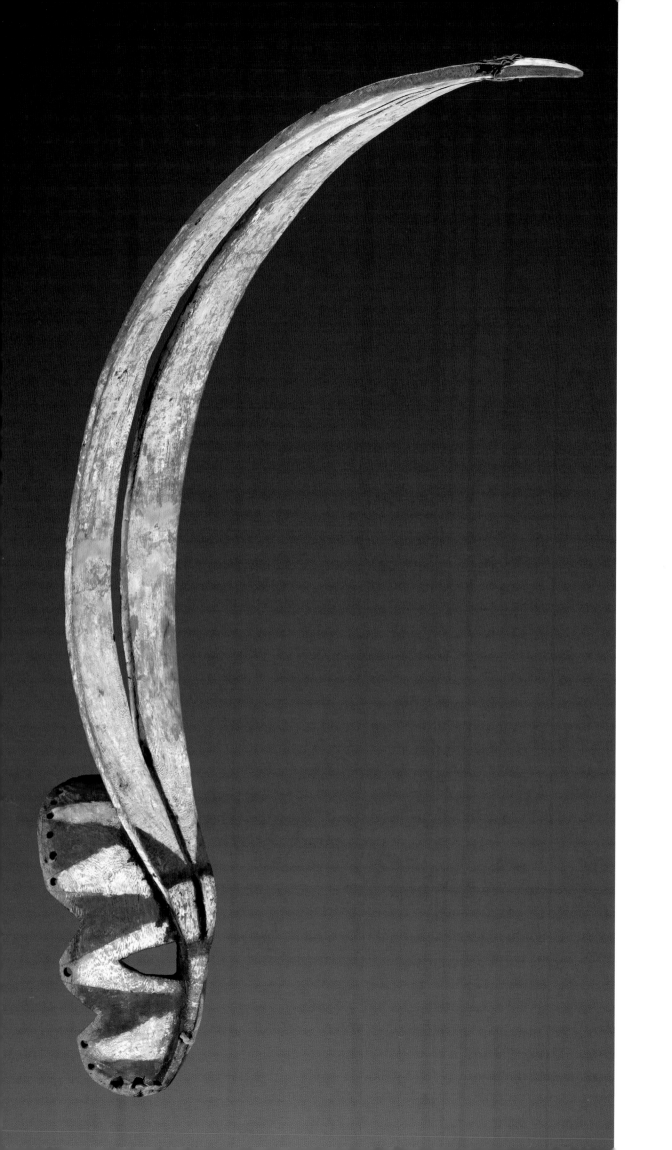

Mask

Northern Mossi peoples, Burkina Faso

Mid-20th century

Wood, paint, leather

*92.7 x 19.1 x 66 cm
(36 1/2 x 7 1/2 x 26 in.)*

Gift of Walt Disney World Co., a subsidiary of The Walt Disney Company, 2005-6-157

The distinctive convex face, together with broad, gracefully curving planks joined at the top and bottom, and a lack of incised patterns are characteristics that identify this mask as Risiam, a style common to the northern Mossi region of Burkina Faso.[1] According to art historian Christopher Roy, Risiam is "a transitional style combining the strong vertical ridge and plank from Yatenga in the west with the convex face from Kaya in the east. It reflects the intermixture of Dogon and Kurumba populations in the area as the Kurumba moved westward, displacing the original Dogon inhabitants in the area."[2] As in numerous plank masks in much of Burkina Faso, the back of this mask is painted with red, black, and white geometric designs that complement the triangular color bands on the face.

Masks of this type, called *karanga* (pl. *karansé*), are found in a number of Mossi areas. They are associated with the antelope, one of several totemic animals featured in the myths of Mossi families and clans. Although Annemarie Schweeger-Hefel suggested a connection between the shape of the horns of this mask and that of a weaving sword,[3] Roy later noted that this is unlikely, since only narrow-strip weaving—done without such an implement—is practiced by Kurumba men in this region.[4]

In the northern Mossi region, masks are used in burials, memorial celebrations, and protective ceremonies; some also perform for entertainment. *Karansé* masks are usually owned by individual Nyonyosé lineage groups, descendants of the indigenous farmer groups who were conquered around 1500 by Dagomba horsemen from the south. The latter became the ruling elite, whose descendants are called Nakomsé, but the groups intermarried and integrated into the ethnic group now called Mossi.[5]

—CMK

Notes

1. Roy 1987, p. 131.

2. Roy 2005: www.uiowa.edu/~africart.

3. Schweeger-Hefel, in Vogel 1981, p. 34.

4. Roy 1987, p. 131.

5. Roy 2005: www.uiowa.edu/~africart.

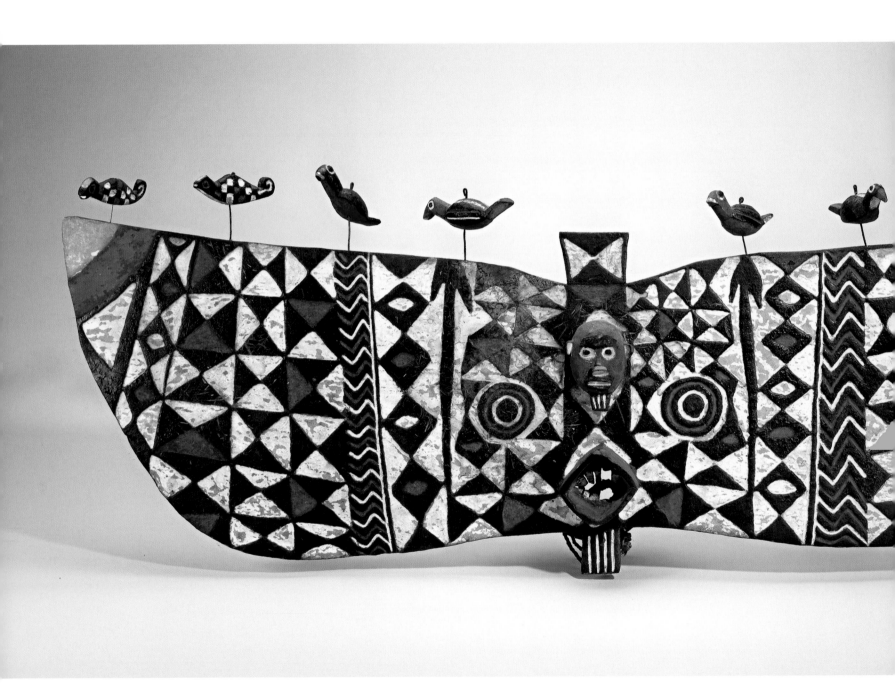

45

Mask

Nuna peoples, Burkina Faso

Mid-20th century

Wood, pigment, metal

60.5 x 173 x 17 cm
(23 13/16 x 68 1/8 x 6 11/16 in.)

Gift of Walt Disney World Co., a sub-
sidiary of The Walt Disney Company,
2005-6-47

Masking traditions in Burkina Faso provide visually spectacular and entertaining occasions for spirits to influence the world of humans. The masks perform protective functions in contexts that include annual renewal ceremonies, burials and memorial celebrations, boys' initiation training, and public entertainment. The names of the masks and their geometric patterns have specific meanings and convey moral lessons that are taught to boys during their initiation training.[1]

This large plank mask's Nuna origins are confirmed by its broad, richly patterned wings—the wings of a butterfly, one of a cast of characters that perform in Nuna masquerades.[2] Since butterflies are harbingers of rain, they are connected with the start of the farming season.[3] The mask, as a representation of a bush spirit, has extraordinary visual elements that suggest its supernatural powers. Its central portion, bordered by arrow designs, is dominated by a large projecting diamond-shaped mouth, a human head carved in high relief, and prominent concentric circles that suggest the arresting gaze of this composite creature. The wings are enlivened by a complex array of geometric patterns—diamonds, triangles, and zigzags. Another Nuna characteristic are the small birds and chameleons that project from the upper edge of the wings (four on each wing, attached by metal pins), adding visual interest.[4]

Masks in this region are typically ornamented with red, black, and white pigments and repainted yearly. The back of this mask is completely covered with a painted black-and-white checkerboard pattern, edged in red. The mask would have been worn with a bulky fiber costume called "*wankuro,* the fur of the mask."[5]

—CMK

Notes

1. Roy 1987, p. 230.

2. Christopher Roy, e-mail to the author, June 20, 2006.

3. Ibid.

4. Ibid.

5. Roy 1987, p. 40.

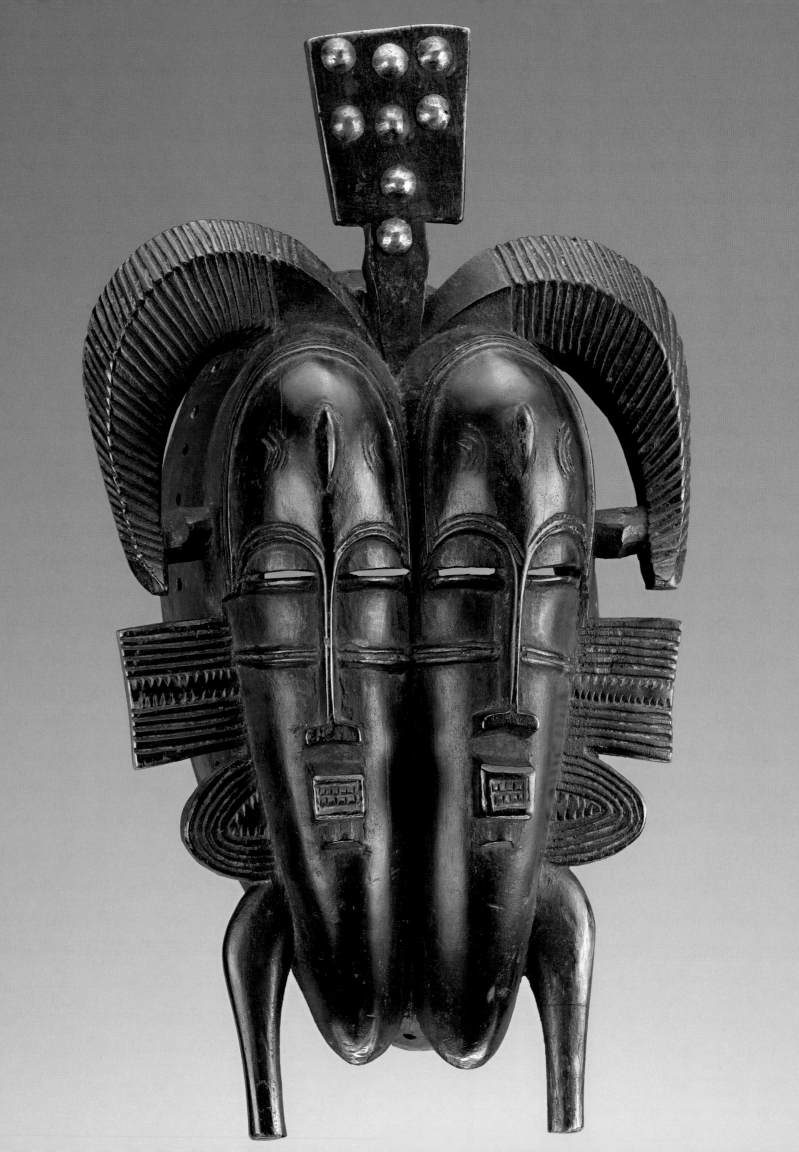

46

Mask

Senufo peoples, Côte d'Ivoire

Late 19th to mid-20th century

Wood, brass tacks

*28.3 x 16.3 x 8.8 cm
(11 1/8 x 6 7/16 x 3 7/16 in.)*

*Gift of Walt Disney World Co., a subsidiary of The Walt Disney Company,
2005-6-49*

The Senufo use the double mask interchangeably with the single mask (see cat. no. 23), although the double mask is rarer. Both are considered feminine in appearance and style of dance performance. Certain details of the double mask shown here contain symbolic references to females: some of the projections suggest women's hairstyles or pendants; and the forehead marks can be interpreted as referring to female genitalia. Elements such as the ram's horns suggest sacrifice. The form projecting from the top of the mask is atypical; more common projections are a hornbill bird, a cluster of pointed bombax tree thorns on a rectangular tablet, or a palm spike. The specific form was requested for this mask because it appeared in a vision sent by a particular type of nature spirit; this element is especially distinctive for its decorative pattern of rounded brass tacks.[1]

Masks of this type are used in Poro society initiations, funerals, and, more recently, public dances.

—BF

Notes

1. Richter, in Vogel 1981, p. 38.

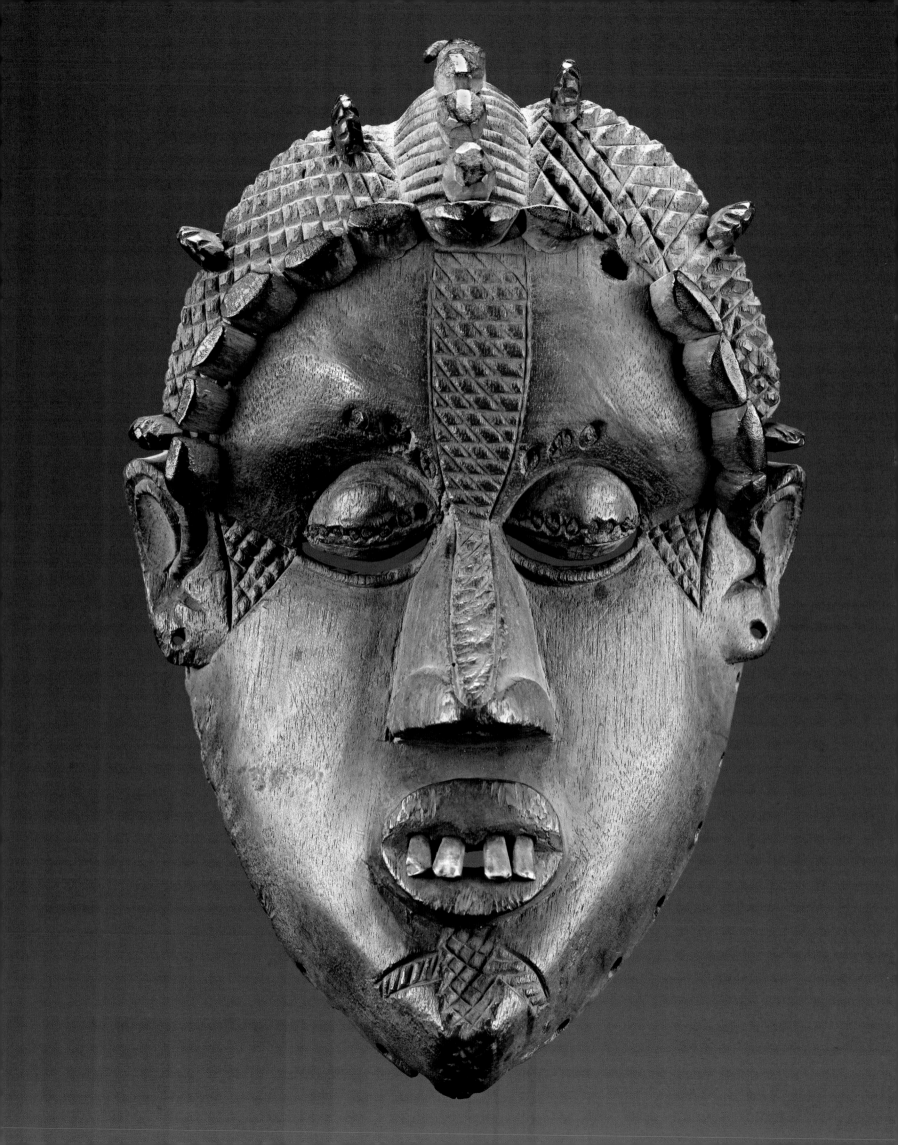

47

Mask

Bassa peoples, Liberia

Late 19th to early 20th century

Wood, bone, iron

21.3 x 14.6 x 7.8 cm
(8 3/8 x 5 3/4 x 3 1/16 in.)

Gift of Walt Disney World Co., a sub-sidiary of The Walt Disney Company, 2005-6-54

This wooden mask is the senior entertainment mask of the men's No association, used in dance performances by Bassa men. However, through the performer's graceful, smooth dance style, it emphasizes desirable traits for women to emulate. Smaller than life-size, it was not worn in front of the dancer's face but was attached to an open-weave basketlike construction concealed beneath part of a larger costume that fully covered the dancer's head. Although the eyes and mouth are pierced with narrow openings, the wearer looked out under the mask through openings in the costume.

Despite certain similarities to the better-known slit-eyed face masks made and used by the Dan peoples of the region, a Bassa mask is distinguished from them by its strongly concave profile and somewhat more frequent additions to the carved portion of the mask. Examples of the latter here are the pegs projecting from the hairstyle, the realistic-looking teeth (here made of bone, but also commonly metal, cane, or actual animal teeth), and insertions of actual hair—only traces of which remain—in the brows and eyelids.

The surface of this mask is that of the natural aged wood, unlike most other examples, which have a stained black surface. The kaolin that probably once highlighted the tattoo patterns on the face has vanished.[1]

—BF

Notes

1. Siegmann, in Vogel 1981, p. 61.

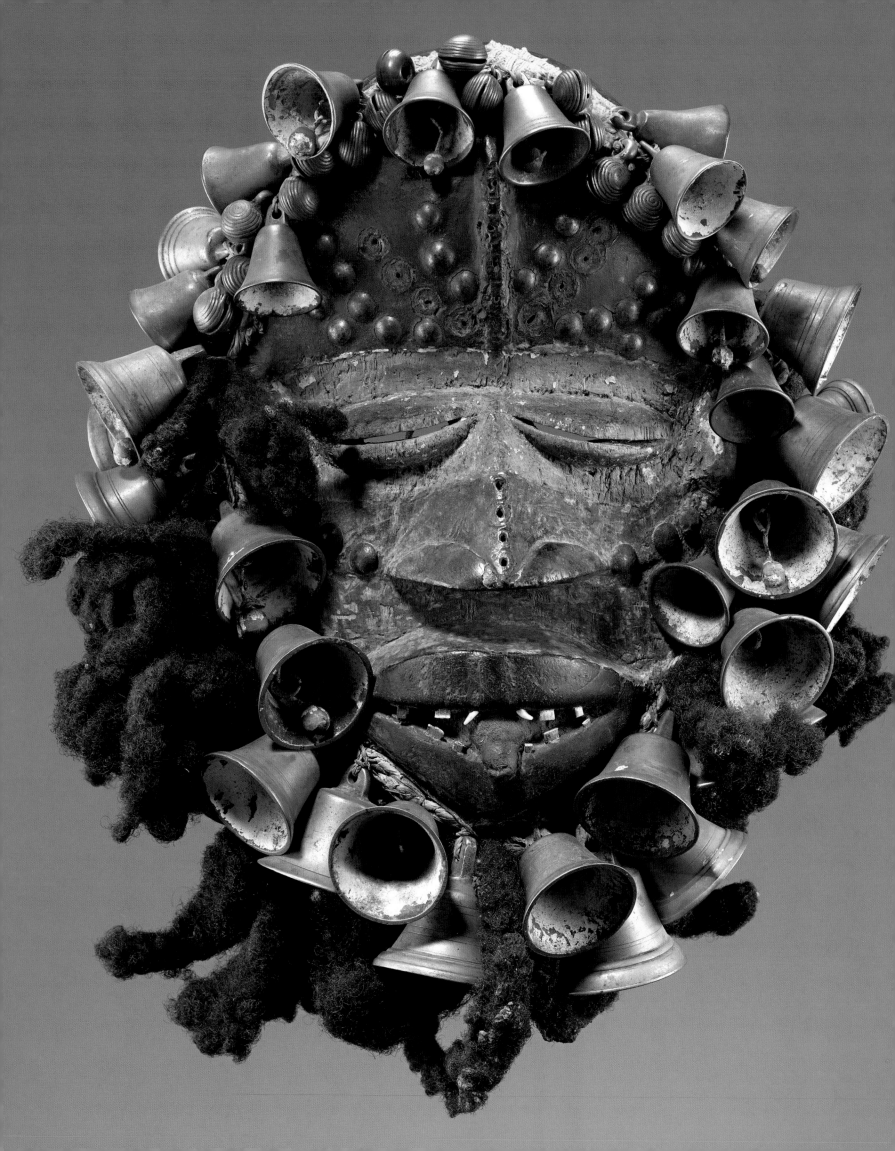

Mask

Wee peoples, Côte d'Ivoire

Late 19th to mid-20th century

Wood, pigment, brass tacks, bells, metal, cloth, hair, teeth

*38 x 28 x 12 cm
(14 15/16 x 11 x 4 3/4 in.)*

Gift of Walt Disney World Co., a subsidiary of The Walt Disney Company, 2005-6-57

This mask displays an overwhelming abundance of materials—wood, pigment, brass tacks, metal, cloth, hair, and two types of bells in great profusion. When it is worn with the masquerade costume, the effect it makes is even more striking. To the communities that make and use such masks, its character is identified by the headdress, the body covering, the dance pattern during performance, and the accompanying percussion instruments and attendants. The name of the mask, which describes its character rather than its appearance, may be announced to the village to herald the masquerader's appearance. However, the function of a mask and its physical appearance—accessories, colors—may change over time as the mask and its owner accrue prestige and spiritual power. The masquerader may be called upon to use this power to settle disputes, and must demonstrate his wit through knowledge of proverbs and attention to detail.[1]

The relatively contained, life-size face, the slightly parted lips, and the slit eyes fit the local categorization of a female mask, the performance style of which would be non-threatening whether it was a beggar (a mask without an attendant who must ask directly for money and gifts, and dances in a comic manner), singer, or praise attendant. Tacks rather heavily mark the lines on cheeks and forehead, suggesting old styles of scarification or the face paint still worn by women for ceremonial occasions.[2]

—BF

Notes

1. Adams 1988: 97.

2. Himmelheber 1997, p. 20.

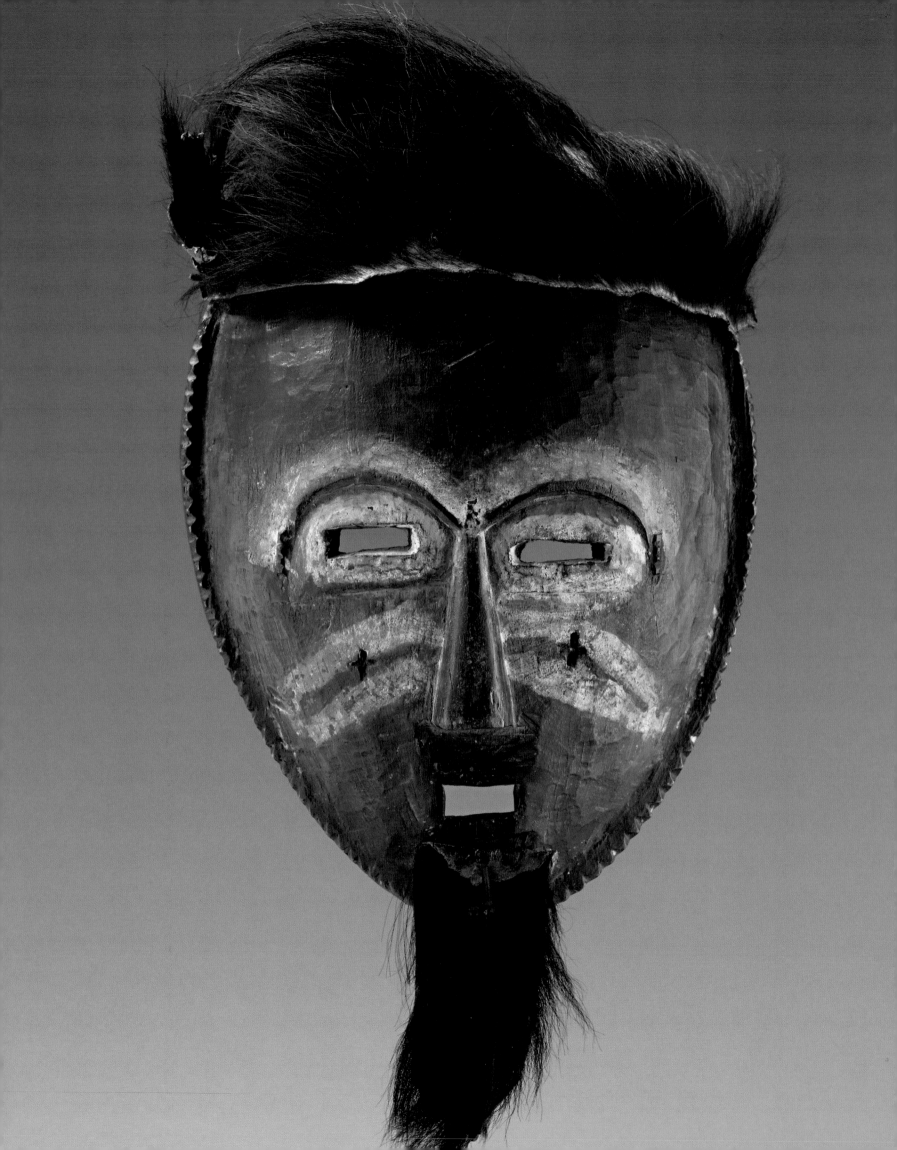

49

Mask

Attie (or Akye) peoples, Côte d'Ivoire

Late 19th to early 20th century

Wood, fur, pigment

35.6 x 20.3 x 12.1 cm
(14 x 8 x 4 3/4 in.)

Gift of Walt Disney World Co., a subsidiary of The Walt Disney Company, 2005-6-63

The Attie (or Akye) are one of a group of 12 southern Ivoirian peoples described collectively as the Lagoon peoples. Masks among the Attie are rare. This particular type is characterized by painted and relief designs, scarification marks on the cheeks, and fur for the hair and beard. Traditionally, Attie masquerades were danced in Do performances, which served not for entertainment but as "an ultimate defense against disasters such as smallpox epidemics. . . or armed aggression."[1] In the absence of such threats, Do masquerades have not been performed for decades.[2]

Similar in context to the Dye/Je masquerades of the Guro, Do performances excluded women and children who might be harmed by the power of the masks. The masquerade ensemble included human, animal, and composite beings—all representing spirit forces of the wilderness—conceptualized through helmet, horizontal, or face masks and raffia-fiber costumes. In the early 1980s, art historian Monica Blackmun Visonà collected verbal descriptions of past Do performances, identifying a disciplinarian yet somewhat amusing masquerade character called Aken. Aken was portrayed by "a small, oval face mask . . . [with] a small rectangular mouth and eyes, and a slender nose," some of which had hair and beards of animal fur.[2] While this description seems to apply to the mask shown here, Visonà cautions that the "identification as Aken may be incorrect" and notes that another context for Attie masks is as entertainment in men's age-grade ceremonies,[3] the rites held by various associations for any group of new members of a similar age and grade.

—CMK

Notes

1. Visonà 1983, pp. 127-28.

2. Ibid., pp. 132-33.

3. Ibid., p. 134.

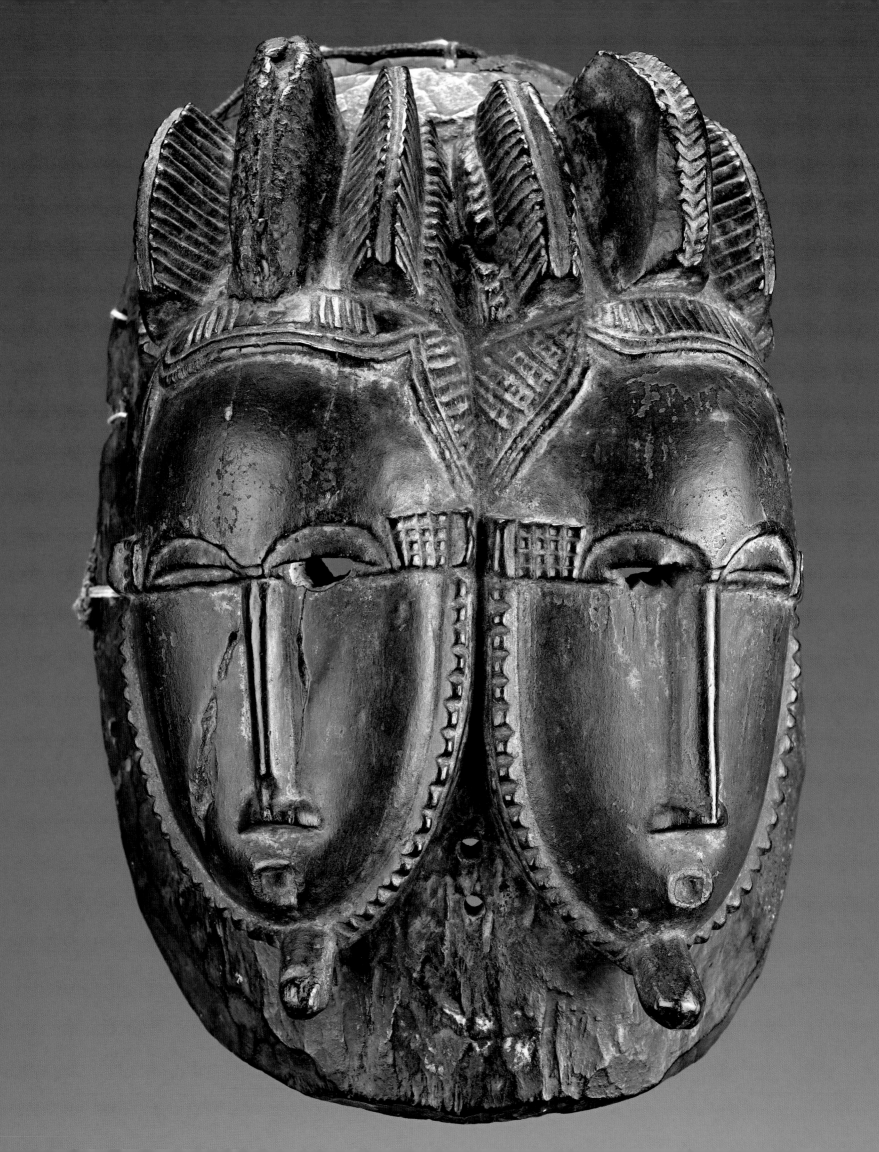

Mask

Baule peoples, Côte d'Ivoire

Late 19th to early 20th century

Wood, cloth, string

24 x 16 x 11.2 cm
(9 7/16 x 6 5/16 x 4 7/16 in.)

Gift of Walt Disney World Co., a subsidiary of The Walt Disney Company, 2005-6-61

Baule masquerades are public entertainments with a succession of masks depicting a variety of individuals and types, including beautiful women (as in this example), heroic men, well-known personages, and domestic animals.[1] Among the Baule, as with most African groups, entertainment is structured to have social value and meaningful content. At a minimum, it encourages the ability to work together, as any masquerade requires logistic preparation and direction of the actual performers. The masks promote Baule concepts of ideal beauty and values. The human faces on this double mask seem serene, quiet but with the potential to respond, and with features that are symmetrical and carefully delineated, as are the coiffures. The scarifications, those blocks of raised marks at the outer edges of the eyes, are considered beautiful by the Baule. They identify the wearer's cultural heritage, yet also suggest individual tactile sensation. The faces appear to be those of a person in the prime of life, but not yet an elder.

Such a double mask, which portrays twins, is less common than the single face mask. Most often, the two faces on one mask are differentiated, showing fraternal rather than identical twins, although all twins are believed to be good luck and to share a soul. When a masquerade is performed, the double mask can appear either midway through the sequence of stock human characters or toward the end with the portrait masks. If the latter, the actual twins (or the surviving single twin) would accompany the mask.[2]

The faces on this mask are smaller than life-size, and the projections from the chin appear to be neither beards nor functional hand grips, unlike on other known masks. The piercing of a single eye on each face, rather than both eyes, is somewhat atypical; other double masks have slits in all four eyes, or a single viewing hole between the faces. The relative roughness of this opening suggests that it was altered after the fact, perhaps because the dancer could not see through the original holes.

—BF

Notes

1. Vogel, in Vogel 1981, p. 75.
2. Ibid., pp. 75, 77.

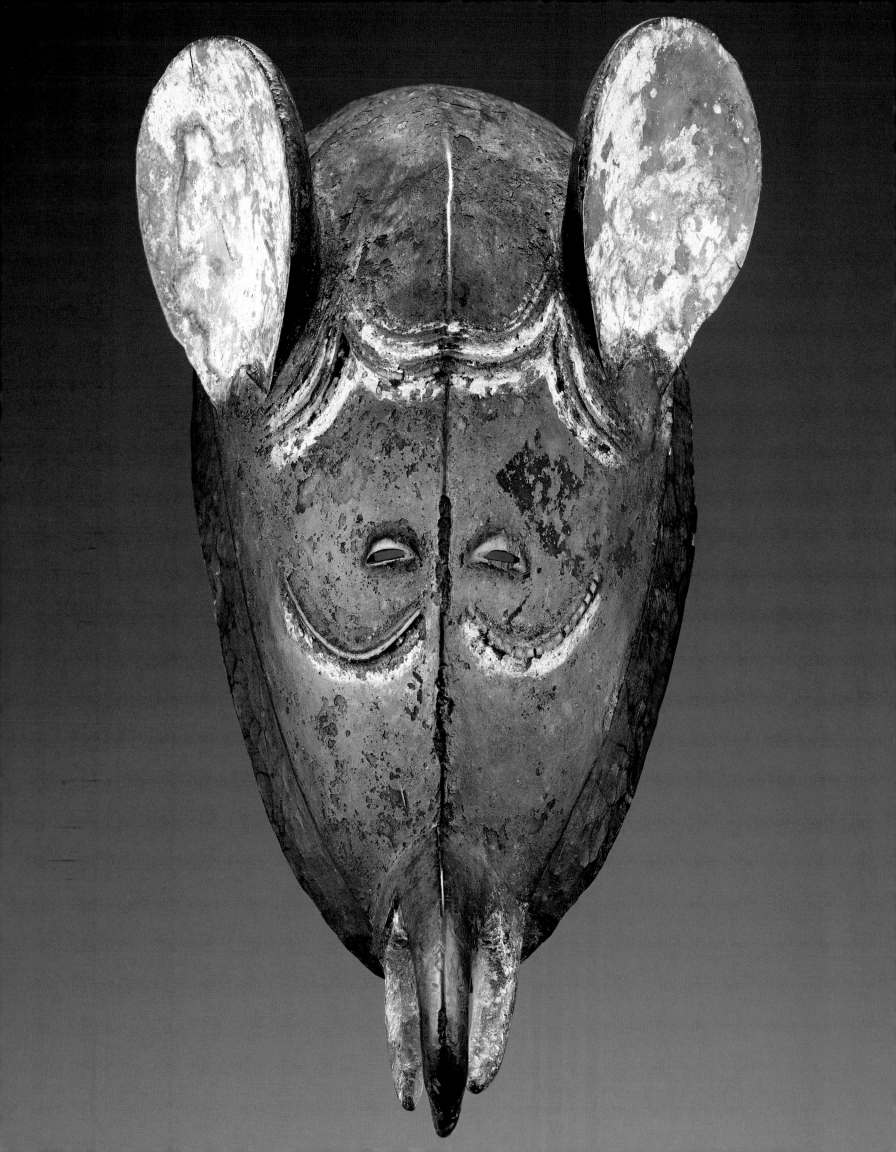

Mask

Guro peoples, Côte d'Ivoire

Early to mid-20th century

Wood, pigment

27.9 x 15.9 x 8.9 cm
(11 x 6 1/4 x 3 1/2 in.)

Gift of Walt Disney World Co., a subsidiary of The Walt Disney Company, 2005-6-214

An effective blending of human and animal features characterizes elephant face masks from central Côte d'Ivoire. In this example, rounded ears, small eyes, and projecting snout and tusks capture the essential traits of the forest elephant, smaller than the savanna variety and increasingly rare in the forested zones of west Africa. The mask's human qualities reside primarily in the linear patterns on the forehead that indicate the hairline and suggest a coiffure. Although the mask is attributed to the Guro, related styles of elephant masks are also found among the Baule and Yaure.

Guro masquerades include a cast of characters—human, animal, and composite—that represent forest spirits. They are depicted by carved and painted masks and cloth or raffia—fiber costumes that juxtapose the civilizing forces of the village with those of the untamed wilderness. While some masquerades may be performed for general entertainment, others adopting very similar forms are associated with *dje,* powerful and sacred masquerades that may be seen only by men.[1] Elephants, antelope, hippopotamuses, and bush pigs are among the wild creatures depicted in *dje* masquerades, but it is uncertain if this particular elephant mask functioned in that context.

In central Côte d'Ivoire masking, the elephant character denotes the power to transform and respond to change, a marked contrast to its meaning in regalia such as flywhisks and staffs, which tend to affirm the stability and authority of the institution of chieftaincy.[2]

—CMK

Notes

1. Visonà et al. 2001, p. 190.

2. Ravenhill, in Ross 1992, p. 126.

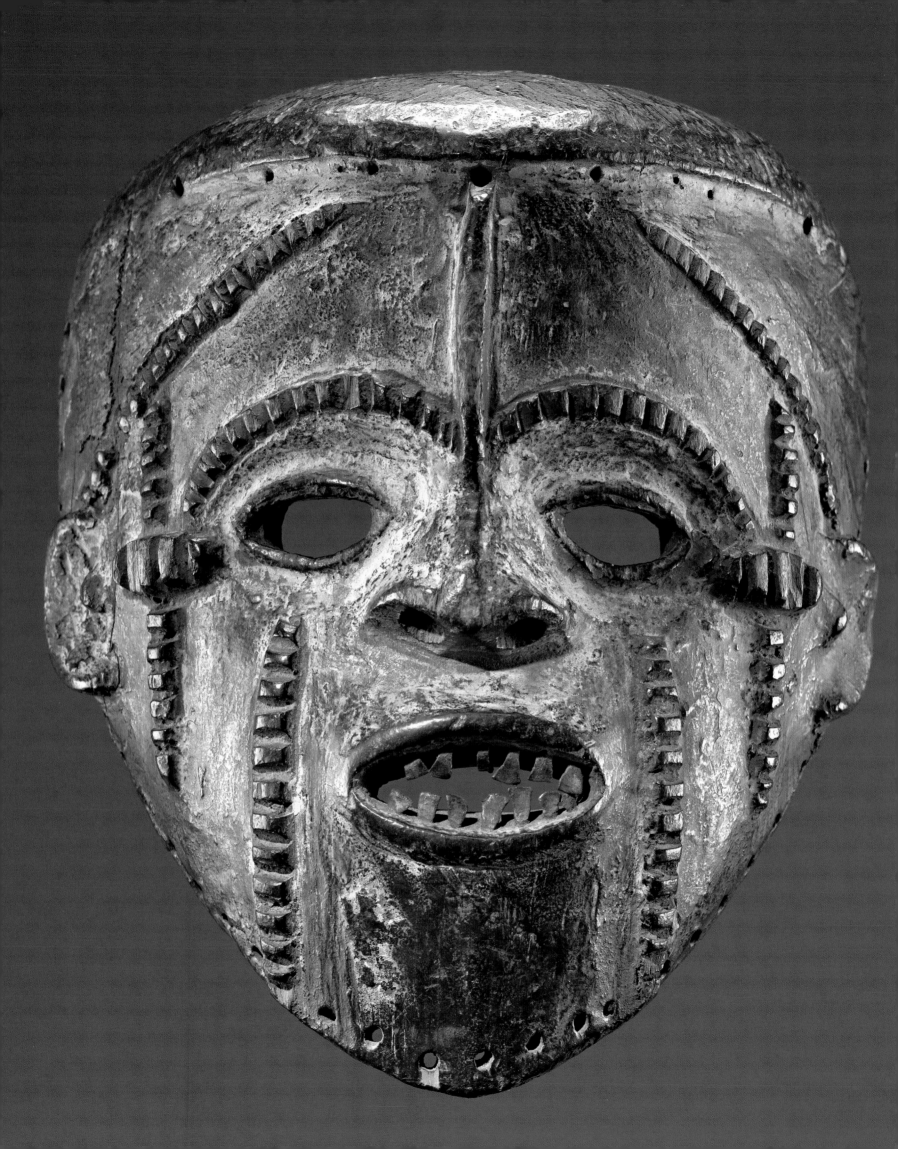

Mask

Idoma peoples, Nigeria

c. 1920–40

Wood, pigment, metal

21.3 x 17.5 x 8.8 cm
(8 3/8 x 6 7/8 x 3 7/16 in.)

Gift of Walt Disney World Co., a subsidiary of The Walt Disney Company, 2005-6-88

Despite the distinctive depiction of scarification here, the source and use of this mask is difficult to pin down. It is from an area where art moved across ethnic divisions and among several men's associations. It is possible that it was used for entertainment, to keep order in the community, or in a mask society member's formal funeral (as opposed to burial).

In writing about this mask in 1981, Roy Sieber pointed out that its facial features, forehead scarification marks, and manner in which the hairline was rendered suggest that it may have been made by artists of a non-Idoma group known as the Akweya of Akpa, but that other features were not consistent with Akweya style.[1] Could this blending of styles be explained by the influence of several early-20th-century Akweya artists? Two of the best-known Akweya carvers, Ochai and Oba from Otobi village, worked for both Idoma and Akweya clients, and there appeared to be a fairly brisk market in carvings that might have served as sources of inspiration to artists within and outside the region.[2] What is lacking is firm collection data (including the name of the artist) that would lend precision to what is now just speculation.

—AN

Notes

1. Sieber, in Vogel 1981, p. 162.
2. Ibid.

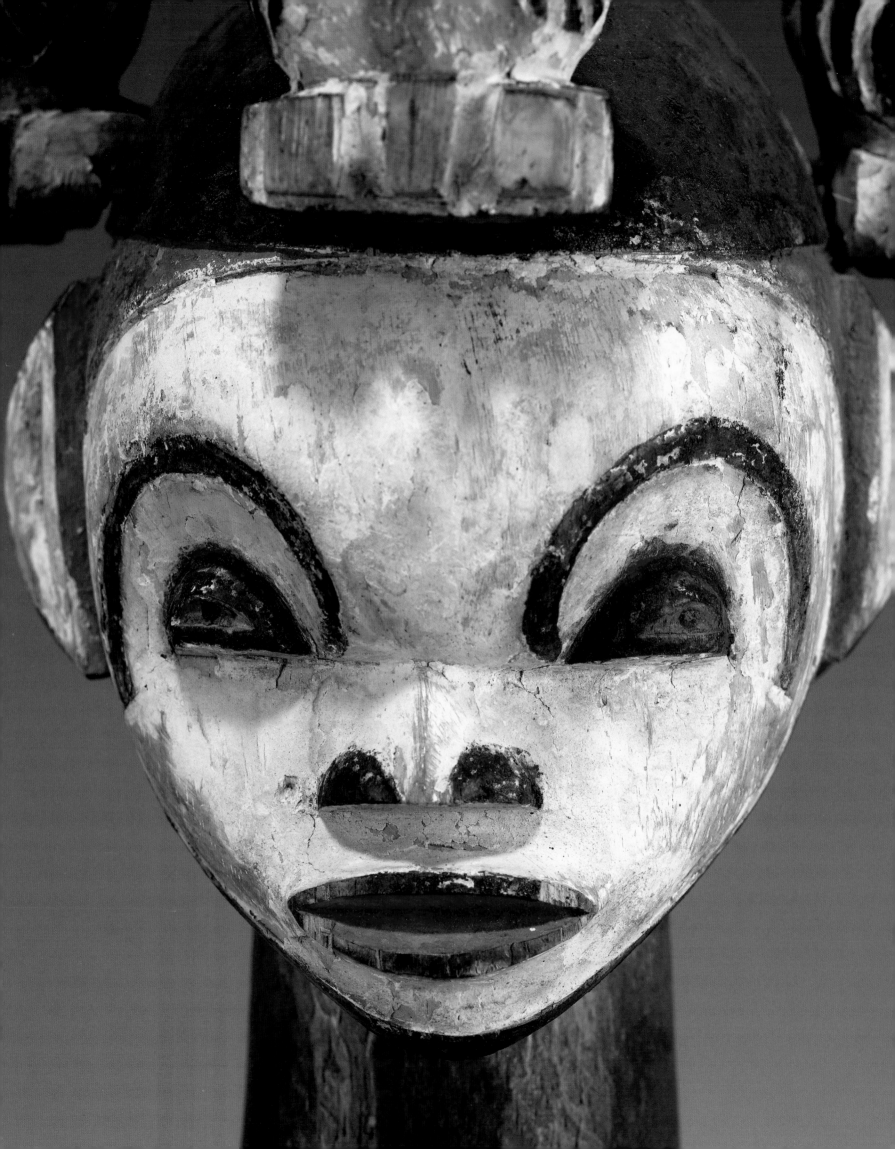

53

Mask

Idoma peoples, Nigeria

c. 1950

Wood, paint, fur, iron nails

*33.8 x 18.8 x 23 cm
(13 5/16 x 7 3/8 x 9 1/16 in.)*

Gift of Walt Disney World Co., a subsidiary of The Walt Disney Company, 2005-6-89

Multifaced masks are fairly rare among the Idoma peoples. Masks of this type were formerly used for social control, but now appear at Christmas, at funerals, and for entertainment, where they are performed by men's dance groups. This one is painted bright red, blue, and white—colors that are typical for this type of mask—which certainly must have enhanced its visual appeal when performed. The birds on the top of the mask shown here are said to be eating ripe fruit and thus refer to the harvest. This Janus mask appears to contain contrasting male and female elements, with the male indicated by the animal-fur beard. Might this suggest something about the cooperation needed between men and women to secure a bountiful harvest?

Writing about the mask in 1981, Roy Sieber cautioned that the term for the mask, *ungulali* ("flute," suggesting its performance context), may not apply broadly to this category of crest mask.[1] Although selected masks of this type have been attributed to the Idoma carver Ochai, Sieber indicated that this particular mask was probably by another hand.[2] To date, the identity of the artist remains unknown.

—AN | CMK

Notes

1. Sieber, in Vogel 1981, p. 165.

2. Ibid.

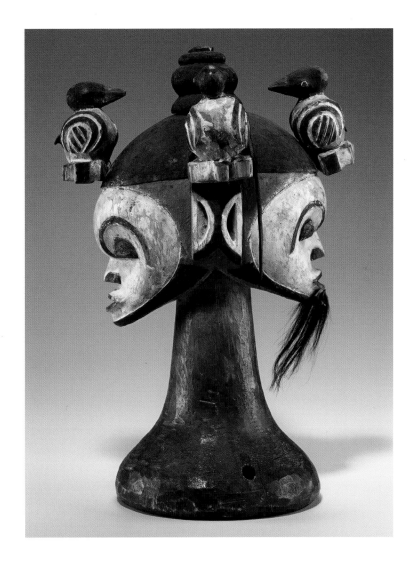

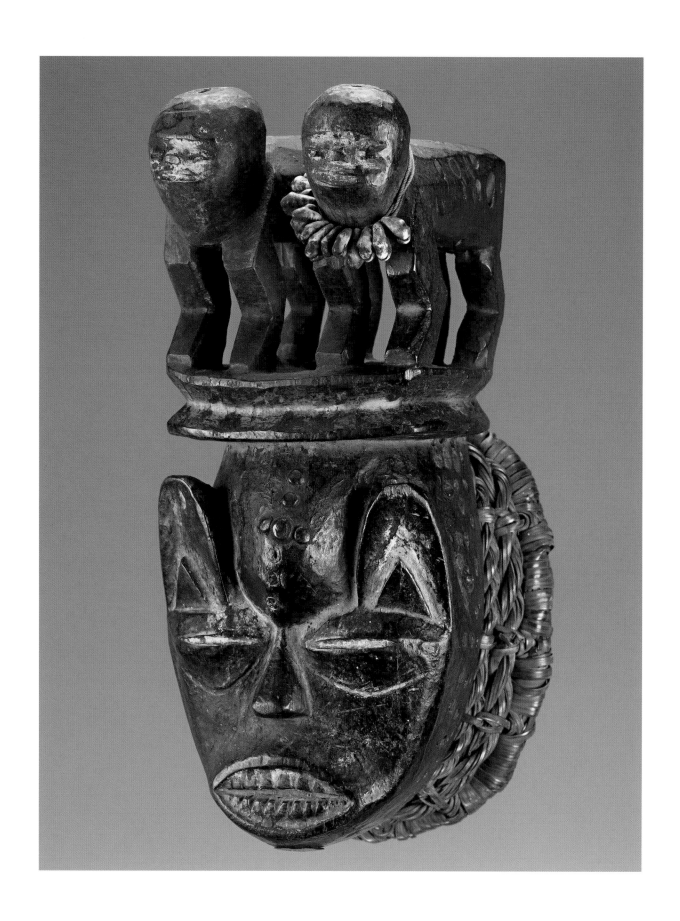

Mask

Isoko peoples, Bendel State, Ase village, Nigeria

Mid-20th century

Wood, plant fiber, cowrie shells, pigment, metal

*30.5 x 14.8 x 15 cm
(12 x 5 13/16 x 5 7/8 in.)*

Gift of Walt Disney World Co., a subsidiary of The Walt Disney Company, 2005-6-83

This mask, believed to come from the village of Ase, probably honored a major local deity associated with warfare.[1] Masqueraders wore costumes of feathers and colorful scarves with these masks, which were "the focus of the Erese festival celebrated each March to cleanse the town before other festivals [could] be held."[2] Consistent with other Erese festival masks photographed by anthropologist Philip Peek, the mask shown here consists of a face topped by a superstructure depicting animals and has a thick wickerwork attachment at the back that would have secured the mask to the head of the performer. The four-legged creatures at the top, one wearing a cowrie-shell necklace, lack sufficient detail to be identified. However, the mask's prominent central face probably depicts a spotted cat, as suggested by its peaked ears and the circular holes, some with pegs, that ring the face, creating the impression of a spotted pelt. Its open mouth with bared teeth, consistent with this type of mask, conveys fierceness appropriate to its likely connection with a war god.

Terminology associated with the mask reflects the past history of the village of Ase, which includes both Igbo and Isoko influences,[3] although today the latter is now dominant.[4]

—AN | CMK **171**

Notes

1. Peek, in Vogel 1981, p. 143.

2. Ibid.

3. Ibid.

4. Philip Peek, e-mail to Andrea Nicolls, June 23, 2006.

Mask

Urhobo peoples, Nigeria

Early to mid-20th century

Wood, pigment, encrustation

*45.7 x 17 x 10.7 cm
(18 x 6 11/16 x 4 3/16 in.)*

*Gift of Walt Disney World Co., a subsidiary of The Walt Disney Company,
2005-6-11*

In the early 1970s, Perkins Foss documented masks of this type being used in the masquerades performed at festivals honoring Ohworhu, a major Urhobo water spirit.[1] The spirit is said to have come from outside Urhobo, in the area where the western Ijo now live,[2] suggesting the dynamism that characterizes the arts of the Niger Delta region. Within this region, water spirits are characterized as unpredictable; some may be beneficial, while others are considered dangerous and potentially harmful.

According to Foss, this particular mask represents a beneficial spirit, one associated with the ideal beauty of a young woman and, in particular, with a bride.[3] This is indicated by the complex coiffure, including the inserted pegs suggesting silver hairpins, which are a feature of bridal headdresses. Foss reported that the gracefully curved horns projecting from the top of the head have been described simply as horns or as part of the hairstyle. The raised vertical marks embellishing the forehead are a form of body ornamentation found not just among the Urhobo but also among other groups in the region.

Foss recently noted that after a hiatus of a decade or so, Ohworhu masquerades are beginning to return to the Urhobo region as part of cultural celebrations and are performed along with stilt dancing and children's groups.[4]

—CMK

Notes

1. Foss, in Vogel 1981, p. 146; Foss 2004, p. 115.

2. Foss, in Vogel 1981, p. 146.

3. Ibid.

4. Foss, e-mail to the author, September 15, 2006.

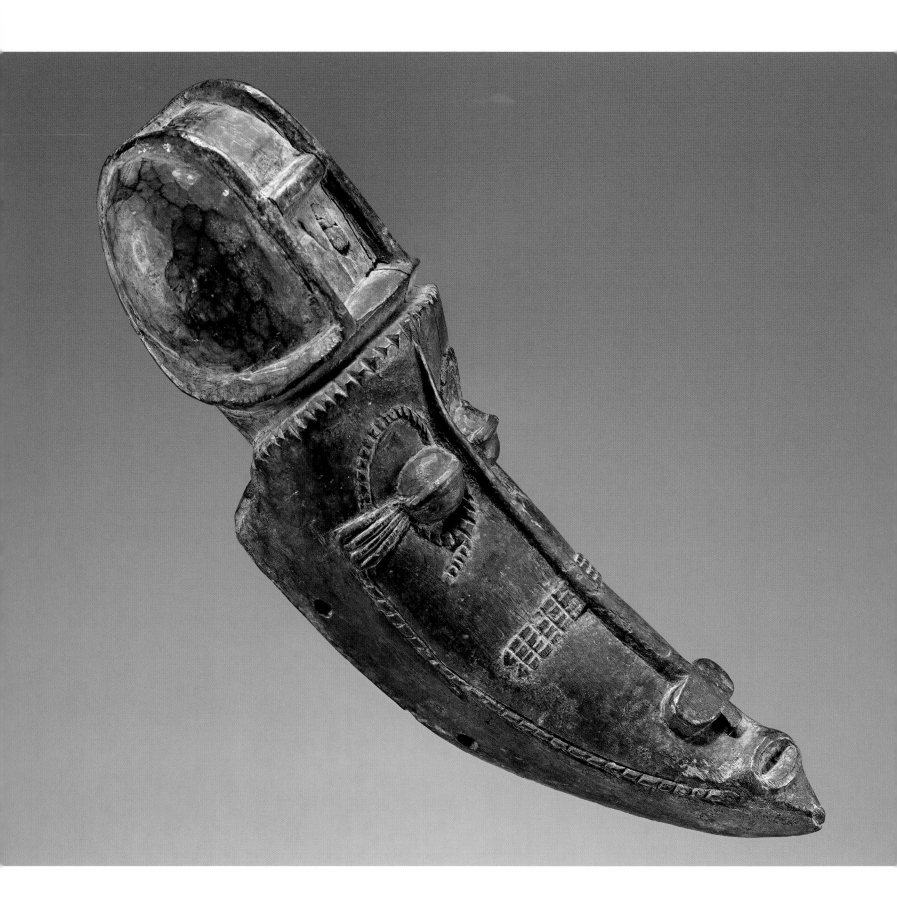

Mask

Eastern Ijo or Nembe Ijo peoples, Nigeria

Early to mid-20th century

Wood

31 x 8.8 x 9 cm
(12 3/16 x 3 7/16 x 3 9/16 in.)

Gift of Walt Disney World Co., a sub-sidiary of The Walt Disney Company, 2005-6-86

The lives and culture of the Ijo revolve around the many waterways of the Lower Niger Delta region. There is a widespread belief in water spirits, and they are invoked in festivals, in shrines, and in masquerades featuring a variety of carved wooden masks that are usually worn on top of the head or on the forehead.

This particular water spirit mask is attributed to the eastern Ijo, although the unusual treatment of the bulging eyes more closely resembles that of a Nembe Ijo mask in the Nigerian Museum.[1] The rectangular indentation in the forehead of this mask may have originally held a mirror or a metal inlay. Such elaborations of the basic form of the mask are a common feature in eastern Ijo masquerades, which tend to dazzle the eyes and reflect positively on those who sponsor the performances, suggesting wealth that has accumulated through trade in the region.[2]

For the Ijo, masquerades serve religious, social, and political functions and provide mechanisms that reinforce connections with the spirit world.[3] The masquerades portray human characters typically found in many Ijo communities, along with a range of water- and land-dwelling animals and composite creatures that defy precise classification.

—CMK

Notes

1. Anderson, in Vogel 1981, p. 150, citing Horton 1965, fig. 60.

2. Anderson, in Anderson and Peek 2002, p. 217.

3. Ibid., p. 216.

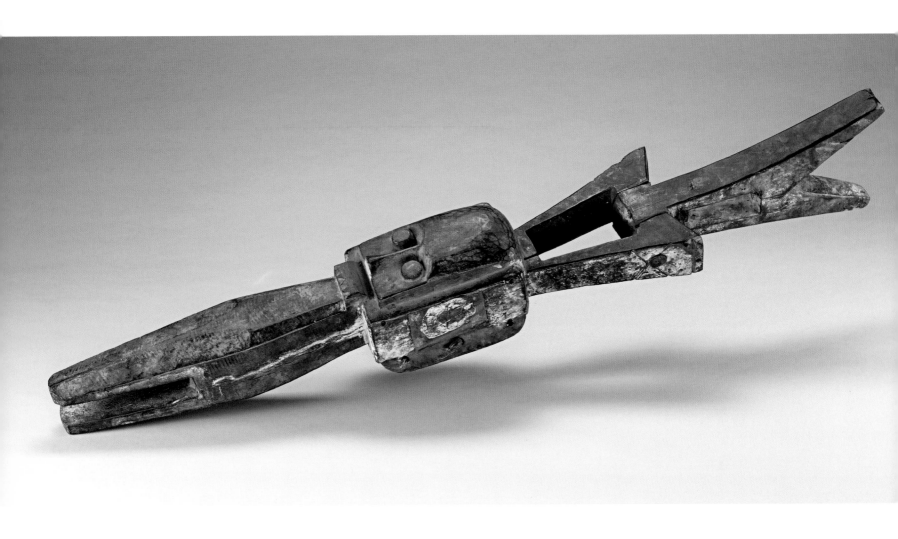

Mask

Ijo peoples, Nigeria

Mid-20th century

Wood, pigment, iron, plant fiber

*101.6 x 17.1 x 12.7 cm
(40 x 6 3/4 x 5 in.)*

Gift of Walt Disney World Co., a subsidiary of The Walt Disney Company, 2005-6-137

This crest mask of a composite creature represents a water spirit. With its elongated form and its combination of features—a skull-like human head, a long snout suggesting a crocodile, and notched fish tail— it exhibits the characteristics of central and western Ijo masks from Nigeria's Niger Delta region.[1] It was originally embellished with color (orange, blue, white, and black), traces of which continue to enliven the surface. Two rectangular recessed areas, one on either side of the head, may have held mirrors or metal inlays that are now missing. When this mask was performed at festivals by a masker dressed in a cloth costume, it was oriented horizontally on top of the head, its imagery facing skyward to suggest the appearance of "spirits floating on the surface of the water."[2]

The Ijo credit water spirits with the invention of masking, "which provides the best opportunity for people raised on tales of water spirits to glimpse inside their fascinating underwater universe."[3] Water spirits may materialize as masks taking a variety of forms in addition to composite creatures—hippo, python, crocodile, swordfish, shark and smaller fish, as well as human. They may also be represented by imported goods, and "prefer a diet of imported food."[4] This is because water spirits and their mas-

querades, popular throughout the Niger Delta, are associated with foreigners and centuries of coastal trade with Europeans, although "much of the 'import' symbolism associated with [water spirits]... is rooted in ideas that predate European contact."[5] In contrast to ancestral spirits that are linked to social order, water spirits are connected to activities beyond the social norm and are "responsible for individual acquisition of abnormal wealth and power, and for the actions of those who introduce strange fashions in clothes and other innovations."[6] Although they must be approached respectfully, Niger Delta water spirits are generally considered more positive and helpful than wilderness spirits that inhabit dry land.

—CMK

Notes

1. Martha Anderson, e-mail to the author, June 14, 2006; see also Anderson, in Anderson and Peek 2002, p. 133, fig. 4.1.

2. Anderson, in Anderson and Peek 2002, p. 148.

3. Ibid., p. 151.

4. Anderson, in Anderson and Kreamer 1989, p. 50.

5. Anderson, in Anderson and Peek 2002, p. 163.

6. Horton 1965, p. 5.

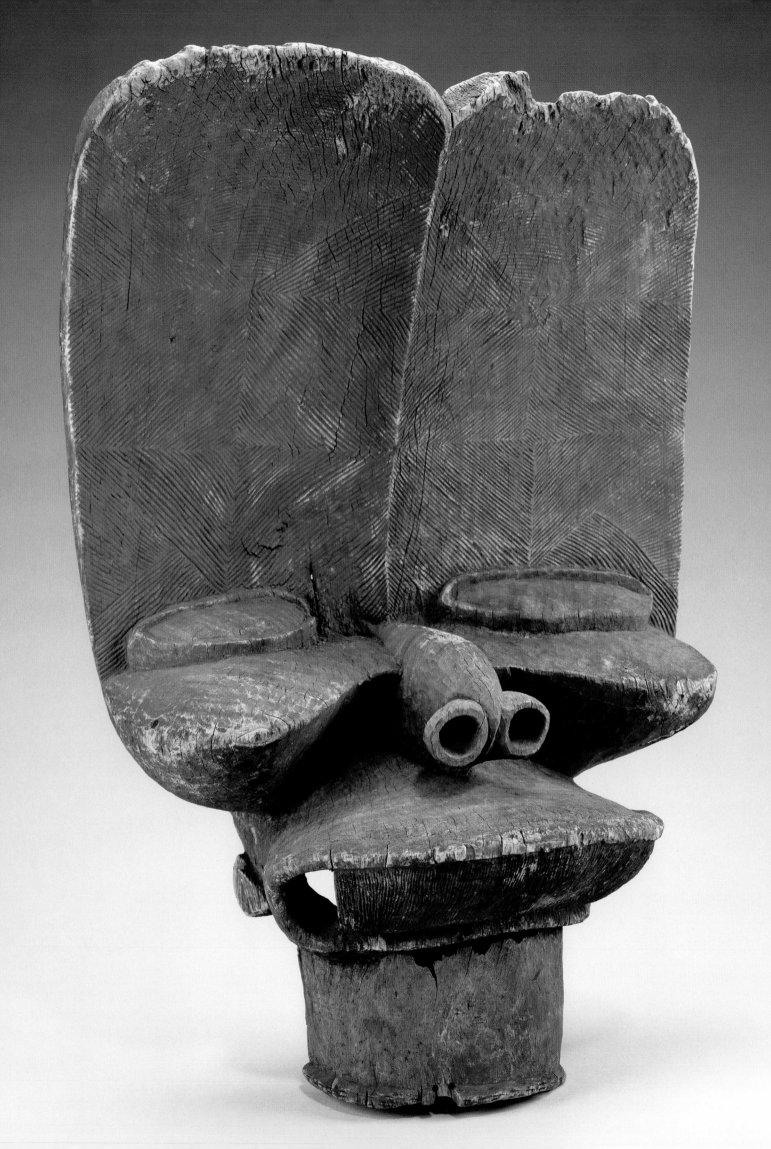

Mask

Bamileke peoples, Grassfields region, Cameroon

Late 19th century

Wood

*77 x 53 x 27.4 cm
(30 5/16 x 20 7/8 x 10 13/16 in.)*

Gift of Walt Disney World Co., a subsidiary of The Walt Disney Company, 2005-6-5

This rare mask represented the power of the king and his court, and was used as an instrument of social control. Its features are large and exaggerated, but still suggest human facial features: tall, concave brows that rise vertically above the horizontally oriented cylindrical eyes, distinctive cheeks with a horizontal upper surface, prominent nose with flaring nostrils, and projecting mouth with a horizontal upper surface.

Pierre Harter, who wrote extensively about this type of mask, attributes the style to the Bamileke peoples and to a particular workshop in Bandjoun.[1] According to collection data, this mask is from the village of Bana, which Harter noted is about a hundred kilometers south of Bandjoun.[2] He reported that this type of mask performed at royal and important court funerals, at the end of harvest celebrations, and at the new year. The dancer, a high-ranking person, wore it on top of his head, together with a costume to conceal his identity, to create the impression of a figure that was larger and more than human.[3] A photograph taken in the 1920s shows a mask of the same type (collected in 1925 and now in the U.C.L.A. Fowler Museum of Cultural History) in a display context, placed centrally atop an elaborately carved caryatid stool along with other royal regalia.[4]

—BF | CMK

Notes

1. Harter, in Vogel 1981, p. 183.

2. Ibid.

3. Ibid.

4. Harter 1972: 22, fig. 5; also cited in Northern 1984, p. 167.

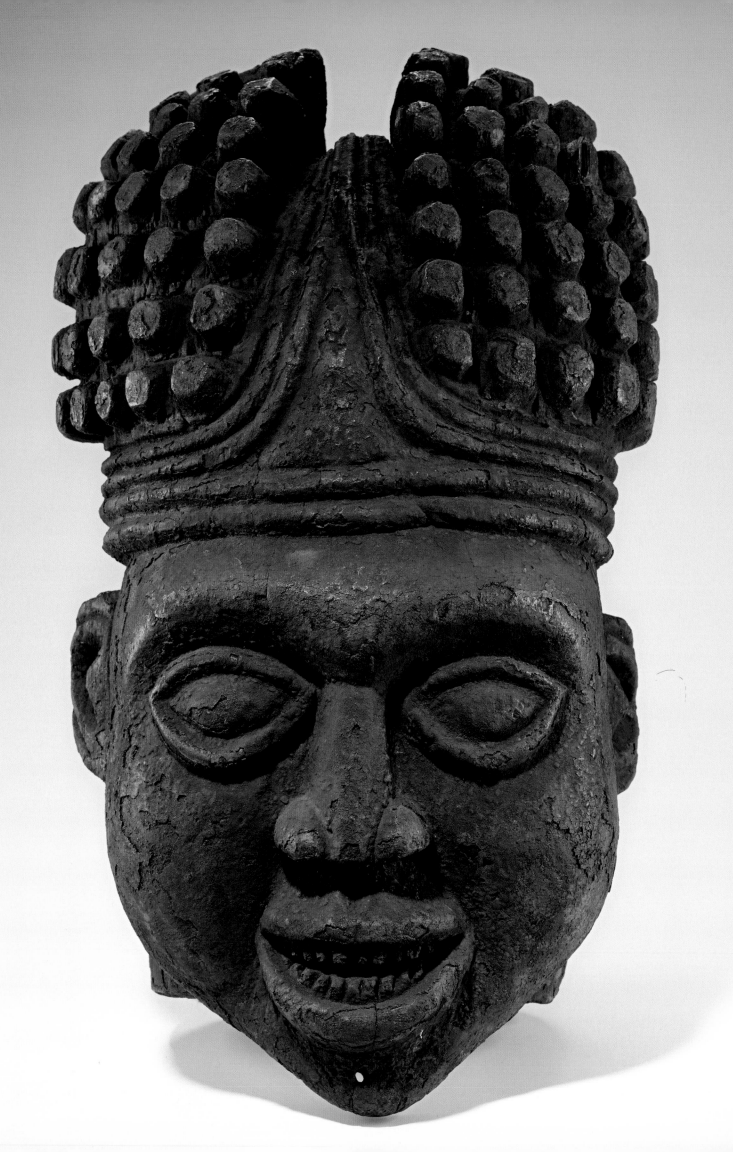

59

Mask

Possibly Kom peoples, Grassfields region, Cameroon

Late 19th to early 20th century

Wood, encrustation

*50.2 x 30.5 x 34.3 cm
(19 3/4 x 12 x 13 1/2 in.)*

Gift of Walt Disney World Co., a subsidiary of The Walt Disney Company, 2005-6-94

This mask, in the form of a human face with an elaborate headdress, is of a type found among many Cameroon chiefdoms located in the Grassfields region. It depicts a man of importance, indicated by the accurate depiction of a prestige cap made of knotted and knobbed fiber, which can only be worn by men of high rank. Masks of this type are usually associated with men's associations, some linked with the palace, others with warriors, lineage groups, and families.

The mask would have been worn as a crest on top of the head, with the masker's identity shielded by a cloth costume. It probably appeared at a funeral, since funerals are a particularly important context for masquerade performances. It's possible that the encrusted patina on the surface may relate to the manner in which such masks were prepared prior to a performance, when they would have been "dressed afresh with palm oil and charcoal."[1]

—CMK

Notes

1. Northern 1973, p. 32.

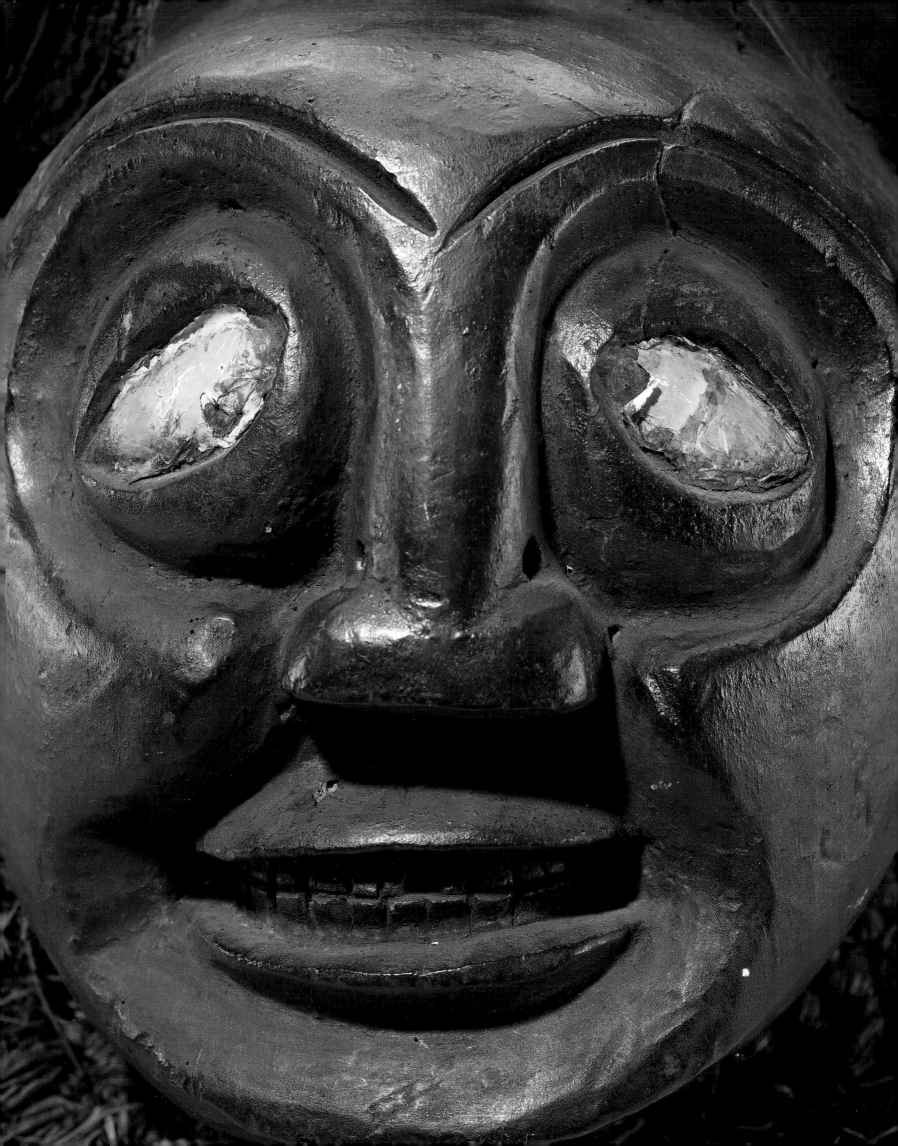

61

Mask

Kwele peoples, Gabon

Early 20th century

Wood, pigment

54 x 19.8 x 6 cm
(21 1/4 x 7 13/16 x 2 3/8 in.)

Gift of Walt Disney World Co., a sub-
sidiary of The Walt Disney Company,
2005-6-97

Human and animal features are combined in this Kwele face mask from Gabon, which was used by members of Beete, a religious organization dedicated to dealing with crises and countering negative, anti-social behavior, thus ensuring order. Masks representing benevolent forest spirits were danced by maskers, or "children of Beete,"[1] during cult ceremonies and funerary and initiation rites. The performances of masks on these occasions provided beautiful, powerful, and entertaining diversions during the lengthy multi-day ritual procedures leading up to "a final rite of expiation and purification" for the community.[2] The traditional use of masks appears to have declined, along with Beete, after the first few decades of the 20th century, although some masking continued into the 1970s[3] and probably still continues in some format as part of cultural displays and as entertainment.

With its tall horns bent at an angle midway up, this mask is a type called *booag,* representing the bongo antelope.[4] The mask's heart-shaped face (formed by the arched eyebrows and the tapered jaw line), elongated eyes, raised triangular nose with narrow-slit nostrils, and its small mouth are characteris-tics of Kwele masks, whether human, animal, or composite. The face is often highlighted in white kaolin pigment, traces of which are visible on this mask.

Louis Perrois has asserted that most Kwele masks known in collections today "were collected between 1920 and 1935, a period when Kwele carvers were still at the height of their technical and artistic production."[5] In cases where the masks show few signs of use and handling, they may not have been activated and worn, but rather were hung on the wall of structures built for the Beete cult or for initiation rites.[6] Kwele masks were also carved to meet the demand of Europeans collectors.

—CMK

Notes

1. Siroto 1995, p. 19.

2. Ibid.

3. Perrois 2001: 107.

4. Siroto 1969, p. 221, cited by Ezra in Vogel 1981, p. 187.

5. Perrois 2001: 90.

6. Ibid.

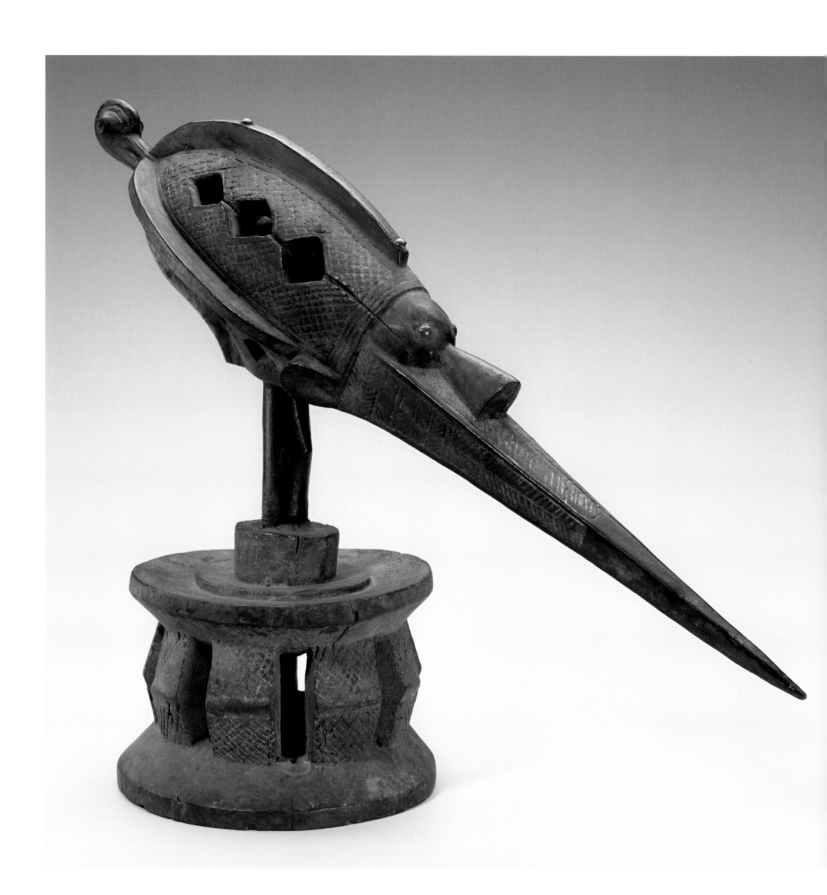

Shrine figure

Baga peoples, Guinea

Late 19th to mid-20th century

Wood, pigment, brass tacks

*51 x 22.2 x 67.5 cm
(20 1/16 x 8 3/4 x 26 9/16 in.)*

*Gift of Walt Disney World Co., a subsidiary of The Walt Disney Company,
2005-6-161*

Among the Baga, the most important of the clan regalia objects was the figure known as *a-Tshol,* a term which is generally translated as "medicine," and "signifying a whole range of substances with powers of healing or protection."[1] The *a-Tshol* figure is carved as a highly stylized composite sculpture with both human and bird attributes. This one has a body in the shape of an openwork stool. They functioned as static shrine objects receiving libations and other offerings, and would also be taken out and danced during initiations, funerals, and annual ceremonies. Earlier discussions of this and similar objects have referred to them as *elek,* a term that also refers to medicine.[2]

—BF | CMK

Notes

1. Lamp 1996, p. 89.

2. Paulme, in Vogel 1981, p. 58.

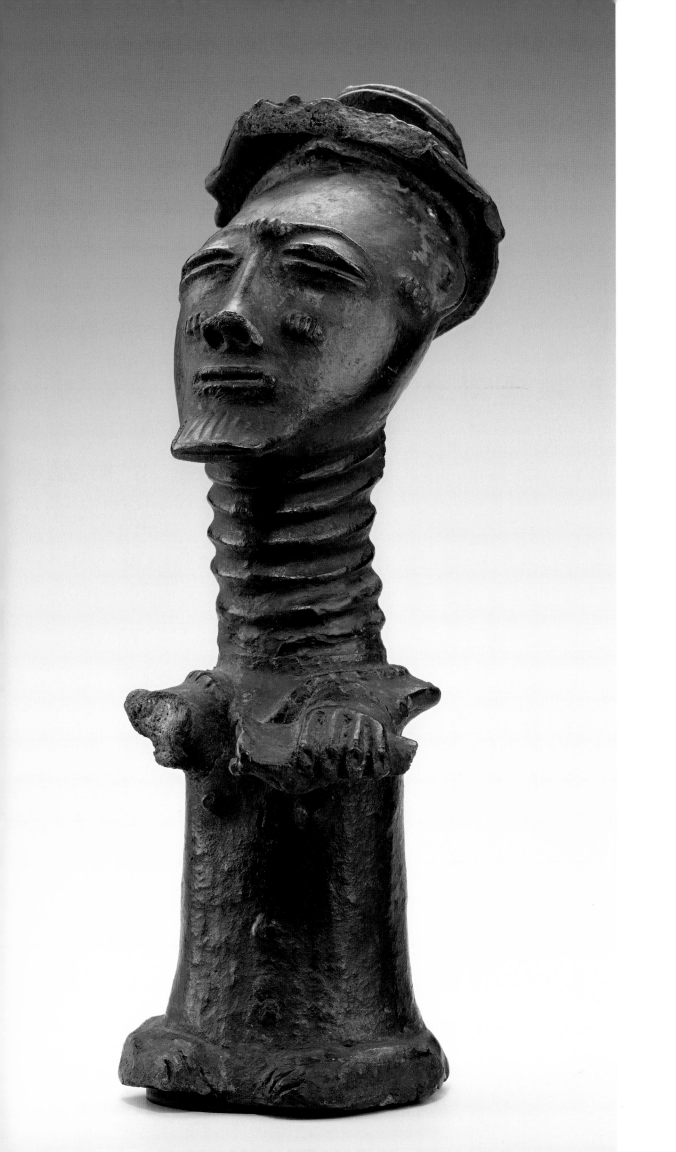

63 _____

Memorial figure

Anyi peoples, Côte d'Ivoire

Early 20th century

Terracotta

38.6 x 14 x 22.2 cm
(15 3/16 x 4 1/2 x 8 3/4 in.)

Gift of Walt Disney World Co., a subsidiary of The Walt Disney Company, 2005-6-162

Among certain Anyi peoples of Côte d'Ivoire, small terracotta figures called *mma* served as funerary portraits. Those identified with the Sanwi kingdom, such as this sculpture, date from the 18th to the early 20th century and are believed to depict deceased royals and their court, according to art historian Robert Soppelsa.[1] Soppelsa has identified this figure as a gong player, one of a small group of statuettes depicting court musicians that also include drummers and horn or flute players.[2] He noted that the left hand grasps a flattened cylindrical gong, while the right, now missing, would have held a clapper.

Typical of other figures in this category, it has an upturned face bearing raised scarification marks, a complex headdress (in this case a conical hat), ringed neck, and foreshortened torso and limbs. The projecting beard defines him as male. Because "musicians are less important than the kings and queen mothers for whom they play," their memorial figures maintain this hierarchy to the grave by being "considerably smaller than the royal figures" and by standing rather than sitting.[3]

Anyi terracottas in this style are part of a broader tradition of commemorative terracottas, both figural and non-figural, found among a range of Akan peoples in southwestern Ghana and southeastern Côte d'Ivoire.

—CMK

Notes

1. Soppelsa 1990; see also Amon d'Aby in Vogel 1981, pp. 78-79.

2. Soppelsa 1990: 77-78.

3. Ibid.

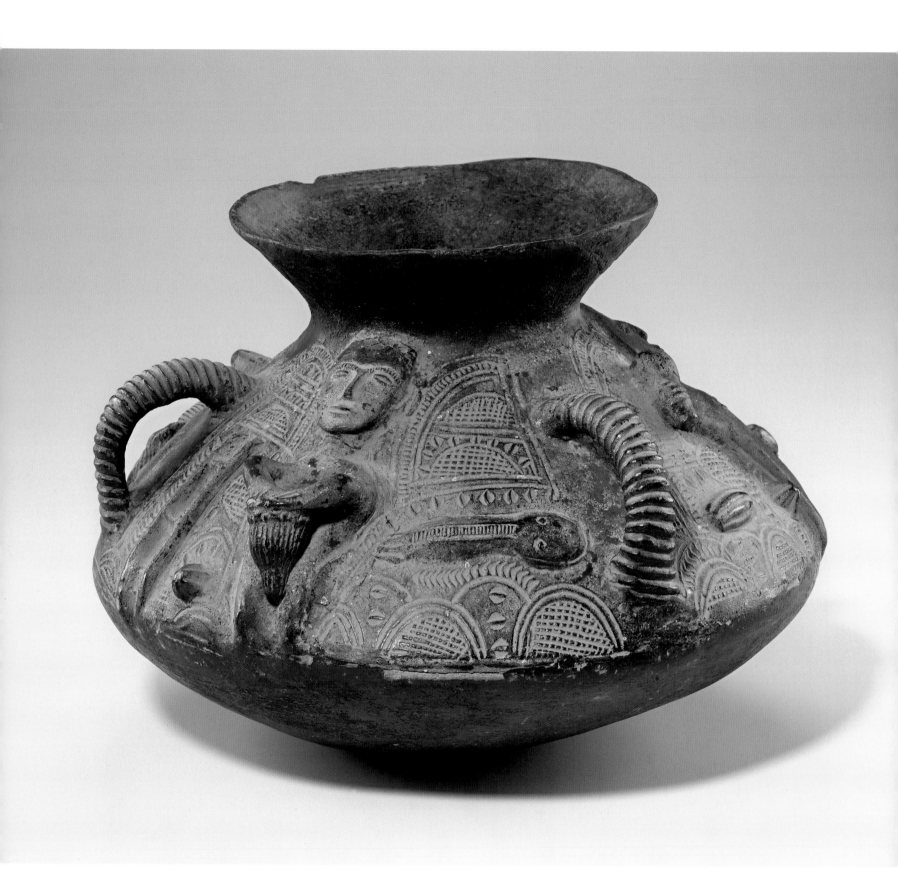

Funerary vessel

Akan peoples, Ghana

Late 19th to early 20th century

Terracotta

21 x 30.4 x 29.4 cm
(8 1/4 x 11 5/16 x 11 9/16 in.)

Gift of Walt Disney World Co., a subsidiary of The Walt Disney Company, 2005-6-164

The link between verbal and visual arts among the Akan peoples in Ghana is well illustrated by this decorated pottery vessel. It is an *abusua kuruwa,* a family or clan pot that is primarily used in funerary practices. Pots of this type may have a tall, narrow cylindrical neck topped with a stopper or, as seen here, a short flared opening. Both versions are highly decorated with incised and relief motifs, many of which recall proverbs that emphasize status, accomplishment, and leadership qualities.

To underscore its funerary function, such vessels, including this pot, are usually ornamented with a raised ladder motif that suggests the inevitability of death through its association with a familiar proverb that roughly translates to "the ladder of death, no single person climbs it." In writing about this particular vessel, George Preston noted that the mudfish, crescent moon, and star decorations probably establish this vessel as one commissioned for a chief or paramount chief.[1] Two snakes, one common to the forest, the other a type associated with the savanna, convey the considerable extent of the ruler's influence. The musical instruments refer to the chief carrying out his role as priest of the royal ancestral cult, and evoke multiple associations with proverbs, history, and human relationships.

Vessels of this type would have been placed not on the grave but in a separate section known as "the place of the pots"[2] or, in the case of some royal vessels, stored in the palace shrine or stool rooms.[3] Early studies of Asante religion and art conducted by R.S. Rattray noted that the pots were used to store hair and nail clippings from members of the deceased's *abusua* (matrilineage) as part of final funerary rites prior to those which make the deceased an ancestor.

The lip of this pot, badly broken long ago, was repaired once the Walt Disney-Tishman Collection was donated to the National Museum of African Art.

—CMK

Notes

1. Preston, in Vogel 1981, p. 83.

2. Rattray 1927, p. 165.

3. Cole and Ross 1977, p. 120.

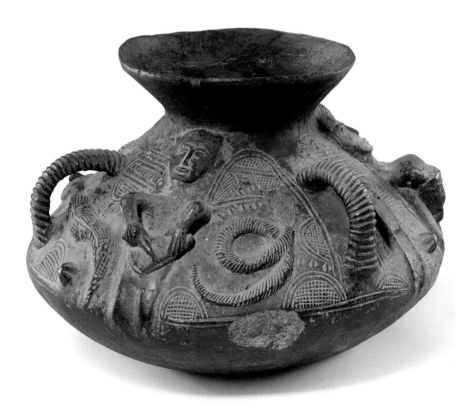

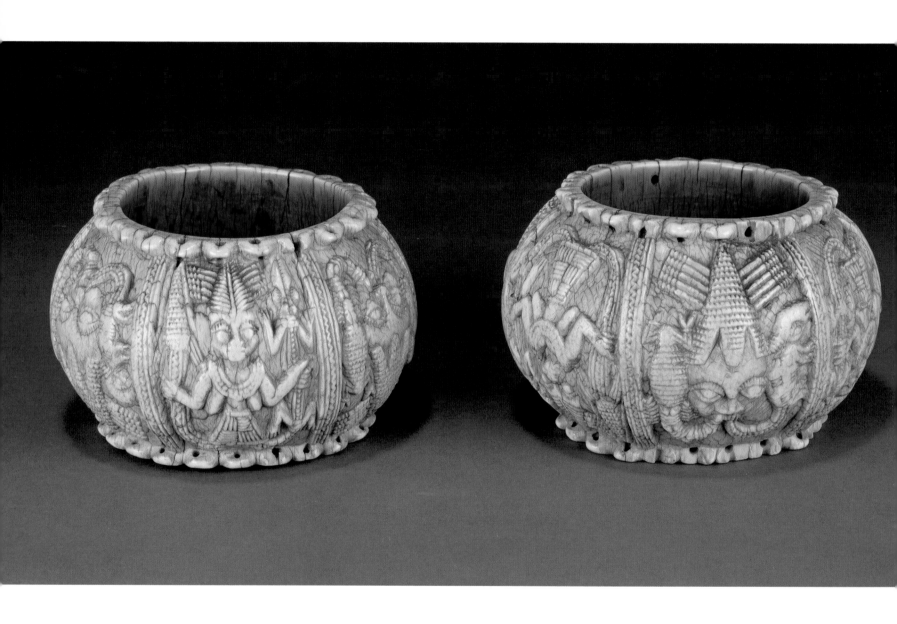

65

Armlets

Yoruba peoples, Owo region, Nigeria

16th to 18th century

Ivory

*7.5 x 12.8 x 12.8 cm
(2 15/16 x 5 1/16 x 5 1/16 in.)*

*7.9 x 13.2 x 13.2 cm
(3 1/8 x 5 3/16 x 5 3/16 in.)*

Gift of Walt Disney World Co., a subsidiary of The Walt Disney Company, 2005-6-7.1, 2005-6-7.2

This massive pair of armlets consumed a lot of valuable ivory, yet they were only part of the royal regalia probably belonging to the Olowo of Owo, a Yoruba king. They would have been worn together with ivory pendants and perhaps a ceremonial sword (see cat. no. 67). The motifs evoke the spiritual forces that shape the world and are controlled by the ruler. Similar motifs can be found on other ivory, copper-alloy, and terracotta archaeological and historic objects found in Owo, as well as in the sacred Yoruba city of Ife, in the neighboring kingdom of Benin (see cat. no. 2) and in scattered other sites.[1]

The heads, with their large, open eyes and creatures issuing from the nostrils, relate to the concept of the head as the locus of spiritual forces, an almost literal swelling of power. The exact nature of the animals being emitted is uncertain, but one is clearly a four-legged land beast, and the other is a sinuous creature, something that can live in water. A related motif can be found on the divination board in this collection (cat. no. 71). The alternating motif on the armlets also suggests a being of two

worlds—land and water, real and spiritual. It is usually described as a fish-legged creature that grasps its own upward-curving fish "legs" in its forelimbs,[2] forming a W (see cat. no. 74). In this case, the "legs" end in a crocodile and what appears to be a mudfish head. The mudfish—in art and myth, a composite of several species—can survive without water. The figure's hat, with its side projections, also suggests the "whiskers" of the fish (see also the hat in cat. no. 73), resembling an American catfish.

These armlets were collected around 1850 by John Jamieson and presented by his great-nephew R.W.S. Mitchseon. They became part of the collection of Harry G. Beasley (1882–1939) at the Cranmore Ethnographical Museum, Chislehurst, Kent, England, and in 1975 they were acquired by Paul Tishman.

—BF

Notes

1. Fraser, in Vogel 1981, p. 128.

2. Ibid.

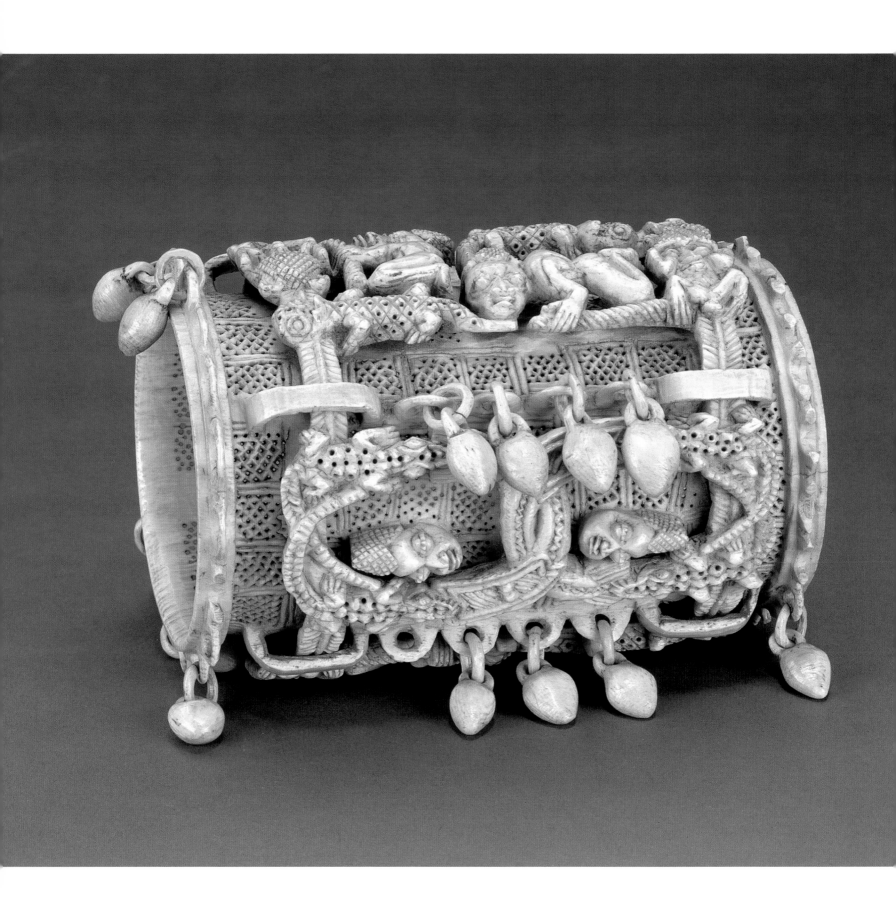

Armlet

Yoruba peoples, Owo region, Nigeria

16th century

Ivory

*14.5 x 10.5 x 10.5 cm
(5 11/16 x 4 1/8 x 4 1/8 in.)*

Gift of Walt Disney World Co., a subsidiary of The Walt Disney Company, 2005-6-8

We tend to fixate on royal art for a reason. Kings not only own more and varied works of art made of the best materials, but command the best artists. The sheer technical virtuosity of the artist who carved this remarkable armlet is extraordinary. It is a single piece of ivory carved into two interlocking movable layers with pendent rattles.

The inner layer is composed of lacelike pierced panels, while the outer layer takes the form of intersecting circles of figures, with a face at the center of each circle. One set of motifs depicts kneeling hunchbacks holding tethered monkeys, possibly a sacrifice. Hunchbacks are regarded as touched by the god Obatala, who shapes the human form in the womb; and Yoruba oral literature describes monkeys as thieves and tricksters who sometimes are caught but at other times outwit their opponents.[1] White is the color symbolically associated with Obatala, which may be why ivory was used for this bracelet. Other circles are composed of crocodiles biting the heads and tails of mudfish. The dangerous crocodile can easily be understood as the ruler of the waters, whereas the mudfish requires more context. Mudfish are widely depicted in west Africa among the Akan

of Ghana, in the Benin kingdom, and among the Yoruba peoples in Nigeria. The mudfish is a composite of several species, creating a metaphor for spiritual power: it is a creature that lives where others die, a fish that can live without water.[2]

The significance of the human face at the center of each of the circles is also ambiguous. Yoruba art includes heads as symbols of sacrifice, and as representations of a watching god on Ifa divination boards and on beaded crowns (see cat. nos. 71, 69). It can also be interpreted as a crowned head, having the same general form but lacking the mudfish tendrils or feather extensions that are visible on the other ivory armlets and the terracotta figure in this collection (see cat. nos. 65, 73).

This armlet was part of the collection of Harry G. Beasley (1882–1939) at the Cranmore Ethnographical Museum, Chislehurst, Kent, England, until it was acquired in 1975 by Paul Tishman.

—BF

Notes

1. Drewal, in Ross 1992, p. 202.

2. Freyer 1987, p. 30.

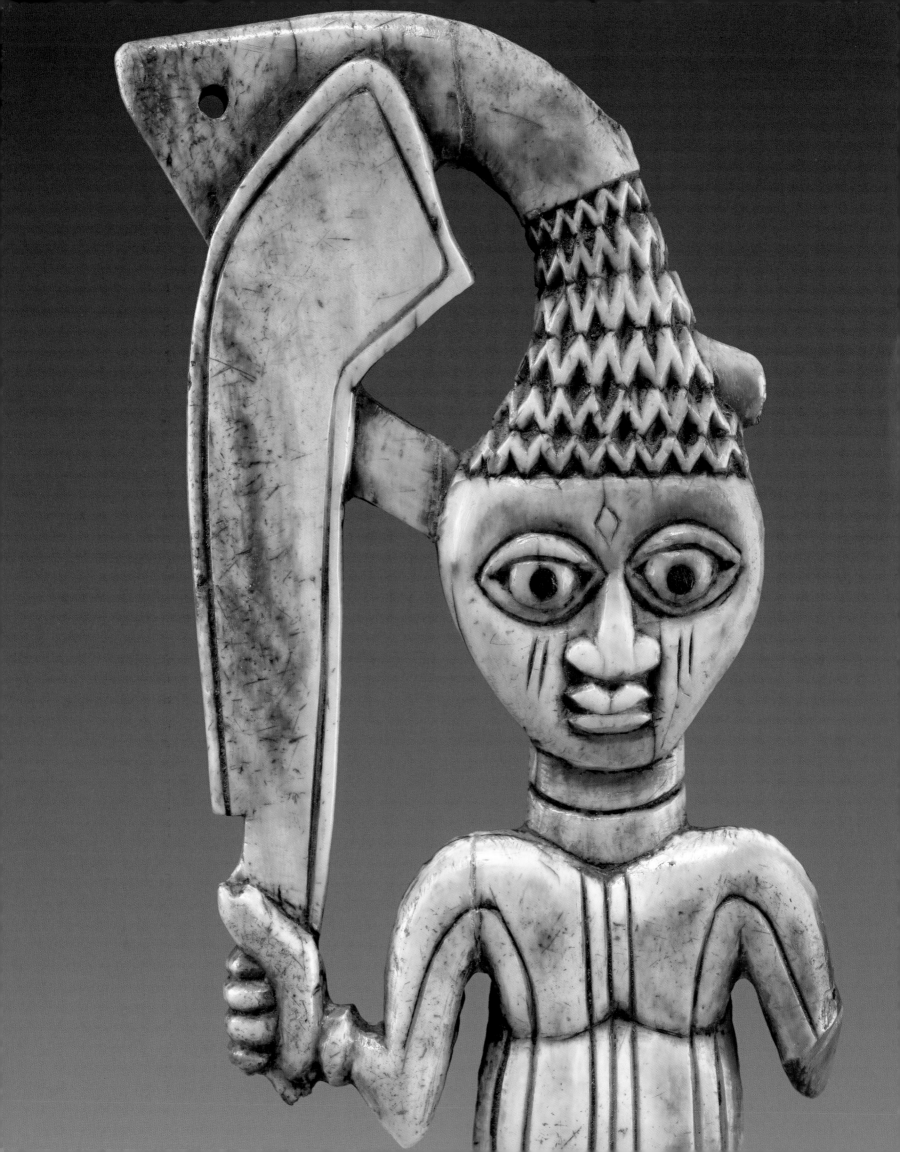

Ceremonial sword fragment

Yoruba peoples, Owo region, Nigeria

Late 19th century

Ivory

*22 x 11 x 1.5 cm
(8 11/16 x 4 5/16 x 9/16 in.)*

Gift of Walt Disney World Co., a subsidiary of The Walt Disney Company, 2005-6-80

Composite line drawing showing the Walt Disney-Tishman Collection ivory sword fragment as it would have appeared in an intact udamalore. *Drawing by Robin Poynor.*

The *udamalore* is a ceremonial sword worn by the Olowo, ruler of Owo, and his high-ranking chiefs. Although it can be made in a variety of materials—brass, iron, or wood covered with imported glass beads—ivory is both particularly prestigious and symbolically significant. According to local informants, the sword conveys that the wearer is considered well-born, mature, powerful, and influential.[1] To the Yoruba, these qualities are associated with the elephant.

Based on comparisons with three complete ivory swords,[2] this fragment is from the tip of the sword blade oriented with the head toward the point. It depicts a crowned figure holding a sword, with the hilt of a now broken second sword on his hip. Again based on present-day court custom and surviving swords, the waist sword is probably the ceremonial *udamalore*, while the raised sword is the practical *uda*. A Yoruba proverb stresses the need for keeping a firm grip on the sword when investigating a father's death.[3] Visually, the two swords are similar in profile; but they are different from another Owo ceremonial sword, the *ada,* which is carried by an attendant.[4]

The crown, with its vertically projecting stem (compare this to the conical crowns illustrated in cat. nos. 69, 74), was probably meant to represent

one made from coral beads similar to those found in the Owo court.[5] Again by comparison with surviving swords, it is likely that a representation of a bird had projected from the side of the cap as an attachment (the stub of its legs is visible). Miniature beaded birds are often present on royal crowns (as in cat. no. 69), where they allude to the ruler's ability not only to communicate with potentially dangerous spiritual powers but to control them.

—BF

Notes

1. Abiodun, in Drewal and Pemberton with Abiodun 1989, p. 109.

2. One sword is in the Celia Barclay collection; it was acquired in Owo by her father, Maurice Cockin, between 1911 and 1914. Another is part of the regalia of the Ojomo of Ijebu in Owo. The third was collected in Lagos, Nigeria, in the 1880s and is now in the British Museum (Poynor, in Vogel 1981, p. 133).

3. Abiodun, in Drewal and Pemberton with Abiodun 1989, p. 109.

4. Ibid.

5. See, for example, the series of photographs taken by Eliot Elisofon in 1959, in the Eliot Elisofon Photographic Archives at the National Museum of African Art, Smithsonian Institution.

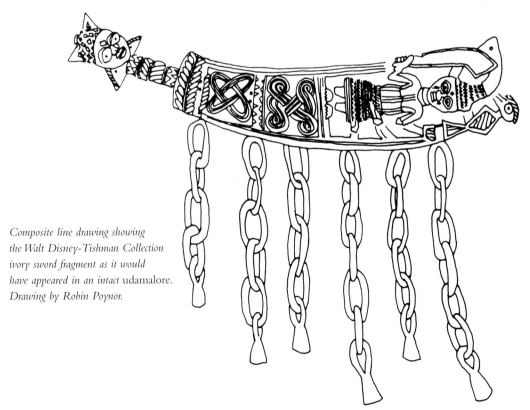

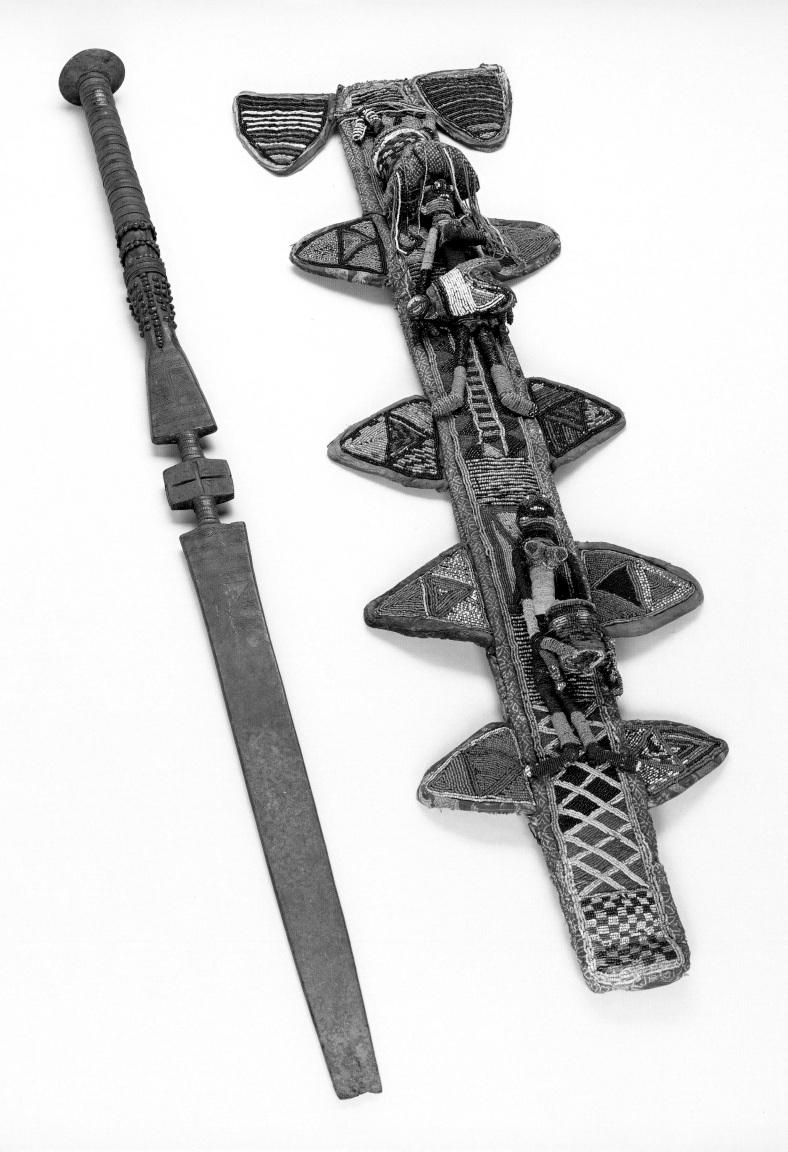

Staff and sheath for Orisha Oko

Yoruba peoples, Oyo region, Irawo village, Nigeria

Late 19th to early 20th century

Staff: iron, wood

152.4 x 9 x 9 cm
(60 x 3 9/16 x 3 9/16 in.)

Sheath: glass beads, cloth, wood

133 x 35.2 x 11.6 cm
(52 3/8 x 13 7/8 x 4 9/16 in.)

Gift of Walt Disney World Co., a subsidiary of The Walt Disney Company, 2005-6-71.1, 2005-6-71.2

Orisha Oko, though not as well known to foreigners as Eshu or Shango, is an important Yoruba deity, associated with the fertility of farms. He also has the power to aid in childbirth, cure the sick with herbal medicines, and protect his devotees from harmful spiritual forces. One of the essential objects associated with Orisha Oko is the iron staff that, ideally, is stored and honored with a cotton sheath decorated with imported glass beads over its entire surface.

Orisha Oko was never a king, but his staff is dressed as one. Some examples of such staffs in collections have miniature royal crowns at the top, although few of these additions have survived. Perhaps as a variation, the sheath shows the crown— in this example, a veiled crown worn by a female figure depicted on the front of the sheath. The crown is topped by a four-legged animal, possibly a horse as sign of royalty, rather than the more common bird form. Robert Farris Thompson proposed that the crowned woman may be "Oko herself, in one of her womanly avatars."[1] The female figure holds a bird that, like those found on crowns, might refer to control of the negative spiritual forces of the childless women who are called "our mothers" by circumspect Yoruba, so as not to anger them, or "witches" by the foolhardy[2] (see also the discussion of the potentially dangerous powers of post-menopausal women at cat. no. 75). However, wooden shrine figures and relief carvings both frequently depict women holding out chickens as sacrificial offerings. Note, too, that the female figure attached to the lower portion of the sheath is holding an open container, as though making an offering. Thompson suggested that the placement of the bird and container over the womb is significant,[3] perhaps reinforcing the connection of Orisha Oko with fertility and childbirth. The *orisha oko* staff and shrine are tended by a woman who is referred to as his bride.

Worship of Orisha Oko has a real physical connection to the village of Irawo, since only its blacksmiths forge his staff emblem. Individuals who seek to build a shrine to the god take ordinary iron farm hoes to be transformed into the god's icon.[4] This reworking of the iron results in a finer, denser metal. The staff form is constant, composed of a solid flat blade-form and rectangular center. A partially wooden upper shaft, wrapped and studded with metal, connects the lower part of the staff to the cone-shaped, solid-metal tip. These sections are referred to as parts of the god's body: the cone top is the head; the mid-point rectangle is the face with eyes. Of possible symbolic significance, and requiring close inspection, are the incised geometric patterns and zoomorphic motifs (birds, lizard, snake) that ornament both sides of the metal shaft and blade.

—BF | CMK

Notes

1. Thompson, in Vogel 1981, p. 98.

2. Ibid.

3. Ibid.

4. Picton, in Vogel 1981, p. 96.

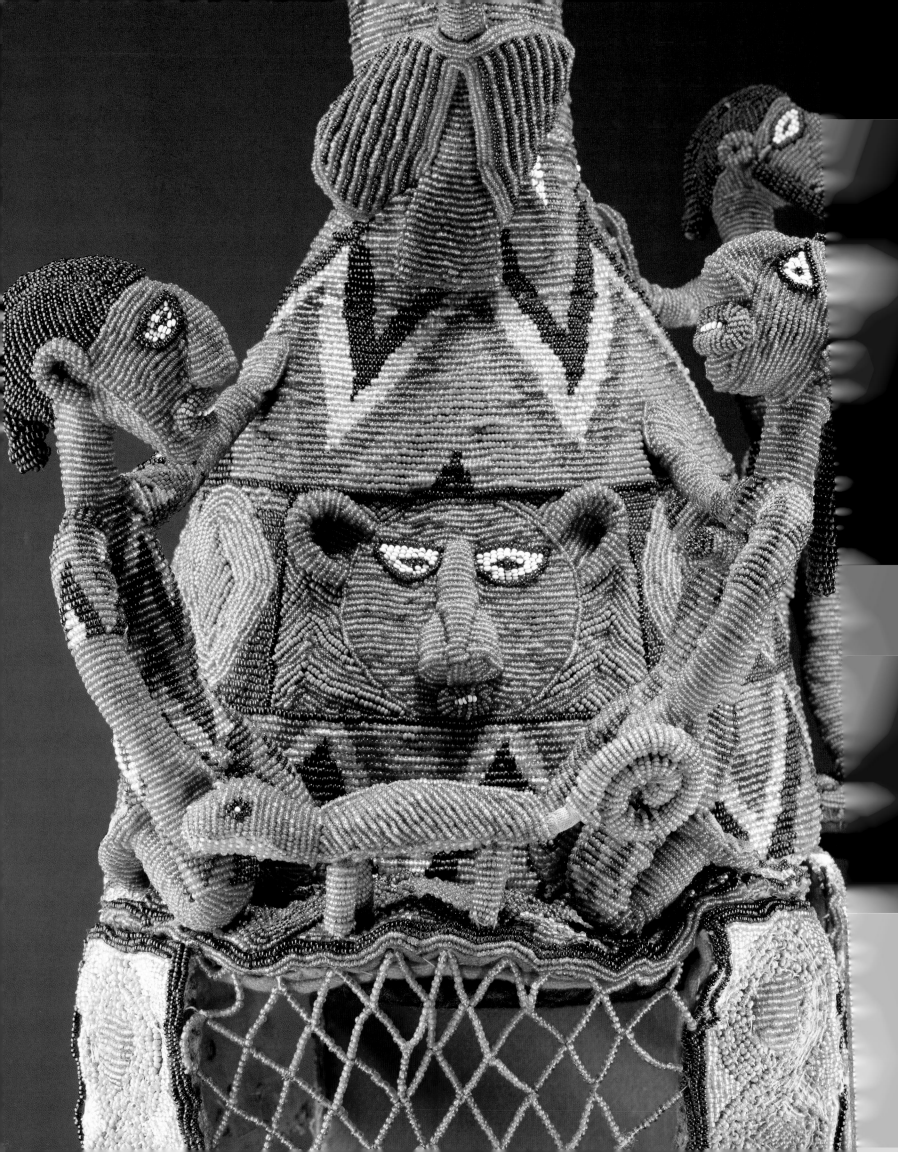

Crown

Yoruba peoples, Ekiti region, Ikere, Nigeria

Early 20th century

Glass beads, cloth, plant fiber, iron

63.5 x 81.3 x 35.6 cm
(25 x 32 x 14 in.)

Gift of Walt Disney World Co.,
a subsidiary of The Walt
Disney Company,
2005-6-72

The exceptional artistry of this beaded crown was praised by British scholar William Fagg, a luminary in the field of African art history who photographed the crown in 1959 at Ikere. Fagg proclaimed it "the finest known," in terms of its sculptural quality, "that appears to show awareness of certain sculptural innovations made by the great carver Olowe of Ise,"[1] active at the turn of the 20th century (see cat. no. 10). Fagg's comments draw attention to the large, three-dimensional attached figures that make this crown particularly rare and unique.[2]

Although it is from the palace of Ikere and is said to have been "worn by the Ogoga [king] in a dance at the annual New Yams Ceremony," Fagg questioned its attribution to "Ogoga Agabaola who reigned from about 1870 to 1880," a claim made by the king's senior wife.[3] That would have been far earlier than the time Olowe created the magnificent veranda posts, door, and lintel carved for the Ikere palace around 1910 to 1914.[4] Thus, the crown may have been made for king Agabaola's successor, Onijagbo Obasoro Alowolodu (r. 1890–1928). It seems less likely that Olowe could have been inspired by the early work of an innovative bead artist, but one must keep an open mind.

While there are many styles of beaded royal crowns, the conical-shaped crown with veil is the principal symbol of divine kingship among the Yoruba. There is also tremendous variation in terms of their beaded designs. In essence, the crown combines the powers of the living king and the ancestors; the patterns and colors of the beads proclaim the king's sacred power and authority. The beaded frontal face represents Oduduwa, founder and first king of Ile-Ife, the sacred first city of the Yoruba.

This is a typical element in most conical crowns, although the artist of this crown has atypically chosen to emphasize in high relief the nose and ears of the frontal face, making it stylistically similar to the features of the three-dimensional figures.

For the beaded attachments, two large figures adopting a respectful kneeling posture are placed frontally on the crown's visor, while a third figure, casually posed with one hand on hip, is attached to a flap along the side. Such large attachments are fairly rare, perhaps because they project out from the crown's surface and thus may fall off or be removed due to damage.

Small three-dimensional figures, especially birds, are often attached to the stem and top of beaded crowns—as they are here, with a bird at the top and another near the base of the crown's stem. The one at the very top is a reference to the positive and negative mystical powers of elderly women and to the king's "powers of supernatural surveillance"[5] that keep evil in check and thus protect his subjects. This crown departs from the norm again with the addition of several beaded chameleons: two at the top flanking the bird, and one placed between the two kneeling figures. In the creation myths of the Yoruba and other African peoples, the chameleon is said to be the first creature on earth, carefully walking about to test its readiness for human beings. With its prominent eyes, careful gait, and unique abilities to change colors, the chameleon serves as a metaphor in many parts of Africa for transformation and the powerful capacities that link the human world to the spiritual realm.

—BF | CMK

Notes

1. Fagg 1980, p. 27.

2. We are grateful to our colleagues Henry Drewal, John Pemberton, and Robert Farris Thompson for drawing our attention to William Fagg's observations and for commenting on other aspects of the crown's design.

3. Fagg 1980, p. 27.

4. Walker 1998, p. 60.

5. Thompson, in Vogel 1981, p. 102.

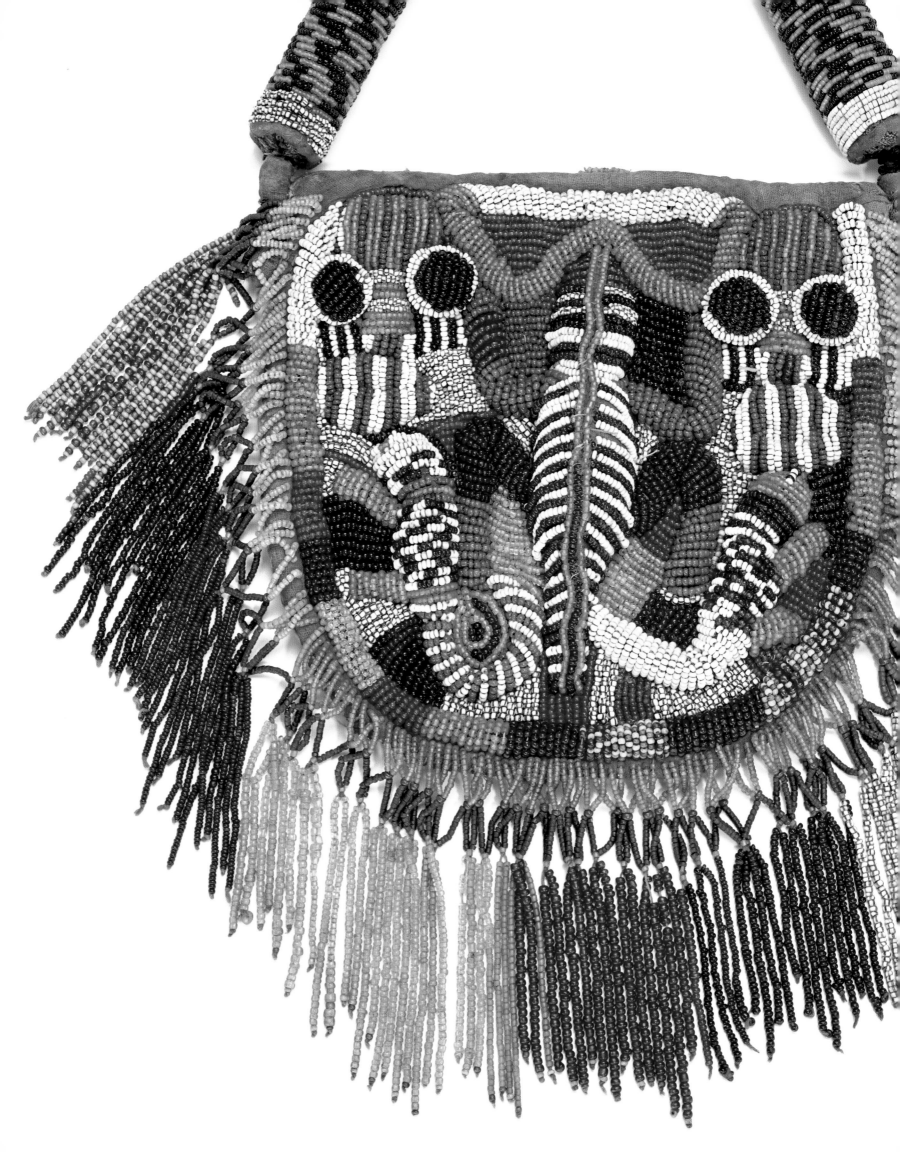

Diviner's bag

Yoruba peoples, Oyo region, Nigeria

Early 20th century

Glass beads, cloth

128.9 x 33 x 2.5 cm
(50 3/4 x 13 x 1 in.)

Gift of Walt Disney World
Co., a subsidiary of The Walt
Disney Company, 2005-6-70

Among Nigeria's Yoruba peoples, only kings and those few others who communicate with the gods are allowed to own totally beaded objects. Beaded bags, both single and double, are particularly associated with Ifa diviners. The sparkling brilliance of a beaded bag would signal that its owner was a successful practitioner; the bag's practical purpose was for carrying the 16 consecrated palm nuts or his other equipment (such as the more efficient, but not sanctified, diviner's chain of linked seed pods).

The meanings of the designs of this double bag are open to different interpretations. Perhaps since the devotees of all the gods consult Ifa diviners, the colored strands of beads forming this bag's fringe and shoulder strap refer to many of the gods in the Yoruba pantheon: alternating red and white beaded strands for Shango, the deity of thunder; white for the creator god Obatala; black for the messenger god Eshu; deep blue, yellow, and maroon for three of the river goddesses; and alternating beads of green and tan, which are associated with Orunmila, the god of destiny and divination.[1] The cylinder-strand construction of the strap suggests the form of both the diviner's necklace and the diviner's chain of linked seed pods that he throws down as part of the divination procedure.

The bag itself is decorated with high-relief figures that are rather difficult to discern amidst the myriad colors and patterns. At the center is a short-tailed animal fashioned out of blue and white beads for the body, and blue and red beads for the legs. It resembles a lizard, but the form has also been interpreted as a chameleon.[2] It is flanked by two similar creatures standing in profile, with curving tails. Although they look somewhat like leopards, they, too, might represent the chameleon, a symbol of transformation, credited in the creation myths of the Yoruba and other African peoples as the first being to set foot upon the earth before it had solidified and been made ready for human habitation. Its significance as a design motif here is open to question, given that in the Ijebu region, for example, the chameleon's threatening hiss is described as a curse, and its bulging eyes as all-seeing[3]—not inappropriate for guarding the bag's contents. Two faces with large bulging eyes decorate the upper corners of the larger panel, and one is placed centrally on the smaller beaded panel. Frontal faces also appear on Yoruba wooden divination boards (see cat. no. 71) and beaded royal crowns (see cat. no. 69), but on this bag these motifs appear exaggerated, perhaps due to a different artistic tradition or symbolic intent.

Finally, the bag's meaning might be linked to one of 256 divination verses chosen by the diviner. One must add to that the complexity of the tonal Yoruba language, which lends itself to puns.

—BF

Notes

1. Bascom, in Vogel 1981, p. 96.

2. See Fagg 1980, p. 60.

3. Drewal, in Drewal and Pemberton with Abiodun 1989, p. 120.

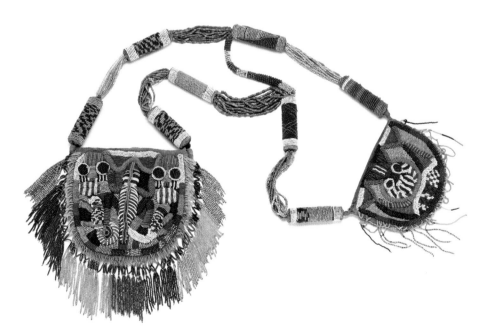

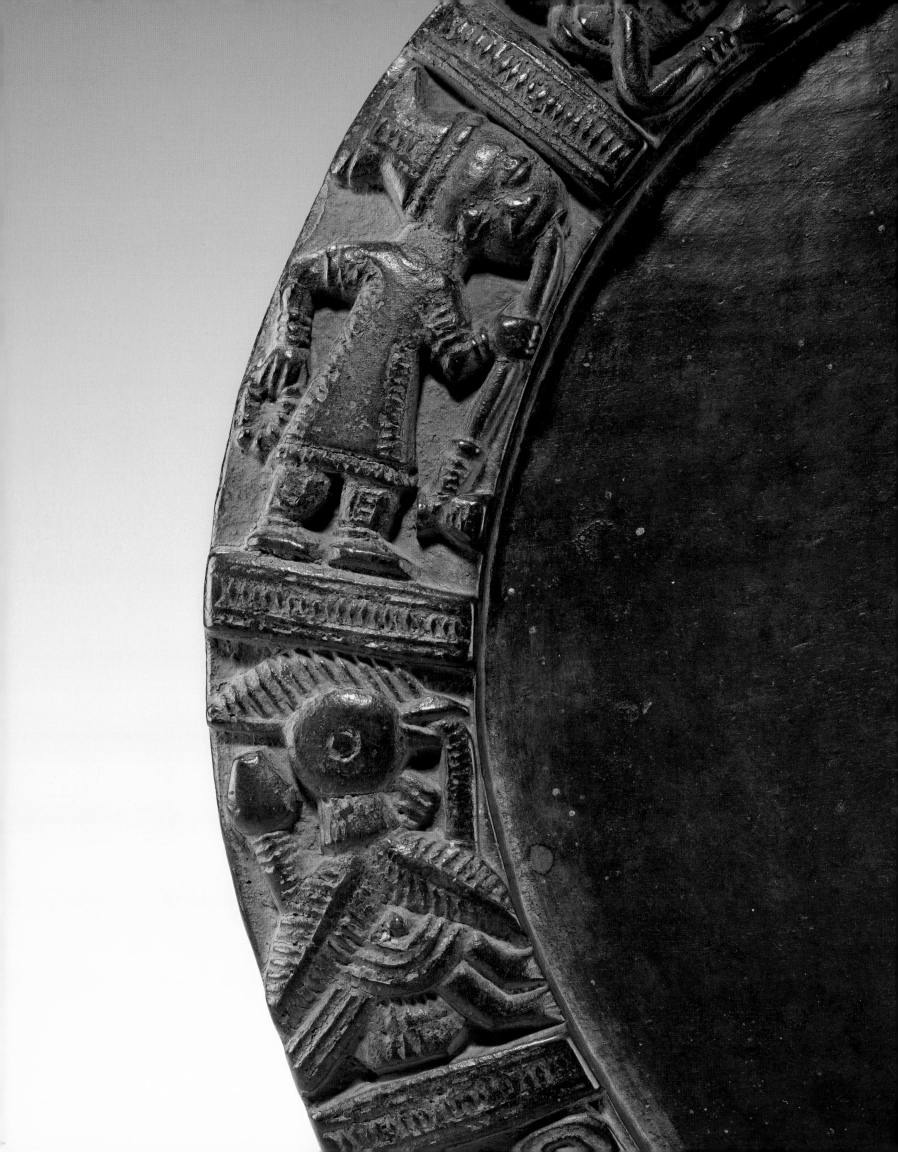

Divination board

Yoruba peoples, possibly Owo region, Nigeria

Late 19th to early 20th century

Wood

36 x 38 x 2 cm
(14 3/16 x 14 15/16 x 13/16 in.)

Gift of Walt Disney World Co., a subsidiary of The Walt Disney Company, 2005-6-69

Prominent in the art of the Yoruba are objects associated with divination. To deal with serious problems, a Yoruba goes to an Ifa diviner to consult Orunmila, the god of fate. The divination board, like other ornamented pieces of a diviner's regalia, is a sign of a successful diviner who can afford to commission objects.

During the consultation, a numerical pattern rather like odds-and-evens is obtained by repeated throws of 16 consecrated palm nuts or seed pods on a chain and recorded on the board. The diviner then recites the divination verse (one of 256) that is related to the resulting pattern, which suggests a sacrifice and a course of action. The board's low-relief images can refer to deities, sacrificial animals, or clients' problems. The face at the top of the board is a constant; it represents Eshu, the messenger who takes sacrifices to the gods and, as a trickster deity, is a force of chance and change. He also watches the diviner. The images in the next "frames," the heads

with triangular crowns on either side of the face, appear to have arms coming from their nostrils. The images next to them, the male figures smoking pipes—a rude gesture in certain circumstances—are in all likelihood full-figure representations of Eshu. The circular strand each of them holds is probably cowrie-shell currency, since Eshu is associated with markets as places of conflict and change. After them, the birds biting snakes suggest cosmic battles and sacrifices, as do the next rather ambiguous images. These have been described previously as mudfish;[1] but when inverted, they could be horned rams' heads with mudfish-like tendrils emerging from the mouth. At the bottom of the board, the curving mudfish flanking the crab are creatures able to move on land and in water, suggesting beings able to move in both the real and spiritual worlds. Similarly, the heads flanking the face of Eshu at the top of the board resemble mudfish and are images of kingship, since the king has power in both worlds. This motif is found elsewhere in Yoruba art and in the neighboring Benin kingdom, but instead of arms coming out of their nostrils, there are mudfish, serpents, or crocodiles emerging—a symbolic stream of power.

—BF

Notes

1. Bascom, in Vogel 1981, p. 94; Drewal and Pemberton with Abiodun 1989, p. 22, no. 14.

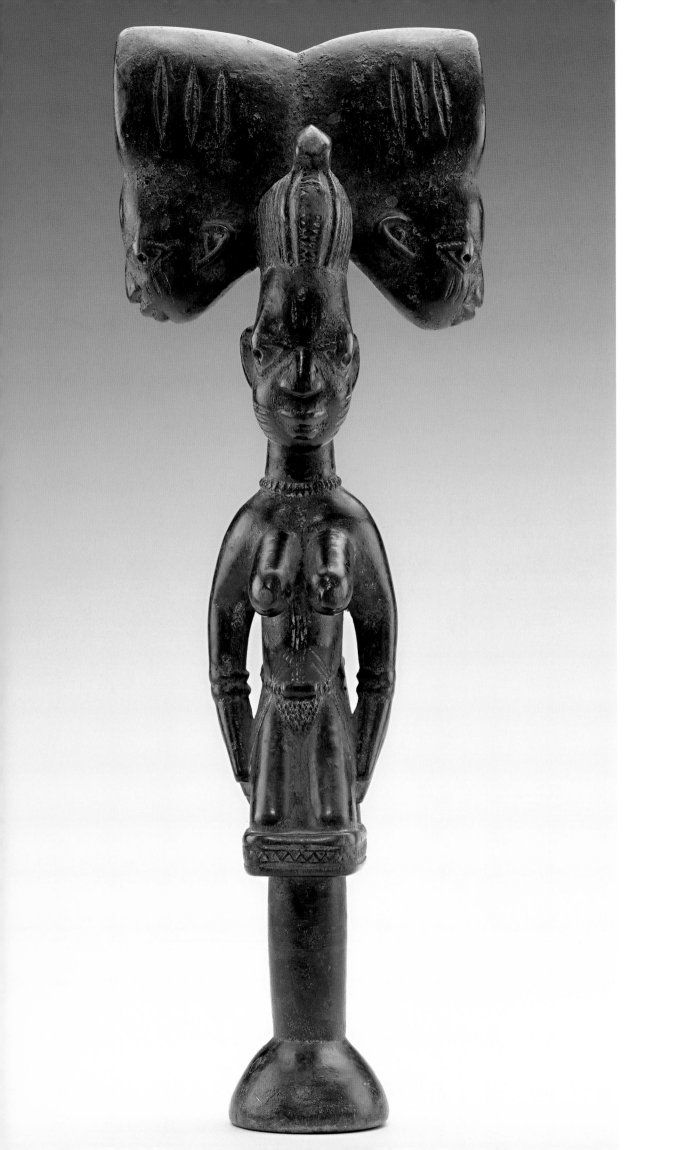

Staff

Yoruba peoples, Oyo region, Nigeria

Early 20th century

Wood, pigment

39 x 14 x 6.5 cm
(15 3/8 x 5 1/2 x 2 9/16 in.)

Gift of Walt Disney World Co., a subsidiary of The Walt Disney Company, 2005-6-67

Shango is the Yoruba god of thunder, and a deified former king of old Oyo. His most sacred symbol is the lightning bolt, manifested in the physical form of neolithic triangular stone axe blades said to be hurled to earth whenever lightning strikes. Just as a woman balances a load on her head, the composition of a Shango devotee's staff balances the seemingly contradictory aspects of the god Shango, who brings both destruction and new life. It combines the idea that Shango hurls thunderbolts to punish wrongdoers with the belief that he is generous, the giver of children, and the particular protector of twins. While less elaborate examples depict only two triangular forms on a shaft, many staffs depict a female devotee kneeling as if in worship while balancing on her head the double-axe motif that symbolizes the god's thunderbolts. The artist who carved this staff varied the image by transforming the axes into twin faces. This may be a visual pun, since the Yoruba call any cutting edge a face.[1] Given Shango's association with twins—it is not uncommon to find statuettes of twins on his altars—the double faces may also be an allusion to twins.

Also on the staff, the carved representations of a necklace and bracelets refer to the alternating red and white glass beads that are worn by Shango devotees in real life[2] and are often strung on staffs and figures honoring this Yoruba deity.

—BF | AN

Notes

1. Lawal, in Vogel 1981, p. 92.
2. Ibid.

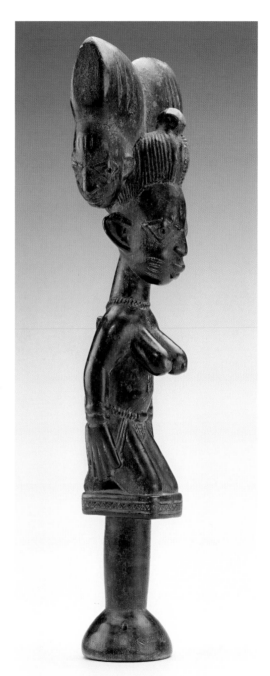

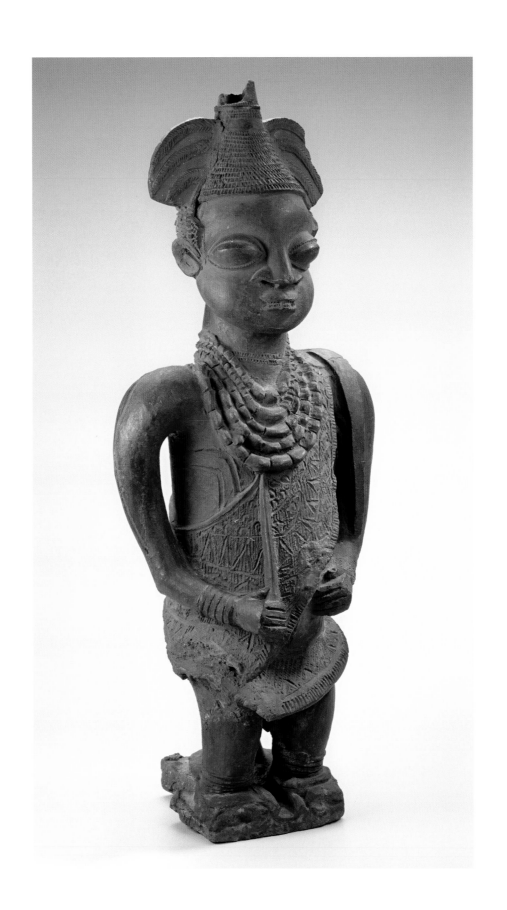

73

Male figure

Yoruba peoples, Nigeria

Date unknown

Terracotta

76.2 x 31.12 x 25.10 cm
(30 x 12 1/4 x 9 7/8 in.)

Gift of Walt Disney World Co., a sub-sidiary of The Walt Disney Company, 2005-6-73

The Oshugbo (or Ogboni) society—the name difference being a regional variation—consists of the oldest and wisest men and women in a Yoruba community. They settle disputes and balance the power of the king. Their authority is based on that of the original founders of the group and the community represented by figures known as *onile,* "owner of the house." This *onile,* an unusual, large terracotta figure, may have formed a pair with a similarly styled kneeling female figure (now at the Afrika Museum, Berg en Dal, The Netherlands). More common are pairs of figures cast in copper alloy, which are known from publications and collections; in addition, as Henry Drewal reported, concrete has been used for figures in Oshugbo lodge courtyards in the Ijebu region, replacing earlier clay examples.[1]

The Oshugbo connection is conveyed by the swelling eyes and forehead of this figure, comparable to the spirit-filled possession seen in the Oshugbo staff emblems (see cat. no. 75). The patterned sash over the shoulder is also associated with Oshugbo. Its placement in this sculpture introduces an element of time. Normally in daily life, the Yoruba give preference to their right hand; Oshugbo members show their special spiritual status by giving preference to their left. Drewal noted that members place their ceremonial sashes on their right shoulders during rituals so as not to impede their active left hand.[2] Here, apparently, this figure with its left shoulder covered is portrayed outside the context of participation in a ceremony. The feathered headdress and the seated pose (the figure is seated on a cylindrical stool) indicate his special leadership role in the Oshugbo society; and the use of a stool is a particular sign that he was appointed to represent the local ruler. This individual chosen by the Oshugbo society literally "sits" in place of the ruler, who traditionally does not attend Oshugbo ceremonies in person.[3]

—BF

Notes

1. Drewal, in Drewal and Pemberton with Abiodun 1989, p. 136.

2. Ibid., p. 140.

3. Ibid., p. 138.

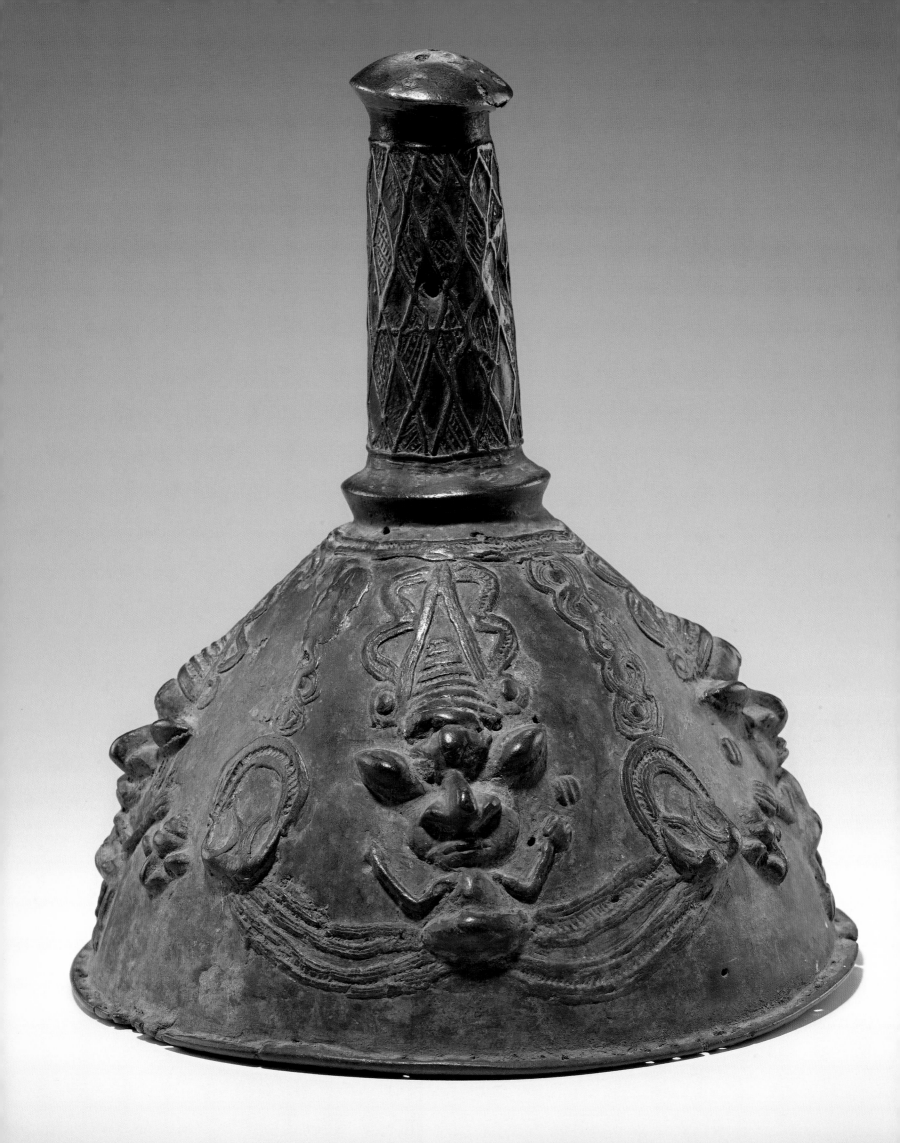

74

Crown

Yoruba peoples, Nigeria

Late 19th to early 20th century

Copper alloy

*23.50 x 19.37 x 21 cm
(9 1/4 x 7 5/8 x 8 1/4 in.)*

*Gift of Walt Disney World Co., a subsidiary of The Walt Disney Company,
2005-6-74*

Metal crowns were documented among Yoruba rulers in the Ekiti, Igbomina, and Ijebu regions during the 1960s, but the tradition is much older, having been mentioned in 16th-century foreign accounts and local oral traditions.[1]

The metal crowns bear certain similarities to Yoruba glass-beaded crowns (see cat. no. 69), including the presence of a vertical structural projection and a motif of a frontal face. On this cast copper-alloy crown, the largest motifs are four highly stylized figures, with eyes that are enlarged and in higher relief. They stare in four directions and are said to represent the all-seeing gods or ancestors. The protruding eyes also signify when the inner or spiritual eye takes the place of ordinary sight. This is comparable to the depiction of the eyes in Oshugbo-related objects (see cat. nos. 73, 75), and the shape of the crown is similar to those depicted on *edan* sculptures (copper-alloy castings on iron spikes joined by a chain, an Oshugbo member's insignia of office), leading one to wonder if the function of the crown might be associated with the Oshugbo society. Clearly indicated male genitalia are present on two of the figures; the other two are probably male, and have linear bands that terminate in what seem to be mudfish for legs. This refers to

supernatural powers in two realms, land and water—or reality and spirit—since the mudfish, a composite of several species, can survive for some time out of water. Miniature heads float in between the main figures; and worn bands of knot (endless loop) patterns provide further decoration. At the bottom of the crown is a narrow flange that is pierced all the way around with small holes, which may have once held a chain veil. The stem and top are also pierced with fewer, but larger holes, possibly for feathers or some other ornament.

The basic form of the crown depends on the underlying Yoruba belief that spiritual power is focused in the head of a special human or a deity and can project from it, like a blade or horn or halo. In African art generally, and Yoruba art in particular, this is shown in hairstyles or in crowns, hats, and headdresses. The vertically projecting stem of this crown could allude to this spiritual power in the wearer's head, and also indicates that the wearer's status puts him above ordinary chores, such as carrying loads on one's head.

—BF

Notes

1. Thompson 1970, pp. 13-15.

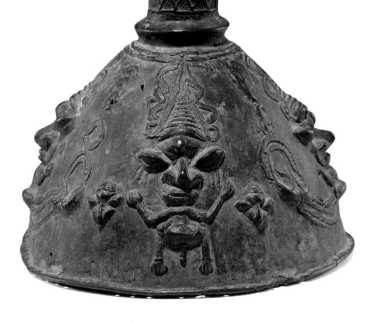

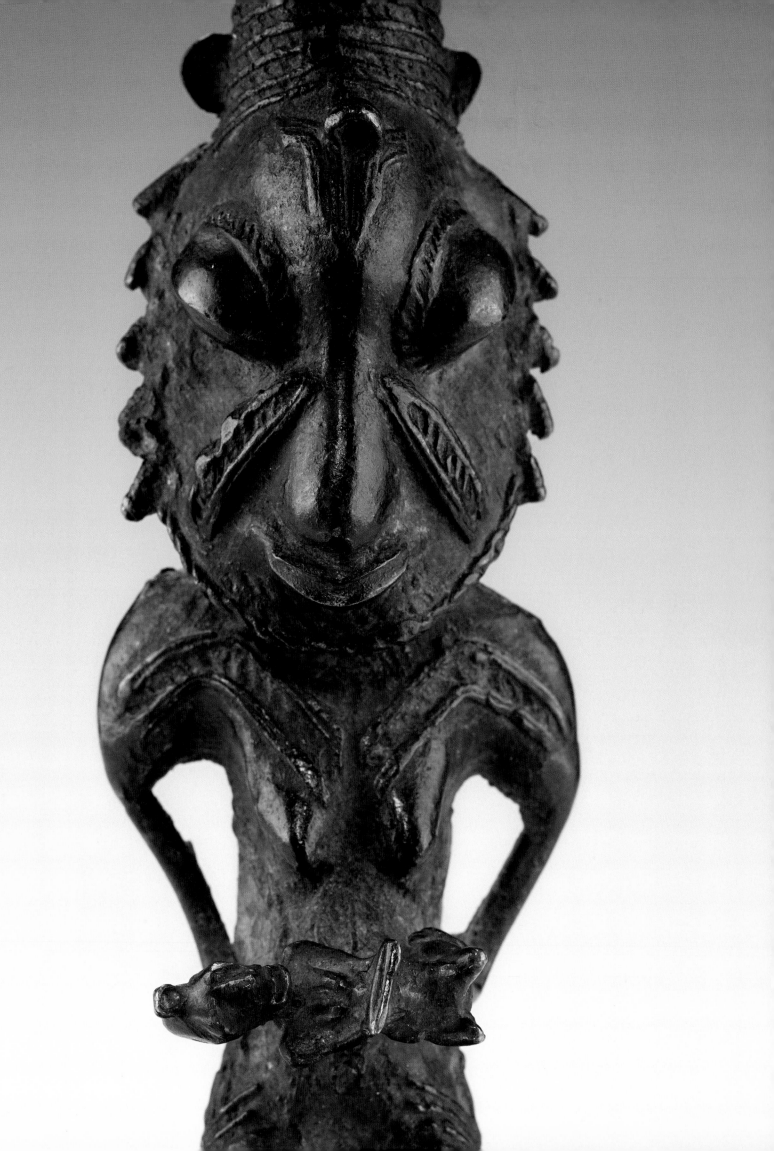

75

Staff

Yoruba peoples, Ijebu region, Nigeria

Early 20th century

Copper alloy, iron

24 x 6.6 x 5 cm
(9 7/16 x 2 5/8 x 1 15/16 in.)

Gift of Walt Disney World Co., a sub-
sidiary of The Walt Disney Company,
2005-6-66

Originally, this was one of a pair of linked male and female figural staffs made of copper alloy over an iron-rod core. The pair was worn in public, draped around the neck of Oshugbo society members who were elders in the community. The staffs served as insignia of office, and as protective amulets. They could also be used to summon individuals to judgment, or act as warning notices, boundary markers, or symbolic locks in a dispute.[1] Oshugbo had important judicial, political, and religious roles in the community, representing not only the balance of people and king but of male and female. While some staff pairs are fashioned only as heads atop metal rods, many have bodies that display distinct sexual characteristics. Although the figure shown here has breasts and holds a smaller kneeling figure, it does not have clearly indicated genitalia.

The figure's bulging eyes and forehead are also stylistic constants in Oshugbo-related art, and are meant to evoke a head literally swelling with spiritual presence.[2] The members' judicial and political duties are mandated by spiritual power, not worldly ambition or competition. At the base of the figure is a bird, another sign of spiritual power. Birds are associated with individuals whose spiritual powers can harm, usually women past child-bearing age, for such women can transform themselves into nocturnal creatures such as birds to conduct covert activities. The fact that this figure appears to be bearded and female can be another reference to a post-menopausal woman who has grown facial hair and attained supernatural powers, since the Yoruba describe an elderly woman with facial hair as one of "our mothers."[3] Birds are also visually linked with those individuals who can control powerful spiritual forces, as suggested by the addition of bird motifs on kings' crowns, and on herbalists and diviners' iron staffs.

—BF

Notes

1. Drewel, in Drewal and Pemberton with Abiodun 1989, p. 140.

2. Drewal, in Vogel 1981, p. 90.

3. Ibid., pp. 90–91.

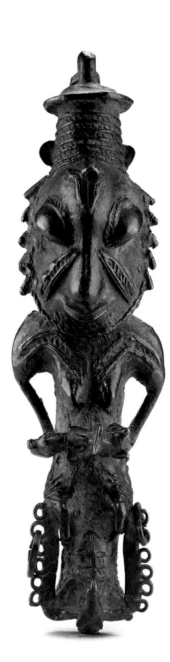

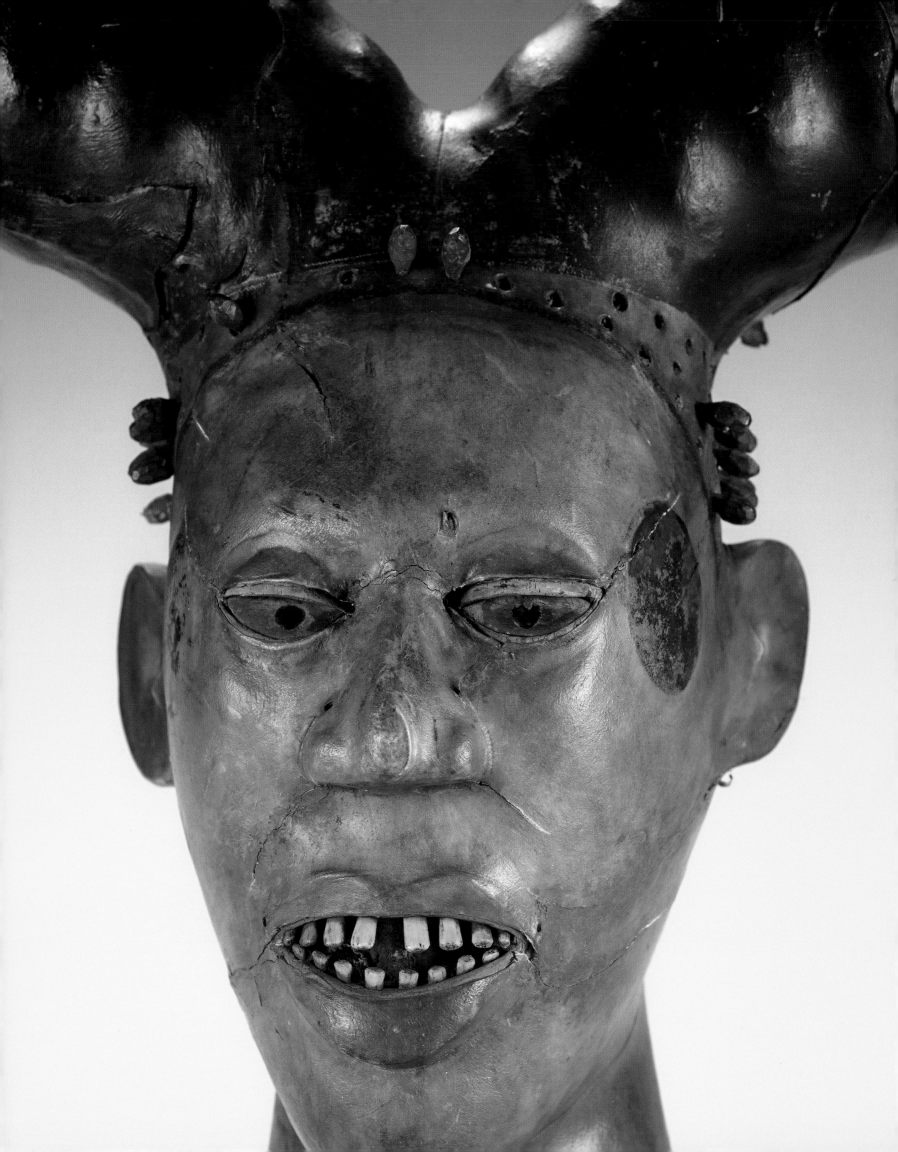

Mask

Possibly Efik peoples, lower Cross River region, Calabar area, Nigeria

Early 20th century

Wood, skin, plant fiber, bone, dye

*41.9 x 83.8 x 21.9 cm
(16 1/2 x 33 x 8 5/8 in.)*

Gift of Walt Disney World Co., a subsidiary of The Walt Disney Company, 2005-6-1

Skin-covered masks in Africa are found primarily in southeastern Nigeria and western Cameroon. They are some of the most powerful and expressive African art forms, as exemplified by this crest mask attributed to the Efik peoples of the lower Cross River region. It would have been worn on top of the head, with a voluminous fiber or cloth costume completely covering the head and body of the masked performer.

The facial features of this mask are realistically portrayed. It has an arresting gaze through partially opened eyes, a prominent nose with flared nostrils, and an open mouth exposing widely spaced teeth. The most striking feature of the mask is the coiffure, represented by two large, downward-curving, hornlike spirals projecting from either side of the head. Though exaggerated, the hairstyle is a variation of one worn by young women of the area during coming-of-age rituals, according to Keith Nicklin.[1] The visual power of these dramatic shapes is exceptional, and reflects the unique vision of a particularly gifted artist. Nicklin, a specialist on the skin-covered mask traditions of southeastern Nigeria, speculated that this mask was the work of Etim Bassey Ekpenyong, an Efik carver of some distinction who is credited for a mask that appears in the Hollywood movie *The Wizard of Oz*.[2]

There does not seem to be scholarly consensus regarding the importance of skin—often identified as antelope skin—as a masquerade material in Nigeria's Cross River region. In addition to its visual potency, skin may hold symbolic values linked to the wilderness, to the aggressive qualities of powerful and successful men, or to the potential to tap into the world of the spirits.

—CMK | AN

Notes

1. Nicklin, in Vogel 1981, p. 167.

2. Ibid., pp. 167–68.

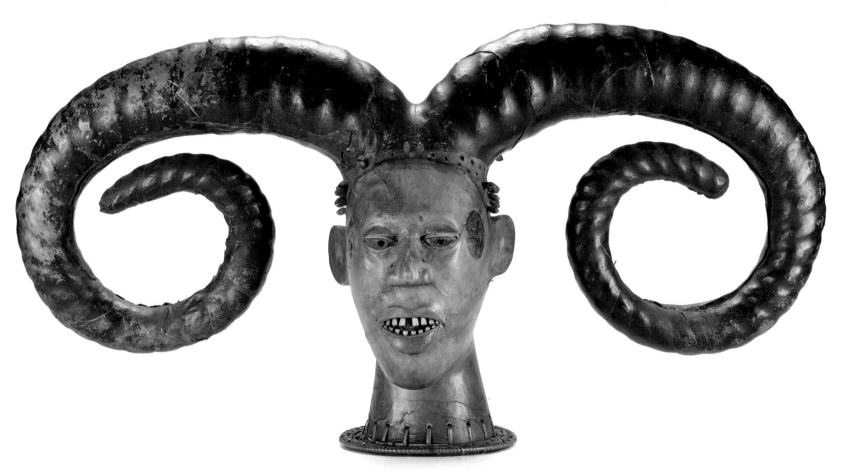

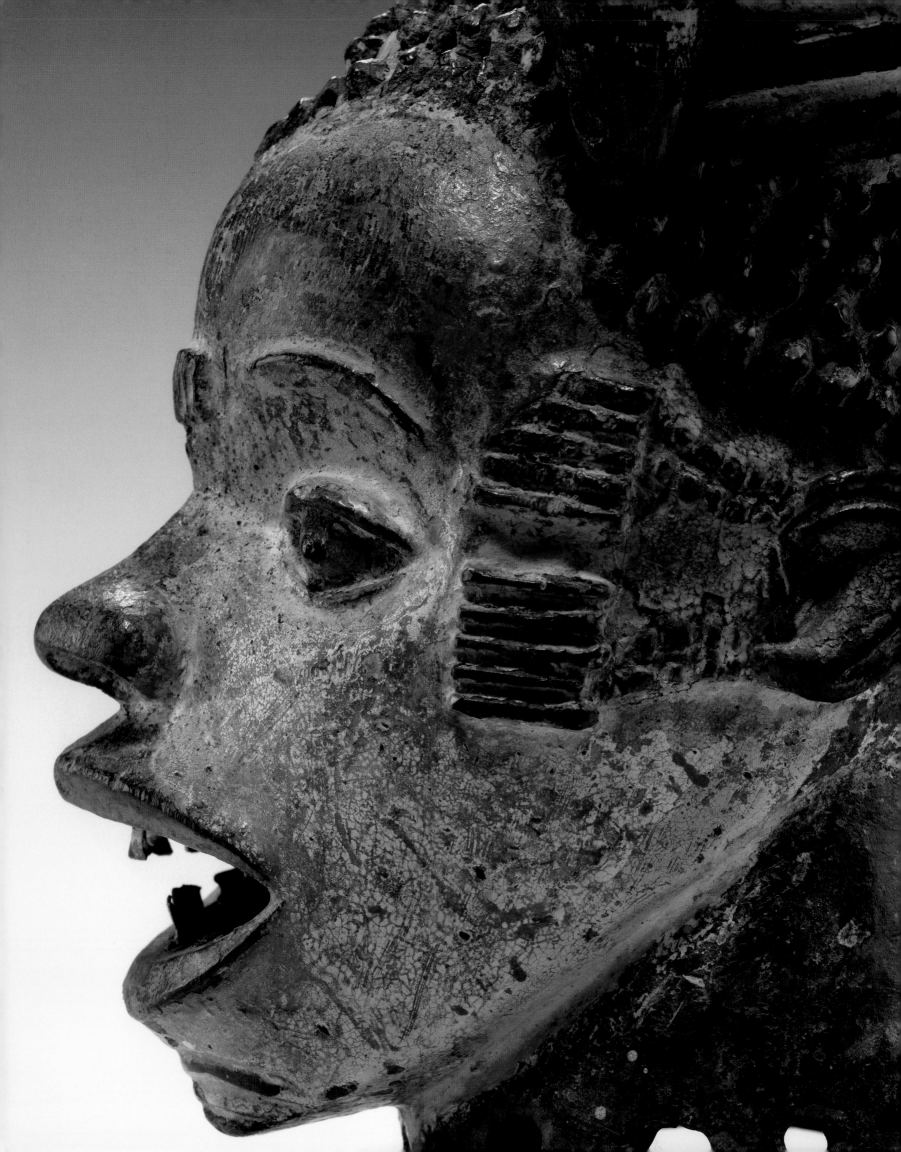

77

Mask

Boki peoples, middle Cross River region, Nigeria

Late 19th to early 20th century

Wood, paint, metal

*39 x 20.3 x 26.5 cm
(15 3/8 x 8 x 10 7/16 in.)*

Gift of Walt Disney World Co., a subsidiary of The Walt Disney Company, 2005-6-90

This mask's expressive features and naturalism forge a stylistic link to the tradition of skin-covered masks found among several Cross River groups. However, instead of skin, this mask is covered with red, black, and white pigment. Ideals of feminine beauty are conveyed through the mask's carefully delineated facial features and dramatic coiffure. The tufted hairstyle is enhanced by the gracefully curving horns that rise up from the head. Thick conical forms inserted just above the temples at the base of the horns suggest hair ornaments.

Though considerably smaller in size than many skin-covered masks, this crest mask—attributed to the Boki—has enormous visual appeal. In its performance contexts, particularly the funerary celebrations of men's traditional warrior or age-grade associations,[1] this mask would have been awe-inspiring.
—CMK | AN

Notes

1. Nicklin, in Vogel 1981, p. 168.

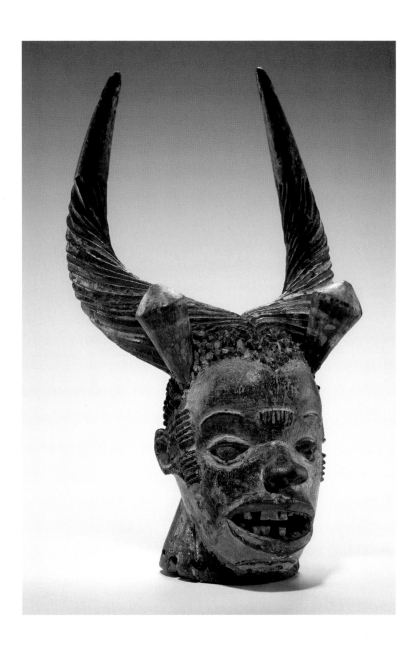

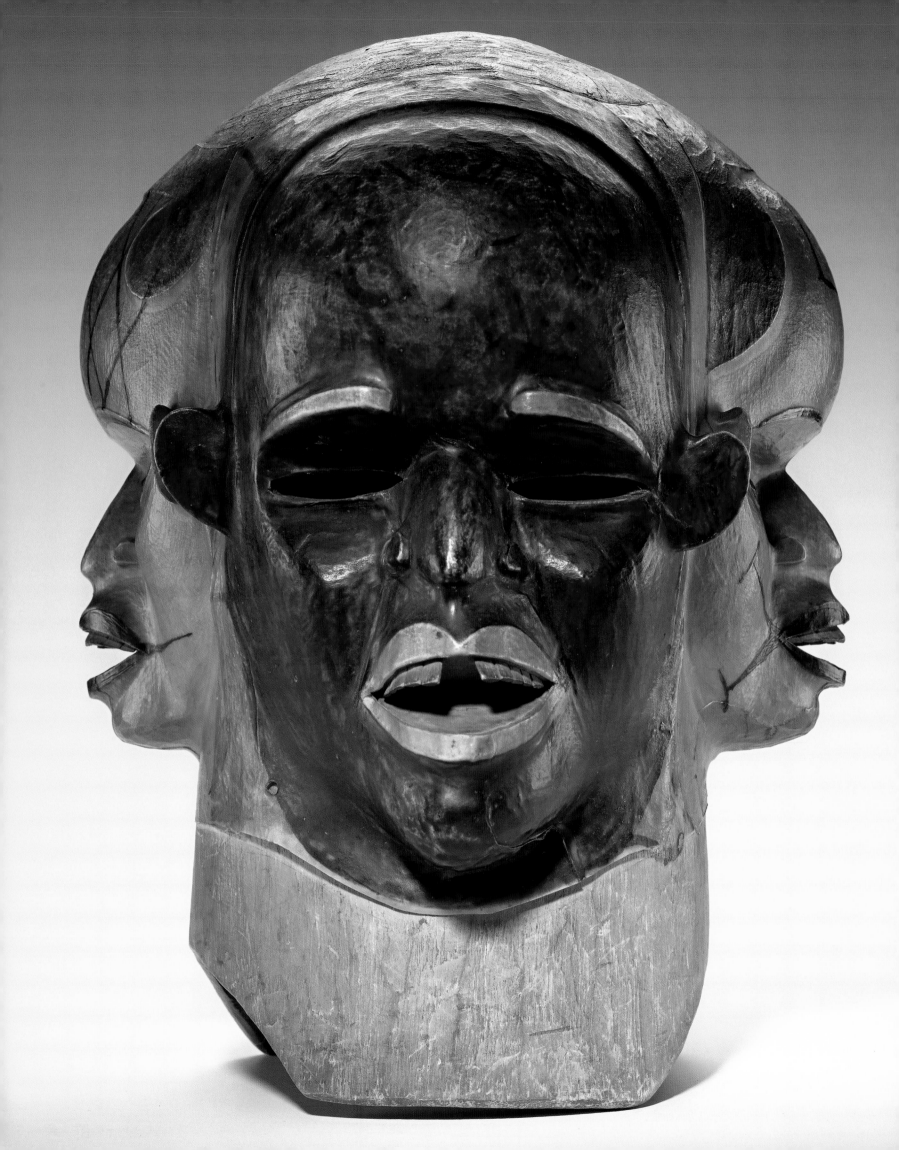

Mask

Attributed to Takim Eyuk (died c. 1915)

Akparabong peoples, Cross River region, Nigeria

c. 1900–15

Wood, skin, dye, iron

*39 x 39 x 33 cm
(15 3/8 x 15 3/8 x 13 in.)*

Gift of Walt Disney World Co., a subsidiary of The Walt Disney Company, 2005-6-92

This skin-covered wooden helmet mask is composed of four faces—one male, painted a dark brown, and three female, distinguished by their lighter coloration. Thin linear patterns, suggesting body ornamentation, emphasize the swelling forehead and draw the eye to the thickly painted hairline. The facial features are carefully modeled. Based on style, this mask was tentatively attributed to Takim Eyuk, an Akparabong carver believed to have died around 1915, whose work also appears in the National Museum, Lagos, and in the Seattle Art Museum's Katherine White collection.[1]

The production of skin-covered masks flourished in the Cross River region during the late 19th century, a result of increased trade in palm oil that brought prosperity to the region and wealthy patrons able to commission masks and to sponsor their performances.[2]

—AN

Notes

1. Nicklin, in Vogel 1981, p. 174.
2. Ibid.

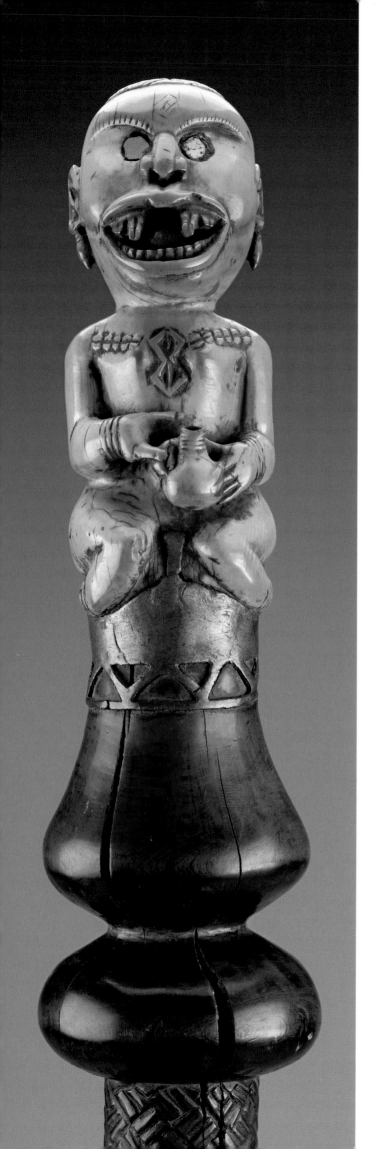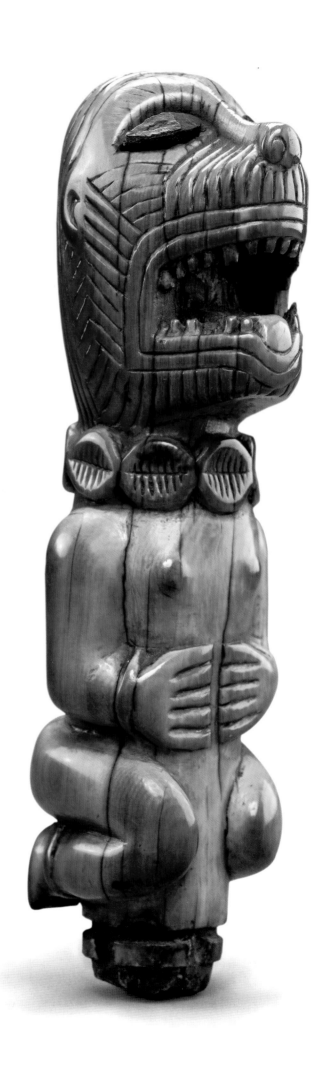

Staff

*Kongo peoples, Democratic Republic
of the Congo*

19th century

Ivory, wood, metal, ceramic

*78.5 x 11 x 10.2 cm
(30 7/8 x 4 5/16 x 4 in.)*

*Gift of Walt Disney World Co., a sub-
sidiary of The Walt Disney Company,
2005-6-32*

LEFT

Staff finial

*Kongo peoples, Mayombe region,
Democratic Republic of the Congo*

19th century

Ivory, iron

*19 x 5.5 x 6 cm
(7 1/2 x 2 3/16 x 2 3/8 in.)*

*Gift of Walt Disney World Co., a sub-
sidiary of The Walt Disney Company,
2005-6-33*

Among the Kongo, carved staffs embellished with exquisitely carved ivory finials conveyed numerous symbolic references to the ruler's political and spiritual powers and responsibilities. Originally, the animal-headed finial at the left would have topped a wooden staff. Its form may be that of a snarling animal, either feline[1] or canine; one feline form that appears often is that of a spotted civet cat or a leopard, animals associated with chiefly authority in much of central Africa. Alternatively, Robert Farris Thompson has suggested that the figure represents a ritual leader whose head becomes that of a dog, a symbol for a medium or a hunter of unseen forces.[2] Regardless, the animal head combined with a human body suggests transformative power, perhaps as part of spirit possession, and may well represent a leader-medium's search for hidden knowledge. The pose with fingers over stomach is assumed by the spiritual guide when putting difficult questions to an individual or group.[3] The bared teeth convey the aggressive power of rulers well-equipped to confront evil. The inlaid eyes suggest the ability to see into the spirit world, while the cowrie-shell necklace is believed to symbolize the ritual capacity to cross between this world and the next.[4] However, all these powers are balanced by the kneeling posture, which suggests respect and humility.

Similarly, the ivory finial on the staff at the far left conveys respect through its kneeling pose. It depicts a woman holding a vessel as though formally offering the contents, perhaps palm wine or water, to a ruler or elder or, in the case of a marriage ritual, to the gathered community.[5] Whatever the specific context, hospitality and appropriate decorum are reinforced through this image. The finial rests atop a staff composed of carved spheres and interlace patterns that Thompson suggested may have symbolic meanings associated with significant events in a ruler's reign and the unifying web of the community itself.[6]

—BF|CMK

Notes

1. Cornet, in Vogel 1981, p. 212.

2. Thompson, in Kerchache 2001, p. 199.

3. Ibid.

4. Ibid.

5. Thompson, in Vogel 1981, p. 212; noted also in Thompson, in Kerchache 2001, p. 202.

6. Ibid.

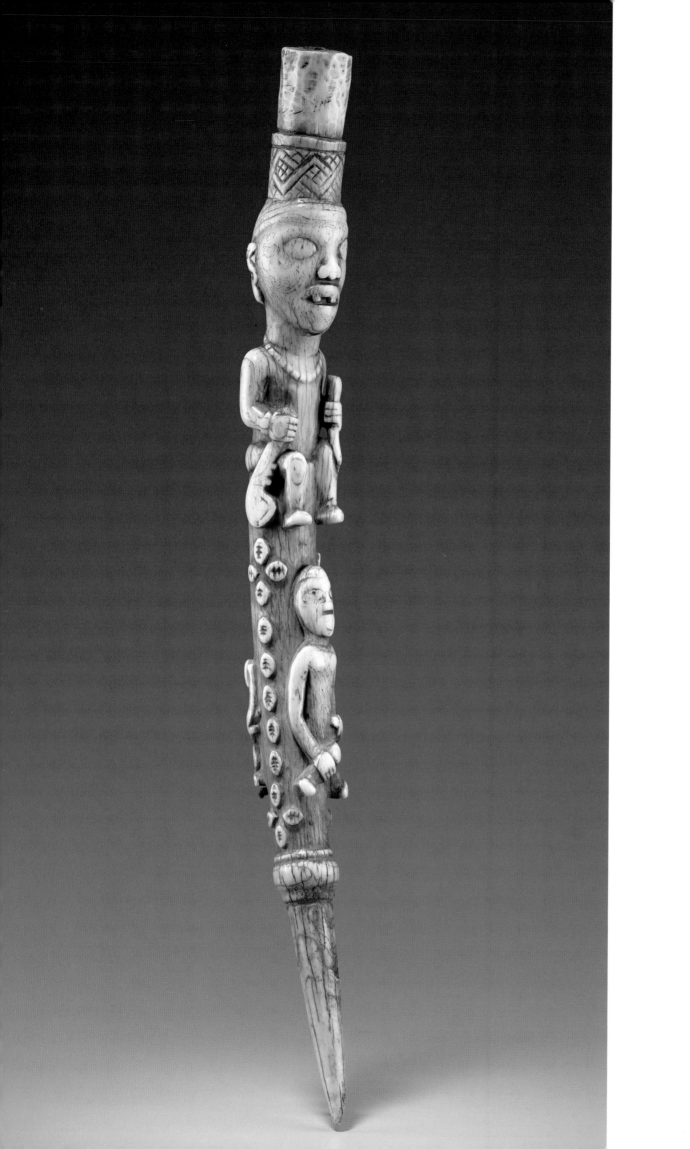

Flywhisk handle

Kongo peoples, Democratic Republic of the Congo

19th century

Ivory

*37.8 x 4 x 3.5 cm
(14 7/8 x 1 9/16 x 1 3/8 in.)*

Gift of Walt Disney World Co., a subsidiary of The Walt Disney Company, 2005-6-108

Part of a ruler's regalia, this flywhisk handle once had a buffalo tail attached to its upper end.[1] The depiction of a seated ruler carved with indicators of royal authority—fiber cap, elaborate coiffure, beaded necklace, armlets, whisk, and knife—further emphasized the status conveyed by the use of ivory. The smaller figure below may be a female figure holding a musical instrument (rattle), possibly suggesting the support of the matrilineal line.[2] The elephant carrying a rooster alludes to a migration myth relating to the founding of the Kongo kingdom.[3] The handle's sides are ornamented with cowrie shells; they may signify wealth, for cowrie shells were used as currency in the past in many parts of Africa, and are also a widespread symbol for female fertility.

—BF | CMK

Notes

1. Volavka, in Vogel 1981, p. 206.

2. Duponcheel 1980, p. 5.

3. Volavka, in Vogel 1981, p. 206.

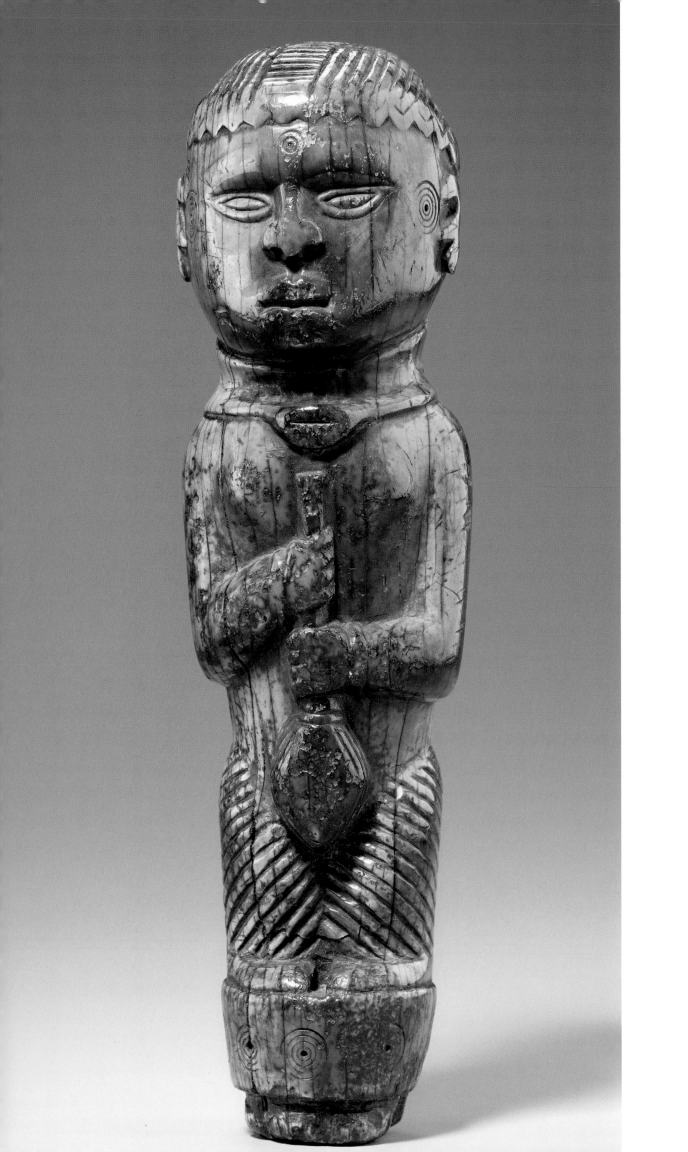

Staff finial

Kongo peoples, Democratic Republic of the Congo

19th century

Ivory

*17.8 x 5 x 5 cm
(7 x 1 15/16 x 1 15/16 in.)*

Gift of Walt Disney World Co., a subsidiary of The Walt Disney Company, 2005-6-109

This ivory figure has been interpreted differently by scholars and specialists of Kongo art and culture. Robert Farris Thompson stated that while on a field expedition with Cornet and other members of the Institut des Musées Nationaux du Zaire, he "came across a woman in a village . . . grinding manioc in a mortar, like the woman represented here."[1] Her stance plus other visual elements—the concentric circles on the figure's brow, temples, and base, and the grooved parallel incisions on its legs—point to this figure as a symbol of sustenance and social continuity.[2]

Alternatively, central African art specialist Marc Leo Felix believes that the figure is holding some kind of mace or scepter. He has observed that the gender of the figure is not clear, because both men and women wore loincloths (suggested by the grooved incisions around the hips and legs). Furthermore, the coiffure depicts a wig or hairstyle probably worn by both men and women in the Kongo since the 18th century.[3] The function of the figure is uncertain, but its prestigious material—ivory—and its grooved base suggest that it may have served as part of a flywhisk or staff for a Kongo ruler or notable, signifying power and status.

—AN

Notes

1. Thompson, in Vogel 1981, p. 208.

2. Ibid.

3. Marc Leo Felix, e-mail to the author, June 28, 2006.

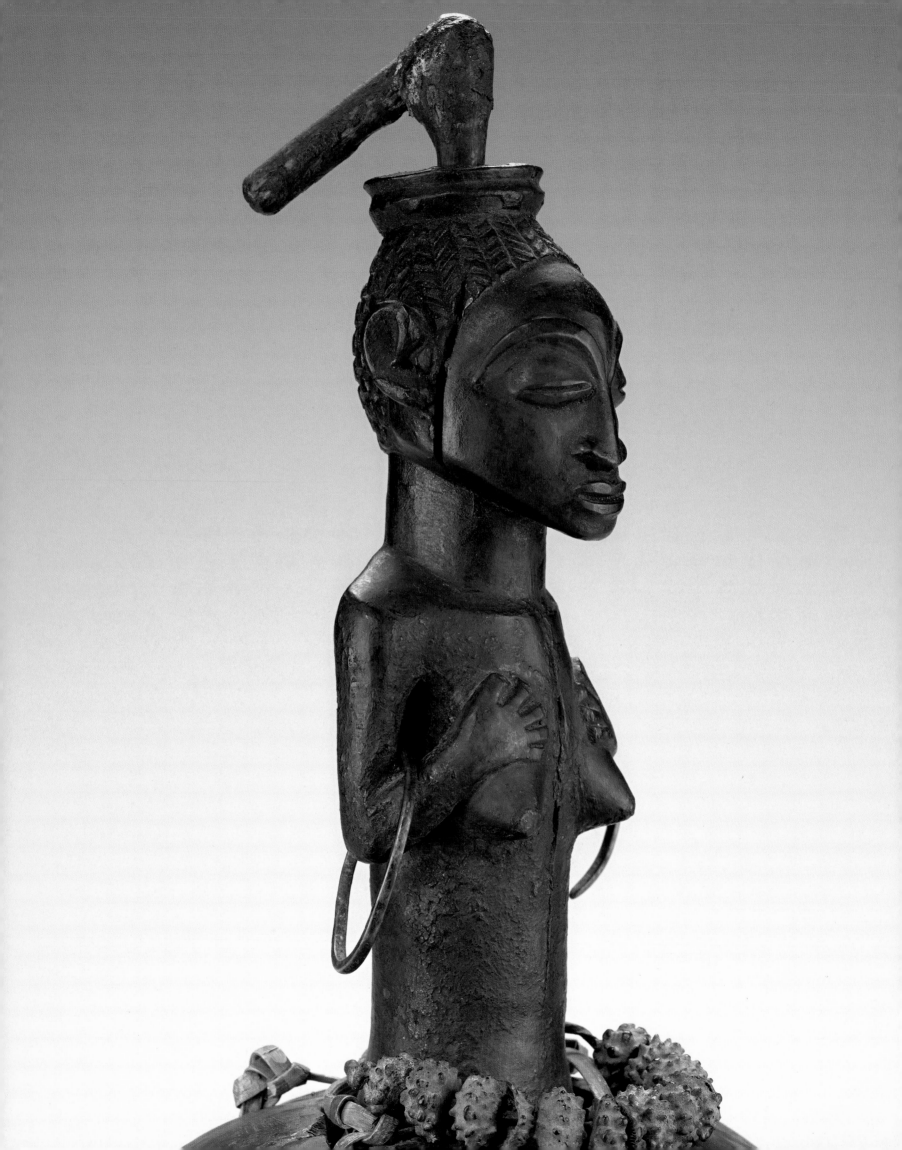

Female figure on a gourd

Luba peoples, Democratic Republic of the Congo

Late 19th to early 20th century

Wood, gourd, seeds, metal, plant fiber

*40.6 x 20.3 x 20.3 cm
(16 x 8 x 8 in.)*

Gift of Walt Disney World Co., a subsidiary of The Walt Disney Company, 2005-6-115

This female figure on a gourd is an outstanding example of the blending of Luba and Hemba styles. The gently rounded face with large coffee-bean-shaped eyes, high-arched brows, aquiline nose, and finely delineated lips conveys the essence of serenity.

The gourd and figure represented the protective spirit of the Bugabo society, a healing and hunting association open to men and some women, and played a role in the initiation of new members.[1] During initiation rituals, "novices would place in the gourd certain secret items that would accumulate over time until the object acquired a power far greater than any of its parts."[2] The gesture of the female figure with hands to breasts may be related to the assertion by some Luba people that women hold the secrets of power within their breasts.[3] The meaning of the adze on top of her head is not known, but may reference the value of work or serve as an emblem of status.

A 1950s field photograph[4] shows that the flared base of this figure originally rested on top of the opening of the gourd (badly cracked and later repaired) and that the surface was encrusted.

—AN

Notes

1. Van Geluwe, in Vogel 1981, p. 225.

2. Roberts and Roberts 1996, p. 204; see also Van Geluwe, in Vogel 1981, p. 225.

3. Mary Nooter Roberts, e-mail to the author, August 31, 2006; also cited in Roberts and Saar 2000, p. 37.

4. Published in Van Geluwe, in Vogel 1981, p. 225.

Selected Bibiliography

A

Adams, Monni
1988 "Double Perspectives: Village Masking in Canton Boo, Ivory Coast," *Art Journal* 47 (2): 95–102.

Agovi, Kofi Ermeleh
1988 "The Aesthetics of Creative Communication in African Performance Situations," *Research Review* (new series, University of Ghana Legon) 4 (1): 1–9.

Anderson, Martha G. and Christine Mullen Kreamer
1989 *Wild Spirits, Strong Medicine: African Art and the Wilderness.* Exh. cat. New York: Center for African Art.

Anderson, Martha G. and Philip M. Peek (eds.)
2002 *Ways of the River: Art and Environment of the Niger Delta.* Exh. cat. Los Angeles: U.C.L.A. Fowler Museum of Cultural History.

Arens, W. and Ivan Karp (eds.)
1989 *Creativity of Power: Cosmology and Action in African Societies.* Washington, D.C. and London: Smithsonian Institution Press.

B

Barbier, Jean Paul (ed.)
1993 *Art of Côte d'Ivoire from the Collections of the Barbier-Mueller Museum.* Geneva: Barbier-Mueller Museum.

Bassani, Ezio and William B. Fagg
1988 *Africa and the Renaissance: Art in Ivory,* ed. Susan Vogel. Exh. cat. New York: Center for African Art, and Munich: Prestel.

Bastin, Marie Louise
1982 *La Sculpture tshokwe.* Meudon, France: Alain et Françoise Chaffin.

Becker, Rayda and Anitra Nettleton
 1989 "Tsonga-Shangana Beadwork and
 Figures." In *Catalogue: Ten Years of Collecting
 (1979–1989),* ed. David Hammond-Tooke and
 Anitra Nettleton. Exh. cat. Johannesburg:
 University of the Witwatersrand Art Galleries.

Beidelman, T.O.
 1993 "Secrecy and Society: the Paradox of
 Knowing and the Knowing of Paradox." In
 Mary H. Nooter, *Secrecy: African Art that
 Conceals and Reveals.* Exh. cat. New York:
 Museum for African Art, and Munich: Prestel.

Beier, H.U.
 1957 "Oshun Festival," *Nigeria Magazine* 53:
 170–83.

Ben-Amos, Paula Girshick
 1999 *Art, Innovation, and Politics in Eighteenth
 Century Benin.* Bloomington: Indiana
 University Press.

Bénézech, Anne Marie
 1988 "So-called Kuyu Carvings," *African Arts*
 22 (1): 52–59, 99.

C

Campbell, Kenneth F.
 1983 "Nsibidi Update/Nsibidi Actualise," *Arts
 d'Afrique Noire* 47 (1983): 33–46.

Carroll, Kevin
 1967 *Yoruba Religious Carving: Pagan and
 Christian Sculpture in Nigeria and Dahomey.*
 New York: Praeger.

Clarke, Christa
 2003 "Defining African Art: Primitive Negro
 Sculpture and the Aesthetic Philosophy of
 Albert Barnes," *African Arts* 36 (1): 40–51,
 92–93.

Clifford, James
 1988 *The Predicament of Culture: Twentieth
 Century Ethnography, Literature, and Art.*
 Cambridge, Mass. and London: Harvard
 University Press.

Cole, Herbert M.
 1985 "Introduction: The Mask, Masking, and
 Masquerade Arts in Africa." In *I Am Not Myself:
 The Art of African Masquerade,* ed. Herbert M.
 Cole. Museum of Cultural History Monograph
 Series, no. 26. Los Angeles: Museum of
 Cultural History, U.C.L.A.

 1989 *Icons: Ideals and Power in the Art of Africa.*
 Exh. cat. Washington, D.C. and London:
 Smithsonian Institution Press, for the National
 Museum of African Art.

Cole, Herbert M. and Chike C. Aniakor
 1984 *Igbo Arts: Community and Cosmos.* Exh.
 cat. Los Angeles: Museum of Cultural History,
 U.C.L.A.

Cole, Herbert M. and Doran H. Ross
 1977 *The Arts of Ghana.* Exh. cat. Los Angeles:
 Museum of Cultural History, U.C.L.A.

Collection Vérité
 2006 *Arts Primitifs, Collection Vérité.* Paris: Hôtel
 Drouot.

Coombes, Annie
 1991 "Ethnography and the Formation of
 National and Cultural Identities." In *The Myth
 of Primitivism: Perspectives on Art,* ed. Susan
 Hiller. London and New York: Routledge.

 1994 *Reinventing Africa: Museums, Material
 Culture and Popular Imagination in Late Victorian
 and Edwardian England.* New Haven and
 London: Yale University Press.

Curnow, Kathy
 1983 "The Afro-Portuguese Ivories:
 Classification and Stylistic Analysis of a Hybrid
 Art Form." Ph.D. dissertation. Bloomington:
 Indiana University.

D

D'Azevedo, Warren L. (ed.)
 1973 *The Traditional Artist in African Societies.*
 Bloomington and London: Indiana University
 Press.

Delange, Jacqueline
 1958 *L'Art de l'Afrique noire.* Preface by Michel
 Leiris. Exh. cat. Besançon, France: Palais
 Granvelle.

 1966 "Introduction." In *Arts Connus et Arts
 Méconnus de l'Afrique Noire: Collection Paul
 Tishman.* Exh. cat. Paris: Musée de l'Homme.

DeMott, Barbara Lois
 1982 *Dogon Masks: A Structural Study of Form
 and Meaning.* Studies in the Fine Arts, no. 4.
 Ann Arbor, Mich.: UMI Research Press.

Drewal, Henry John
 1980 *African Artistry: Technique and Aesthetics in
 Yoruba Sculpture.* Exh. cat. Atlanta: High
 Museum of Art.

Drewal, Henry John and John Pemberton III, with
Rowland Abiodun
1989 *Yoruba: Nine Centuries of African Art and
Thought,* ed. Allen Wardwell. Exh. cat. New
York: Center for African Art, in association
with Harry N. Abrams.

Drewal, Margaret Thompson
1977 "Projections from the Top in Yoruba Art,"
African Arts 11 (1): 43–49, 91–92.

DuChaillu, Paul B.
1867 *A Journey to Ashango-land: and Further
Penetration into Equatorial Africa.* New York:
D. Appleton.

Duponcheel, Christian
1980 "The Kwele." In *Masterpieces of the Peoples
Republic of the Congo.* Exh. cat. New York:
African-American Institute.

E

Ezra, Kate
1981 Exhibition review, "For Spirits and Kings:
African Art from the Paul and Ruth Tishman
Collection," *African Arts* 14 (4): 70–71.

1986 *A Human Idea in African Art: Bamana
Figurative Sculpture.* Exh. cat. Washington, D.C.:
Smithsonian Institution.

1988 *Art of the Dogon: Selections from the Lester
Wunderman Collection.* Exh. cat. New York:
Metropolitan Museum of Art.

2001 "The 'Traditional' Panels," *African Arts* 34
(3): 87.

F

Fagg, William
1980 *Yoruba Beadwork, Art of Nigeria.* New York:
Rizzoli, for Pace Editions.

Felix, Marc Leo
1987 *100 Peoples of Zaire and Their Sculpture:
A Handbook.* Brussels: Zaire Basin Art History
Research Foundation.

Felix, Marc Leo et al.
2003 *Kongo Kingdom Art.* Hong Kong: Ethnic
Art and Culture Limited.

Foss, Perkins
1981 "African Art from the Paul and Ruth
Tishman Collection," *African Arts* 15 (1):
28–37, 86.

2004 *Where Gods and Mortals Meet: Continuity
and Renewal in Urhobo Art.* Exh. cat. New York:
Museum for African Art, and Ghent, Belgium:
Snoeck-Ducaju and Zoon.

Foucault, Michel
1980 *Power/Knowledge: Selected Interviews and
Other Writings,* ed. Colin Gordon; trans. Colin
Gordon, Leo Marshall, John Mepham, and Kate
Soper. New York: Pantheon Books.

Fraser, Douglas and Herbert M. Cole
1972 *African Art and Leadership.* Madison:
University of Wisconsin Press.

Freyer, Bryna
1987 *Royal Benin Art in the Collection of the
National Museum of African Art.* Exh. cat.
Washington, D.C. and London: Smithsonian
Institution Press, for the National Museum
of African Art.

G

Garlake, Peter S.
1973 *Great Zimbabwe.* New York: Stein
and Day.

Gebauer, Paul
1964 *Spider Divination in the Cameroons.*
Publications in Anthropology no. 10.
Milwaukee, Wisconsin: Milwaukee Public
Museum Press.

Gell, Alfred
1998 *Art and Agency: An Anthropological Theory.*
Oxford: Clarendon Press.

Goldwater, Robert
1964 *Senufo Sculpture from West Africa.* Exh. cat.
New York: Museum of Primitive Art.

1986 [1938] *Primitivism in Modern Art* (enlarged
edition). Cambridge, Mass. and London:
Belknap Press of Harvard University Press.

Gollnhofer, Otto, Pierre Sallee, and Roger Sillans
1975 *Art et Artisanat Tsogho.* Paris: Office de la
Recherche Scientifique et Technique Outre-
Mer (ORSTROM), for the Musée des arts et
traditions du Gabon.

Greenberg, Joseph
 1963 "The Languages of Africa (Part 2)," *International Journal of American Linguistics* 29 (1).

Griaule, Marcel
 1938 *Masques dogons.* Paris: Institut d'ethnologie.

H

Harter, Pierre
 1972 "Les masques dit 'batcham,'" *Arts d'Afrique Noire* 3: 18–45.

 1986 *Arts anciens du Cameroon.* Arnouville, France: Arts d'Afrique Noire.

Herreman, Frank (ed.)
 2003 *Material Differences: Art and Identity in Africa.* Exh. cat. New York: Museum for African Art.

Himmelheber, Hans
 1997 *Masken der We und Dan Elfenbeinkuste.* Exh. cat. Zurich: Museum Rietberg.

Hinsley, Curtis M.
 1991 "The World as Marketplace: Commodification of the Exotic at the World's Columbian Exposition, Chicago, 1893." In *Exhibiting Cultures: The Poetics and Politics of Museum Display,* ed. Ivan Karp and Steven D. Lavine. Washington, D.C. and London: Smithsonian Institution Press.

Horton, Robin
 1965 *Kalabari Sculpture.* Apapa: Nigerian National Press, for the Department of Antiquities, Nigeria.

I

Imperato, Pascal James
 2003 "Tabouret rituel a quatre paires de personages ancestraux appeles nommo: Mali, autour de Bandiagara, Dogon." In *Sieges d'Afrique noire du musée Barbier-Mueller,* ed. Purissima Benitez-Johannot. Milan: 5 Continents, and Geneva: Musée Barbier-Mueller.

Israel Museum
 1967 *Masterpieces of African Art, Tishman Collection.* Exh. cat. Jerusalem: Israel Museum.

J

Jopling, Carol F. (ed.)
 1971 *Art and Aesthetics in Primitive Societies.* New York: E.P. Dutton.

K

Kerchache, Jacques, with Vincent Boulore (eds.)
 2001 *Sculptures: Africa, Asia, Oceania, Americas,* trans. into English by John O'Toole, Charles Penwarden and L-S Torgoff. Orig. French edition, *Sculptures: Afrique, Asie, Océanie, Amériques.* Exh. cat. (Musée du Louvre, 2000). Paris: Réunion des Musées Nationaux, 2000.

Klopper, Sandra and Karel Nel
 2002 "Kings, Commoners and Foreigners: Artistic Production and the Consumption of Art in the Southeast Africa Region." In *The Art of Southeast Africa from the Conru Collection.* Milan: 5 Continents.

Kreamer, Christine Mullen and Sarah Fee (eds.)
 2002 *Objects as Envoys: Cloth, Imagery and Diplomacy in Madagascar.* Exh. cat. Washington, D.C..: National Museum of African Art, in association with the University of Washington Press.

L

LaGamma, Alisa
 1996 "The Art of the Punu Mukudj Masquerade: Portrait of an Equatorial Society." Ph.D. dissertation. New York: Columbia University.

Lamp, Frederick
 1996 *Art of the Baga: A Drama of Cultural Reinvention.* Exh. cat. New York: Museum for African Art, and Munich: Prestel.

Lamp, Frederick (ed.)
 2004 *See the Music, Hear the Dance: Rethinking African Art at the Baltimore Museum of Art.* Exh. cat. Munich: Prestel.

Laude, Jean
 1971 *The Arts of Black Africa,* trans. Jean Decock. Berkeley, Calif.: University of

California Press. Orig. French edition, *Les Arts de l'Afrique Noire.* Paris: Livre de poche, 1966.

1973 *African Art of the Dogon.* Exh. cat. New York: Brooklyn Museum, in association with Viking Press.

Lawal, Babatunde
2000 "Orilonse: The Hermeneutics of the Head and Hairstyles among the Yoruba." In *Hair in African Art and Culture,* ed. Roy Sieber. Exh. cat. New York: Museum for African Art, and Munich: Prestel.

Leloup, Helene
1994 *Dogon Statuary.* Strasbourg: Editions Amez.

M

MacGaffey, Wyatt and Michael Harris
1993 *Astonishment and Power.* Exh. cat. Washington, D.C.: Smithsonian Institution Press, for the National Museum of African Art.

Malraux, André
1974 *La Tête d'obsidienne.* Paris: Gallimard.

Musée de l'Homme
1966 *Arts connus et arts méconnus de l'Afrique noire: Collection Paul Tishman.* Exh. cat. Paris: Musée de l'Homme.

N

National Museum of African Art
1999 *Selected Works from the Collection of the National Museum of African Art.* Washington, D.C.: National Museum of African Art, Smithsonian Institution.

Nettleton, Anitra
1988 "History and the Myth of Zulu Sculpture," *African Arts* 21 (3): 45–51, 86–87.

Nevadomsky, Joseph
1987 "Brass Cocks and Wooden Hens in Benin Art," *Baessler Archiv* 35: 221–46.

Neyt, François
1977 *La Grande Statuaire Hemba du Zaire.* Louvain-la-Neuve, Belgium: Institut Supérieur d'Archéologie et d'Histoire de l'Art.

Neyt, François and Louis de Strycker
1975 "Approches des Arts Hemba." *Arts d'Afrique Noire,* supplement to vol. 11. Villiers-le-Bel, France.

Northern, Tamara
1973 *Royal Art of Cameroon: The Art of the Bamenda-Tikar.* Exh. cat. Hanover, N.H.: Hopkins Center Art Galleries, Dartmouth College.

1984 *The Art of Cameroon.* Exh. cat. Washington, D.C.: Smithsonian Institution Traveling Exhibition Service.

P

Palmer, Colin
1992 "The Cruelest Commerce: African Slave Trade," *National Geographic* 182 (3): 62–91.

Perani, Judith and Fred T. Smith
1998 *The Visual Arts of Africa: Gender, Power and Life Cycle Rituals.* Upper Saddle River, N.J.: Prentice Hall.

Perrois, Louis
1985 *Ancestral Art of Gabon from the Collections of the Barbier-Mueller Museum.* Exh. cat. Geneva: Barbier-Mueller Museum.

1997 *L'Esprit de la forêt: Terres du Gabon,* ed. Louis Perrois. Exh. cat. Bordeaux: Musée d'Aquitaine, in association with Somogy Éditions d'art, Paris.

2001 "Art of the Kwele of Equatorial Africa," *Tribal Arts* 4 (Spring): 80–113.

Phillips, Tom (ed.)
1995 *Africa: The Art of a Continent.* Exh. cat. London: Royal Academy of Arts, and Munich: Prestel.

Picton, John
1994 "Sculptors of Opin," *African Arts* 27 (3): 46–59.

Poupon, Alfred
1918 "Étude ethnographique de la tribu kouyou," *L'anthropologie* 29: 53–88, 297–335.

Preble, Duane and Sarah Preble
2002 *Artforms: An Introduction to the Visual Arts,* revised by Patrick Frank. Saddle River, N.J.: Prentice Hall.

R

Rattray, R.S.
 1927 *Religion and Art in Ashanti*. Oxford: Oxford at the Clarendon Press.

Roberts, Allen F.
 1995 *Animals in African Art: From the Familiar to the Marvelous*. Exh. cat. New York: Museum for African Art, and Munich: Prestel.

Roberts, Mary Nooter and Alison Saar
 2000 *Body Politics: The Female Image in Luba Art and the Sculpture of Alison Saar*. Los Angeles: U.C.L.A. Fowler Museum of Cultural History.

Roberts, Mary Nooter and Allen F. Roberts (eds.)
 1996 *Memory: Luba Art and the Making of History*. Exh. cat. New York: Museum for African Art, and Munich: Prestel.

Ross, Doran H.
 1982 Book review, "For Spirits and Kings: African Art from the Paul and Ruth Tishman Collection," *African Arts* 15 (3): 12–15.

Ross, Doran H. (ed.)
 1992 *Elephant: The Animal and Its Ivory in African Culture*. Exh. cat. Los Angeles: Fowler Museum of Cultural History, U.C.L.A., 1992.

Roy, Christopher D.
 1987 *Art of the Upper Volta Rivers*. Meudon, France: Alain et Françoise Chaffin.

 2005 "Mossi Mask Styles as Documents of Mossi History," in *Art and Life in Africa Online* (http://www.uiowa.edu/~africart). Iowa City: University of Iowa.

S

Schildkrout, Enid and Curtis A. Keim (eds.)
 1998 *The Scramble for Art in Central Africa*. Cambridge, U.K. and New York: Cambridge University Press.

Schmalenbach, Werner (ed.)
 1988 *African Art from the Barbier-Mueller Collection, Geneva*. Munich: Prestel.

Sieber, Roy
 1969 "Collectors: Paul and Ruth Tishman," *Art in America* 57 (2): 50–61.

 1990 "Fierce or Ugly." In *Art as a Means of Communication in Pre-Literate Societies,* ed. Dan Eban, Erik Cohen, and Brenda Danet. Jerusalem: Israel Museum.

Sieber, Roy and Arnold Rubin
 1968 *Sculpture of Black Africa: The Paul Tishman Collection*. Exh. cat. Los Angeles: Los Angeles County Museum of Art.

Sieber, Roy and Roslyn A. Walker
 1988 *African Art in the Cycle of Life*. Exh. cat. Washington, D.C. and London: Smithsonian Institution Press, for the National Museum of African Art.

Siegmann, William C.
 1977 *Rock of the Ancestors*. Suakoko, Liberia: Cuttington University College.

Siroto, Leon
 1969 "Masks and Social Organization among the BaKwele People of Western Equatorial Africa." Ph.D. dissertation. New York: Columbia University.

 1995 *East of the Atlantic, West of the Congo: Art from Equatorial Africa*. The Dwight and Blossom Strong Collection. Exh. cat. San Francisco: Fine Arts Museum of San Francisco.

Soppelsa, Robert
 1990 "A *Mma* in the Metropolitan Museum of Art," *African Arts* 23 (3): 77–78, 104.

Steiner, Christopher B.
 1990 "Body Personal and Body Politic: Adornment and Leadership in Cross-Cultural Perspective," *Anthropos* 85: 431–45.

 1996 "Can the Canon Burst?" *Art Bulletin* 78 (2): 213–17.

 2002 "The Taste of Angels in the Art of Darkness: Fashioning the Canon of African Art." In *Art History and Its Institutions: Foundations of a Discipline,* ed. Elizabeth Mansfield. London and New York: Routledge.

Stocking, George W., Jr. (ed.)
 1985 *Objects and Others: Essays on Museums and Material Culture*. History of Anthropology, Vol. 3. Madison: University of Wisconsin Press.

T

Tardits, Claude
 2004 *L'Histoire singulière de l'art Bamoum*. Paris: Maisonneuve & Larose.

Thompson, Robert Farris
 1970 "The Sign of the Divine King: An Essay on Yoruba Bead-Embroidered Crowns with Veil and Bird Decorations," *African Arts* 3 (3): 8–17, 74–80.

1974 *African Art in Motion.* Los Angeles, Berkeley, and London: University of California Press.

Thompson, Robert Farris and Joseph Cornet
1981 *The Four Moments of the Sun: Kongo Art in Two Worlds.* Exh. cat. Washington, D.C.: National Gallery of Art.

Tishman, Paul
1966 [Collector's note]. In *Arts connus et arts méconnus de l'Afrique noire: Collection Paul Tishman.* Exh. cat. Paris: Musée de l'Homme.

1970 [Collector's note]. In "Special Addendum," *Sculpture of Black Africa: The Paul Tishman Collection,* p. VM-4. Exh. cat. Richmond: Virginia Museum.

U

Urbain-Faublée, Marcelle
1963 *L'Art malgache.* Paris: Presses Universitaires de France.

V

Visonà, Monica Blackmun
1983 "Art and Authority among the Akye of the Ivory Coast." Ph.D. dissertation. Santa Barbara: University of California.

Visonà, Monica Blackmun et al.
2001 *A History of Art in Africa.* New York: Harry N. Abrams.

Vogel, Susan
2006 "Whither African Art: Emerging Scholarship at the End of an Age," *African Arts* 38 (4): 12–17, 91.

Vogel, Susan (ed.)
1981 *For Spirits and Kings: African Art from the Paul and Ruth Tishman Collection.* Exh. cat. New York: Metropolitan Museum of Art.

1988 *The Art of Collecting African Art.* Exh. cat. New York: Center for African Art.

W

Walker, Roslyn Adele
1998 *Olowe of Ise: A Yoruba Sculptor to Kings.* Exh. cat. Washington, D.C.: National Museum of African Art, Smithsonian Institution.